Canon® EOS 5D
Digital Field Guide

Canon® EOS 5D Digital Field Guide

Charlotte K. Lowrie

WILEY

Wiley Publishing, Inc.

Canon® EOS 5D Digital Field Guide

Published by
Wiley Publishing, Inc.
10475 Crosspoint Blvd.
Indianapolis, IN 46256
www.wiley.com

Copyright © 2008 by Wiley Publishing, Inc., Indianapolis, Indiana

Published simultaneously in Canada

ISBN: 978-0-470-17405-0

Manufactured in the United States of America

10 9 8 7 6 5 4 3 2 1

For general information on our other products and services or to obtain technical support, please contact our Customer Care Department within the U.S. at (800) 762-2974, outside the U.S. at (317) 572-3993 or fax (317) 572-4002.

Wiley also publishes its books in a variety of electronic formats. Some content that appears in print may not be available in electronic books.

Library of Congress Control Number: 2008923601

WILEY

About the Author

Charlotte K. Lowrie is a professional editorial, portrait, and stock photographer and an award-winning writer based in the Seattle, Washington, area. Her writing and photography have appeared in newsstand magazines and books, advertisements, and commercial products as well as in photography exhibits. Her images have appeared on the Canon Digital Learning Center, and she is a featured photographer on www.takegreatpictures.com.

Charlotte is the author of eight books including the best-seller, the *Canon EOS Digital Rebel XTi Digital Field Guide*, and she is the coauthor of *Exposure and Lighting for Digital Photographers Only*. Charlotte also teaches photography classes at BetterPhoto.com. You can visit Charlotte's Web site at wordsandphotos.org.

Credits

Acquisitions Editor
Kim Spilker

Project Editor
Chris Wolfgang

Technical Editor
Marianne Wallace

Copy Editor
Lauren Kennedy

Editorial Manager
Robyn B. Siesky

Vice President & Group Executive Publisher
Richard Swadley

Vice President & Publisher
Barry Pruett

Business Manager
Amy Knies

Marketing Manager
Sandy Smith

Project Coordinator
Erin Smith

Graphics and Production Specialists
Alissa D. Ellet
Jennifer Mayberry
Shane Johnson

Quality Control Technician
Jessica Kramer

Proofreading
Broccoli Information Management

Indexing
Sherry Massey

*I dedicate this book with love to my mother,
Margie Kissler, whose love and support has seen
me through the best and worst of times, and to
Jesus Christ, the son of God — through
Him, all things are possible.*

Acknowledgments

My thanks to Chris Wolfgang and the fine editing team at Wiley. Thanks for your hard work, dedication, and support.

Introduction

Welcome to the Canon EOS 5D Digital Field Guide. With the introduction of the 5D, Canon offered the first lightweight, full-frame camera in a price range that made it ideal as either a backup body for the 1D-series cameras or a primary body. With the full-frame sensor, 5D photographers can take full advantage of their lenses with no focal-length conversion factor, so capturing the ambience of a bride and groom at the altar along with the sweep of the interior architecture is possible, as is capturing the breadth of a majestic landscape.

Like many professional photographers of my acquaintance, I originally bought the EOS 5D as a backup body for the EOS 1Ds Mark II. For me, the lightweight, full-frame sensor, stunning color, and image quality played heavily into the decision to buy the 5D. What I eventually discovered, however, is that the camera's ease of use, including its small and light footprint and the quality of images, made the 5D the camera that I often selected as the primary body for shooting portraits and weddings. If you've used other Canon digital SLRs, you'll find that the 5D sports some of the best and most usable features of those cameras, including a top LCD panel that puts commonly used controls just a finger's reach away, a no-foolishness Mode dial, a great, wide-angle-view LCD, and big text for menus.

While the 5D is not as speedy as the 1D's Mark II, it's lighter and, unlike its bigger EOS counterparts, many often-used functions thankfully do not require using both hands. With the EOS 5D, I spend less time with the lens pointed down using two hands as I do on other EOS cameras. Since the 5D lacks the extensive weather sealing of the 1Ds Mark III, I do hesitate to take it out for documentary shooting in bad weather. But it is a very capable camera for virtually every other shooting scenario.

The EOS 5D has a full complement of features that offer exceptional creative control and expression, all the while producing big, data-rich files that translate into stunning enlargements. Be sure to read the Professional Performance section in the Quick Tour for an overview of the features and functions that distinguish this digital SLR as a professional level tool.

Getting the Most from This Book

This book is designed to offer not only instruction on how to use the 5D, but also notes on my experience using the 5D for shooting assignments. But beyond that, I hope that this book will offer inspiration in a variety of photography specialty areas — areas in which the 5D performs with grace and style. Throughout this book, we assume that readers are advanced hobbyists and working professional photographers.

The first half of the book is devoted to not only setting the camera controls, but also to the effect of using different controls and settings during shooting. In addition, where possible, we point out ways to make workflow more efficient by setting up the camera for specific shooting venues. The 5D offers many opportunities to customize the function and use of the camera. Chapter 3 is a must-read if you want to get the best personalized performance from the camera. You'll also find discussions of Canon lenses and Speedlites. These chapters are designed as a quick reference, not an exhaustive compendium of lens test results and flash shooting techniques — both of which are book-length topics on their own.

The second half of the book concentrates on the primary specialty areas in which the EOS 5D is a stand-out performer. In addition to sample images and field notes, we offer an overview of the specialty area and current trends. The intent of this part of the book is to discuss camera performance and capability in various venues and provide workflow efficiency suggestions and comments. As with any area of photography, there are as many options, preferences, and opinions as there are photographers. The information provided here is one photographer's experience, and we hope that it is a springboard for your thinking and ongoing work.

I hope that this book is a rewarding journey for you in getting the best quality and most efficient shooting from the EOS 5D. And as every author hopes, I also hope that along the journey, you will be inspired and challenged in using the 5D to capture stunning, one-of-a-kind images. Regardless of the camera you use, it is the photographer who makes the picture. The EOS 5D is, at a minimum, a fine tool to help you achieve your photographic vision.

The editors, the staff at Wiley, and I hope that you enjoy reading and using this book as much as we enjoyed creating it for you.

Contents at a Glance

Acknowledgments . ix
Introduction . xi

Part I: Using the Canon EOS 5D . 1
Chapter 1: Exploring the Canon EOS 5D . 3
Chapter 2: Color and Picture Styles. 67
Chapter 3: Customizing the EOS 5D . 89

Part II: Lenses and Speedlites . 111
Chapter 4: Selecting and Using Lenses. 113
Chapter 5: Working with Canon EX Speedlites 131

Part III: Shooting with the EOS 5D. 145
Chapter 6: Event Photography. 147
Chapter 7: Nature, Landscape, and Travel Photography. 159
Chapter 8: Portait Photography . 183
Chapter 9: Stock and Editorial Photography. 203
Chapter 10: Wedding Photography . 215
Chapter 11: Canon Programs, Software, and Firmware 233

Part IV: Appendixes. 245
Appendix A: Canon CMOS Sensors and Image Processors 247
Appendix B: EOS 5D Specifications . 251
Glossary . 257

Index. 267

Contents

Acknowledgments ix

Introduction xi

Getting the Most from This Book xii

Part I: Using the Canon EOS 5D 1

Chapter 1: Exploring the Canon EOS 5D 3

Anatomy of the EOS 5D 4
 Camera controls 4
 Top camera controls 4
 Rear camera controls 7
 Front camera controls 10
 Camera terminals 10
 Side and bottom camera features 11
 Lens controls 11
 Viewfinder display 13
 Camera menus 14

Setting the Date and Time 14
Choosing the File Format and Quality 17
 JPEG capture 17
 RAW capture 18
Setting File Numbering 19
Creating Folders on the CF Card 22
Using the EOS 5D 23
 Full Auto 24
 Program AE 25
 Shutter-Priority AE 26
 Aperture-Priority AE 29
 Manual 30
 Bulb 31
 C (Register Camera Settings) 31
 AutoFocus and selecting AutoFocus modes 32
 Improving Autofocus accuracy and performance 36
Selecting a Metering Mode 38
 Evaluating the 5D's dynamic range 40
 Evaluating exposure 40
 Brightness histogram 40
 RGB histogram 41
Modifying Exposure 42
 Auto Exposure Lock 43
 AutoExposure Bracketing 45
 Exposure Compensation 47
Setting the ISO 49
 ISO range, expansion, and Custom Function options 50
 Setting the ISO and extended range ISO 53

Selecting a Drive Mode 55
 Single Shooting mode 55
 Continuous Drive mode 55
 Self-timer Drive mode 56
Viewing and Playing Back Images 57
 Playback display options 58
 Jump quickly among images 59
 Index display 60
 Auto Playback 61
Erasing Images 61
Protecting Images 62
Restoring the Camera's Default
 Settings 63
Cleaning the Image Sensor 64

Chapter 2: Color and Picture Styles 67

About Color Spaces 67
Choosing a Color Space 69
Understanding and Setting the
 White Balance 70
 Choosing a white balance
 approach 71
 Set a custom white balance 74
 Use White-Balance Auto
 Bracketing 77
 Set a White-Balance Shift 78
 Specify a color temperature 80
Choosing and Customizing a
 Picture Style 81
Registering a User-defined
 Picture Style 87

Chapter 3: Customizing the EOS 5D 89

Exploring Custom Functions 89
 C.Fn-01: Set function when
 shooting 90
 C.Fn-02: Long exp. noise
 reduction 91
 C.Fn-03: Flash sync speed in
 Av (Aperture-Priority) mode 91
 C.Fn-04: Shutter/AE Lock
 button 92
 C.Fn-05: AF assist beam 92
 C.Fn-06: Exposure level
 increments 92
 C.Fn-07: Flash firing 93
 C.Fn-08: ISO expansion 94
 C.Fn-09: Bracket sequence/
 Auto cancel 94
 C.Fn-10: Superimposed
 display 95
 C.Fn-11: Menu button
 display position 95
 C.Fn-12: Mirror lockup 96
 C.Fn-13: AF-point selection
 method 96
 C.Fn-14: E-TTL II 97
 C.Fn-15: Shutter curtain sync 97
 C.Fn-16: Safety shift in
 Av or Tv 98
 C.Fn-17: AF-point activation
 area 98
 C.Fn-18: LCD displ -> Return
 to shoot 99
 C.Fn-19: Lens AF Stop button
 function 99

C.Fn-20: Add original decision
data 99
C.Fn-00: Focusing screen 101
Sample Customizations 102
Registering Camera Settings 105

Part II: Lenses and Speedlites 111

Chapter 4: Selecting and Using Lenses 113

Understanding Canon Lenses 113
EF lens mount 114
Ultrasonic Motor 115
L-series lenses 115
Image Stabilization 116
Macro 116
Full-time manual focusing 116
Inner and rear focusing 116
Floating system 116
AF Stop button 117
Focus preset 117
Diffractive Optics 117
Prime versus Zoom Lenses 117
Single-focal-length lens
advantages 117
Single-focal-length lens
disadvantages 118
Zoom lenses 118
Zoom lens advantages 119
Zoom lens disadvantages 120
Using Wide-Angle Lenses 120
Using Telephoto Lenses 122
Using Normal Lenses 123
Using Macro Lenses 124
Using Tilt-and-Shift Lenses 125
Using Image-Stabilized Lenses 125
Exploring Lens Accessories 128
Extending the range of any
lens with extenders 128
Increasing magnification
with extension tubes and
close-up lenses 129

Chapter 5: Working with Canon EX Speedlites 131

Exploring E-TTL Technology 131
Choosing a Canon EX-series
Speedlite 133
Evaluating EOS 5D-
compatible Speedlites 134
Canon Speedlite Transmitter,
ST-E2 136
Using Speedlites 140
Flash Exposure
Compensation 140
Flash Exposure Bracketing 140
Flash Exposure Lock 140
High-speed sync 141

A Compendium of Flash
 Techniques 142
 Using a Speedlite as an
 auxiliary light 142
 Working with wireless
 multiple flash setups 143
 Balancing lighting extremes 144

Part III: Shooting with the EOS 5D 145

Chapter 6: Event Photography 147

Overview and Trends 147
Inspiration and Creative
 Resources 149
Packing Your Gear Bag 151
Shooting Events 153
A Compendium of Practical
 Advice 155

Chapter 7: Nature, Landscape, and Travel Photography 159

Overview and Trends 159
Inspiration and Creative
 Resources 160
Packing Your Gear Bag 162
Shooting Nature, Landscape,
 and Travel Images 166
 Using the characteristics of
 natural light 169
 Presunrise and sunrise 169
 Early morning to midday 170
 Presunset, sunset, and
 twilight 170
 Diffused light 173
 Exposure techniques for
 atypical scenes 174
 Shooting in lowlight 177
A Compendium of Practical Advice 177

Chapter 8: Portait Photography 183

Overview and Trends 183
Inspiration and Creative
 Resources 186

Packing Your Gear Bag 187
Shooting Portraits 189
 Making outdoor portraits 189
 Getting the best color 191
 Use C mode 192
 Making indoor portraits 193
 Window light 194
 Ambient interior and
 mixed light 195
 Studio lighting 197
A Compendium of Practical Advice 199

Chapter 9: Stock and Editorial Photography 203

Overview and Trends 203
Inspiration and Creative Resources 206
Packing Your Gear Bag 207
Shooting Stock and Editorial
 Images 209
A Compendium of Practical Advice 211

Chapter 10: Wedding Photography 215

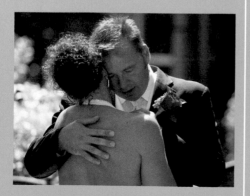

Overview and Trends 215
Inspiration and Creative Resources 219
 Slideshows and DVDs 219
 Printed and bound albums 220
Packing Your Gear Bag 220
Shooting Weddings 222
 Getting ready 223
 Capturing the ceremony 225
 Focus on the details, portraits,
 and the reception 227
 Details 227
 Portraits 228
 The reception 229
A Compendium of Practical Advice 230

Chapter 11: Canon Programs, Software, and Firmware 233

Characteristics of RAW Images 234
Choosing a RAW Conversion
 Program 236
Sample RAW Image Conversion 239
Creating an Efficient Workflow 241
Updating the 5D Firmware 243

Part IV: Appendixes 245

Appendix A: Canon CMOS Sensors and Image Processors 247

Canon-produced CMOS Sensors 247
 CCD sensors 248
 CMOS sensors 249
DiG!C II Image Processor 250

Appendix B: EOS 5D Specifications 251

Type 251
Image Sensor 251
Recording System 252
White Balance 252
Viewfinder 252
Autofocus 253
Exposure Control 253
Shutter 254
External Speedlite 254
Drive System 254
LCD Monitor 254
Playback 254
Image Protection and Erase 255
Power Source 255
Dimensions and Weight 255
Operating Environment 255

Glossary 257

Index 267

Using the Canon EOS 5D

◆ ◆ ◆ ◆

In This Part

Chapter 1
Exploring the Canon
EOS 5D

Chapter 2
Color and Picture Styles

Chapter 3
Customizing the
EOS 5D

◆ ◆ ◆ ◆

Exploring the Canon EOS 5D

In This Chapter

Anatomy of the EOS 5D

Setting the date and time

Choosing the file format and quality

Setting file numbering

Creating folders on the CF card

Using the EOS 5D

Selecting a metering mode

Modifying exposure

Setting the ISO

Selecting a drive mode

Viewing and playing back images

Erasing images

Protecting images

Restoring the camera's default settings

Cleaning the image sensor

The Canon EOS 5D is a star performer in terms of image resolution, quality, and camera handling. The 5D pioneered ease-of-use improvements that are now incorporated in the majority of Canon's EOS bodies, including the top LCD panel with key exposure settings; large, wide-angle view; detailed LCD; and large menu text, all of which translate into enabling you to make quick camera adjustments as you shoot.

Standard shooting modes are easy to move among on the Mode dial, and the camera offers the full complement of metering and drive-mode options for a range of shooting scenarios. ISO options, including ISO expansion, cover a broad range of lighting needs, and the noise performance is low to moderate even at the highest sensitivities. Depending on the ISO, the 5D's dynamic range — measured in f-stops or Exposure Values (EV), the range of dark to light values that the camera can maintain without clipping, or losing detail — runs from approximately 7-8 f-stops.

Note *Dynamic range figures have been adapted from Dave Etchells' testing of the EOS 5D on www.imaging-resource.com and from Phil Askey's 5D review on www.dpreview.com.*

Autofocus performance is quick with an elliptical distribution of nine visible autofocus (AF) points across a bright, optical viewfinder that provides a 96-percent view. The 5D delivers rich, saturated color using any of the seven preset white balance options, custom white balance, or by setting a specific color temperature. The 5D supports color-managed workflow with two color space options.

This chapter concentrates on the camera controls, menus, autofocus, and exposure options, as well as file quality and numbering, and usage and review notes.

Anatomy of the EOS 5D

Many of the EOS 5D controls are within a finger's reach for quick adjustments as you're shooting. Less frequently used functions are accessible only via the menus, and other controls require you to use two controls simultaneously. Regardless, using the controls is easy to master, particularly when you understand Canon's functional logic and grouping of controls.

Camera controls

The 5D groups commonly used functions in four main areas:

✦ **Mode dial.** This dial enables you to switch among five shooting modes as well as to use Bulb and the customizable C mode. Turn the Mode dial until the mode you want lines up with the white mark beside the dial. Each shooting mode is detailed later in this chapter.

✦ **LCD panel and buttons.** This panel and the buttons are on the top right of the camera. The buttons include focusing mode, white balance, drive mode, ISO, metering, and flash compensation. Each LCD panel button has two functions. To speed up adjustments, just remember that you use the

 • Main dial to control the first listed function

 • The Quick Control dial to adjust the second listed function

For example, if you press the AF-WB button, you turn the Main dial to select the AF mode, or you turn the Quick Control dial to select the WB setting. Also, when changing the settings on the LCD panel, you do not need to confirm changes by pressing the Set button. The settings you choose remain in effect until you change them, even if you turn off the camera.

✦ **Camera menus.** These are accessed by pressing the Menu button on the back top left side of the camera. Three tabs organize functions into Shooting (color-coded red), Playback (blue), and Set-up (yellow) groups. You move between menu tabs by pressing the Jump button, or you can scroll continuously using the Quick Control dial. The menu scroll bar is color-coded with menu tab colors. To display submenus, press the Set button located in the center of the Quick Control dial. If the menu expands further, you can use the Quick Control dial to scroll among options and the Set button to select and/or confirm a selection. Each menu and its options are detailed later in this chapter.

Top camera controls

Top camera controls provide ease of use so that the thumb and index finger of both the right and left hand control common adjustments quickly and without taking the camera out of shooting position. Moving from left to right, here is a look at the top camera controls.

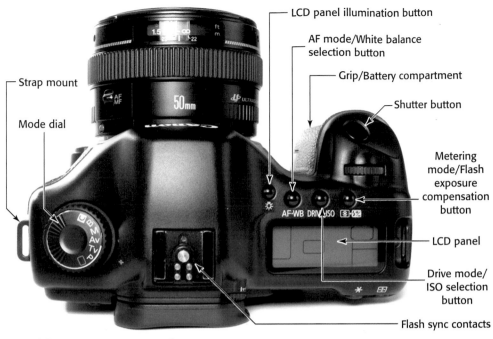

LCD panel illumination button

AF mode/White balance selection button

Grip/Battery compartment

Shutter button

Strap mount

Mode dial

Metering mode/Flash exposure compensation button

LCD panel

Drive mode/ ISO selection button

Flash sync contacts

1.1 EOS 5D top camera controls

✦ **Mode dial.** Rotate this dial to change the Shooting modes. Shooting modes determine how much control you have over the exposure. The dial provides fully automatic shooting with Full Auto, semi-automatic modes including P, Tv, and Av, full Manual, and the customizable C mode.

✦ **Flash sync contacts.** The hot shoe has standard dedicated flash contacts for mounting a Canon EX-series Speedlite or third-party flash unit. The flash sync speed is 1/200 second or slower, or it can be fixed at 1/200 second using C.Fn-03.

✦ **LCD panel Illumination button.** The LCD panel Illumination button, located to the left side of the LCD panel buttons, turns on an amber backlight so you can see the panel options in low-light or dark shooting situations. Pressing the button toggles the LCD panel light on and off. Otherwise, it stays illuminated for 6 seconds before turning off automatically.

✦ **LCD Panel and buttons.** Located behind the Shutter button, the LCD panel buttons and the LCD panel control and display frequently used exposure and metering settings and options. Options you change on the LCD panel are displayed only on the LCD panel, except for ISO and Flash Exposure Compensation adjustments which are simultaneously displayed in the viewfinder. The settings you choose remain in effect until you change them, even after turning off the camera.

Table 1.1 shows LCD panel buttons and options and the dials that you use to change the settings.

Table 1.1
Main and Quick Control Dials

Button	Main Dial	Quick Control Dial
AF-WB (Autofocus mode/White balance selection)	Autofocus mode • One-shot (locks focus with a half-press of the shutter button) • AI Focus AF (monitors subject movement and switches to AI Servo AF mode if the camera detects subject movement) • AI Servo AF (full-time predictive focus)	White Balance • Auto (3000 7000 degrees Kelvin [K]) • Daylight (5200 K) • Shade (7000 K) • Cloudy (6000 K) • Tungsten (3200 K) • Fluorescent (4000 K) • Flash (6000 K) • Custom (2000-10,000 K) • K (2800-10,000 K) *Note:* All temperatures are approximate
Drive-ISO (Drive mode/ ISO sensitivity)	Drive modes • Single-shot • Continuous • Self-timer (default: 10 sec.)	ISO options* • L (with C.Fn-08** Expansion turned on) • 100 • 125 • 160 • 200 • 250 • 320 • 400 • 500 • 640 • 800 • 1000 • 1250 • 1600 • 3200 (with C.Fn 08 Expansion turned on)
Metering mode-Flash exposure compensation	Metering modes • Evaluative (35-zone TTL full-aperture metering) • Partial (8 percent at center frame) • Spot (3.5 percent at center frame) • Center-weighted Average	Flash exposure compensation Plus/minus 2 stops EV in 1/3 or 1/2-stop increments (chosen using C.Fn-06)

* Details on the EOS 5D performance at both low and high ISO sensitivities are provided later in this chapter.
** See Chapter 3 to set Custom Functions.

✦ **Main dial.** This dial selects a variety of settings and options. Turn the Main dial to select options after pressing an LCD panel button, to manually select an AF point after pressing the AF point selection/Enlarge button, to set the aperture in Av and C modes, the shutter speed in Tv and Manual mode, and to shift the exposure program in P mode. Additionally, you can use the Main dial to scroll through the camera menus.

✦ **Shutter button.** Pressing the shutter button halfway sets the point of sharpest focus at the selected AF point in manual AF-point selection mode, and it sets the exposure. Unless you use Auto Exposure Lock, focus and exposure are always coupled at the selected AF point. Focus remains locked for approximately 4 seconds, after which time you have to refocus on the subject. Pressing the shutter completely makes the exposure. In any mode except direct printing, you can half-press the shutter button and dismiss camera menus and image playback.

Cross-Reference *See Chapter 5 for more information on using Canon Speedlites with the 5D and Chapter 3 for details on setting Custom Functions.*

Rear camera controls

The back camera controls provide quick access to the menu, various playback and image deletion controls, Picture Styles, and exposure information. They include the following:

✦ **Direct Print button.** When the camera is connected with a PictBridge, Canon CP Direct, or Canon Bubble Jet Direct-enabled printer and the camera is set to Print/PTP, this button in conjunction with the Playback button displays JPEG-only images for cropping, layout, and direct printing.

✦ **Menu button.** Press to display camera menus. Menus tabs and options are detailed later in this chapter.

✦ **Info button.** Press one or more times to change how images are displayed on the LCD during image playback. You can display images with no shooting information (default display); with file and filename, shutter speed, and aperture information overlaid on the LCD image; or with the image thumbnail, RGB histogram, and detailed shooting and file information.

✦ **Jump button.** When the camera menus are displayed, pressing this button moves among menu tabs, and sometimes displays submenus. In Playback mode, this button allows you to jump by 10 or 100 images at a time, or to jump by shot date, or folder. When jumping by multiple images, the camera overlays a scroll bar on the LCD image to show movement within the images stored on the CF card.

✦ **Playback button.** Displays or turns off the playback display of the images on the LCD. Pressing the AE Lock/FE Lock/Index button on the top right back of the camera during playback displays nine images at a time in a 3x3 image grid. You can scroll through the index display using the Quick Control or Main dials.

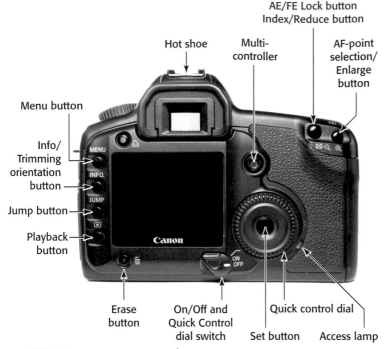

1.2 EOS 5D rear camera controls

✦ **Erase button.** Press to display options to delete the current or all images on the CF card. When you press the Erase button, the options are Cancel, Erase (current image only), or All (images on the CF card).

✦ **On/Off button.** There are three positions on the On/Off switch. Off does what it says it will do: It turns the camera off. In the On position, the camera limits the functionality of the Quick Control dial. The top-most position enables full functionality of the Quick Control dial.

✦ **Quick Control dial, Set button, Access lamp.** Turning this dial selects shooting-related settings and menu options. Inset within the

Quick Control dial is the Set button that serves as a menu selection and confirmation button, much like clicking OK in a computer program. To the lower-right side of the Quick Control dial is an access light that glows red when images are being written to the CF card.

✦ **Multi-controller.** The eight-way Multi-controller acts as a button when pressed and as a joystick when tilted in any direction. You can use it to select an AF point in conjunction with the AF-point selection/Enlarge button, select White balance correction, scroll around an enlarged image on the LCD, or to move the trim frame when printing directly from the camera.

✦ **AE Lock/FE Lock/Index/Reduce button.** On the back right side of the camera, the left button sets Auto Exposure (AE) or Flash Exposure (FE) lock, displays Index mode during image playback, or reduces the size of an enlarged LCD image during playback.

✦ **AF-point selection/Enlarge button.** This button turns on manual AF point selection and enlarges the playback image size. Both this button and the AE Lock button are press-and-hold buttons used in conjunction with the Main, Quick Control, or Multi-controller dials. For example, to manually select an AF point, you press and hold the AF-point selection/Enlarge button

and turn the Main, Quick Control, or Multi-controller dial to select the AF point you want.

✦ **Dioptric adjustment knob.** Located beside the viewfinder, turn this dial to adjust the sharpness of the scene in the viewfinder to suit your eyesight. The range of dioptric adjustment is -3 to +1 diopters. A white mark in the center of the knob shows the movement within the range. To set the dioptric adjustment, focus the lens by pressing the shutter halfway down, and then turn the knob until the image in the viewfinder is sharp. If you wear eyeglasses when shooting, be sure to wear them when setting the dioptric adjustment.

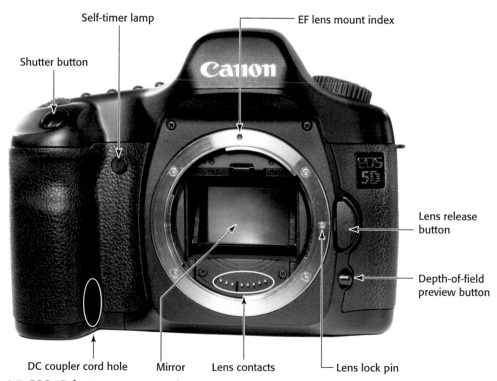

Self-timer lamp

EF lens mount index

Shutter button

Lens release button

Depth-of-field preview button

DC coupler cord hole Mirror Lens contacts Lens lock pin

1.3 EOS 5D front camera controls

Front camera controls

The front of the camera is one view of the camera that photographers seldom see. But there are lamps and connections that you'll use often. From left to right, the buttons and lamps on the front of the 5D include the following:

✦ **DC coupler cord hole.** Lifting this rubber flap allows you to connect the camera to household power using the option AC Adapter Kit ACK-E2, which provides a coupling unit that inserts into the battery compartment. This DC power option can come in handy for extended studio shooting or in the unlikely event of battery failure.

✦ **Self-timer lamp.** This red lamp flashes to count down the seconds to shutter release when the camera is set to Self-timer mode. More details on the Self-timer mode are included later in this chapter.

✦ **Depth-of-field preview button.** Pressing this button stops down the lens diaphragm to the aperture you've set to preview the depth of field in the viewfinder. The larger the area of darkness in the viewfinder, the more extensive the depth of field will be. At the lens's maximum aperture, the depth of field button cannot be depressed because the diaphragm is fully open. The aperture cannot be changed as long as the depth-of-field preview button is depressed.

✦ **Lens release button.** Pressing this button disengages the lens from the lens mount so that you can turn the lens to the right to remove it. Because the 5D uses the Canon EF lens mount, all EF lenses are compatible with the camera. EF-S lenses with the short back focus are incompatible with the 5D and should not be mounted on the camera. For details on Canon EF lenses, see Chapter 4.

Camera terminals

On the side of the 5D is a set of terminals under two rubber covers. Each cover is embossed with icons that identify the terminals underneath. The terminals include the following:

✦ **PC terminal.** This threaded terminal is under the first cover closest to the front of the camera body. The terminal connects a flash unit that uses a flash sync cord. The maximum sync speed with non-Canon flash units is 1/200 second. This type of flash unit can be used in concert with a Speedlite attached to the camera's hot shoe. The PC Terminal can also sync with various studio lighting systems. The maximum sync speed with studio lighting systems is 1/125 second.

✦ **Remote control terminal.** This N3-type terminal, also located under the front cover, connects with a remote control switch to fire the camera to avoid camera shake when shooting with telephoto and macro lenses, and when using Bulb exposures. The optional Remote Switch RS-80N3 replicates the functionality of the Shutter button providing half- and full depression of the Shutter button as well as Shutter-release lock.

PC terminal Digital terminal

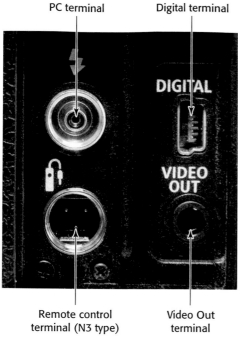

Remote control Video Out
terminal (N3 type) terminal

1.4 Camera terminals

✦ **Digital terminal.** Located under the second cover and at the top, the Digital terminal connects the camera to a compatible printer. The cable for direct printing comes with the printer, and printer cables must support PictBridge, PictBridge and CP Direct, PictBridge and Bubble Jet Direct, CP Direct only, or Bubble Jet Direct only.

✦ **Video Out terminal.** Located under the second cover and at the bottom, the Video Out terminal allows you to connect the camera to a television set using the video

cable provided in the 5D box. To view images on the camera's CF card on TV, turn off both the TV and the camera. Connect one end of the cable to the camera and the other end to the TV's Video In terminal. Then set the TV's line input to Video In, turn on the camera, and press the Play button on the camera.

Side and bottom camera features

On the opposite side of the terminals is the CF card slot and CF card eject button with standard insertion and ejection functionality. The bottom of the camera includes the release latch for the battery compartment, tripod socket, and the cover for the CR2016 lithium date and time battery.

 Note *The estimated life of the date and time battery is five years.*

Lens controls

All Canon EF lenses provide both autofocus and manual focusing functionality via the AF/MF (Autofocus/Manual Focus) switch on the side of the lens. If you choose manual focusing, the 5D provides focus assist to confirm sharp focus in the viewfinder. When sharp focus is achieved, the Focus confirmation light in the viewfinder burns steadily and the camera emits a focus confirmation beep.

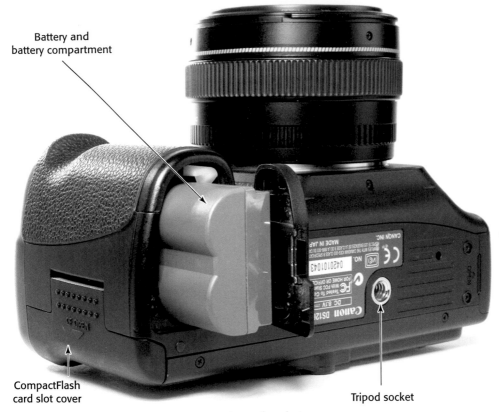

Battery and
battery compartment

CompactFlash
card slot cover

Tripod socket

1.5 Bottom camera covers, compartments, and sockets

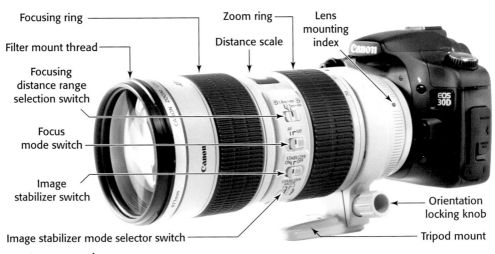

Focusing ring

Filter mount thread

Focusing
distance range
selection switch

Focus
mode switch

Image
stabilizer switch

Image stabilizer mode selector switch

Zoom ring

Distance scale

Lens
mounting
index

Orientation
locking knob

Tripod mount

1.6 Lens controls

Depending on the lens, additional controls may include the following:

✦ **Focusing distance range selection switch.** This switch can be set to one of two settings to limit the range that the lens uses when seeking focus, and thereby to speed up autofocusing. The focusing distance range varies by lens.

✦ **Image stabilizer switch.** This switch turns optical image stabilization on or off. Optical Image Stabilization (IS) compensates for vibrations at any angle when you're handholding the camera and lens. IS lenses typically allow sharp images up to one or two f-stops over the lens's maximum aperture.

✦ **Image stabilizer mode switch.** Offered on some telephoto lenses, this switch offers two modes: one for standard shooting and one for use when panning at right angles to the camera's panning movement.

✦ **Focusing ring and zoom ring.** The focusing ring can be used at any time regardless of focusing mode. On zoom lenses, the zoom ring zooms the lens in or out at the focal lengths marked on the ring.

✦ **Distance scale and Infinity compensation mark:** Shows the lens's minimum focusing distance to infinity. The Infinity compensation mark compensates for shifting the infinity focus point resulting from changes in temperature. You can set the distance scale slightly past the infinity mark to compensate.

 Cross-Reference *For more detailed information on Canon lenses, see Chapter 4.*

Viewfinder display

The 5D offers an eye-level pentaprism viewfinder that displays approximately 96 percent of the vertical and horizontal coverage. Etched into the viewfinder are nine visible AF points. When you change AF points, the viewfinder displays each AF point in red as you press the Multi-controller or turn the Main or Quick Control dial. When you press the shutter button halfway down to focus, the selected AF point is displayed in red in the viewfinder. The Spot meter circle, approximately 3.5 percent of the viewfinder at center, is also etched in the center of the focusing screen.

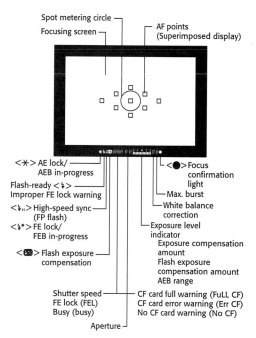

1.7 EOS 5D viewfinder display

In all but Full Auto mode, the viewfinder displays pertinent exposure information, including AE Lock, AE Bracketing (AEB) progress, Flash ready, Flash mode and bracketing progress, flash exposure compensation, shutter speed and Flash Exposure (FE) Lock, aperture, the exposure level indicator with exposure compensation, flash exposure compensation, and AEB range, White balance correction, maximum burst, and a focus confirmation light.

Camera menus

While the LCD panel and the controls on the body of the 5D provide much of the functionality for standard shooting, the camera menus offer other functions. For quick reference, the following tables show the menus and the options for each camera menu option.

Setting the Date and Time

While setting the date and time seems like a basic task that professional photographers do first when setting up the 5D, I include it here for photographers who are switching from film to digital and for those who are just beginning to set up a workflow. As most veteran digital photographers know, setting the date and time impacts workflow in numerous ways. After image capture, the image date and time figures into everything from file naming and file sorting on the computer, to file storage and backup schemes. As a result, ensuring that the date and time are set correctly helps to ensure a smooth and consistent workflow.

Table 1.2
Shooting Menu (Red)

Command	Options
Quality	Large/Fine, Large/Normal, Medium/Fine, Medium/Normal, Small/Fine, Small/Normal, *RAW, or *RAW + any one of the JPEG image quality settings
Beep	On/Off
Shoot without a card	On/Off
*AEB (Auto Exposure Bracketing)	1/3-stop increments, plus/minus 2 stops
*WB SHIFT/BKT (White balance shift/bracketing)	9 levels of Blue/Amber (B/A) and Magenta/Green (M/G) color bias. B/A and M/G bias 1 level, plus or minus 3 levels
*Custom WB	Set a manual white balance
*Color temp.	2800 to 10,000K in 100K increments
*Color space	sRGB, Adobe RGB
*Picture Style	Standard, Portrait, Landscape, Neutral, Faithful, Monochrome, User Defined 1, 2, and 3

* These menu items are not displayed when the camera Mode dial is set to Full Auto mode.

Table 1.3
Playback Menu (Blue)

Command	Options
Protect	Protect image
Rotate	Manually rotate image by 90-270 degrees clockwise for playback only
Print order	Select images to be printed (Digital Print Order Format or DPOF)
Auto play	Hands-free playback images as an LCD slideshow
Review time	Off; 2, 4, or 8 sec. or Hold
AF points	Display, Not display
Histogram	Bright. (displays Brightness values), RGB (displays separate Red, Green, Blue color channels)

Table 1.4
Set-up Menu (Yellow)

Command	Options
Auto Rotate	On/Off (when enabled, images shot in the vertical format will be displayed in the correct orientation on LCD)
LCD brightness	Five adjustable levels for the LCD backlight
Date/Time	Sets the date and time and the format for the date and time
File numbering	Continuous, Auto reset, Manual reset
Select folder	Allows you to select an existing folder or create new folders on the CF card
Language	Choose from 15 languages
Video system	NTSC/PAL
Communication	Print, PTP, PC connect
Format	Initializes and erases images on CF card
*Custom Functions (C.Fn)	21 options to customize the operation of the camera
*Clear Settings	Clear all camera settings (restore camera defaults) Clear all Custom Functions (restore all Custom Functions defaults) Clear registered camera set (resets the C mode on the Mode dial to the camera's defaults)
*Register camera	Register current camera settings to the C setting on the Mode dial settings

Continued

Table 1.4 (continued)

Command	Options
*Sensor cleaning	Raises and holds the reflex mirror up for sensor cleaning
Image transfer (LAN) settings	Displayed only when Wireless File Transmitter WFT-E1/E1A is used
*Firmware Ver. (Firmware Version)	Displays the existing firmware version number, and enables firmware updates

* These menu items are not displayed when the camera Mode dial is set to Full Auto mode.

When you set the date and time, the data travels with each image file as part of the *metadata*. Metadata is a collection of all the information about an image, including the filename, date created, size, resolution, color mode, camera make and model, exposure time, ISO, f-stop, shutter speed, lens data, and white balance setting, among other information.

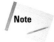 **Note** *EXIF, a term often used interchangeably with metadata, is a particular form of metadata.*

Because you have access to the metadata in Adobe Bridge, Photoshop, Canon Digital Photo Professional, and other editing programs, you can do batch file renaming and include the date in the filename. File naming strategies vary by photographer, but most incorporate the date or date and time in both folder and file naming on all devices they use, including handheld drives, computers, mass storage drives, and DVDs.

With the 5D, you can set the format for date and time file naming, and then use that format for subsequent file and folder naming on all devices. This approach helps maintain consistency across devices and avoids the need to rename folders on the devices.

To set the date and time:

1. **Press the Menu button, and then press the Jump button until the Set-up (yellow) menu is displayed.**

2. **Turn the Quick Control dial clockwise to highlight Date/ Time, and then press the Set button.** The camera displays the date and time options with the month option activated.

3. **Press the Set button, and then turn the Quick Control dial to change the month.** Turn the Quick Control dial clockwise to move to a higher number, and vice versa.

4. **Press the Set button to confirm the change.**

5. **Turn the Quick Control dial clockwise to highlight the day option, and then press the Set button.**

6. **Turn the Quick Control dial to change the day, and then press the Set button to confirm the change.** Repeat steps **5** and **6** to change the year, minute, second, and date/time format options.

7. **Turn the Quick Control dial to select the date format, mm/dd/yy, and then press the Set button.**

8. **Turn the Quick Control dial to change the date format.** Turning the Quick Control dial clockwise, the options are mm/dd/yy, yy/mm/dd, or dd/mm/yy.

9. **When all options are set, turn the Quick Control dial to select OK, and then press the Set button.**

Tip *If you travel to different time zones, you may want to change the date and time to reflect those of the area where you are shooting.*

Choosing the File Format and Quality

The file format you choose determines whether the images are stored on the CF card in JEPG or in RAW format. And the quality level you choose determines the number of images you can store on the card, as well as the overall image quality and the sizes at which you can enlarge and print images.

Your choice of file format and quality may be assignment-and/or output-specific. For example, I shoot RAW images during wedding preparations, the ceremony, and for the formal portraits, but then I often switch to Large/Fine JPEG format for the reception because I know that these images will likely be printed no larger than 5x7 inches. But for most other assignments, I shoot only RAW images to get the highest image quality and to have the widest latitude for converting and editing images.

If you are making the switch from film to digital photography, or if you have always shot JPEG images, it's worthwhile to briefly outline differences between JPEG and RAW capture.

JPEG capture

JPEG, which stands for Joint Photographic Experts Group, is a lossy, but a highly portable file format that enables you and your clients to view the images on any computer platform. But the lossy file format means that some image data is discarded while compressing image data to reduce file size for storing images on the CF card. Because JPEG images are compressed to a smaller file size, more images can be stored on the CF card. However, as the compression ratio increases, more image data is discarded and the image quality degrades accordingly. Additional image data is discarded each time you save the file when you edit JPEG images on the computer.

In addition to loosing image data during compression, JPEG files are automatically converted from 12- to 8-bit, and are processed — or pre-edited — by Canon's internal hardware/software before they are stored on the CF card. As a result of the low bit-depth and preprocessing, color in general, and skin tones in particular, as well as subtle tonal gradations suffer. By the time you get the JPEG image on the computer, you have less latitude for editing with moves in tones and color becoming exaggerated by the lower bit depth.

However, the JPEG format enjoys universal acceptance, which means that the images can be displayed on any computer, opened in any image-editing program, and can be printed directly from the camera or the computer.

If you choose the JPEG format, then you can choose among different image sizes and among two compression ratios ranging from low (denoted as "Fine") compression to high (denoted as "Normal").

RAW capture

RAW files are stored in a proprietary format that does not discard image data to save space on the CF card. Because the images are stored in a proprietary format, they can be viewed only in programs that support Canon's .CR2 file format. RAW files save the data that comes off the image sensor with little internal camera processing. Because many of the camera settings have been "noted" but not applied to the data in the camera, you have the opportunity to make changes to key settings such as exposure, white balance, contrast, and saturation when you convert the RAW files on the computer. The only camera settings that the camera applies to RAW files are ISO, shutter speed, and aperture.

This means that during RAW image conversion, you control the image rendering including the colorimetric rendering, tonal response, sharpening, and noise reduction. Plus you can take advantage of saving images in 16-bits per channel when you convert RAW images versus the low, 8-bit depth of JPEG images. In a nutshell, the higher the bit depth, the finer the detail, the smoother the transition between tones, and the higher the dynamic range (the ability of the camera to hold detail in both highlight and shadow areas) in the image.

In short, with JPEG capture, the camera processes the image according to the exposure and image parameters set in the camera, converts the image from 12-bits to 8-bits per channel, and then compresses the file as a JPEG — a process that discards image data and introduces unwanted artifacts to the file. The result is a pre-edited and much less robust file than a RAW file. In the process of converting files to 8-bits per channel, image data such as levels of brightness that you may need and want during image editing is permanently discarded.

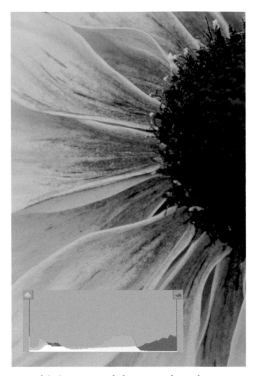

1.8 This image and the next show how dramatically the histogram changes from an 8-bit image, shown here, to a 16-bit image. Notice the spike on the right side of the histogram that indicates potential clipping in the Red channel highlights as well as clipping in the shadows shown on the spike on the left side of the histogram.

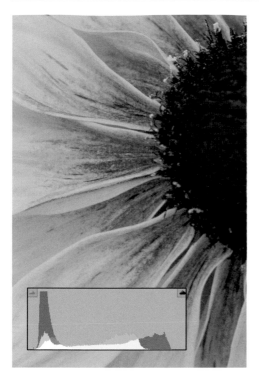

1.9 The inset histogram on this image shows a 16-bit rendering of the file. Notice that the image is slightly underexposed but there are no spikes on the right or left to indicate clipping or discarding of pixels in the image.

Conversely, when you choose RAW capture, you postpone the processing of image data, and you retain the ability to decide for yourself whether to preserve or discard tonal levels, decide how you want the color interpreted, and much more.

The choice of format is yours, of course. If you want to learn more about shooting and converting RAW images, be sure to read Chapter 12. And for an overview of the difference in color richness between JPEG and RAW capture, see Chapter 2.

Table 1.5 shows the file format and quality options that you can choose on the 5D.

Setting File Numbering

Regardless of whether or how file numbering figures into your image workflow, the 5D offers enough options to please almost any photographer. The 5D's default for continuous file numbering is the top choice for many photographers because continuous file numbers are often an integral part of the image naming logic for filing, sorting, and archiving images. But in addition to continuous file numbering, you can choose to reset file numbering automatically or manually. File numbering also affects folder creation and structure on the CF card. The next section in this chapter details creating and selecting a folder on the CF card.

> **Note** File names begin with the designation IMG_ followed by the image number and file extension: .JPG for JPEG files, or _MG_ followed by the image number and file extension .CR2 for RAW images.

✦ **Continuous.** With Continuous numbering, images are numbered sequentially using a unique four-digit number from 0001 to 9999. With unique filenames, managing and organizing images on the computer is easy because you don't have to worry about images having duplicate filenames. If you insert a CF card that already has images on it taken with the 5D, then the camera starts numbering with the highest number that is either used on the stored images on the card, or that was last captured. Continuous file numbering is the default setting on the 5D.

What is bit-depth and should you care?

A digital picture is made up of many pixels. Each pixel is made up of a group of bits, the smallest unit of information that a computer can handle. In digital images, each bit stores information that when aggregated with other pixels and color information, provides an accurate representation of the picture.

Since digital images are based on the Red, Green, Blue (RGB) color model, an 8-bit digital image has eight bits of color information for red, eight bits for green, and eight bits for blue. This gives a total of 24 bits of data per pixel (8 bits × 3 color channels). Because each bit can be one of two values, either 0 or 1, the total number of possible values is 2 to the 8th power, or 256 per color channel.

In the RGB color model, the range of colors is represented on a continuum from 0 (black) to 255 (white). On this continuum, an area of an image that is white (with no image detail) is represented by 255R, 255G, and 255B. An area of the image that is black (with no detail) is represented by 0R, 0G, 0B.

An 8-bit file offers 256 possible colors per channel. A 12-bit file, offered with 5D RAW capture, provides 4,096 colors per channel. And then if you save the 12-bit RAW file as a 16-bit file during RAW conversion, the image provides 65,000 colors per channel.

This is important because the higher the bit depth in the file, the finer the detail, the smoother the transition between tones, and the higher the dynamic range (the ability of the camera to hold detail in both highlight and shadow areas) in the final converted and edited image.

Table 1.5
EOS 5D File Format and Quality

Image Quality	Approximate Recording and Print Sizes	Image Size (Pixels)	Format	Approximate File Size	Maximum Burst
L (Large/ *Fine)	Records images at approximately	4368x2912	.JPG	** ***4.6 MB	60
L (Large/ Normal)	12.7 megapixels			2.3 MB	150
M (Medium/ Fine)	Records images at approximately 6.7 megapixels	3168x2112		2.7 MB	120
M (Medium/ Normal)				1.4 MB	319
S (Small/ Fine)	Records images at approximately 4.2 megapixels	2496x1664		2.0 MB	200
S (Small/ Normal)				1.0 MB	446

Image Quality	Approximate Recording and Print Sizes	Image Size (Pixels)	Format	Approximate File Size	Maximum Burst
RAW	Records images at approximately 12.7 megapixels with no image degradation from compression	4368x 2912	.CR2	12.9 MB	17
******RAW +JPEG**	Simultaneously records RAW images at approximately 12.7 megapixels together with the JPEG image quality you select	4368 x 2912 for the RAW image plus the size JPEG you select	.CR2 + JPEG	12.9 MB + the size JPEG you select	12

* Fine and Normal denote different levels of compression for JPEG images. A lower rate of compression is applied to Fine than to Normal designations. The lower the compression rate, the better the image quality and also the larger the file size.

** If you're shooting in Monochrome Picture Style, image file sizes are smaller than indicated in this table.

*** The image size and maximum number of images during continuous shooting vary by ISO, shutter speed, subject, shooting mode, and Picture Style.

**** RAW and JPEG images are saved using the same file number in the same folder. They are distinguished by the file extension.

✦ **Auto Reset.** If you use Auto Reset, both file and folder numbering restarts when you insert another CF card. If you prefer to organize images by CF card, then Auto Reset is a useful option. Folder numbers begin with 100, and file numbering begins with 0001, unless the CF card contains a previous image, in which case, numbering begins with the highest file number in the highest numbered folder on the CF card. However, multiple images will have the same filename. Because of this, you should create separate folders on the computer and other devices for each download and otherwise follow scrupulous folder organization to avoid filename conflicts and potential overwriting of images on the computer.

✦ **Manual Reset.** The third option is to manually reset file numbering. With this option, a new folder is created with the next higher number than the last and the file number restarts with 0001. Subsequent images are saved in the new folder. Whichever file numbering method you previously used (Auto Reset or Continuous) takes effect when you take additional images.

To change the file numbering method on the EOS 5D:

1. **Press the Menu button, and then press the Jump button until the Set-up (yellow) menu is displayed.**

2. **Turn the Quick Control dial to highlight File numbering, and then press the Set button.** The File numbering options appear.

3. **Turn the Quick Control dial to select Auto Reset, or Manual Reset, or highlight Continuous if another option was previously set.**

4. **Press the Set button.**

Creating Folders on the CF Card

Related to image file naming is a system for naming folders on the CF card. Creating CF card folders is one of the early steps in managing image workflow. Establishing a consistent folder naming system can help make image downloading and archiving more seamless within the total structure of your folder and file-naming scheme. And, at the very least, CF folders help you organize files by shoot or segment during extended shooting or multiple assignments.

You have a choice in how you create folders on the CF card. You can create folders on the camera and let Canon give each folder a number, such as the initial 100EOS5D folder. Alternately, you can create the CF-card folders on the computer. But if you're in a hurry, or you're in the field without a laptop, creating folders using the camera's default folder names is better than pitching

all the images into the default folder that the camera creates.

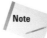 **Note** *If you use Continuous file naming, the folder maximum is 9,999 images. When you reach that number, the camera displays a "Full" warning whether or not the CF card has additional space on it. Then the camera automatically creates a new folder to save subsequent images. It's a good idea to create additional folders on the CF card in advance so you can maintain your preferred folder naming structure.*

If you create folders on the computer, you'll find that the file naming structure set by Canon isn't especially flexible, but it is usable.

Here is the general process and the rules for creating folders on the CF card on the computer:

1. **Create a folder named DCIM.** Create subfolders within it.

2. **Begin naming the subfolders with three digits from 100 to 999.** Note that you cannot use the same three digital for two folders regardless of whether the text following the numbers is different.

3. **Add five text letters from A to Z in upper and/or lower case.** You can use an underscore as one of the letters.

4. **Do not include spaces in the filename.**

Thus a folder name might be 408BSL_A, where the digits denote the month and year, the letters abbreviate the client's name, and the trailing letter indicates folder A in a series of multiple folders for a single shooting session.

For my folder naming system, the restrictions on the numerals means that I cannot create multiple folders that begin with the session date (mm/yy) because the same sequence of numbers can't be repeated across multiple folders. An alternate strategy is to create folders using a session numbering strategy, or some similar logic.

While the naming convention lacks flexibility, Canon doesn't skimp on the number of folders that you can create. If you're so inclined, you can create up to 900 folders.

To create a new folder on the CF card using Canon's default folder naming, or to select an existing folder on the CF card:

1. **Press the Menu button, and then press the Jump button until the Set-up (yellow) menu is displayed.**

2. **Turn the Quick Control dial to highlight Select Folder, and then press the Set button.** The Select folder screen appears with the default folder selected along with a Create folder option. Existing folders show the number of images contained in them on the right of the screen.

3. **Turn the Quick Control dial to select Create folder, and then press the Set button.** The camera displays a confirmation message asking if you want to create folder 101 where the final number is the next highest file folder number. Successive folder names are incremented by one digit.

4. **Select OK, and then press the Set button.** The camera displays the Create folder screen where you can create another folder, or select an existing folder.

5. **Select the folder you want, or choose the Create folder option to create another folder.** To return to shooting, lightly press the Shutter button.

To create and name folders on your computer, follow these steps:

1. **Insert the CF card inserted into a card reader, and then navigate to and open the CF on your computer.**

2. **Create a new folder named DCIM on the CF card.**

3. **Open the DCIM folder.**

4. **Create a new folder within the DCIM folder and name it using Canon's naming guidelines.** Folder names must use three digits from 100 to 999 followed by five upper and/or lowercase letters. You can use an underscore as one of the five letters. Do not use spaces in the folder name.

5. **Insert the CF card in the camera, and then follow the steps in the previous section to select the folder that you want.**

Using the EOS 5D

The 5D Mode dial offers a Full Auto mode, as well as the traditional shooting modes that you've grown to know and love including Program AE (P), Shutter-Priority (Tv), Aperture-Priority (Av), and Manual (M) modes. In addition, the 5D features Bulb (B) along with Camera User Setting, denoted as "C" on the Mode dial.

Full Auto, denoted as a green rectangle on the Mode dial, offers camera-controlled automatic exposure and focusing. P, Tv, and Av modes offer semiautomatic exposure control. As the name implies, Manual mode (M) offers full manual control over exposures. Bulb, while usually categorized as a shutter speed rather than as a shooting "mode," keeps the shutter open as long as the Shutter button is fully pressed.

The following sections describe each mode. To use any of the shooting modes:

1. **Turn the Mode dial and line up the mode you want with the white mark on the camera body next to the dial.**

2. **Set the aperture, shutter speed, or both depending on the mode you choose, except for Full Auto mode.**

Full Auto

In Full Auto mode, the camera automatically sets the image quality, exposure, drive mode, autofocus mode, AF point(s), white balance, and Picture Style. In short, Full Auto mode provides point-and-shoot functionality. In this mode, the camera settings are as follows:

✦ **Image quality:** Large/Fine JPEG

✦ **Color space:** sRGB

✦ **ISO:** Auto

✦ **White balance:** Auto (AWB)

✦ **Drive mode:** Single Shot

✦ **Metering mode:** Evaluative

✦ **Focus mode:** AI Focus. In automatic focus mode, the camera focuses on the closest subject with

readable contrast. If the subject is large enough to cover more than one AF point, it may choose multiple AF points for autofocusing.

The only option that you can select in Full Auto mode is whether to use the Self-timer drive mode.

At first blush, Full Auto mode would appear to be a handy mode for grab shots. But my experience shows that it is questionable in that capacity for two primary reasons. First, the camera too often sets an unnecessarily aggressive ISO, usually ISO 400, even in bright light, and it does so annoyingly often. If your goal is to maintain the highest image quality possible, and you know that a lower ISO setting provides better overall image quality, then this is the first strike against using Full Auto mode.

Second, autofocus is controlled entirely by the camera. Automatic AF-point(s) selection ranges from the camera choosing a single AF point on an area of the subject that is closest to the lens, to selecting multiple AF points. This usually means that in a portrait, the subject's nose, which is closest to the lens and has readable contrast, is tack sharp while the eyes are a bit soft. This, of course, is not what you want.

The camera displays the selected AF points in red in the viewfinder, so you can see where the camera will set the point of sharpest focus. If the camera doesn't set the point of sharpest focus where you want, you can try to force it to choose a different AF point by moving the camera position slightly one or more times. But after all is said and done, you can save time by switching to another mode and setting the correct AF point yourself.

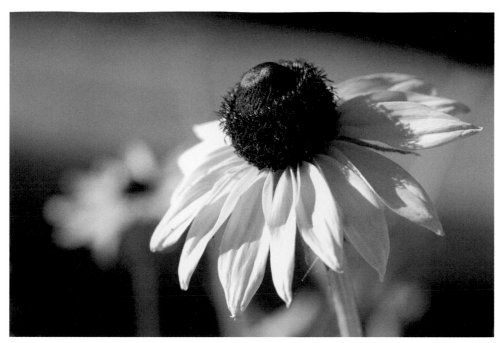

Figure 1.10 Despite bright light in Full Auto mode, the camera set ISO 400 for this shot. To get the AF points toward the top left of the flower, I had to move the camera several times until it chose my desired focus points. Exposure: ISO 400, f/6.3, 1/500 sec. EF 100mm f/2.8 USM lens.

Program AE

Program AE mode, denoted as P on the Mode dial, is an automatic but "shiftable" mode. Shifting means that you can change the camera's recommended exposure to an equivalent exposure. When you turn the Main dial to shift the aperture, the camera automatically adjusts the shutter speed. For example, if the camera initially sets the exposure at f/2.8 at 1/30 second, and you turn the Main dial one click to the left to shift the program, the exposure shifts to f/3.2 at 1/20 second. Turning the Main dial to the right shifts the exposure to f/4.0 at 1/15 second, and so on.

This mode allows you to control the aperture and/or shutter speed with a minimum of manual adjustments. After you shift the exposure and make the picture, the camera then automatically reverts back to its automatic settings for the next image.

The advantage of Program AE mode over Full Auto mode is that you have full control over the camera settings so that you can shoot JPEG or RAW, or RAW+JPEG images, set the color space, ISO, White Balance, and the Drive, Metering, and Autofocus modes, and manually select the AF point.

Program AE Mode versus Full Auto Mode

If you like control and the convenience combined with some automation, Program AE mode provides a good balance, particularly for opportunistic grab shots. Following are the settings that you can control in Program AE mode but cannot control in Full Auto mode.

✦ **Shooting settings.** AF mode and AF-point selection, drive mode, ISO, metering mode, program shift, exposure compensation, AEB, AE lock, depth-of-field preview, register camera settings, clear all camera or clear registered camera settings, Custom Function and Clear All Custom Functions, and sensor cleaning

✦ **EX-series Speedlite settings.** Manual/stroboscopic flash, high-speed sync (FP flash), FE lock, flash ratio control, flash exposure compensation, FEB, second-curtain sync, and modeling flash

✦ **Image-recording settings.** RAW and RAW+JPEG Large selection, Picture Styles selection and customization, color space, white balance, custom white balance, white balance correction, white balance bracketing, and color temperature setting

P mode is the mode that makes sense for grab shots at a wedding, an event, or for personal family snapshots. Typically, you'll already have the camera set to your preferred drive and metering modes, color space, image quality, etc. so switching to P mode offers the advantage of semiautomated shooting. With a quick turn or two of the Main dial you can shift to a more desirable shutter speed or aperture and begin shooting.

Shutter-Priority AE

Shutter-Priority AE mode, denoted as Tv on the Mode dial, is the semiautomatic mode that offers you control over the shutter speed. The 5D features electronically controlled focal-plane shutter speeds from 1/8000 to 30 seconds. And, of course, you can also use Bulb by switching to it on the Mode dial. (Bulb is covered later in this section.) In Tv mode, you control the shutter speed by turning the Main dial; the camera then automatically calculates the appropriate aperture based on the light meter reading, the metering mode, and the ISO. The 5D displays the shutter speed in the viewfinder and on the LCD panel only when you select it.

If the exposure falls outside of the exposure range, the aperture value blinks in the viewfinder and on the LCD panel, letting you know to set a different shutter speed to avoid overexposure or underexposure. If the lenses' maximum aperture blinks, the image will be underexposed. If the lenses' minimum aperture blinks, the image will be overexposed. In either case adjust the

shutter speed slower or faster respectively until the aperture value stops blinking, or set a lower or higher ISO setting.

In Shutter-Priority AE mode, you can set the image quality, color space, ISO, white balance, and the Drive, Metering, and AutoFocus modes.

Shutter speed increments can be changed from the default 1/3-stop to 1/2-stop increments using C.Fn-06. Flash sync speed is 1/200 second or slower.

 Note *For details on setting Custom Functions, see Chapter 3.*

1.11 In Full Auto mode, the 5D automatically selects the AF points, white balance, and all exposure settings. Exposure: ISO 400, f/2.8, 1/30 second using an EF 100mm f/2.8 Macro USM lens.

1.12 For this image, I switched to P mode, and changed the aperture to get more extensive depth of field. I set the white balance to Tungsten. Exposure: ISO 100, f/5.6, 1/8 second using an EF 100mm f/2.8 Macro USM lens.

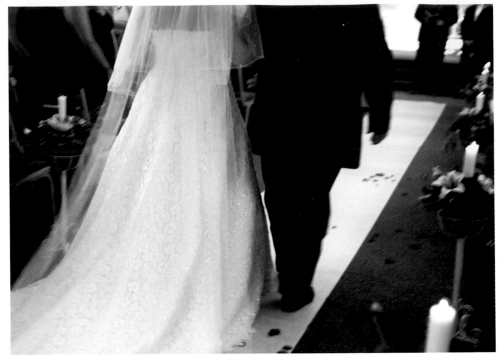

1.13 To show some motion in the bride's dress, I switched to Tv mode, checked to ensure that IS was turned on, and then set the shutter speed to 1/13 sec. Exposure: ISO 320, f/3.2, 1/13 sec., EF 70-200mm, f/2.8L IS USM lens.

In the default 1/3-stop increments, the following shutter speeds are available (in terms of seconds):

1/8000	1/6400	1/5000	1/4000
1/3200	1/2500	1/2000	1/1600
1/1250	1/1000	1/800	1/640
1/500	1/400	1/320	1/250
1/200	1/160	1/125	1/100
1/80	1/60	1/50	1/40
1/30	1/25	1/20	1/15
1/13	1/10	1/8	1/6
1/5	1/4	0.3	0.4
0.5	0.6	0.8	1
1.3	1.6	2	2.5
3.2	4	5	6
8	10	13	15
20	25	30	

Shutter designations in the viewfinder and LCD panel are shown with the number representing the denominator of the fractional value. For example, 8000 indicates 1/8000. When shutter speeds are displayed using a zero and a double-quote mark, the quote mark denotes a decimal point. So 0"3 is 0.3 seconds while 15" indicates 15.0 seconds.

Note For both Tv and Av modes, you can set C.Fn-16 to enable a safety shift in exposure. The shift comes into play if the subject lighting changes enough to make the current shutter speed or aperture unsuitable. Enabling this function causes the camera to automatically shift to a suitable exposure. For details on setting Custom Functions, see Chapter 3.

Aperture-Priority AE

Aperture-Priority AE mode, denoted as Av on the Mode dial, is the semiautomatic mode of preference for everyday shooting because it offers quick control over the aperture, and, hence, control over one factor that determines depth of field. In this mode, you control the aperture by turning the Main dial, and the camera automatically calculates the appropriate shutter speed based on the light meter reading, the metering mode, and the ISO. The 5D displays the selected aperture in the viewfinder and on the LCD panel.

Pressing the Shutter button halfway initiates the camera's exposure calculation based on the aperture you select. If the exposure is outside the camera's exposure range, the shutter speed value blinks in the viewfinder and on the LCD panel. If "8000" blinks, the image will be overexposed. If "30" blinks, the image will be underexposed. In either case, adjust to a smaller or larger aperture respectively until the blinking stops or set a lower or higher ISO setting.

> **Tip** You can preview the depth of field by pressing the depth-of-field preview button on the front of the camera. When you press this button, the lens diaphragm stops down to the selected aperture so that you can preview the range of acceptable focus. This button has no effect if the lens is already stopped down.

The range of available apertures depends on the lens you're using. Aperture increments can be set in either 1/3- or 1/2-stop values depending on the setting you choose in C.Fn-06. The default setting is 1/3 stop. The increment you set applies the shutter speed, aperture, exposure compensation, and AutoExposure bracketing.

1.14 Av mode is the ticket for controlling the rendering of the background. Here the lilac against an early evening sky created great bokeh and color contrasts. Exposure: ISO 250, f/4, 1/500 sec., EF 24-105mm, f/4L IS USM lens.

In 1/3-stop increments, and depending on the lens you use, the available apertures are as follows:

f/1.0 1.1 1.2 1.4 1.6 1.8 2.0
2.2 2.5 2.8 3.2 3.5 4.0 4.5
5.0 5.6 6.3 7.1 8.0 9.0 10
11 13 14 16 18 20 22
25 29 32 36 40 45 51
57 64 72 81 91

Practically speaking, however, the narrowest minimum aperture is f/45 on the Canon EF 75-300 f/4-5.6 lenses.

In Aperture-Priority AE mode, you can set the image quality, color space, ISO, White Balance, and the Drive, Metering, and AutoFocus modes.

 Cross-Reference *For more information on Canon lenses, see Chapter 4.*

Manual

Manual mode, denoted as M on the Mode dial, is, as the name says, fully manual. This mode gives you control over aperture and shutter speed. Manual mode is useful in a variety of shooting scenarios including shooting fireworks, when you want to intentionally underexpose or overexpose a part of the scene, or when you want a consistent exposure across a series of photos such as for a panoramic series.

In Manual mode, turn

✦ Main dial to select the shutter speed

✦ Quick Control dial to select the aperture

Pressing the shutter halfway initiates the metering based on the metered value, metering mode, and ISO. The camera's ideal

exposure is indicated when the exposure level mark is at the center of the exposure level indicator shown in the viewfinder.

The exposure level meter in the viewfinder and on the LCD panel indicates the amount of overexposure or underexposure from the camera's calculated ideal exposure. If the amount of under- or overexposure is +/- 2 EV, the exposure level indicator bar blinks to show the amount of plus or minus EV in the viewfinder and on the LCD panel. You can then adjust either the aperture or shutter speed until the exposure level you want appears in the viewfinder and on the LCD panel.

The same aperture and shutter speed values detailed in the preceding sections are available in Manual mode. In Manual mode, you can set the image quality, color space, ISO, white balance, and the Drive, Metering, and Autofocus modes.

Bulb

Bulb mode, denoted by B on the Mode dial, is a rarity for most EOS SLRs. On most other cameras, Bulb is an option available in Manual mode, but on the 5D its status is raised to the Mode dial for easy access. Bulb simply keeps the shutter open for as long as the Shutter button is fully pressed, either by you holding it or by using the Remote Switch RS-80N3 or Timer Remote Controller TC-80N3.

Bulb is handy for low-light and night shooting, fireworks, celestial shots, and other creative long-exposure renderings. In this mode, you set the ISO and aperture, and then use the Timer Remote Controller, or watch the elapsed time on the LCD panel for the length of exposure time that you want. Exposure time display ranges from 1 to 999 seconds. In addition, you can use

1.15 Manual mode is great for exposure shots such as the moon where I know in advance what settings work best. Exposure: ISO 125, f/9.5, 1/2 sec., EF 70-200mm, f/2.8L IS USM lens.

Mirror Lockup (C.Fn-12) to prevent vibration from the reflex mirror being swung up at the start of a long exposure.

Because long exposures introduce digital noise and increase the appearance of grain, consider turning on one of the long exposure noise reduction options available with C.Fn-02.

1.16 Depending on your preference, you can use either Manual mode or Bulb mode to capture fireworks. Exposure: ISO 100, f/11, 1/7 sec., EF 70-200mm, f/2.8L IS USM lens.

 Cross-Reference *For details on setting Custom Functions, see Chapter 3.*

C (Register Camera Settings)

The 5D pioneers the use of a customizable mode by elevating it to the Mode dial. With C mode, officially named Camera Settings mode, you can save and recall your favorite or most frequently used camera settings. This mode is ideal for photographers who routinely shoot in the same venue, such as a specific chapel, studio, or event location, and want to quickly recall the camera settings specific to that venue. In this mode, the camera saves and recalls settings, including white balance, shooting mode, color space, Picture Style, Custom Functions, and more.

 Cross-Reference *The Register Camera Settings mode is covered in detail in Chapter 3.*

AutoFocus and selecting AutoFocus modes

The speed and accuracy of focusing and the ease of manually selecting an AF point are as critical to camera performance as having a good on-board metering system. The EOS 5D AF performance is excellent, and AF selection is customizable. Getting tack-sharp focus, of course, depends on three factors: the resolving power of the lens (its ability to render fine details sharply), the resolution of the image sensor, and the resolution of the printer for printed images.

While the resolution of printers is beyond the scope of this book, I can address the other two factors. The EOS 5D has excellent image sensor resolution as is born out in

numerous tests by Web reviewers including Dave Etchells of Imaging-Resource.com. In regard to the resolving power of the lens, the 5D's full-frame sensor puts lenses to a stringent test, revealing any tendencies that the lens has toward edge softness, chromatic aberration, and distortion. While I cover the details of optics in Chapter 4, the take-away concerning image sharpness here is that the better the optics, the better is the overall sharpness of 5D images.

In terms of setting focus on the 5D, you have several choice; you can either let the camera select the AF points automatically, or you can manually select one of the nine AF points displayed in the viewfinder.

If you choose to have the camera automatically select the AF point or points and the camera is set to One-Shot mode, the camera focuses on the subject or the part of the subject that is closest to the lens that has readable contrast -- whether or not that's the appropriate point for sharpest focus. Or if you combine AF-point selection with AI Servo AF, the camera uses only the center AF point to identify the subject, and then subsequently uses all the AF points to track subject movement.

1.17 This diagram shows the six invisible AF points that come into play by turning C.Fn-17 to Expanded when you're shooting in AI Servo AF mode. Otherwise, the nine AF points that are not shaded in this diagram can be manually selected or selected automatically by the camera.

Note *An additional six invisible AF points are brought into play by selecting the Expanded option with C.Fn-17. Expanded AF point activation uses the six invisible AF points in AI Servo AF mode, so that a total of seven AF points track focus on the subject within the center spot-meter area of the viewfinder. You can learn more about Custom Functions in Chapter 3.*

For most day-to-day shooting, manually selecting an AF point ensures tack-sharp focus precisely where you want it.

To manually select an AF point or to choose automatic AF use the following:

1. **Set the Shooting mode to any mode except Full Auto, and then press the Shutter button halfway.** The current AF point or points light in red in the viewfinder and are displayed on the LCD panel.

2. **Press the AF-point selection/ Enlarge button on the back top right side of the camera.** The selected AF point lights in red in the viewfinder and is displayed on the LCD panel.

3. **To select a single AF point, turn the Main or the Quick Control dial or tilt the Multi-controller in the direction of the AF point you want to select.** If you're using the Multi-controller, you can also press the center of the Multi-controller to quickly select the center AF point.

What Are Cross-Type and Invisible AF Sensors and Should You Care?

Canon's autofocus system includes high-precision AF points that are suited for use with fast lenses. High-precision AF is designed to increase the accuracy of autofocus within the central area of the viewfinder—the area encompassed by the spot meter circle in the center of the viewfinder—by using cross-type AF points. High-precision AF points are sensitive to vertical and horizontal line detection and have the ability to maintain single-line autofocus at smaller apertures such as f/8. With the camera held in horizontal orientation, three invisible AF points are located above and below the center AF point. The three points in a vertical line, including the center AF, have vertical-line sensitivity at f/2.8. The four outside AF points have horizontal-line sensitivity at f/5.6.

You may rightly wonder why this is important. Canon originally designed this system with the needs of sports photographers and photojournalists in mind, although it works nicely for wedding and portrait photographers as well. Sports photographers and photojournalists often shoot in vertical format to accommodate the page orientation and layout of magazines and newspapers. Hence, Canon optimized the AF system for vertical shooting and for the fast, f/2.8 lenses that these photographers often use. With the camera held vertically and when using AI Servo AF mode, the cross-type sensors are spread across the subject from left to right to provide maximum coverage so that the camera continues focus tracking even if the subject moves slightly off the center AF point. But if the subject moves away from the center spot metering area, then focus tracking continues using adjacent AF points as long as the AF point covers the subject.

4. **Press the shutter halfway to focus using the selected AF point or the camera's selected AF points.** The camera emits a beep when accurate focus is achieved, and the AF light in the viewfinder remains lit continuously.

5. **Press the shutter button completely to make the picture**.

In step **3**, if you choose the option where all AF points are lit in red, then the camera switches to automatic AF-point selection and automatically selects the AF point(s).

Tip *Manual focusing is available by sliding the switch on the side of the lens from the AF to MF position. Alternately, you can use autofocus on the camera, and then tweak the focus by manually adjusting the focusing ring on the lens.*

You can verify image sharpness by pressing the Playback button, and then pressing and holding the AF-point selection/Enlarge button on the back of the camera. The image will be enlarged from 1.5× to 10× on the LCD monitor. To scroll through an enlarged image, press and hold the Multi-controller in the direction you want to scroll. To reduce the enlarged preview, press and hold the Reduce button, or lightly press the Shutter button to dismiss image playback.

Tip *If you're shooting in a quiet venue such as a wedding ceremony, you can silence the AF confirmation beeper. Just press the Menu button. On the Shooting (red) menu, highlight Beep, and then press the Set button. Select Off, and then press the Set button.*

It's important to know that the AF point is also the point where exposure is set. In other words, whatever AF point achieves focus is also where the camera meters and sets the exposure. This may or may not be the point of critical exposure. If you want to decouple autofocus from metering, use AutoExposure Lock, a technique discussed later in this chapter.

The 5D provides three autofocus Modes:

✦ **One-Shot.** One-Shot AF mode is designed for shooting where the subject is stationery and is likely to remain so. This is also the best autofocus mode for low-light venues. In this mode, pressing the Shutter button halfway establishes focus, and holding the Shutter button halfway locks focus.

✦ **AI Focus AF.** This mode automatically switches from One-Shot AF mode to AI Servo AF mode if the camera detects subject movement. A soft beep alerts you that the camera is switching to AI Servo AF mode, and the focus confirmation light in the viewfinder is no longer lit. To initiate focus tracking, press the Shutter button halfway. Pressing the Shutter button completely after focus is established releases the shutter in the shortest time.

✦ **AI Servo AF.** In this mode, the camera tracks focus on moving subjects regardless of changes in focusing distance from side to side or approaching or moving from the camera and sets exposure at the moment the image is made. The camera uses either the manually selected AF point; or if the camera automatically sets the AF point, it uses the center AF point and the

six invisible AF points provided that the Expanded option is set with C.Fn-17. This predictive autofocus calculates the subject's rate of speed as it comes toward or away from the camera and focuses based on the subject's predicted position.

Tip

Because keeping the Shutter button pressed halfway shortens battery life, anticipate the shot and press the Shutter button halfway just before making the picture to maximize battery life.

Table 1.6 shows how autofocus and drive modes behave when used in combination.

In addition, camera stores such as B&H Photo Video offer two additional focusing screen options, both of which incorporate either a crop line or a black mask to aid in shooting to a fixed aspect ratio. The Canon Ee Crop Line set consist of two screens, one showing a square format and the other delineating a 4x5/8x10 format with a thin crop line displayed in the screen. The Canon Ee Black Mask Focusing Screen Set offers the same formats but with opaque black outside the aspect ratio area. Neither set requires adjustment for ambient or flash metering. These screen sets are noticeably more expensive at approximately $120 per set.

If you change focusing screens, you also have to select the specific screen you're using by setting C.Fn-00 to the proper option. The Ee-A screen is installed and set in C.Fn-00 as option 0. To set the camera for the Ee-D screen, set the option to 1. For the Ee-S screen, set the option to 2. For details on setting Custom Functions, see Chapter 2.

Table 1.6
Autofocus and Drive Modes

Drive Mode	Focus Mode		
	One-Shot *AF*	**AI Focus *AF***	**AI Servo *AF***
One-shot shooting	In One-Shot AF mode, the camera must confirm accurate focus before you can take the picture. Once focus is achieved, it is locked as long as the shutter is half-pressed. If you're using Evaluative metering, exposure is also locked at the AF point that achieves focus.	The camera focuses on the subject and maintains focus during subject movement. The exposure is set at the moment the image is captured.	If the subject moves, the AF mode automatically switches from One-Shot AF to AI Servo AF to track and focus on the moving subject.
Continuous shooting	Identical to above cell's definition during continuous shooting. In continuous shooting, focusing is not executed when shooting at 3 frames per second (fps).	Identical to above cell's definition with autofocus continuing during continuous shooting at the maximum of 3 fps.	

Interchangeable Focusing Screens

The 5D offers the option of three interchangeable focusing screens, and third-party vendors offer additional focusing screens. Depending on your shooting needs and lenses, you may want to consider swapping out the default focusing screen to make focusing clearer and brighter for manual focus with fast lenses. Alternately, you can opt for a focusing screen with a grid that helps you square up lines during composition. You can order and install the focusing screens yourself. As of this writing, the focusing screens cost approximately $35 each. The three focusing screens supported on the 5D are as follows:

✦ **Ee-A: Standard Precision Matte.** This focusing screen is installed in the 5D. It offers good viewfinder brightness, accurate manual focusing, and it is optimized for use with EF f/5.6 and slower lenses.

Continued

Continued

✦ **Ee-D: Precision Matte with grid.** If you shoot architecture, interiors, or just need assistance keeping vertical and horizontal lines in the frame square, the matte screen with a grid is a good option. It features a 3x6 line grid to help you align horizontal and vertical lines during image composition. The grid is superimposed over the nine AF points in the viewfinder. This screen offers good viewfinder brightness and is optimized for use with EF f/5.6 or slower lenses.

✦ **Ee-S: Super Precision Matte.** This focusing screen is optimized for manual focusing with f/2.8 or faster lenses. It offers finer microlenses than the other two screens, and it has a steeper parabola of focus to bring the image in and out of focus more vividly in the viewfinder—a benefit with very fast lenses such as the EF 85mm f/1.2 II. Because this screen is darker than the other two screens, it is not recommended for use with slower lenses or when using an extender on the lens.

To select an Autofocus mode:

1. **Set the lens switch to AF, and set the camera to any shooting mode except Full Auto.**

2. **Press the AF-WB button, and the turn the Main dial to select the AF mode you want.** Each mode is represented by text on the LCD panel. The AF mode you choose remains in effect until you change it.

Improving Autofocus accuracy and performance

Autofocus speed depends on factors including the size and design of the lens, the speed of the lens focusing motor, the speed of the AF sensor in the camera, the amount of light in the scene, and the level of subject contrast. Given these variables, it's helpful to know how to get the speediest and sharpest focusing. Here are some tips for improving overall AF performance.

✦ **Light.** In low-light scenes, AF performance depends in part on the lens speed and design. In general, the faster the lens, the faster the AF performance. Provided that there is enough light for the lens to focus without an AF-assist beam, lenses with a rear-focus optical design, such as the EF 85mm f/1.8 USM, will focus faster than lenses that move their entire optical system, such as the EF 85mm f/1.2L II USM. But regardless of the lens, the lower the light, the longer it takes for the system to focus.

Low-contrast subjects and/or subjects that are in low light slow down focusing speed and can cause autofocus failure. With a passive autofocus system, autofocusing depends on the sensitivity of the AF sensor. Thus, autofocusing performance will always be faster in bright light than in low light, and this is true in both One-Shot and AI Servo AF modes. In low light, consider using an EX Speedlite's AF-assist beam as a focusing aid.

Does Focus-Lock-and-Recompose Work?

According to Canon's 5D manual, you can use a popular point-and-shoot technique of locking focus by half-pressing the Shutter button, and then moving the camera to recompose the image. However popular the technique, in my experience, the focus shifts slightly during the recompose step regardless of the AF point selected. As a result, focus is not tack-sharp.

Some Canon documents concede that at distances within 15 feet of the camera and when shooting with large apertures, the focus-lock-and-recompose technique increases the chances of *backfocusing*. Backfocusing is when the camera focuses on an element behind where you set the focus. Of course, the downside of not using the focus-lock-and-recompose technique is that you're restricted to composing images using the nine AF points in the viewfinder. The placement of the nine AF points isn't the most flexible arrangement nor are the AF points the optimal way to compose images. But manually selecting one of the nine AF points and not moving the camera to recompose is the technique that ensures tack-sharp focus.

The Speedlite AF-assist beam fires twice; first, a pre-fire to communicate focusing distance data to the camera, and then a second beam to confirm that the subject is in focus. Then the shutter fires.

✦ **Focal length.** The longer the lens, the longer the time to focus. This is true because the range of defocus is greater on telephoto lenses than on normal or wide-angle lenses. You can improve the focus time by manually focusing first in the general focusing range, and then using autofocus to set the sharp focus.

✦ **AF-point selection.** Manually selecting a single AF point provides faster AF performance than using automatic AF-point selection because the camera doesn't have to determine which and then select the AF point(s) to use first.

✦ **Subject contrast.** Focusing on low-contrast subjects is slower than focusing on high-contrast subjects. If the camera can't focus, shift the camera position to an area of the subject that has higher contrast, such as a higher contrast edge.

✦ **EF extenders.** Using an EF extender reduces the speed of the lens focusing drive.

✦ **Wide-angle lenses and small apertures**: Sharpness can be degraded by diffraction when you use small apertures with wide-angle or wide-angle zoom lenses. Diffraction happens when light waves pass around the edges of an object and enter the shadow area of the subject, producing softening of fine detail that cannot be corrected during post processing. To avoid diffraction, avoid using apertures smaller than f/16 with wide-angle prime and zoom lenses.

Selecting a Metering Mode

The EOS 5D offers a full menu of reflective-based metering options. The default mode is the 35-zone TTL full-aperture metering system that is linked to the selected AF point or points. In this mode, the onboard microcomputer evaluates input from 35 zones, and then calculates the exposure from this data. Depending on your exposure needs, you can also choose Partial, Spot, or Center-weighted Average metering modes.

The following is a rundown of the metering options on the 5D:

✦ **Evaluative metering.** Calculates exposure based on data from 35 zones throughout the viewfinder area and is based on the subject position (indicated by the selected AF point), brightness, background, and back and front lighting. Evaluative metering produces excellent exposure in average scenes that include an average distribution of light, medium, and dark tones, and it functions well in back-lit scenes.

1.18 I made the next series of images using each of the metering modes. I intentionally included bright highlights and a bright background to show the overall metering performance of each mode. I took this image using Evaluative metering mode. Exposure: ISO 100, f/5.6, 1/125 sec., EF 100mm, f/2.8 Macro USM lens.

1.19 I made this image using Partial metering mode. Exposure: ISO 100, f/5.6, 1/160 sec.

✦ **Partial metering.** Calculates exposure based on approximately 8 percent of the viewfinder at the center. This metering option weights metering data at the center of the viewfinder in slightly less than twice the size of the spot metering circle. This is a good metering option for strongly backlit or side-lit scenes where you want to ensure that the main subject is properly exposed.

✦ **Spot metering.** Calculates exposure from approximately 3.5 percent of the viewfinder at the center. Spot metering is the mainstay of photographers who need critical subject-area metering, such as skin highlights for portraits. For accurate readings for portraits, for example, move close and fill the frame with the subject's face, and then meter the critical area such as a highlight.

✦ **Center-weighted Average metering.** Weights metering for the center of the frame, and then averages for the entire scene to calculate exposure. The center area encompasses a slightly larger area than used with Partial metering. Although Center-weighted Average metering is somewhat "old school," it can be useful for quickly evaluating existing light scenes.

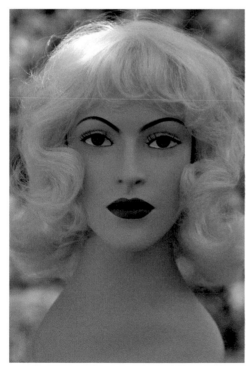

1.20 I made this image in Spot metering mode. Exposure: ISO 100, f/5.6, 1/160 sec.

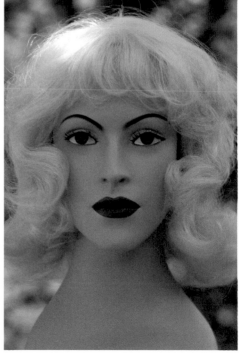

1.21 I made this image using Center-weighted Average metering mode. Exposure: ISO 100, f/5.6, 1/125 sec.

Evaluating the 5D's dynamic range

In general terms, dynamic range is the range of highlight to shadow tones as measured in f-stops in a scene. That's only, however, one measure of dynamic range. In practice, you have to factor in the "usable" range by considering the effect of digital noise. If, for example, during image editing, using a Curve brings up the details in the shadow areas, but it also makes digital noise (which is most prevalent in the shadows) more visible. In addition, the "grain" size of noise also impacts how noticeable the noise appears. So considering these factors, there is a point at which this noise becomes obnoxious and limits your ability to make high-quality enlargements from the image.

Evaluating exposure

Following each exposure, you can evaluate the exposure by looking at the histogram.

If you're new to digital capture, the concept of a histogram will also be new. The histogram is a bar graph that shows the distribution of pixels in the image. The horizontal axis shows the range of values and the vertical axis displays the number of pixels at each location. The 5D offers two types of histograms: a brightness or luminance histogram, and an RGB histogram that shows the tonal values for the Red, Green, and Blue color channels.

Brightness histogram

A brightness, or luminance histogram, shows grayscale brightness values in the image along the horizontal axis of the graph. The tonal values range from black (level 0 on the left of the graph) to white (level 255 on the right of the graph). This histogram shows you the exposure bias and the overall tonal reproduction of the image. If the histogram has pixels crowded against the far left or right side of the graph, then the image is underexposed or overexposed with a subsequent loss of detail in the shadows and highlights, respectively.

Some scenes cause a weighting of tonal values more to one or the other side of the graph. For example, in scenes that have predominately light tones, the pixels are weighted toward the right side of the histogram, and vice versa. But in an average scene, good exposure is shown on the histogram as a fairly even distribution of tonal values across the entire graph with highlight pixels just touching the right side of the histogram. The goal for good exposure is to avoid exposures that have pixels slammed against the right edge of the graph. If the pixels are crowded against the right edge of the graph, it means that some highlight values are beyond the limit of the sensor, and the pixels are blown; in other words, they are at 255, or totally white with no detail.

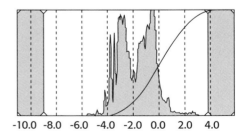

-10.0 -8.0 -6.0 -4.0 -2.0 0.0 2.0 4.0

1.22 This is a brightness histogram from a RAW capture image in Canon's Digital Photo Professional conversion program. In the camera, the histogram showed slight overexposure, but once on the computer, the highlights began just at the right side of the histogram, which is on target for a good RAW conversion.

Also, you want to avoid having pixels crowded against the left edge of the histogram because that stacking indicates blocked shadows; in other words, pixels at 0, or totally black with no detail.

RGB histogram

An RGB histogram shows the distribution of brightness levels of each of the three color channels: Red, Green, and Blue. Each color channel is displayed in a separate histogram so you can evaluate the color channel's saturation, gradation, and color bias. The horizontal axis shows how many pixels exist for each color brightness level while the vertical axis shows how many pixels exist at that level. More pixels to the left indicate that the color is darker and more prominent, while more pixels to the right indicate that the color is brighter and less dense. If pixels are spiked at the left or right side, then color information is either lacking or oversaturated.

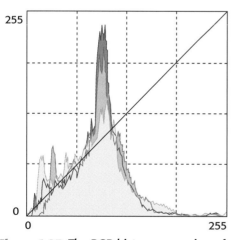

Figure 1.23 The RGB histogram version of the luminance histogram that is shown in figure 1.22; this is a RAW capture as seen in Canon's Digital Photo Professional conversion program.

Choosing the type of histogram to display depends on the shooting situation and your priority in that situation. For a fashion shoot where color reproduction is critical, the RGB histogram is most useful. For a wedding, outdoor shooting, and nature shooting, the brightness histogram can be most useful for evaluating critical highlight exposure.

The histogram is a very accurate tool to use in evaluating JPEG captures because it is based on the JPEG image. If, however, you shoot RAW, the histogram is also based on the JPEG conversion of the image, and is less accurate. Due to the linear nature of RAW data, it isn't feasible to display a RAW histogram. So if you shoot RAW, remember that the histogram is showing a less robust version of the image than you'll get during image conversion. For example, there will be more data in the highlights than the JPEG-based histogram indicates. Despite the JPEG-based rendering, the histogram is still a useful tool to gauge RAW exposure in the field.

Tip *If you're shooting RAW capture, you won't know what the histogram looks like until you see it in the conversion program. However, you can set Picture Style parameters (see Chapter 2) to a lower contrast to get a better overall sense of the RAW histogram in the camera and to reduce the likelihood of clipping (or discarding image pixels).*

Histograms on the 5D can be displayed during image playback. Once you set the type of histogram, it is displayed until you change to the other type of histogram.

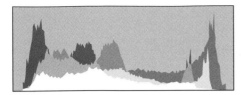

1.24 The spike on right side of the histogram shows overexposure in the Red channel highlights.

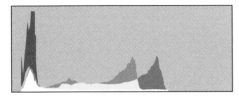

1.25 The gap between where the pixels begin on the right and the right side of the histogram indicate underexposure. In addition, the spike on the left shows the effect of the underexposure.

1.26 This is the type of histogram that has a good exposure with the tonal range distributed nicely across the range and no spikes in either the highlights or shadows.

To set the type of histogram displayed during image playback:

1. **Press the Menu button, and then press the Jump button to display the Playback (blue) menu.**

2. **Turn the Quick Control dial to highlight Histogram, and then press the Set button.** The camera displays the Bright. (abbreviation for the Brightness) and RGB options.

3. **Turn the Quick Control dial to select the histogram option you want, and then press the Set button.** If you choose the brightness histogram, the camera's highlight alert shows clipped highlight pixels as alternating black and white blinking during image review. This blinking display is helpful in identifying localized overexposure problems.

To display the histogram for a captured image:

1. **Press the Playback button.** The camera displays the most recently captured image. If you want to check the histogram of a different image, turn the Quick Control dial to select the image whose histogram you want to display.

2. **Press the Info button twice if the playback display is set to display only the image thumbnail.** The camera displays the image thumbnail, histogram, and detailed exposure and file information for the image.

Modifying Exposure

For average scenes, using the camera's suggested exposure produces a fine image. However, many scenes are not average due to the specifics of light in a particular scene. And in those scenes, you can choose from any of the 5D's exposure-modification options including AutoExposure Lock, AutoExposure Bracketing, and Exposure Compensation. Each exposure option is detailed in the following sections.

Differences in Exposing for JPEG and RAW

If you are new to digital photography or to RAW capture, it's worthwhile to point out important differences in exposure techniques for JPEG and RAW capture.

When you're shooting JPEG images, it's important to expose images as you would for slide film by metering for the highlights. Just as you can't recover detail that isn't captured in a slide film image, you also can't recover highlight detail that's not recorded in a JPEG capture. To ensure that images retain detail in the brightest highlights, you can use one of the exposure techniques, described later in this chapter, such as Auto Exposure Lock or Auto Exposure Compensation.

Conversely, for RAW capture, exposure is more akin to positive film in that you have a fair amount of latitude to overexpose the image, and then recover some of the highlight details during conversion of the RAW images in Canon's Digital Photo Professional or Adobe Camera Raw. In fact, because CMOS sensors are linear devices in which each f-stop records half the light of the previous f-stop, the lion's share of light or image detail is recorded in the first f-stop of light. To be exact, fully half of the total image data is contained in the first f-stop in RAW capture. This fact alone underscores the importance of taking full advantage of the first f-stop by not underexposing the image. In the everyday world, that means weighting the exposure slightly toward the right side of the histogram. This type of histogram has highlight pixels just touching, but not spiked, against the right edge of the histogram.

With this type of exposure, the image preview on the LCD may look a bit light, but in a RAW conversion program, you can bring the exposure back and redistribute the pixels on the histogram. As a bonus, exposing in this way minimizes noise in the shadow areas and posterization, where breaks in tonal ranges reduce fine tonal gradations in the image.

Auto Exposure Lock

As noted in earlier sections, Canon sets exposure to the AF point that you select. This approach is fine as long as the area of critical exposure falls within the point where you want sharpest focus. Often, however, that's not the case. And when you need to decouple the exposure from the point of sharpest focus, AutoExposure Lock (AE Lock) is the technique to use.

In fact, I use AE Lock for the majority of my photography. Because I shoot RAW capture 99 percent of the time, AE Lock allows me to get exposures that are biased to the right of the histogram yet maintain detail in the highlights. There is a bit more latitude in RAW capture because you can recover varying amounts of highlight detail during image conversion.

If you shoot JPEGs, then using AE Lock is a great way to ensure that the image retains detail in the brightest highlights.

For example, I use AE Lock in combination with Evaluative metering and manual AF-point selection when exposing to maintain fine detail in the highlights of a bride's wedding dress, to retain highlight detail in macro and nature shots (although, if you composite multiple exposures, bracketing may be a better technique), and to maintain detail in skin highlights in portraits.

There are, however, some gotchas for using AE Lock. First, it doesn't work in Full Auto or, of course, Manual modes. And in Tv and Av modes, you have to use Evaluative metering, manual AF-point selection, and autofocusing rather than manual focusing (via the switch on the side of the lens). And if One-Shot AF or AI Focus AF is set and AI Servo AF isn't active, then pressing the Shutter button halfway automatically sets AE Lock.

Table 1.7 shows the relationship of AE Lock to the various metering and autofocus modes on the 5D.

Before you set the AE Lock, ensure that the camera is set to:

✦ Av or Tv mode

✦ Evaluative metering

✦ Manual AF-point selection with the lens focusing switch set to AF

Follow these steps to set AE Lock:

1. **Press the Shutter button halfway to focus on the part of the scene that you want to meter.** For example, if you want to ensure that detail is retained in the highlight area on a subject's face, focus on a bright highlight.

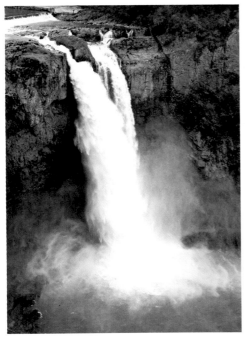

1.27 This image was taken without using AE Lock and the brightest highlights went to white. Exposure: ISO 125, f/8, 1/30 sec., EF 24-70mm, f/2.8L USM lens.

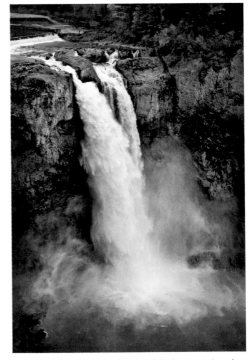

1.28 With AE Lock, the highlights retained much more detail in this image. Exposure: ISO 125, f/8, 1/50 sec., EF 24-70mm, f/2.8L USM lens.

Table 1.7
AE Lock Behavior with Metering and AF-Point Selection

Metering Mode	AF- Point Selection		Manual Focus
	Manual AF-Point Selection	**Automatic AF-Point Selection**	**With the Lens Switch Set to MF**
Evaluative	AE Lock is set at the selected AF point	AE Lock is set at the AF point that achieves focus	AE Lock is set at the center AF point
Partial	AE Lock is set at the center AF point		
Spot			
Center-Weighted Average			

2. **Continue to hold the Shutter button halfway as you press and hold the AE Lock button on the back right side of the camera.** This button has an asterisk above it. An asterisk is displayed in the viewfinder indicating the exposure is locked.

3. **Release the Shutter button, move the camera to recompose the shot, press the Shutter halfway to focus, and then make the picture.** As long as you continue holding the AE Lock button, you can take additional images using the locked exposure. When you release the AE Lock button, the exposure is reset when you focus the lens again.

AutoExposure Bracketing

AutoExposure Bracketing (AEB) takes three exposures of the same scene: one exposure at the camera's recommended setting, an image above, and an image below the recommended exposure. This is the traditional technique for ensuring an acceptable exposure in scenes that have challenging and/or high-contrast lighting and in scenes that are difficult to set up again or that can't be reproduced.

AEB is also used for image compositing where you take three different exposures of a high dynamic range scene, and composite them in an image-editing program to produce a final image that offers the best of highlight detail, midtone, and shadow detail. Using this technique, photographers can produce a final image that exceeds the range of the camera's sensor. Additionally, AEB is a mainstay of High-Dynamic Range (HDR) imaging, which merges three to seven or more bracketed exposures in Photoshop to create a 32-bit image with excellent rendering throughout the tonal range.

Tip *HDR imaging brackets exposures by shutter speed rather than by aperture to avoid slight shifts in focal length rendering.*

On the 5D, the default exposure bracketing level is 1/3 stop, although you can reset the increment to 1/2 stop using C.Fn-06: Exposure level increments. AEB captures up to +/- 2 stops.

Here are some things that you should know about AEB:

✦ **AEB settings remain in effect until you change them.** AEB settings are retained even when you turn the camera off and then on again, and when you change the battery or CF card.

✦ **In Continuous mode, you have to press and hold the Shutter button to make all three bracketed exposures.**

✦ **In Self-Time drive mode, press the Shutter button once to make the three bracketed images in rapid succession.** If the mirror is locked up, you have to press the Shutter button three times to get the full sequence of bracketed images.

✦ **In One-Shot AF mode, press the Shutter button three times to make the bracketed sequence.**

✦ **The order of bracketed exposures begins with the standard exposure followed by decreased and increased exposures.** You can change the order of bracketed exposures by setting C.Fn-09.

✦ **AEB is available in all modes except Bulb, and you can't use AEB when you've mounted an EX Speedlite or third-party flash unit.**

✦ **You can use AEB in combination with Exposure Compensation.**

✦ **If C.Fn-12/1 is set for mirror lockup, and you're using AEB and Continuous drive mode, only one of the bracketed shots is taken a time.** And with mirror lockup, you press the Shutter button once to lock up the mirror and again to make the exposure. In other words, a total of six presses of the shutter button are required to get three bracketed exposures.

 For details on setting Custom Functions, see Chapter 3.

Converting an AEB Sequence of RAW Images

If you shoot RAW capture, and if you use a RAW conversion program that automatically applies its best guess conversion settings to RAW images, you're not likely to see much difference among the three bracketed exposures. To see the difference, you have to first turn off the automatic adjustments in the conversion program. For example, if you use Adobe Camera Raw, click the Default text above the Exposure control to show the image without automatic adjustments.

Avoid the urge to over-correct the bracketed images during RAW conversion because you can lose the differences that you'll later need for the composite.

To set AEB, follow these steps:

1. **Set the Mode dial to P, Tv, or Av.**

2. **Press the Menu button, and, if necessary, press the Jump button to select the Shooting (red) menu.**

3. **Turn the Quick Control dial to highlight AEB, and then press the Set button.** The Exposure Level Meter display is activated.

4. **Turn the Quick Control dial clockwise to set the AEB amount that you want, and then press the Set button.** As you turn the Quick Control dial, the tick mark on the Exposure Level Meter separates into three marks to indicate the bracketing amount. You can set up to +/- 2 stops of bracketing. The bracketing amount is also displayed in on the LCD panel. AEB remains in effect until you turn it off.

To turn off AEB repeat steps **1** to **4**, but in step **4**, turn the Quick Control dial to merge the three tick marks back into a single tick mark at the center of the Exposure Level Meter.

With AEB set, when you press the Shutter button to take the exposures, the bracketing amount is displayed in the viewfinder and on the LCD panel as each shot is made.

Exposure Compensation

Another way to modify the standard exposure on the EOS 5D is by using Exposure Compensation. Unlike AE Lock and AEB, which serve well for specific shooting scenarios, Exposure Compensation enables you

to purposely and continuously modify the standard exposure by a specific amount up to +/- 2 f-stops in 1/3 stop increments, or in 1/2 stop increments via C.Fn-06.

Scenarios for using Exposure Compensation vary widely, but a common use is to override the camera's suggested ideal exposure in scenes that have large areas of white or black. In these types of scenes, the camera's onboard meter averages light or dark scenes to 18 percent gray to render large expanses of whites as gray and large expanses of black as gray. You can use Exposure Compensation to override the meter. For example, a snow scene requires between +1 to +2 stops of compensation to render snow as white instead of dull gray. A scene with predominately dark tones might require -1 to -2 stops of compensation to get true dark renderings.

I've also used Exposure Compensation in conjunction with a handheld incident meter to set the 5D's standard exposure to the incident meter reading when there is a difference in exposure between the onboard meter and the incident meter. This technique works well especially if the subject light remains constant over a series of images.

Occasionally, you may notice that the camera consistently overexposes or underexposes images, and in those cases, compensation allows you to modify the exposure accordingly. (If underexposure or overexposure is a consistent problem, it's a good idea to have the camera checked by Canon.) Exposure compensation is useful in other scenarios as well, such as when you want to intentionally overexpose skin tones for a specific rendering effect.

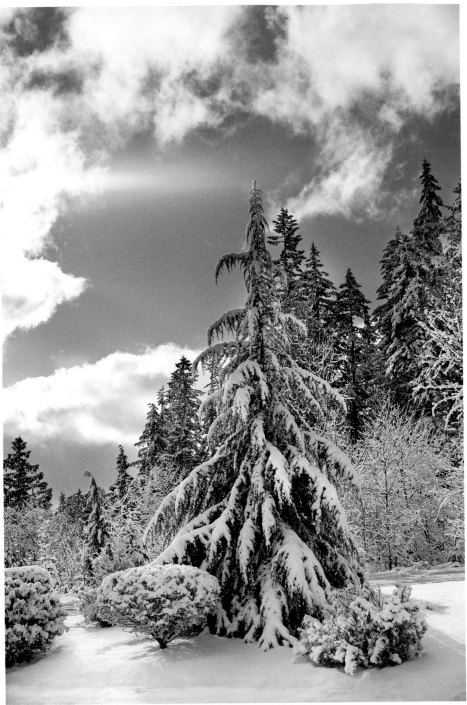

1.29 Snow scenes are a good time to use Exposure Compensation. This exposure was difficult with the bright cloud highlights and the stream of light coming from camera left to the top of the tree. Exposure: ISO 125, f/8, 1/2000 sec., -1 exposure compensation with an EF 24-70mm, f/2.8L USM lens.

Here are some things that you should know about Exposure Compensation.

✦ **The amount of Exposure Compensation you set remains in effect until you reset it.** This applies whether you turn the camera off and back on, change the CF card, or change the battery.

✦ **Exposure Compensation works in P, Tv, and Av modes, but not in M, Bulb, or Full Auto modes.** If you are in Tv mode, setting Exposure Compensation changes the aperture by the specified amount of compensation. In Av mode, it changes the shutter speed. In P mode, compensation changes both the shutter speed and aperture by the exposure amount you set.

✦ **It is annoyingly easy to inadvertently set Exposure Compensation by rotating the Quick Control dial.** Canon recommends setting the On switch to the On position rather than the topmost setting, but this limits the functionality of the Quick Control dial. Because I've fallen victim to this many times, I find that the best way to avoid unintentional Exposure Compensation is to keep the On switch set to the topmost position and always check the Exposure Level meter in the viewfinder before shooting. If the center tick mark is off-center more than the compensation that I set, or if it is off-center and I haven't set compensation, then I know to reset it.

To set Exposure Compensation:

1. **Set the On switch to the topmost position.**

2. **Set the Mode dial to P, Tv, or Av.**

3. **Press the Shutter button halfway, and then turn the Quick Control dial clockwise to set a positive amount of compensation or counterclockwise to set negative compensation.** As you turn the Quick Control dial, the tick mark on the Exposure Level Meter moves to the right or left in 1/3 stop increments up to +/- 2 stops.

Setting the ISO

Where the chemistry of film leaves off, the technology of digital imaging sensors begins, and film speed is replicated in ISO settings on digital cameras. In very general terms, ISO is the sensitivity of the sensor to light in the same conceptual way that film speeds are more or less sensitive to light. But there are differences between film and digital sensors; specifically as the sensitivity setting increases on a digital camera, the output of the sensor is also amplified. So while you have the option of increasing the ISO sensitivity at any point in shooting, the tradeoff in increased amplification or the accumulation of an excessive charge on the pixels is an increase in digital noise. And the result of digital noise is an overall loss of resolution and image quality.

Partly because the 5D has relatively large pixels on the sensor, and because Canon has done a fine job of implementing advanced internal noise reduction processing, the 5D stands out as a top performer even at high sensitivity settings, particularly at exposure times of 30 seconds or less.

ISO range, expansion, and Custom Function options

The 5D offers a default ISO range from 100 to 1600 in 1/3 stop increments or 1/2 stop increments using C.Fn-06. The ISO range can be expanded to include ISO 50, displayed as "L," and 3200, displayed as "H," by setting C.Fn-08 to On. Be aware that ISO 50 reduces the dynamic range in the highlights by approximately one stop, which makes this sensitivity less useful in high-contrast light. ISO 50 can be useful in a studio setting by providing flexibility in aperture choice.

Note *Dynamic range is the difference in gradations from highlight to shadow measured in f-stops.*

With the EOS 5D, Canon offers an option to reduce or eliminate noise in long exposures. Using the "dark frame" option, available by using C.Fn-02: Long exp. noise reduction, noise is totally or virtually eliminated by taking a second picture after the first picture. The second picture, commonly referred to as a "dark frame," is taken with the shutter closed, and it is exposed for the same amount of time as the first image. Then, the camera uses the dark frame to subtract the fixed-pattern noise from the first frame.

If you want to see ISO sensitivity comparisons of the 5D to other Canon digital SLRs and to other brands of SLRs, review the test results on Digital Photography Review at www.dpreview.com/reviews/CanonEOS5D/page21.asp. At the time of this writing, the sensitivity test results are included in the "Photographic tests" section of Phil Askey's "5D In-depth review."

In practice, the most compelling benchmark in evaluating digital noise is the quality of the image at the final output size. If the digital noise is visible and objectionable in an 11x14-inch print when viewed at a standard viewing distance of a foot or more, then the digital noise degraded the quality to an unacceptable level. It is worthwhile to test

1.30 As mentioned earlier, the EOS 5D delivers excellent high ISO performance. This image was taken in theatre-type light, and the pianist was in the shadow area below the stage. During image editing, I used Curves in Photoshop CS3 to bring up the brightness. Usually bringing up shadowy areas is a recipe for revealing ugly noise, but this ISO-1250 image made a lovely 8x10-inch print, and it could print at 11x13 with good results. Exposure: ISO 1250, f/4, 1/8 sec., EF 24-105mm, f/4.0L IS USM lens.

Types of Digital Noise

As the signal output of the image sensor increases, digital noise increases as well, analogous to the hiss on an audio system turned to full volume. In a digital image, the "hiss" translates into random flecks of color in shadow areas as well as a grainy look much like you see with film. Three types of digital noise are common in digital photography:

✦ **Random noise.** This noise is common with short exposures at high ISO settings. Random noise appears on different pixels and looks like a colorful grain or speckles on a smooth surface. This type of noise increases with fast signal processing. The 5D technology is designed to suppress random noise by having the sensor reset the photodiodes that store electrical charges while reading and holding the initial noise data. After the optical signal and noise data are read together, the initial noise data is used to remove the remaining noise from the photodiode and to suppress random noise.

✦ **Fixed-pattern noise.** This type of digital noise includes hot pixels that have intensity beyond that of random noise fluctuations. Hot pixels, or very bright pixels, are minor manufacturing defects that result in unusually high dark-current levels. Fixed-pattern noise is caused by an uneven signal boost among different pixel amplifiers. This type of noise happens with long exposures and is worsened by high temperatures. Fixed-pattern noise gains its name because under the same exposure and temperature conditions, the noise pattern will show the same distribution. The 5D uses on-chip noise reduction technology that detects fixed-pattern noise and removes it.

✦ **Banding noise.** This type of noise is more camera-dependent and is introduced as the camera reads data from the image sensor. It becomes visible in the shadow areas of images made at high ISO settings. This type of noise is visible when shadow tones are lightened during image editing.

In addition, digital noise exhibits fluctuations in color and luminance. Color, or chroma, noise appears as bright speckles of unwanted color in the image shadow areas primarily. Luminance noise, on the other hand, takes on the appearance of film grain.

the camera by using all of the ISO settings, processing and printing enlargements at the size as you typically print, and then evaluating for yourself how far and fast you want to take the 5D on the average shooting day.

Noise reduction or suppression can give fine details, such as the detail in hair, a painted or watercolor appearance. Details are flat, color definition become indistinct, and it looks as if an editing program filter has been applied to these areas.

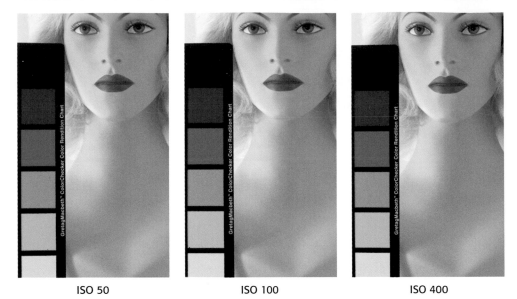

ISO 50 ISO 100 ISO 400

1.31 These images show the performance of the 5D at ISO 50 to 400.

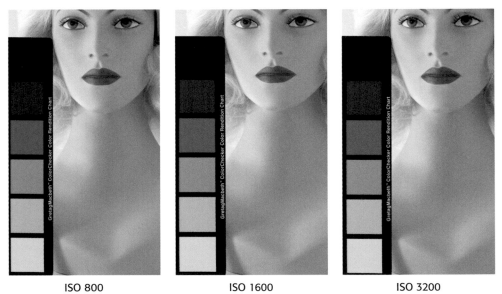

ISO 800 ISO 1600 ISO 3200

1.32 These images show the performance of the 5D at ISO 800 to 3200.

The 5D maintains a good level of fine detail, even in areas of subtle contrast, until the ISO is pushed to 1600 and 3200 (with expansion) when digital noise and suppression becomes visible. At these levels, fine detail tends to blur and noise becomes apparent. However, I've made acceptable 8x10-inch prints at ISO 3200. And at 13x19 inches, ISO 1600 produces acceptable prints.

Long exposures at high ISO settings also tend to reveal hot pixels in images when the dark frame option is not used. So if your shooting scenario lends itself to using the dark frame option, I recommend setting this option to On using C.Fn-02.

 Cross-Reference *For details on setting Custom Functions, see Chapter 3.*

To change the ISO:

1. **Press the Drive-ISO button above the LCD panel.** The current ISO setting appears on the LCD panel and in the viewfinder.

2. **Turn the Quick Control dial clockwise to set a higher sensitivity or counterclockwise to set a lower sensitivity.** The camera displays the ISO sensitivity settings as you turn the dial. If you have ISO Expansion turned on using C.Fn-08, then ISO 50 is shown as L and ISO 3200 is shown as H. The ISO option you select remains in effect until you change it again.

Unfortunately, Canon chose not to display the current ISO setting as part of the exposure displays in the viewfinder or on the LCD panel. So if you need to check the current ISO setting, press the Drive-ISO button to display it.

1.33 This event image is a 100 percent crop from the original image. This represents about a one-third section of the original. Prints from this image showed excellent detail with only slight effects from noise reduction in the darkest areas of the hair. Exposure: ISO 1600, f/4.0, 1/60 sec., using an EF 25-105mm f/4.0L IS USM lens.

Setting the ISO and extended range ISO

With testing of the ISO settings on the 5D, I think that you'll find that the ISO range is very versatile for a wide range of shooting situations.

To change the ISO setting on the 5D:

1. **Press the Drive-ISO button above the LCD panel.** The current ISO setting appears on the LCD panel and in the viewfinder.

2. **Turn the Quick Control dial clockwise to set a higher sensitivity or counterclockwise to set a lower sensitivity.** The camera displays the ISO sensitivity settings as you turn the dial. If you have ISO expansion turned on using C.Fn-08, then ISO 50 is displayed as L and ISO 3200 is displayed as H. The ISO option you select remains in effect until you change it again.

To turn on ISO expansion:

1. **Press the Menu button, and then press the Jump button until the Setup (yellow) tab is displayed.**

2. **Turn the Quick Control dial to highlight Custom Functions (C.Fn), and then press the Set button.** The Custom Function screen appears and the Custom Function number control in the top right corner of the screen is activated.

3. **Turn the Quick Control dial to set the C.Fn number to 08, and then press the Set button.** The ISO expansion control is activated.

4. **Turn the Quick Control dial clockwise to select the option 1: On, and then press the Set button.** ISO expansion remains turned on until you change it.

Selecting a Drive Mode

The 5D offers three drive-mode options: Single, Continuous Shooting, and Self-timer. Each mode has its uses for different shooting

situations. Certainly the 5D isn't the fastest camera in Canon's professional line-up, but it performs nicely in moderately fast-action scenes such as wedding recessionals.

Single Shooting mode

In Single Shooting mode, one image is captured with each press of the Shutter button for up to three frames per second. Switching to Continuous Shooting mode gives you maximum burst rates of approximately 60 Large/Fine JPEGs or 17 RAW files. The actual number of frames in a burst depends on the shutter speed, file size, and the space remaining on the CF card.

Continuous Drive mode

As with its other SLRs, Canon uses smart buffering to deliver large bursts of images. The images are first delivered to the camera's internal buffer. Then the camera immediately begins writing and offloading images to the CF card. The time required to empty the buffer depends on the speed of the card, the complexity of the image, and the ISO setting. JPEG images that have a lot of fine detail and digital noise tend to take more time to compress than images with less detail and low-frequency content. Using a SanDisk Extreme III 2-GB CF card, the buffer offloads 16 RAW images in 21 seconds. That's not a bad speed considering that the camera is firing off 19 MB images with each shot.

But 21 seconds can seem like an eternity when the bride and groom are walking down the aisle toward you, and you need buffer space to continue shooting. Thanks to smart buffering, you can continue shooting in one, two, or three-image bursts almost immediately after the buffer is filled and

offloading begins to release buffer space. The point at which you can continue shooting after filling the buffer is indicated by a 9 in the viewfinder and on the LCD panel. The time from buffer full to the next burst of 9 ranges is from approximately 6 to 7 seconds for JPEG/Large Fine images and 16 seconds for RAW images.

In Continuous Shooting mode, the viewfinder displays a "Busy" message when the buffer is full and the number of remaining images shown on the LCD panel blinks. You can press the shutter button halfway and look in the bottom right of the viewfinder to check the current number of remaining shots in the maximum burst.

> **Note** If you see "Full CF" displayed in the viewfinder and on the LCD panel, be sure to wait until the red access lamp next to the Quick Control dial stops blinking before opening the CF card door cover. If you open the CF card door cover while the access lamp is blinking, some images will be lost. There is no warning to let you know not to open the CF card door cover while images are being written to the card. Be sure to make it a habit to check the red access light status before opening the CF card door.

Self-timer Drive mode

Self-timer is the third drive mode. In this mode, the shutter delays firing by 10 seconds after pressing the shutter button. The time changes to 2 seconds when using mirror lockup set with C.Fn-12. The Self-timer lamp on the front of the camera blinks and a beep is emitted slowly for 8 seconds, and then

speed of the beep and the lamp blinking increase for the final 2 seconds before the shutter fires. The camera displays the countdown to firing on the LCD panel as well.

This mode is useful in nature, landscape, and close-up shooting, and it can be combined with Mirror Lock-up (C.Fn-12) to prevent vibration from the reflex mirror action and from manually pressing the Shutter button. If you use this combination, you have to press the Shutter button once to lock the mirror, and press it again to make the exposure.

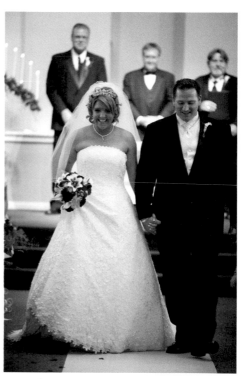

1.34 The 5D is speedy enough for capturing the action following the nuptials such as this recessional. Exposure: ISO 320, f/2.8, 1/60 sec., using an EF 70-200mm, f/2.8L IS USM lens.

To use Self-timer mode, focus on the subject, press the shutter button completely, and then take your place in the picture, or wait for the timer to fire the shutter. Be sure that you are not standing in front of the camera when you press the Shutter button because it will cause inaccurate focus.

The 5D is set to Single Shooting drive mode by default.

To switch drive mode:

1. **Press the Drive-ISO button above the LCD panel.** The camera activates Drive mode selection in the LCD panel.

2. **Turn the Main dial clockwise one click to select Continuous Shooting or two clicks to select Self-Timer drive mode.** A single rectangle denotes Single-shooting mode, a tiled rectangles icon denotes Continuous Shooting mode, and a stop-watch icon denotes Self-timer mode. The Drive mode you set remains in effect until you change it.

Note *The maximum number of images that you can capture during a burst of continuous shooting depends on the image recording quality and on the size and speed of the CF card you use along with the other factors including exposure settings. At a minimum, with the image quality set to Large/Fine JPEG, approximately 85 images per burst are possible with a 1 GB SanDisk Extreme III CF card while with RAW, 14 to 17 images can be captured. White balance bracketing lowers the maximum burst.*

CF Card Types and Speed Ratings

Directly related to the speed of the camera is the speed of the CF card — how quickly images can be written from the camera to the card. Equally important is the speed of the card when it transfers images to the computer. Both factors are important to achieving a speedy and efficient workflow. In addition to evaluating CF card speed, also consider the reliability of the card and the manufacturer's support.

The EOS 5D accepts CF Type I and Type II media cards as well as microdrives. And, because the 5D supports the FAT32 file system, you can use media cards with capacities of 2 GB and larger. As you evaluate cards, remember that the type and speed of media you use affect the camera's response times for tasks such as writing images to the media card and the ability to continue shooting during that process, the speed at which images are displayed on the LCD, and how long it takes to zoom images on the LCD. In addition, the file format that you choose also affects the speed of certain tasks — the speed when writing images to the media card, for example. JPEG image files write to the card faster than RAW files or RAW+JPEG files.

If speed is your main goal, then be sure to review Rob Galbraith's test results on CF cards and microdrives. Rob updates the CF/SD Performance Database periodically as new CF cards are introduced. You can find his latest test results at www.rob galbraith.com. Click the CF/SD link at the upper left of the Web site.

Viewing and Playing Back Images

Never before have photographers been able so extensively to review images in the field as now. Viewing, or playing back, images after capture goes beyond a quick glance to see if the image exposure and composition are acceptable. Image review includes magnifying the LCD image to check for sharpness, reviewing the brightness (luminance) histogram for localized areas of overexposure, and/or reviewing the color histogram to check color saturation, gradation, and white-balance bias.

And with this unprecedented ability to gauge exposure and composition on the spot, image evaluation can quickly solidify the settings for a commercial or studio shoot, or alert you to the need for a quick exposure change before the light changes on a stunning landscape scene.

Tip *If you haven't already set the camera so that it won't shoot if a CF card isn't inserted, be sure to turn off this dubious feature. Why anyone would want to shoot without a CF card is beyond me, but the 5D and other Canon digital SLRs offer this option. To turn off the option, press the Menu button, and then press the Jump button until the Set-up menu is displayed. Highlight Shoot w/o card, and then press the Set button. Turn the Quick Control dial clockwise to select Off, and then press the Set button again.*

One of the first things you'll want to do is to change the default display time, which is initially set to 2 seconds, hardly enough time to move the camera from your eye to catch the image preview. The display time is intentionally set conservatively to maximize battery life, but given the excellent battery performance, a display time of 4 to 8 seconds is more useful and it doesn't significantly impact the battery performance. Also, if you're showing an image on the LCD to clients or subjects and you want the image to stay displayed until you dismiss it, you can set the display time to the Hold option so that the image is displayed until you dismiss the playback.

To change the length of image playback review time, follow these steps:

1. **Press the Menu button, and then press the Jump button until the Playback (blue) menu is displayed.**

2. **Turn the Quick Control dial clockwise to highlight Review time, and then press the Set button.** The Review time options, Off, 2, 4, and 8 seconds, and Hold appear.

3. **Turn the Main dial to select the Review time option that you want, and then press the Set button.** If you select Hold, the picture is displayed until you press the Shutter button to dismiss the display. Viewing images for a longer time depletes the battery faster. The option you choose remains in effect until you change it.

Playback display options

The 5D offers several image playback display options including single-image display with three options for displaying or not displaying exposure information, magnified view, index display, or auto (slideshow) playback.

When you press the Playback button, the most recently captured image is displayed first, without accompanying shooting information. To move through multiple images on the CF card, turn the Main or Quick Control dial counterclockwise to view the next most recent image, or turn the dial clockwise to view the first captured image on the CF card.

As the name suggests, single-image display enables you to see one image on the LCD at a time. This is the default playback mode on the 5D. For single-image playback, you can choose three display formats.

✦ **Single image with no shooting information.** This is the default playback display on the 5D. When shooting a portrait, commercial, or editorial session where you want to show the subject or client the images being captured, this is a good display option because it provides a clean, uncluttered view of the images.

✦ **Single image display with basic shooting information.** With this option, shooting information is overlaid on the preview image in light gray screen areas at the top right and bottom left of the LCD preview. The top right display shows file folder and file numbers while the bottom left display shows the shutter speed, aperture, and the image number relative to the number of images captured; for example, 11/11, or 11 of 11 stored images. This display option is useful during a quick image review to verify exposures for an AEB series of images, or to recall exposure settings for a previous image.

✦ **Single image with shooting information.** This data-rich view includes all the exposure and file information, a black-and-white flashing display showing areas of overexposure, flash exposure, capture time, the histogram you've selected, and more. To display this amount of information, the image preview is necessarily reduced to about one-fourth of the full-LCD preview size.

✦ Figure 1.35 shows this display option and identifies the data displayed. This display option is invaluable at all stages of shooting so you can check the histogram, exposure, color and just about anything else you'd want to verify. If you set AF points to be displayed, the AF point that achieved focus in One-Shot AF mode is also displayed on the image preview. Or if you were in AI Servo AF mode, the AF points that achieved focus are displayed.

Tip — *If you want the AF point or points that achieved focus displayed during image playback, press the Menu button, and then press the Jump button until the Playback (blue) menu is displayed. Select the AF points option, press the Set button, and then select Display. Then press the Set button. The AF point or points that achieve focus in either One-Shot AF or AI Servo AF mode are displayed as a red rectangle on LCD preview images.*

Unless I'm shooting portraits or an editorial session where I show subjects or clients the images on the LCD, I use the single-image mode with shooting information. I like this display because I can check the brightness

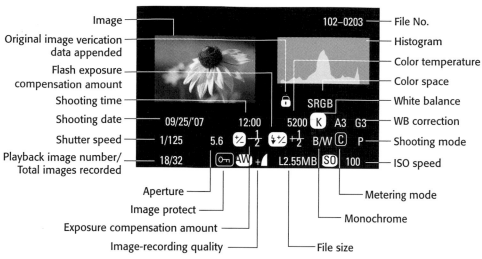

Labels (left side, top to bottom):
- Image
- Original image verication data appended
- Flash exposure compensation amount
- Shooting time
- Shooting date
- Shutter speed
- Playback image number/ Total images recorded
- Aperture
- Image protect
- Exposure compensation amount
- Image-recording quality

Labels (right side, top to bottom):
- File No.
- Histogram
- Color temperature
- Color space
- White balance
- WB correction
- Shooting mode
- ISO speed
- Metering mode
- Monochrome
- File size

Display values: 102–0203, SRGB, 09/25/'07, 12:00, 5200 K, A3, G3, 1/125, 5.6, B/W, P, 18/32, L2.55MB, 100

1.35 This is the single-image shooting information displayed during image playback.

histogram, and I can magnify the image to verify sharp focus. (You can, of course, magnify the preview image with any display.)

To change the display format in single-image playback:

1. **Press the Playback button.** If you have not changed the default single-image playback display, the most recently captured image is displayed with no shooting information.

2. **Press the Info button once to display basic shooting information, or press it twice to display full shooting information with a histogram.** The display option you choose remains in effect until you change it.

Jump quickly among images

When a high-capacity CF card is full or nearly full, it's challenging to find a single image among all the images stored on the

card. To make searching easier, you can jump through images by 10s or 100s, by folder, or by shot date to find one or more images.

To move forward or back 10 images at a time:

1. **Press the Playback button, and then press the AE Lock/FE Lock/Index/Reduce button on the back top of the camera.** This button has a checkerboard icon beneath it. The camera displays an index of multiple images with a green rectangle around the images and with a scroll bar at the bottom of the LCD display.

2. **Turn the Quick Control dial and move forward or backward by 10 images at a time.** As you move, the scroll bar shows the progress relative to the number of images stored on the CF card.

3. **When you get to the image page you want, press the Jump button to select a single image at a time.**

To change the method of moving through images:

1. **With the Jump scroll bar displayed on the LCD, press the Set button.** The jump control to the left of the scroll bar is activated.

2. **Turn the Quick Control dial to scroll through the options for jumping.** You can choose to move by 100 images at a time, to jump by folder, or to jump by shot date.

3. **When the option you want is displayed in the window, press the Set button.** If you choose to jump by folder, turn the Quick Control dial to move to the previous or next folder and display the first image in the folder. If you choose to jump by shot date, turn the Quick Control dial to move to the previous or next date. If there are multiple images taken on the same date, then the camera displays the first image taken on that date.

To dismiss Jump mode, press the Jump button.

Ensuring that you have tack-sharp focus immediately after capturing an image is another advantage that Playback mode offers. You can magnify the LCD image display, and then use the Multi-controller to scroll to verify sharp focus.

To magnify and move within the image:

1. **In any playback display mode, press and hold the AF point selection/Enlarge button.** A small screen with a rectangle displays the relative amount of magnification. If you are using the single-image with shooting information display option, then the camera temporarily switches to basic shooting information display and magnifies the image preview. You can magnify the image by 1.5× to 10×.

2. **Tilt the Multi-controller in the direction you want to move within the zoomed image.** If you want to check other images, turn the Quick Control or Main dial to move to the next or previous image at the same position and magnification.

3. **Press and hold the Reduce button to return to the original image size**. If you were in the single-image with shooting information display, the camera switches back to that display to show the full shooting information.

Index display

In addition to evaluating individual images, you can view multiple images on the CF card as an index; essentially, this is a miniature, electronic version of a contact sheet. Index display shows nine thumbnails of images at a time. This display is handy when you need to verify that you've captured a picture of everyone at a party or event, and it's a handy way to find a particular image quickly. You can use Index display regardless of which single-image display option you're using.

To display images as an index:

1. **Press the Playback button.**

2. **Press the AE Lock/FE Lock/Index button on the back of the camera.** The camera displays the last images captured, and the selected image is displayed with a green border. If the Index display shows only one or a few images, turn the Quick Control dial counterclockwise to move to the previous page of images. If you are using single-image with shooting information or with basic shooting information, then the Index display includes basic shooting information with the selected image on the index display.

3. **Turn the Quick Control to move among individual images on a single Index page.** To display the selected image in single-image display, press the Playback button. You can press and hold the Enlarge button to magnify the image. To return to Index display, press and hold the Reduce button until the single-image display appears, and then press the Reduce button again to return to Index display.

4. **Press the Jump button to display a scrollbar and then turn the Quick Control dial to move among sets of nine images.**

5. **Press the Playback button to turn off the Index display and return to the selected single-image display mode.**

Auto Playback

When you want to sit back and review all the pictures on the CF card or run through the images with the people you're photographing or with a client, the Auto Playback option is the ticket. Auto Playback displays all of the images on the CF card for three seconds as a slide show. This is also a good option for verifying that you've taken all the shots that you intended to take during a shooting session.

To use Auto Playback:

1. **Press the Menu button, and then press the Jump button until the Playback (blue) menu is displayed.**

2. **Turn the Quick Control dial to highlight Auto play, and then press the Set button.** The camera loads images and displays them in the Playback mode display you've chosen. The best way to review images is to have the display set to Single-image. To pause and restart the slide show, press the Set button.

4. **Press the Shutter button lightly to return to shooting.**

Erasing Images

Erasing images is a fine thing when you know without a doubt that you don't want the image you're deleting. From experience, however, I know that some images that

appear to be mediocre on the LCD often can be salvaged with judicious image editing on the computer. For that reason along with the inability to recover erased images, it pays to erase images only with great caution. Of course, if you know that something is wrong with an image you just made, erasing the image helps keeps the number of images on the CF card down and makes better use of your time when evaluating images on the computer later.

If you want to delete an image:

1. **Press the Playback button on the back of the camera, and then turn the Quick Control dial to navigate to the image you want to delete.** Alternately, you can also use the Main dial to move through images.

2. **Press the Erase button, and then turn the Quick Control dial to select Erase if you want to delete only the displayed image, or to All if you want to delete all images on the CF card.** If you change your mind, choose Cancel to not erase any images.

3. **Press the Set button to erase the image or images. If you chose All, the camera displays a message asking you to confirm that you want to erase all images. Turn the Quick Control dial to select OK, and then press the Set button.** The red access button lights while the images are being erased. The camera erases the image or images except those

that have protection applied to them. Note that if a series of images shot in burst mode are being written to the CF card when you choose Erase, these images are erased as well.

4. **Lightly press the Shutter button to continue shooting.**

Note *It's a good idea to periodically format the CF card. Before formatting the card, be sure to download all the images from the card to the computer. To format the CF card, press the Menu button, press the Jump button until the Set-up (yellow) menu is displayed. Turn the Quick Control dial clockwise to highlight Format, and then press the Set button. The Format confirmation screen appears. Turn the Quick Control dial clockwise to select OK, and then press the Set button. The camera displays a progress screen as the card is formatted.*

Protecting Images

At the other end of the spectrum from erasing images is the ability to ensure that images you want to keep are not accidentally deleted. To prevent accidental erasure, you can apply protection to one or more images.

Setting protection means that no one can erase the image when using the Erase or Erase All options. However, protected images are erased if you format the CF card.

To protect an image:

1. **Press the Playback button, and then turn the Quick Control dial to move to the image you want to protect.**

2. **Press the Menu button, and then press the Jump button to select the Playback (blue) menu.**

3. **Turn the Quick Control dial to highlight Protect, and then press the Set button.** A small key icon appears at the bottom of the display.

4. **Press the Set button again.** A small key icon appears at the bottom of the image to show that the image is protected. To protect additional images, turn the Quick Control dial to scroll to the image you want to protect, and then press the Set button to add protection. If you later decide that you want to erase a protected image, you must remove protection by repeating steps **1** to **4** and pressing the Set button to remove protection for each image.

Restoring the Camera's Default Settings

With all of the different settings, you may sometimes want to start fresh instead of backtracking to reset individual settings. The 5D offers several restore settings including Clear all camera settings. This option is a good way to start fresh, but be aware that it resets all shooting and image quality settings back to the factory defaults.

In addition to the fresh start advantage, I've found that a quick way out of any type of shooting problem that you might encounter with the camera is to use the Clear all camera settings option. I include this story for the sake of illustrating the advantages of using the restore option and to underscore the importance of keeping the camera firmware up to date.

I was shooting an editorial assignment after I had changed a variety of camera settings and the method of choosing an AF point via a Custom Function. As the shooting began, I noticed that the AF points did not light in red, and the autofocus confirmation beep was ominously silent. I suspected that the problem was a conflict in the settings, and I remembered that I hadn't updated the firmware on the camera to the latest version either. To keep the shoot moving, I quickly reset the camera to the defaults, and then reset the image quality and color space. Resetting the defaults solved the conflict and the camera performed throughout the shoot without a hitch. Later, I updated the firmware, reset the Custom Functions, and I haven't had a problem with the camera since then.

Table 1.8 shows the default settings for the 5D.

If you customize the 5D and want to restore the default camera settings, follow these steps:

1. **Press the Menu button, and then press the Jump button until the Set-up (Yellow) menu is displayed.**

2. **Turn the Quick Control dial to highlight Clear settings, and then press the Set button.** The Clear settings screen appears.

Table 1.8
Clear All Camera Settings Defaults

Shooting Settings		Image Recording Settings	
AF mode	One-shot	Quality	Large/Fine
AF-Point Selection	Automatic	ISO	100
Metering mode	Evaluative	Color space	sRGB
Drive mode	Single-shooting	White balance	AWB
Exposure Compensation	Zero	Color temperature	5200K
AEB	Off	White balance correction	Off
Flash Exposure Compensation	Zero	White balance bracketing	Off
Custom Functions	Retains current settings	Picture Style	Standard

3. **Turn the Quick Control dial to select Clear all camera settings, and then press the Set button.** A confirmation screen appears.

4. **Turn the Quick Control dial to select OK, and then press the Set button.** The camera restores settings to the camera defaults.

Cleaning the Image Sensor

Few early digital photographers managed to escape tedious hours spent spotting images. Regardless of how careful they were when changing lenses, inevitably dust particles — some rivaling the size of digital meteors — would quickly accumulate on the sensor.

Of course, dust still accumulates on image sensors. The dust and spots come from external dust and clothing particles that fall into the chamber while changing lenses, and from dust or lubricants within the camera body that are dislodged by carrying the camera and by changes in air pressure.

Regardless of the source, the task of cleaning the image sensor is easier than ever before. Using the mirror lock-up function and any of several excellent cleaning products available, photographers can clean the image sensor in a few minutes' time.

Canon recommends using a rubber bulb blower like the one you'd buy at a drug store. This is the safest approach to cleaning. But there are other products that work very well too. I use VisibleDust (www.visible dust.com) products, particularly the brushes that you "charge" by blowing them with air

before swiping them across the sensor. The company offers cleaning solutions, swabs, and state-of-the-art soft brushes designed to gently clean or lift dust and spots without damaging the sensitive sensor surface. VisibleDust also offers tutorials on how to clean the sensor using their products. But you can also find a variety of cleaning products with a quick Google search.

Regardless what product you use, you'll spend more time shooting and less time cleaning up images if you clean the sensor every week or so depending on camera use and in what conditions you shoot. Never use canned air to clean the sensor because the force of the air on the sensor may damage it. Also the gas propellant can freeze on the sensor. You don't want either to happen. Also don't use a blower with a brush attached because it can scratch the sensor.

Once you choose the product you'll use to clean the sensor, do these things first:

1. **Ensure that the battery is fully charged.** You can't use the optional BG-E4 battery grip with AA batteries in it to clean the sensor.

2. **Find a place indoors, away from drifting lint, dust, pets, and so on, that has bright light so that you can see the sensor as you clean it.**

3. **Read the steps for cleaning before you begin so you have a general idea of the task flow.**

4. **Assemble the products you'll use and prepare them before you begin**.

5. **Remove the lens and attach the body cap until you're ready to begin.**

When you're ready, follow these steps to clean the image sensor:

1. **Press the Menu button, and then press the Jump button until the Set-up (yellow) menu is displayed.**

2. **Turn the Quick Control dial to highlight Sensor cleaning, and then press the Set button.** The Sensor cleaning screen appears with a reminder to turn off the camera when you finish.

3. **Turn the Quick Control dial to select OK, and then press the Set button.** The camera flips up the mirror, locks it up, and opens the shutter. Remove the body cap if you placed it on the camera during the preparation phase. CLn blinks in the LCD panel.

 Caution *Do not do anything that would disrupt power to the camera during cleaning.*

4. **Use the bulb blower or a sensor brush to clean the sensor.** If you use a sensor brush specifically designed for sensor cleaning, wipe in a single down, across, and upward motion. If you use a blower brush, turn the camera so the lens mount faces down, and blow away dust.

5. **Turn the Power switch to the Off position.** The camera turns off, the shutter closes, and the mirror flips back down.

To determine how well you cleaned the sensor, make and evaluate a few pictures of a blue sky at a large aperture.

In years of digital photography, I've not found any sure-fire ways to avoid dust accumulating on the image sensor other than common-sense approaches that include avoiding changing lenses in windy and/or dusty outdoor areas, keeping the rear optical element of lenses scrupulously clean, changing lenses with the 5D lens mount pointed downward, and always keeping a lens mounted or putting the body cap on the lens mount when no lens is mounted. I also carry large, unused plastic bags in my camera bag. If I'm in dusty outdoor areas, I put the camera body in the bag to change lenses. These precautions certainly help keep the sensor clean, but none are fool-proof.

Color and Picture Styles

In This Chapter

About color spaces

Choosing a color space

Understanding and setting the white balance

Choosing and customizing a Picture Style

Registering a User-defined Picture Style

Never has accurate color been as accessible as it is with digital photography. And as digital technology matures, the options and techniques for ensuring accurate and visually pleasing color become easier and more varied. Color accuracy begins by setting the color space on the 5D that matches your workflow. The process continues by selecting one of Canon's Picture Styles that set the tonal curve, sharpness, color rendering, and saturation of images. You can choose among a variety of Picture Styles that replicate traditional film looks or render color in different ways.

In terms of color, the white balance options on the EOS 5D also leave little to be desired whether you prefer using the preset white balance settings, setting the color temperature yourself, or setting a custom white balance. In this chapter, I discuss how each option is useful in different shooting scenarios. In addition, you'll learn some widely used techniques for ensuring accurate color.

About Color Spaces

If you are just transitioning from film to digital photography, it's worthwhile to talk about color spaces and how they fit into the overall workflow, from shooting through final output.

A color space defines the range of colors that can be reproduced and the way that a device such as a digital camera, a monitor, or a printer reproduces color. Of the two color space options offered on the 5D, the Adobe RGB color space is richer because it supports a wider gamut, or range of colors, than the sRGB color space option. And in digital photography,

the more data captured, or, in this case the more colors captured by the camera, the richer and more robust the file. And it follows that the richer the file, the more color that you have to work with while either converting RAW images or editing JPEG images.

Note *The same principle – getting the most that the 5D image sensor offers – also holds true in regard to image bit depth, as detailed in Chapter 1.*

Choosing a color space and keeping it consistent throughout the workflow also helps to ensure that colors are accurately represented on devices, including the computer monitor and the printer.

While Adobe RGB is the color space of choice for printing on inkjet, commercial, and many photo lab printers, it isn't the color space that displays colors most accurately online. Rather, because the sRGB color space produces brighter and more saturated colors than Adobe RGB, sRGB is the color space of choice for displaying images on the Web or in e-mail. While this may sound like a conflict in choosing color spaces, for most workflows, it translates into maintaining the Adobe RGB color space for capture, conversion, editing, and printing. But when an image is needed for online display, a copy of the image is made and converted to sRGB in an editing program such as Photoshop CS3.

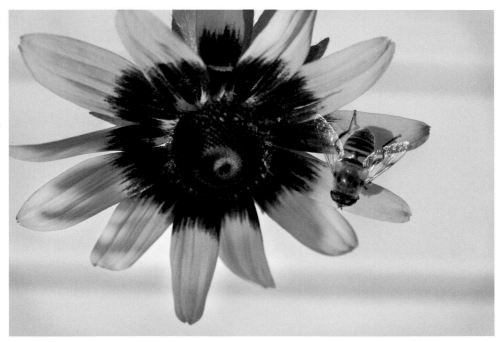

2.1 The histograms shown in figures 2.2, 2.3, and 2.4 are based on this RAW image that was converted in Adobe Camera Raw and edited in Photoshop CS3. Exposure: ISO 250, f/8, 1/200 sec.

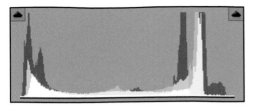

2.2 An Adobe Camera Raw histogram using ProPhoto RGB. Notice the additional headroom in the highlights (right side of the histogram) that this large color space provides. Also notice the rich amount of color in this histogram compared to the following histograms. After evaluating these histograms, you can see how much more image data is retained by using a wide color space such as ProPhoto RGB. And while the image may eventually be converted to a smaller color space, you want to keep this rich image data to use during conversion and initial editing in Photoshop.

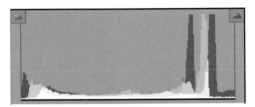

2.3 An Adobe Camera Raw histogram using Adobe RGB. Both the highlights and the shadows clip as shown by the spikes on the right and left sides of the histogram respectively.

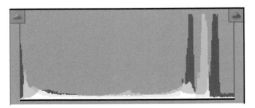

2.4 An Adobe Camera Raw histogram using sRGB. Here the shadow spike increases noticeably.

Choosing a Color Space

You should make your choice of color space to enhance your overall workflow, to give you the ability to maintain color reproduction consistently across devices, and to capture as much data as possible in images. Ultimately, the choice is yours. Whichever option you choose, remember that it's easy to change the color space in Photoshop if you need to.

If you choose Adobe RGB, the 5D image filenames are appended with _MG_ . While the 5D does not embed the color, or ICC, profile to the file, you can embed the camera's ICC profile in Photoshop 6.0 or later. Embedding the ICC profile ensures that the profile stays with the file so that the color space information can be read by other devices, such as monitors and printers that support ICC profiles.

> **Note** ICC is an abbreviation for the International Color Consortium that promotes the use and adoption of open, vendor-neutral, cross-platform color management systems. This group introduced the standard device profile format used to characterize color devices.

Photoshop, and other applications that support ICC profiles, use the profiles to produce colors more accurately, so that colors are consistent when printed or viewed on different devices. Photoshop also uses profiles to convert RGB values to CMYK (Cyan, Magenta, Yellow, Black) and CMYK to RGB, to display photo CD image color more accurately, and to soft proof an image at a different setting so that you can see how the image will look.

To set the color space on the 5D:

1. **Set the Mode dial to any mode except Full Auto.**

2. **Press the Menu button, and then press the Jump button to display the Shooting (red) menu.**

3. **Turn the Quick Control dial to highlight Color space, and then press the Set button.** The camera displays the color space options.

4. **Turn the Quick Control dial to select the color space you want, and then press the Set button.** The color space remains in effect until you change it, or until you switch to Full Auto shooting mode which automatically switches to sRGB.

Understanding and Setting the White Balance

If you prefer to shoot instead of sitting at the computer color correcting images, then mastering white balance is important. Different shooting assignments, the type and consistency of light, and the amount of time you have to set up the camera before and during a shoot are some of the factors that influence which white balance approach you choose to use.

On the EOS 5D, white balance options give you a variety of ways to ensure color that accurately reflects the light in the scene. You can set the white balance by choosing one of the seven preset options, by setting a specific color temperature, or by setting a custom white balance that is specific to the scene.

Tip *If you shoot JPEG images, the white balance is set in the camera by the setting you choose, If you shoot RAW images, the white balance setting is only "noted," and you can set or adjust the white balance in the RAW conversion program after the image is captured.*

Table 2.1 provides the 5D white balance options, and their approximate color temperature and color temperature range in degrees Kelvin.

What Does White Balance Do?

This question can be best answered with a comparison to human vision. The human eye automatically adjusts to the changing colors (temperatures) of light. We see a person's white shirt as white in tungsten, fluorescent, or daylight light; in other words, regardless of the type of light in which you view a white object, it appears to be white. Digital image sensors, however, are not as adaptable. To distinguish white in different types of light, you must set the white balance to an approximate or specific light temperature.

Light temperature is measured on the Kelvin scale and is expressed in degrees Kelvin (K). Once you set the white balance to specify the light temperature, the camera can render white as white. On the 5D, a preset white balance option covers a range of light temperatures, which is more an approximate than a specific approach. A custom white balance is a specific light temperature and renders neutral color in the image.

How Color Temperature Is Determined

Unlike air temperature that is measured in degrees Fahrenheit (or Celsius), light temperature is based on the spectrum of colors that is radiated when a black body radiator such as a black metal pot is heated. As the pot is heated, it glows red. As the heat intensifies, the metal color changes to yellow, and with even more heat, it glows blue-white. In this spectrum of light, color moves from red to blue as the temperature increases. The absolute temperature of the pot is expressed in degrees Kelvin which is equivalent to degrees Celsius plus 273 degrees. But when referring to color temperature, the unit of measure "degree" is dropped and only "K" is used.

In short, the color temperature is the absolute temperature of the black metal pot when the pot color spectrum, or chromaticity, matches that of the light source. For fluorescent light which can only approximate a black body's chromaticity, scientists apply correlated color temperature by calculating chromaticity value. Also, color temperature refers only to the visual appearance of the light source, and it doesn't account for light sources such as gas lamps and fluorescent light that do not have a spectral distribution similar to the black body radiator.

At first glance, the concept of color temperature seems backward because we usually think of "red hot" as being significantly warmer than "icy blue." But in the world of color temperature, blue is a much higher color temperature than red. That also means that the color temperature at noon on a clear day is higher than the color temperature of a fiery red sunset. And you care about this because it affects the color accuracy of your images. So keep this general principle in mind: The higher the color temperature is, the bluer the light; the lower the color temperature is, the redder the light.

the Quick Control dial to highlight Picture Style, and then verify that the style is not set to Monochrome. To change from Monochrome, press the Set button, turn the Quick Control dial to select another style, and then press the Set button.

2. **In the light that will be used for the subject, position a piece of unlined white paper so that it fills the center of the viewfinder (the spot metering circle), and take a picture.** If the camera cannot focus, switch the lens to MF (Manual Focus), and focus on the paper. Also ensure that the exposure is neither underexposed nor overexposed.

3. **Press the Menu button.**

4. **Press the Jump button until the Shooting (red) menu is displayed, and then turn the Quick Control dial to highlight Custom WB.** The camera displays the Custom WB screen with the last image captured.

5. **Press the Set button.**

6. **If necessary, rotate the Quick Control dial until the image of the white or gray card or paper is displayed.**

7. **Press the Set button.** The EOS 5D imports the white balance data from the selected image, and then it displays a message reminding you to set the white balance to Custom WB.

options work well to get neutral color quickly in mixed lighting scenes. If you're shooting RAW capture, one option is to shoot a gray or white card as I described in the "The Easy Way to Ensure Accurate Color with RAW Capture" sidebar. The second option is to set a custom white balance. Setting a custom white balance ensures that white is rendered as white in the specific light you're shooting in. It is relatively easy to set, and is a great way to ensure accurate color.

An advantage to setting a custom white balance is that it can be used whether you're shooting JPEG or RAW capture. The thing to remember is that if light changes, you must set a new custom white balance.

To set a custom white balance:

1. **Ensure that the Picture Style is not set to Monochrome.** To do this, press the Menu button, and then press the Jump button to display the Shooting (red) menu. Turn

2. 7 This shot, taken for stock, was taken using the Auto white balance setting. The mix of daylight and office lighting is evident with a warm yellow tint. Exposure: ISO 100, f/4.0, 1/15 sec.

2.8 Using the back of the vet's prescription pad, I quickly set a custom white balance and reshot the stethoscope. The color is much more neutral and vibrant in this variation with identical editing in Photoshop CS3. Exposure is the same as in figure 2.7.

The Easy Way to Ensure Accurate Color with RAW Capture

If you are shooting RAW images, the easiest way to ensure accurate color is to photograph a white or gray card in the same light the subject is in, and then use the gray card to set color balance when you process the images on the computer. Gray cards are specifically designed to render accurate color by providing a neutral white balance reference point that you can use during image editing to color-balance batches of images. Once an accurate gray point is established for the image, all other image colors automatically fall into place.

For example, if you're taking a portrait, ask the subject to hold the gray card under or beside their face for the first shot, and then continue shooting without the card in the scene. When you begin converting the RAW images, open the picture that you took with the gray or white card. Using the conversion program's white balance tool, click the gray card to correct the color, and then click Done to save the corrected white balance settings. If you're using a RAW conversion program such as Adobe Camera RAW or Canon's Digital Photo Professional, you can then copy the white balance settings from the corrected image and apply it to all of the images shot under the same light. In a few seconds, you can color balance 10, 20, 50 or more images.

This technique, also called *click-balancing*, is a quick way to provide a neutral reference point in any light. For example, if you're shooting a wedding, the light changes from the bride's dressing room, to the church sanctuary, and again in the reception area. Instead of setting a custom white balance for each type of light, you can take a picture of a white card in each of the different areas as you shoot, before you start shooting, or even the day after shooting. Just be sure that the light on the card isn't so bright that it registers as the brightest highlight.

There are a number of white and gray card products you can use such as the WhiBal cards from RawWorkflow.com (www.rawworkflow.com/products/whibal) or ExpoDisc from ExpoImaging (www.expodisc.com/index.php) to get a neutral reference point. There are also small reflectors that do double duty by having one side in 18 percent gray and the other side is white or silver. The least expensive option, and one that works nicely, is a plain white unlined index card.

Whatever your approach is to using white balance options, the time you spend using and understanding them and how they can enhance your workflow is time that you'll save color-correcting images on the computer.

5. **Turn the Quick Control dial to set the color temperature that you want, and then press the Set button.** The color temperature you set remains in effect until you change it.

Set a custom white balance

Mixed light scenes, such as tungsten and daylight, can wreak havoc on getting accurate or visually pleasing image color. Two

2.6 By comparison, this image was captured using the Shade white balance setting and the Standard Picture Style. Notice the strong yellow color cast of this white balance setting that did not match the actual light temperature in the scene.

images onsite as a slideshow, then setting a custom white balance is a good approach because the color is correct as you shoot.

To preset a white balance option such as Daylight, Tungsten, and Shade:

1. **Set the Mode dial to any mode except Full Auto.** In Full Auto mode, the 5D automatically uses AWB, and you cannot change the white balance setting.

2. **Press the AF-WB button above the LCD panel, and then turn the Quick Control dial until the white balance option you want appears on the LCD panel.** The white balance settings are shown with icons that represent different types of lights. The white balance option you set remains in effect until you change it.

To set a specific color temperature:

1. **Press the AF-WB button above the LCD panel, and then turn the Quick Control dial until the K option is displayed on the LCD panel.**

2. **Press the Menu button.**

3. **Press the Jump button until the Shooting (red) menu is displayed.**

4. **Turn the Quick Control dial to highlight Color temp, and then press the Set button.** The camera activates the Color temp control.

2.5 This image was captured using the Daylight white balance setting and the Standard Picture Style. The colors are neutral. (Picture Styles are discussed later in this chapter.) Exposure: ISO 100, f/8, 1/400 sec.

temperature meter, this is a great option to use in non-studio scenarios. In short, use the specific color temperature white balance setting in any scene where you know the specific light temperature.

✦ **Setting a custom white balance.** Setting a custom white balance is an option that produces very accurate color because the white balance is set precisely for the light temperature of the scene. To use this option, you shoot a white or gray card, select the image, and the camera imports the color data and uses it to set the image color. You can use the custom white balance as long as you're shooting in the same light, but if the light changes, you have to repeat the

process to set a new custom white balance. Certainly for JPEG capture, this is an accurate technique that is highly recommended.

For RAW capture, there are easier techniques. For my work, I alternate between setting a custom white balance and shooting a gray card, and then color balancing batches of images during RAW conversion. Both techniques work in the same general way; they differ in when you set the white balance. With one, you set the white balance before shooting, and with the other, click-balance technique, you set it during RAW image conversion. However, if you are shooting a wedding and showing

Table 2.1
White Balance and Color Temperature Ranges

White Balance option	EOS 5D Setting and Corresponding Color Temperature (K)
Auto (AWB)	3000-7000
Daylight	5200
Shade	7000
Cloudy, twilight, sunset	6000
Tungsten	3200
White fluorescent	4000
Flash	6000
Custom*	2000-10000
Color temperature	2800-10000

* Custom White Balance is a technique for setting the white balance to match the color temperature of a specific scene. The technique is detailed later in this section. Table 2.1 shows the range of color temperature that the camera supports for a custom setting.

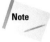

Note *The automatic white balance setting evaluates the colors in the scene and makes an "educated guess" on white balance.*

Choosing a white balance approach

The 5D offers three basic approaches to setting white balance. This gives you flexibility to use different approaches in different shooting scenarios. Here are some examples to provide a starting point for using each of the three approaches:

✦ **Using preset white balance settings.** For outdoor shooting, especially in clearly defined lighting such as bright daylight, an overcast sky, or in fluorescent light, using a preset white balance setting produces accurate color. The exception is shooting in tungsten light and using the Auto white balance setting (AWB) option, which produces less than stellar color rendition. Otherwise, the preset white balance settings have very good color, hue accuracy, and color saturation. However, be aware that the 5D tends to oversaturate color almost exclusively in the reds, which can cause a loss of shape and detail in certain subjects, such as a close-up of a red flower, particularly when shooting at the default Standard Picture Style. (Picture Styles are detailed later in this chapter.)

✦ **Setting a specific color temperature.** With this option, you set the specific light temperature manually. This is the best approach to use for studio shooting when you know the temperature of the strobes. And if you happen to have a color

8. **Press the Shutter button to dismiss the menu.**

9. **Press the AF-WB button above the LCD panel.**

10. **Turn the Quick Control dial to select Custom WB.** The Custom WB icon is two triangles on their side with a solid rectangle between them. The Custom white balance remains in effect until you change it by setting another white balance. All of the images you take will be balanced for the custom setting.

When you finish shooting in the light where you set the Custom white balance and move to a different light, remember to reset the white balance option.

Use White-Balance Auto Bracketing

Given the range of indoor tungsten, fluorescent, and other types of lights that are available, the preset white balance options may or may not be spot-on accurate. In addition, you may prefer a bit more of a green or blue bias to the overall image colors. With the 5D, you can use White-Balance Auto Bracketing to get a set of three images each with +/- 3 shifts in blue/amber and magenta/green bias from the base white balance setting.

This option is handy particularly when you don't know which bias will give the most pleasing color, and when you don't have time to set a manual white balance bias. The bracketed sequence gives you a set of three images from which to choose the most visually pleasing color. If you're shooting JPEG and use the Standard, Portrait, or Landscape Picture Styles, bracketing can be

a good choice to reducing post-processing time.

To set White-Balance Auto Bracketing:

1. **Press the Menu button, and then press the Jump button until the Shooting (red) menu is displayed.**

2. **Turn the Quick Control dial clockwise to highlight WB SHIFT/BKT, and then press the Set button.** The camera displays the WB correction/WB bracketing screen.

3. **Turn the quick Control dial clockwise to set blue/amber bias, or counterclockwise to set a magenta/green bias.** As you turn the dial, three squares appear and the distance between them increases as you continue to turn the Quick Control dial. The distance between the squares sets the amount of bias. On the right of the screen, the camera indicates the bracketing direction and level under BKT. You can set up to plus/minus three levels of bias.

4. **Press the Set button.**

5. **Press the Shutter button three times in one-shot drive mode to capture the bracketed images. As you shoot, the White Balance setting icon on the LCD panel flashes.** With a blue/amber bias, the standard white balance is captured first, and then the bluer and more amber bias shots are captured. If magenta/green bias is set, then the image-capture sequence is the standard, more magenta, and then more green.

2.9 This is the standard tungsten white balance setting. This and the next two images were made with the Canon EF 85mm, f/1.2L II USM lens. Exposure: ISO 100, f/1.6, 1/100 sec.

2.10 With the white balance bracketing set to +2, this is the blue/amber white balance bracketed image. Even though the difference between the two photos is quite subtle, I prefer this bias for its warmer and slightly more neutral color.

Note *You can combine White-Balance Auto Bracketing with AutoExposure Bracketing. If you do this, a total of nine images are taken for each shot.*

To cancel White-Balance Auto Bracketing, repeat steps **1** to **4** except in step **3**, reset the bias to +/- 0 and a single point on the graph. When you reset the white balance bracketing, the white balance icon in the LCD panel stops flashing.

Note *You can use change the sequence of White-Balance Auto Bracketing by setting C.Fn-09. For details on setting Custom Functions, see Chapter 3.*

Set a White-Balance Shift

Similar to White-Balance Auto Bracketing, you can manually set the color bias of images to a single setting by using White-Balance Shift. The color can be biased toward blue (B), amber (A), magenta (M), or green

2.11 This is the magenta/green shift image.

(G) in up to nine levels measured as mireds, or densities. Each level of color correction that you set is equivalent to five mireds of a color-temperature conversion filter. When you set a color shift or bias, it is used for all images until you change the setting.

> **Note** On the EOS 5D, color compensation is measured in mireds, a measure of the density of a color temperature conversion filter — similar to densities of color correction filters that range from 0.025 to 0.5. Shifting one level of blue/amber correction is equivalent to five mireds of a color-temperature conversion filter.

The White-Balance Shift technique is handy when you know that a particular lighting needs correction such as cooling down an extremely warm tungsten light source, or in the same way that you would use a color-correction filter for warming up or cooling down outdoor and indoor light.

> **Note** Manipulating the White-Balance Shift and bracketing screen on the 5D can be confusing. The main difference is the control you use — either the Multi-controller or the Quick Control dial. To set a White-Balance Shift you use the Multi-controller to set the bias, and to set White-Balance Auto Bracketing, you use the Quick Control dial.

To set White-Balance Shift:

1. **Press the Menu button, and then press the Jump button until the Shooting (red) menu is displayed.**

2. **Turn the Quick Control dial to highlight WB SHIFT/BKT, and then press the Set button.** The camera displays the White-Balance Correction and White-Balance Auto Bracketing screen.

3. **Tilt the Multi-controller in the direction you want to set the bias, toward a blue, amber, magenta, or green shift.** On the right of the screen, the SHIFT panel shows the bias and correction amount. For example, A2, G1 shows a two-level amber correction with a one-level green correction.

4. **Press the Set button.** The color shift you set remains in effect until you change it.

To cancel the White Balance Correction, repeat steps **1** to **5**, but in step **3** use the Multi-controller to set the cursor to 0,0 — the center of the graph — and then press the Set button.

Specify a color temperature

Setting the white balance for a specific color temperature is the easiest way of getting neutral color in the least amount of time. The caveat, of course, is that you must know the temperature of the light to get good results. In most studios, you'll know the light temperature and you can easily dial it into the 5D. And if you're fortunate enough to have a color-temperature meter, then you can use this white balance option with abandon in any type of scenario.

In terms of workflow, this option speeds up post-processing for either JPEG or RAW capture.

Here is how to specify a color temperature on the 5D:

1. **Press the AF-WB button above the LCD panel, and then turn the Quick Control dial to select K (color temperature).**

2. **Press the Menu button, and then press the Jump button until the Shooting (red) menu is displayed.**

3. **Turn the Quick Control dial to highlight Color temp., and then press the Set button.** The camera activates the Color temperature control.

2.12 When I work in my studio, where I know that the temperature of my studio strobes is 5500K, setting a specific color temperature is the easiest way to get an accurate color with the fewest steps. Exposure: ISO 100, f/22, 1/125 sec.

4. **Turn the Quick Control dial clockwise to select a higher color temperature, or counter-clockwise to select a lower color temperature.** The range of temperatures you can set is 2800 to 10,000K.

5. **Press the Set button.** The specific Color temperature you set remains in effect until you change it.

Choosing and Customizing a Picture Style

The 5D attaches a Picture Style to every image that you shoot with the 5D. More specifically, Picture Styles are the foundation for how the camera delivers tonal curves, color rendering, color saturation, and sharpness in the final image.

The 5D offers six Picture Styles detailed in Table 2.2, and it uses the Standard Picture Style as the default style. All Picture Styles have specific settings for sharpness, contrast, color saturation, and color tone. Individual Picture Styles mimic the look of films such as Fuji Velvia for rendering landscape and nature shots with vivid color saturation, or Kodak Portra for rendering portraits with warm, soft skin tones. You can also modify the settings to suit your preferences, and you can create up to three User-defined styles that are based on one of Canon's Picture Styles.

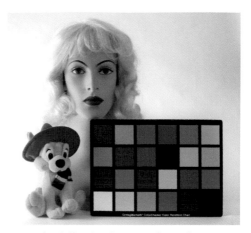

2.13 The following images show the differences in Canon's Picture Styles using the same scene. This image uses the Standard Picture Style. Exposure: ISO 100, f/4.5, 1/125 sec.

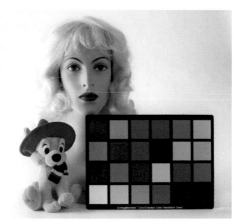

2.14 This image uses the Portrait Picture Style. The color saturation and sharpness are much more subdued, but this leaves a good deal of latitude for RAW conversion tweaks and editing in Photoshop.

2.15 This image uses the Landscape Picture Style that offers an obviously modified tonal curve and saturated colors, particularly green (and blue).

2.16 This image uses the Neutral Picture Style. Color is neutral with a lower overall contrast than the Standard Picture Style. This rendering, however, provides very pleasing color.

2.17 This image uses the Faithful Picture Style, which is colorimetrically adjusted to 5200K. Obviously, the color temperature of this scene did not match 5200K, but the image allows you to see all the styles in sequence.

2.18 This is the same scene in the Mono-chrome Picture Style with a green filter effect applied. The Monochrome option offers snappy contrast, but a nice overall tonal range in the mid and high end of the tonal range.

Whether you customize an existing style or create a new one you have ample latitude in setting parameters. The 5D belongs to a generation of Canon dSLR cameras that offer the widest range of adjustments with nine levels of adjustment for contrast, saturation, and color tone, and eight adjustment levels for sharpness.

Besides forming the basis of image rendering, Picture Styles are designed to produce classic looks that need little or no post-processing so that you can print JPEG images directly from the CF card with prints that look sharp and colorful. If you shoot RAW capture, you can't print directly from the CF card, but you can apply Picture Styles either in the camera or during conversion using Canon's Digital Photo Professional conversion program.

You can and should use Picture Styles for both JPEG and RAW capture. Choosing and customizing Picture Styles are how you get the kind of color results out of the camera that you need for your workflow, whether you prefer the contrasty, saturated-color look of the default Standard style, or the more neutral color rendition that the Neutral and Faithful styles provide.

Tip *You can judge the effect of a Picture Style's tonal curve by checking the brightness histogram after making the picture. Or if you want to see if a color channel is being clipped, you can check the RGB histogram. To change histogram displays, press the Menu button, and then press the Jump button until the Playback (blue) menu is displayed. Turn the Quick Control dial to highlight Histogram, and then press the Set button. Turn the Quick Control dial to select the histogram you want, and then press the Set button.*

Following are parameter adjustments that you can modify for each Picture Style:

✦ **Sharpness: 0 to 7.** Level zero applies no sharpening and renders a very soft look (due largely to the anti-aliasing filter in front of the image sensor that helps ward off various problems including moiré, spectral highlights, and chromatic aberrations). Using a high range of sharpening can introduce sharpening halos, particularly if you also sharpen after editing and sizing the image in an editing program. The Standard Picture Style uses a level 3 for sharpening.

✦ **Contrast: -4 to +4.** The important thing to know about contrast is that the changes you make change the tonal curve. A negative adjustment produces a flatter look but helps to maintain the dynamic range of the data coming off the sensor. A positive setting stretches the tonal range. High settings can lead to clipping (discarding bright highlight tones and dark shadow tones).

✦ **Saturation: -4 to +4.** This setting affects the strength or intensity of the color. The key to using this setting is to find the point at which individual color channels do not clip. The Standard Picture Style uses a level zero for saturation. A +1 or +2 setting is adequate for snappy JEPG images that are destined for direct printing.

✦ **Color Tone: -4 to +4.** Adjustments to color tone warm up or cool down the color hue. Negative tone settings increase the blue hue while positive settings increase the yellow hue.

With the Monochrome Picture Style, only the sharpness and contrast parameters are adjustable, but you can apply toning effects as detailed in Table 2.2.

Table 2.2 provides an overview of the 5D Picture Styles.

Table 2.2
EOS 5D Picture Style Descriptions and Settings

Picture Style	Description	Tonal Curve	Color Saturation	Default Settings*
Standard	Vivid, sharp, crisp	Higher contrast	Medium-high saturation	3,0,0,0
Portrait	Enhanced skin tones, soft texture rendering, low sharpness	Higher contrast	Medium saturation, rosy skin tones	2,0,0,0
Landscape	Vivid blues and greens, high sharpness	Higher contrast	High saturation for greens/ blues	4,0,0,0
Neutral	Allows latitude for conversion and processing with low saturation and contrast	Low, subdued contrast	Low saturation, neutral color rendering	0,0,0,0
Faithful	True rendition of colors with no increase in specific colors; no sharpness applied	Low, subdued contrast	Low saturation, colormetrically accurate	0,0,0,0
Monochrome	Black-and-white or toned** images with slightly high sharpness	Higher contrast	Yellow, orange, red, and green filter effects available	3,0, NA, NA

* Settings shown in this sequence: Sharpness, Contrast, Color saturation, Color Tone, Filter effect (Monochrome), Color toning (Monochrome).

** RAW images captured in Monochrome can be converted to color using the software bundled with the camera. However, in JPEG capture, Monochrome images cannot be converted to color.

It seems logical that a zero setting for one Picture Style setting would directly correspond to the same setting in another style. For example, a zero Contrast setting on the Standard Picture Style should correspond to a zero setting on the Portrait style. But that's not necessarily true, and the differences in the tonal curve are sometimes enough to result in clipping. You can evaluate the effect of the Picture Style's tonal curve on RAW images by viewing the image histogram in Canon's Digital Photo Professional program.

Ensuring Image Consistency Across Studios

Because Picture Styles are standard on most of Canon's EOS digital SLR cameras, you can use and/or modify Picture Styles to standardize image settings across multiple 5D camera bodies, or across different Canon cameras that are used in multiple studio locations. Using this approach not only makes workflow more efficient, but it also opens the door to easily creating a signature studio look out of the camera, which is especially useful if you shoot JPEG and print direct.

For example, if your studio wants to standardize on a portrait "look," you can use or adjust the parameters for the Portrait Picture Style as a starting point.

The default Portrait color tone is subdued with slightly more magenta to produce pleasing skin tones. You can pump up the rosy tone with a -2 adjustment, or move to a more yellow rendition with a +1 or +2 adjustment. With some experimentation, and by carefully watching the brightness and color histograms, you can arrive at a style that suits your needs.

To choose a Picture Style:

1. **Press the Menu button, and then press the Jump button until the Shooting (red) menu is displayed.**

2. **Turn the Quick Control dial to highlight Picture Style.** The camera displays the Picture Style screen.

3. **Turn the Quick Control dial to select the Picture Style you want, and then press the Set button.** The Picture Style you choose remains in effect until you change it or switch to Full Auto mode which uses the Standard Picture Style.

After using, evaluating, and printing with different Picture Styles, you may want to change the default parameters to get the rendition that you want. Additionally, you can create up to three Picture Styles that are based on an existing style.

After much experimentation and frustration with oversaturation in the Red channel using the Standard picture style, I settled on a modified style that is based on the Neutral Picture Style. Here is how I modify the Neutral Picture Style settings:

✦ **Sharpness:** +3

✦ **Contrast:** +1

✦ **Saturation:** +1

These settings provide excellent skin tones provided that the image isn't underexposed and the lighting isn't flat. You can try this variation and modify at will. It's always a good idea to evaluate the image settings in Digital Photo Professional (DPP). DPP offers a great degree of control over color management settings.

Here's how to modify a Picture Style:

1. **Press the Menu button, and then press the Jump button until the Shooting (red) menu is displayed.**

2.19 This is the same setup using my modified settings that are based on the Neutral Picture Style.

2. **Turn the Quick Control dial to highlight Picture Style, and then press the Set button.** The camera displays the Picture Style selection screen.

3. **Turn the Quick Control dial to select the Picture Style you want, and then press the Jump button.** The camera displays the Detail set. screen for the style you chose.

4. **Turn the Quick Control dial to select the setting you want to change, and then press the Set button.** The camera activates the control.

5. **Turn the Quick Control dial to set the level that you want for the setting, and then press the Set button.** Negative settings decrease sharpness, contrast, and saturation, and positive settings provide higher sharpness, contrast, and saturation. Negative color tone settings provide reddish tones and positive settings provide yellowish skin tones.

6. **Repeat steps 4 to 5 to change additional settings.** The Picture Style setting changes remain in effect until you change them.

7. **Press the Menu button.** The camera displays the Picture Style selection screen with modified settings shown in blue.

Registering a User-defined Picture Style

With an understanding of the settings you can change with Picture Styles, you can create a picture style to suit your specific preferences and workflow needs. Each style that you create is based on one of Canon's existing styles. And given you can create three User-defined styles, there is latitude to set up styles for different types of shooting.

For example, to create a set of styles for wedding shooting, one style could be a variation of the portrait parameters that you use for formal portraits. A second style, based

on the Neutral or Faithful style could provide more latitude for post-processing, and a third style based on the Standard Picture Style could provide a snappier, more saturated variation for reception images. And, if you first carefully evaluate the tonal curves and color rendering that the custom style produces, you'll be able to serve up prints during the reception with confidence that they will be predictable and pleasing.

To create and register a Picture Style:

1. **Press the Menu button, and then press the Jump button until the Shooting (red) menu is displayed.**

2. **Turn the Quick Control dial to highlight Picture Style, and then press the Set button.** The camera displays the Picture Style selection screen.

Using Monochrome Filter and Toning Effects

You can customize the Monochrome Picture Style by following the previous set of steps, but only the Sharpness and Contrast parameters can be changed. However, you have the additional option of applying a variety of Filter and/or Toning effects.

✦ **Monochrome Filter effects.** Filter effects mimic the same types of color filters that photographers use when shooting black-and-white film. The Yellow filter makes skies look natural with clear white clouds. The Orange filter darkens the sky and adds brilliance to sunsets. The Red filter further darkens a blue sky and makes fall leaves look bright and crisp. The green filter makes tree leaves look crisp and bright and renders skin tones realistically.

✦ **Monochrome Toning effects.** You can choose to apply a creative toning effect when shooting with the Monochrome Picture Style. The Toning effect options are None, Sepia (S), Blue (B), Purple (P), and Green (G).

To apply a Filter or Toning effect, press the Menu button. On the Shooting (red) menu, select Picture Style. Turn the Quick Control dial to select Monochrome. Press the Jump button, and then turn the Quick Control dial to highlight either Filter effect or Toning effect. Press the Set button. The camera displays options that you can choose. Turn the Quick Control dial to highlight the option you want, and then press the Set button. The style remains in effect until you change it.

3. **Turn the Quick Control dial to highlight User Def. 1, and then press the Jump button.** The camera displays the Detail set. User Def. 1 screen with the base Picture Style, Standard.

4. **Press the Set button.** The camera activates the base Picture Style control.

5. **Turn the Quick Control dial to select the base Picture Style you want, and then press the Set button.**

6. **Turn the Quick Control dial to select the setting you want to change, and then press the Set button.** The camera activates the control.

7. **Turn the Quick Control dial to set the level that you want, and then press the Set button.**

8. **Repeat steps** 6 **and** 7 **to change the remaining settings.**

9. **Press the Menu button to register the style.** The camera displays the Picture Style screen. The base Picture Style is displayed to the right of User Def. 1. If the base Picture Style parameters are changed, then the Picture Style on the right of the screen is displayed in blue. This Picture Style remains in effect until you change it.

You can repeat these steps to set up User Def. 2 and 3 styles.

Tip *If you want quick access to the Picture Styles screen, set C.Fn-01 to Option 2 to display the screen when you press the Set button. Custom Functions are covered in detail in Chapter 3.*

Customizing the EOS 5D

C H A P T E R

3

O ne of the first things most photographers do when setting up a new camera is to customize it for their personal shooting preferences. The EOS 5D offers rich options for customizing the operation of controls and buttons and the shooting functionality both for everyday shooting and for shooting specific venues.

The 5D offers two main techniques for customizing the camera.

✦ ✦ ✦ ✦

In This Chapter

Exploring Custom Functions

Sample customizations

Registering camera settings

✦ ✦ ✦ ✦

- ✦ **Custom Functions.** With Custom Functions, you can customize everything from how you select an auto-focus point to changing the function of camera and lens controls.

- ✦ **Register Camera Settings.** Camera Settings, or "C" on the Mode dial, enable you to save your favorite camera and menu settings and quickly return to them by selecting the C mode.

This chapter is organized in a task flow sequence for customizing the camera starting with Custom Functions and then setting and registering a broader range of customized settings.

Exploring Custom Functions

Custom Functions enable you to customize camera controls and operation to better suit your shooting style, and, thus, save time. After you set a custom function option, it remains in effect until you change it. Some Custom Functions are handy for all shooting situations, while others are specific to different situations. For example, if you grow weary of pressing the AF-(AutoFocus) point selection button before manually selecting an AF point, or using the Multi-controller, then check out Custom Function 13; it enables you to assign

AF-point selection to the Quick Control dial or the Multi-controller. This function has saved me more time than any other Custom Function.

> **Tip** *Canon refers to Custom Functions using the abbreviation C.Fn-[number].*

The EOS 5D offers 21 Custom Functions. Some Custom Functions are more broadly useful than others, and some are useful for specific shooting situations. Be sure to remember how you have set the Custom Functions because some options change the behavior of the camera controls and, in some cases, they change the functioning of super-telephoto lens controls.

C.Fn-01: Set function when shooting

You can use the options in this function to change the behavior of the Set button. I find this function very helpful in accessing menu items that I use often, such as accessing the Picture Style option. By setting Option 2, for example, you can access the Picture Styles screen by pressing the Set button. The C.Fn-01 options appear in Table 3.1.

Table 3.1
C.Fn-01 Options

Option Number	Option Name	Description
0	Default	Standard Set button function so that it confirms choices and opens submenus.
1	Change quality	Pressing Set while shooting displays the Quality menu on the LCD. You can then change the image quality setting using the Quick Control dial. The Set button continues to perform its default functions as well with menus and submenus.
2	Change picture style	Pressing the Set button displays the Picture Style selection screen on the LCD. Then you can use the Quick Control dial to select the Picture Style and press the Set button to confirm the selection.
3	Menu display	Pressing the Set button displays the camera menu on the LCD. This option duplicates the function of the Menu button, but it may be handier to press the larger Set button for quick access to the menus.
4	Image replay	Pressing the Set button starts image playback. This option duplicates the function of the Playback button.

C.Fn-02: Long exp. noise reduction

The options of this function allow you to turn noise reduction on or off, or to set it to automatic for long exposures. If you turn on noise reduction, the reduction process takes the same amount of time as the original exposure. In other words, if the original image exposure is 1.5 seconds, then the camera will take a second picture with the shutter closed at 1.5 seconds. This is called a "dark" frame and the camera uses it to reduce noise. But the second frame means that you cannot take another picture until the noise reduction process finishes.

I keep the 5D set to Option 2 to automatically perform noise reduction if it is detected in long exposures, which is good insurance for avoiding digital noise. The C.Fn-02 options appear in Table 3.2.

C.Fn-03: Flash sync speed in Av (Aperture-Priority) mode

With this function, you can set the flash sync speeds slower than 1/200 second, or use a fixed 1/200 second sync speed. The C.Fn-03 options appear in Table 3.3.

Table 3.2
C.Fn-02 Options

Option Number	Option Name	Description
0	Off	No noise reduction dark frame is taken after exposures of 1 sec. or longer. For more details on digital noise, see Chapter 1.
1	Auto noise reduction	The camera performs noise reduction when it detects noise from a long exposure.
2	On	The camera automatically performs noise reduction on all exposures of 1 sec. or longer, regardless of whether the camera detects noise or not.

Table 3.3
C.Fn-03 Options

Option Number	Option Name	Description
0	Auto	Automatically syncs Speedlites at speeds slower than 1/200 seconds.
1	1/200 seconds (fixed)	Automatically sets the flash sync speed to 1/200 sec. in Aperture-Priority AE mode. If you're using high-speed sync, 1/200 second is the minimum time that it takes for the focal plane shutter curtain to fully traverse the sensor plane. If you use this sync speed against the night sky, the background goes dark.

C.Fn-04: Shutter/ AE Lock button

With this function, you can change the function of the AF/AE Lock button. An advantage of this function is Option 1 where you can focus and meter separately. If you seldom use AE Lock, you can reassign the AE Lock button for focusing functions in AI Servo AF mode. C.Fn-04 and C.Fn-19 also affect these functions, and if you set and use both of these functions, the latter operation will not work, except when AF stop is initiated after AF start. The C.Fn-04 options appear in Table 3.4.

C.Fn-05: AF assist beam

This function allows you to control whether an accessory EX Speedlite's AF assist light is used to help the camera establish focus. As I mentioned in Chapter 1, the EX Speedlite AF-assist beam can help speed up autofocusing. Unless there is a compelling reason to not use the AF-assist beam light, the best option is 0, which is the 5D's default. The C.Fn-05 options appear in Table 3.5.

C.Fn-06: Exposure level increments

You can use the options of this function to set the shutter speed, aperture, exposure compensation, and AE Bracketing (AEB) exposure increments in 1/3- or 1/2-stop increments. The exposure increment you choose is displayed in the viewfinder and on the LCD as double marks at the bottom of the exposure level indicator. If you often shoot bracketed exposures to composite in

Table 3.4
C.Fn-04 Options

Option Number	Option Name	Description
0	AF/AE Lock	The default operation where you press the AE/AF Lock button to_lock exposure, and then press the Shutter button halfway to lock focus.
1	AE Lock/AF	Allows you to focus and meter separately, which Option 1 does as well. But this option swaps the button functions. You press the AE/AF Lock button to_focus on the subject, and then press the Shutter button halfway to lock exposure (AE).
2	AF/AF Lock, no AE Lock	In AI Servo AF mode, pressing the AF/AE Lock button momentarily stops autofocusing to prevent the focus from being thrown off if an object passes between the lens and the subject. Releasing the button resumes autofocusing. The camera sets exposure at the moment the shutter is released.
3	AE/AF, no AE Lock	In AI Servo AF mode if the subject motion starts and stops, you can press the AE Lock button to start and stop AI Servo AF focus tracking. The exposure is set at the moment the shutter is released.

an editing program, the 1/2-stop option provides a good exposure difference among images from my experience. The C.Fn-06 options appear in Table 3.6.

C.Fn-07: Flash firing

You can use the options of this function to allow or prevent an accessory Speedlite or a non-Canon flash connected to the PC terminal to fire. The C.Fn-07 options appear in Table 3.7.

Table 3.5
C.Fn-05 Options

Option Number	Option Name	Description
0	Emits	When an accessory Canon EX Speedlite is mounted on the camera, the camera uses the Speedlite's AF assist beam to establish focus. This is especially helpful in low-light or low subject contrast situations, where the camera's autofocus system has difficulty establishing focus.
1	Does not emit	The EX Speedlite's AF assist beam does not light to assist with autofocus.

Table 3.6
C.Fn-06 Options

Option Number	Option Name	Description
0	1/3-stop	Uses a 1/3 stop as the exposure level increment for changes in shutter speed, aperture, exposure compensation, and AEB.
1	1/2-stop	Sets 1/2 stop as the exposure level increment for shutter speed, aperture, exposure compensation, and AEB changes.

Table 3.7
C.Fn-07 Options

Option Number	Option Name	Description
0	Fires	Fires a Canon EX Speedlite or non-Canon flash connected to the PC terminal.
1	Does not fire	Prevents an accessory flash unit connected to the PC terminal from firing, but does not disable the AF-assist beam from lighting, depending on the C.Fn-05 setting.

C.Fn-08: ISO expansion

You can use the options of this function to choose two additional ISO sensitivity settings, "H," equivalent to ISO 3200 and "L," equivalent to ISO 50. The C.Fn-08 options appear in Table 3.8.

C.Fn-09: Bracket sequence/Auto cancel

You can use the options of this function to change the sequence of images that are bracketed by shutter speed or aperture. And

Table 3.8
C.Fn-08 Options

Option Number	Option Name	Description
0	Off	At this default setting, you cannot select the low (ISO 50) and high (ISO 3200) ISO sensitivity settings.
1	On	Allows you to select both the expanded ISO settings of 50 (L) and 3200 (H). With this option, the two additional ISO sensitivities are available and can be selected in the same way that other ISO sensitivities are selected.

Table 3.9
C.Fn-09 Options

Option Number	Option Name	Description
0	0, -, +/ Enable	This is the default setting that captures bracketed images beginning with the standard exposure or white balance, then the decreased exposure or white balance, and then the increased exposure or white balance. Auto cancel is enabled as described previously.
1	0, -, +/ Disable	The first shot is the standard exposure or the standard white balance, then the decreased exposure or white balance, and then the increased exposure or white balance. Auto cancel works only if the flash is ready.
2	-, 0, +/ Enable	Changes the sequence of bracketed images beginning with the decreased exposure or white balance, then the standard exposure or white balance, and then the increased exposure or white balance. Auto cancel is enabled as described previously.
3	-, 0, +/ Disable	Auto cancel works only if the flash is ready. Repeats the bracketing sequence as in Option 2. Auto cancel works only if the flash is ready.

you can change the sequence for White-Balance Bracketing (WB-BKT). Note that if you choose Auto cancel, bracketing is cancelled as follows:

✦ AEB is cancelled when you turn the On/Off switch to Off, change lenses, have the flash-ready condition, replace the battery, or replace the CF card.

✦ WB-BKT is cancelled when you turn the On/Off switch to Off or replace the battery or the CF card.

For details on the White-Balance Bracketing sequence, see Table 3.10. The C.Fn-09 options appear in Table 3.9.

C.Fn-10: Superimposed display

You can use the options of this function to turn off the red light that flashes when an AF point is selected in the viewfinder.

C.Fn-11: Menu button display position

You can use the options of this function to choose which menu is displayed when you press the Menu button.

Table 3.10
AEB, WB-BKT Bracketing Sequence

AEB	Blue/Amber bias	Magenta/Green Bias
0 : Standard exposure	0 : Standard white balance	0 : Standard white balance
- : Decreased exposure	- : More blue	- : More magenta
+ : Increased exposure	+ : More amber	+ : More green

Table 3.11
C.Fn-10 Options

Option Number	Option Name	Description
0	On	The AF point you select or that is selected by the camera in automatic AF selection, or AI Servo AF, or AI Focus AF modes flashes red in the viewfinder when the Shutter button is half-pressed.
1	Off	Turns off the red light flashing when one or more AF points are selected in any autofocus mode. The AF point is highlighted in white when you select it, but when you half-press the Shutter button, no AF point lights. If you need a reminder on which AF point is selected, press the AF-point selection button to briefly light the selected AF point light in red.

Table 3.12
C.Fn-11 Options

Option Number	Option Name	Description
0	Previous, or top menu after turning off the camera	Displays the last menu you accessed with the last active option highlighted. If you turn off the camera, then when you turn on the camera again, the top menu (Shooting menu) is displayed the next time you press the Menu button.
1	Previous	Displays the last menu that you accessed with the last active option highlighted even if the camera is shut down and turned on again.
2	Top	Displays the top menu – the Shooting menu – with the Quality option selected.

C.Fn-12: Mirror lockup

You can use the options of this function to prevent blur that can be caused in close-up and telephoto shots by the camera's reflex mirror flipping up to begin an exposure. If you're a nature and landscape photographers who uses mirror lockup often, then you can make the function more accessible by setting C.Fn-11 to display the Setup menu with the Custom Functions option highlighted.

 Note *During mirror lockup, never point the camera toward the sun to avoid damaging the shutter curtains.*

C.Fn-13: AF-point selection method

You can use the options of this function to change how you select an AF point. For anyone who has an aching thumb from press-

Table 3.13
C.Fn-12 Options

Option Number	Option Name	Description
0	Disable	Prevents the mirror from being locked up.
1	Enable	Locks the mirror for close-up and telephoto images to prevent mirror reflex vibrations that can cause blur. When this option is enabled, you press the Shutter button once to swing up the mirror, and then press it again to make the exposure. With mirror lockup, the drive mode is automatically set to Single-shot. The mirror remains locked for 30 seconds.

ing the AF-point selection button and turning the Main dial or the Multi-controller to select an AF point, this Custom Function is priceless.

C.Fn-14: E-TTL II

You can use the options of this function to choose between Evaluative and Average flash exposure.

C.Fn-15: Shutter curtain sync

You can use the options of this function to determine whether the flash fires at the beginning or end of an exposure, thereby determining whether light trails come before or after the subject.

Table 3.14
C.Fn-13 Options

Option Number	Option Name	Description
0	Normal	Press the AF-point selection button, and then press the Multi-controller or Main dial to select the AF point.
1	Multi-controller direct	Allows you to select the AF point by using only the Multi-controller. If you press the AF-point selection button, the camera automatically switches to automatic AF point selection. This can be handy if you typically use automatic AF-point selection for some of your routine shooting.
2	Quick Control dial direct	Enables you to select the AF point using the Quick Control dial without first pressing the AF-point selection button. This is by far the easiest and fastest method of selecting the AF point. Just be sure that the On switch is set to the topmost position. If you choose this option then the Quick Control dial can't be used to set exposure compensation. To set exposure compensation, hold down the AF-point selection button and turn the Main dial to set the amount of exposure compensation.

Table 3.15
C.Fn-14 Options

Option Number	Option Name	Description
0	Evaluative	Provides fully automatic flash photography in all types of light including using the flash for fill-flash.
1	Average	Averages the flash for the entire area being covered and does not apply automatic flash exposure compensation. To use flash exposure compensation and FE lock, you must set them manually.

C.Fn-16: Safety shift in Av or Tv

With this function enabled, the camera automatically changes the aperture or shutter speed if there is a sudden shift in lighting that would cause an improper exposure. While photographers are adept and watchful of sudden lighting changes, this function can be very helpful in stage and theater lighting where musicians or actors move among bright spotlights and less brightly lit areas of the stage.

C.Fn-17: AF-point activation area

Use the options of this function to enlarge the AF-point selection area in AI Servo AF mode so that it includes six invisible AF points located within the center Spot-meter circle in the viewfinder. The expansion option increases the accuracy of AI Servo AF focusing.

Table 3.16
C.Fn-15 Options

Option Number	Option Name	Description
0	1st-curtain sync	With a slow shutter speed, the flash fires at the beginning of the exposure, creating light trails in front of the subject.
1	2nd-curtain sync	With a slow shutter speed sync, the flash fires just before the shutter closes, creating light trails behind the subject. This function works with an accessory Speedlite whether or not it offers this feature. If the Ex-series Speedlite has this feature, the Speedlite's setting overrides this Custom function. When you press the Shutter button, a preflash fires for flash metering and the main flash fires just before the shutter closes.

Table 3.17
C.Fn-16 Options

Option Number	Option Name	Description
0	Disable	Maintains the current exposure regardless whether the subject brightness changes.
1	Enable	In Shutter-Priority AE (Tv) and Aperture-Priority AE (Av) modes, the shutter speed or aperture automatically shifts to provide an acceptable exposure if the subject brightness suddenly changes.

C.Fn-18: LCD displ -> Return to shoot

You can use the options of this function to return to shooting during image playback using a variety of buttons or just the Shutter button.

C.Fn-19: Lens AF Stop button function

For super telephoto lenses with an AF Stop button, the options of this function modify the operation of the focusing, AutoExposure Lock, and Image Stabilization. At this writing, lenses with the AF Stop button include the EF 300mm f/2.8L IS USM, EF 400mm f/2.8L IS USM, EF 400mm f/4 DO IS USM, EF 500mm f/4L IS USM, and EF 600mm f/4L IS USM lenses. On lenses that do not have an AF Stop button, changing the options for this function has no effect.

C.Fn-20: Add original decision data

When this option is turned on, data is appended to verify that the image is original and hasn't been changed. This is useful when images are part of legal or court proceedings. The optional Data Verification Kit DVK-E2 is required.

Table 3.18
C.Fn-17 Options

Option Number	Option Name	Description
0	Standard	The camera uses the center AF point in AI Servo AF mode.
1	Expanded	When the center AF point is selected in AI Servo AF mode, the camera activates six additional but invisible AF points within the Spot-meter circle. As a result, a total of seven AF points track subject movement. Selecting this option increases the accuracy of focus tracking, particularly for subjects that move erratically.

Table 3.19
C.Fn-18 Options

Option Number	Option Name	Description
0	With Shutter button only	During image playback or menu display, pressing the Shutter button dismisses the display so you can return to shooting.
1	Also with AE Lock button and more buttons.	During image playback or menu display, pressing any of the following buttons dismisses the display to return to shooting: AE Lock, AF-WB, AF-point selection, Metering mode, Drive-ISO, LCD Panel Illumination, or the depth-of-field preview.

Table 3.20
C.Fn-19 Options

Option Number	Option Name	Description
0	AF Stop	Provides normal functioning of the AF Stop button to stop autofocusing when the button is pressed. This is a good option for nature and wildlife shooting and for action scenes where the subject is blocked temporarily by another object.
1	AF start	Autofocusing is active only while the AF Stop button is pressed. AF operation with the camera is disabled.
2	AE Lock while metering	Applies AE Lock while the AF Stop button is pressed and metering is active. Like traditional AE Lock (described in Chapter 1), this option decouples metering from focusing.
3	AF point: M -> Auto / Auto -> ctr	In Manual AF-point selection, the camera switches to automatic AF-point selection and selects the center AF point as long as you hold the button down. This option is useful when you can't track a subject when you're using Manual AF-point selection in the AI Servo AF mode.
4	One Shot <-> AI Servo	Switches from One-Shot to AI Servo AF mode when the button is held down. If you are in One-Shot AF mode, pressing and holding the button switches to AI Servo AF as long as the button is held down. If you are in AI Servo AF, pressing and holding the button switches to One-Shot AF mode as long as the button is held down. This is a quick and convenient way to switch between autofocus modes for subjects that frequently start and stop moving.
5	IS start	When the IS switch on the lens is turned on, IS works only when you press the AF Stop button. Autofocusing is initiated from the camera. With this option, you can use your left hand to control IS and your right hand to control AF point selection and release the Shutter button.

Table 3.21
C.Fn-20 Options

Option Number	Option Name	Description
0	Off	No verification data is appended.
1	On	Appends data to verify that the image is original. During image playback, an icon denotes verification data.

C.Fn-00: Focusing screen

Use this function if you install one of the two other interchangeable focusing screens. Focusing screen options are discussed in Chapter 1. Note that this is the only Custom Function that is not included if you register camera settings and recall them by switching to C on the Mode dial.

Depending on your shooting preferences and needs, you may immediately recognize functions and options that would make your shooting faster or more efficient. You may also find that combinations of functions are useful for specific shooting situations. Whether used separately or together, Custom Functions can significantly enhance your use of the 5D.

To set a Custom Function:

1. **Set the camera to any shooting mode except Full Auto, press the Menu button, and then press the Jump button until the Set-up (yellow) menu appears.**

2. **Turn the Quick Control dial clockwise to highlight Custom Functions (C.Fn), and then press the Set button.** The Custom

Functions screen appears with the Custom Function number control activated.

3. **Turn the Quick Control dial to select the Custom Function number you want, and then press the Set button.** The Custom Function option control is activated.

4. **Turn the Quick Control dial to scroll through the options. When you see the option you want, press the Set button.** Repeat steps **3** to **5** to set other Custom Functions. Lightly press the Shutter button to return to shooting (depending on the C.Fn-18 setting).

If you want to restore all Custom Function options to the camera's default settings, follow these steps.

1. **Set the camera Mode dial to any mode except C or Full Auto.**

2. **Press the Menu button, and then press the Jump button until the Set-up (yellow) menu is displayed.**

3. **Turn the Quick Control dial to select Clear Settings, and then press the Set button.** The camera displays the Clear settings screen.

Table 3.22
C.Fn-00 Options

Option Number	Option Name	Description
0	Ee-A	Standard Precision Matte, the default focusing screen that offers good viewfinder brightness and good manual focusing.
1	Ee-D	Precision Matte with grid. This screen features five vertical lines and three horizontal lines to help square lines in the scene.
2	Ee-S	Super Precision Matte. Designed to make manual focusing easier. The viewfinder is darker.

4. **Turn the Quick Control dial to highlight Clear all Custom Functions, and then press the Set button.** The camera displays the Clear all Custom Functions screen.

5. **Turn the Quick Control dial to select OK, and then press the Set button.** Press the Shutter button lightly to return to shooting.

Sample Customizations

As a starting point for thinking about specific shooting situations, here are two sample Custom Function groupings. Your shooting preferences and the requirements of the specific scene may mean that the functions and options suggested here won't work for you. But these sample groups can give you ideas for using groups of Custom Functions in different situations.

Unfortunately, you can't save groups of Custom Functions and recall them as a group except when you register camera settings for the C mode (detailed in the next section of this chapter). Setting or changing Custom Functions is relatively quick, so it's worthwhile to consider creating job-specific Custom Function settings.

Table 3.23
Custom Functions: Wedding Set

C.Fn-number	Option	Rationale
01: Set function when shooting	2: Change Picture Style	As you move from shooting formal portraits using the Portrait Picture Style, you can quickly press the Set button to change to the Standard or Faithful Picture Style for the ceremony shots.
11: Menu button display position	1: Previous	This option displays the last accessed menu when you press the Menu button. If you set a custom white balance as the wedding moves into different areas of light, then pressing the Menu button will display the Set-up menu with the Custom White Balance option highlighted.
13: AF-point selection method	1: Multi-controller direct, or 2: Quick Control dial direct	If you prefer to manually select the AF point, then either of these options save the requirement of pressing the AF-point selection button to activate AF-point selection. If you choose option 2, then you can set exposure compensation by pressing the AF-point selection button and turning the Main dial to set the compensation amount.

C.Fn-number	Option	Rationale
15: Shutter curtain sync	1: Second-curtain sync	With the Speedlite set to fully automatic, you can use second-curtain flash to get a light trail following the limo as the couple leaves — provided that the departure occurs at dusk or in the evening.
17: AF point activation area	1: Expanded	This expands the center Spot-meter area to include six invisible AF points and the center AF point. So in AI Servo AF focus mode, you'll get more accurate focus tracking of the bride and groom coming up the aisle, and other action sequences during the wedding.

Table 3.24
Custom Functions: Landscape/Nature Set

C.Fn-number	Option	Rationale
01: Set function when shooting	3: Menu display	This provides a quick access to the menu when you want to use AEB to make a series of images that will later be composited in an image-editing program. As I mentioned earlier, this option displays the last accessed menu with the last highlighted menu option, making it easy to access the AEB setting on the Shooting (red) menu.
02: Long exposure noise reduction	2: On	Use this option if the shooting includes low-light scenes with exposures of 1 sec. or longer.
04: Shutter/AE lock button	2: AF/AF Lock, no AE Lock	This option allows you to press the AE Lock button to temporarily stop focus tracking in AI Servo AF mode to prevent focus tracking from being thrown off if something passes between the lens and the subject. This is handy if you're tracking focus on one bird in a flock or an animal in a herd where other animals or birds come between the lens and the subject.
06: Exposure level increments	1: 1/2-stop	If you use AEB to create a series of bracketed images for compositing, then you may prefer the 1/2-stop increment to the default 1/3-stop increment.

Continued

Table 3.24 *(continued)*

C.Fn-number	Option	Rationale
09: Bracket sequence/ Auto cancel	2: -, 0, +/Enable	This option simply changes the order in which the camera makes the bracketed exposure sequence. My personal preference is the decreased, standard, and then increased exposure sequence. Your preference may be for Option 1: 0, -, +. The Enable portion of this option means that you can stop the bracketing sequence by turning the camera off, changing lenses, or having a flash ready condition.
11: Menu button display position	1: Previous	You can set this option to display the last accessed menu and menu option when you press the Menu button. This functionality is the same as described in Option 01.
12: Mirror lockup	1: Enable	Prevents potential blur in super telephoto, macro, and long exposure shots caused by the action of the reflex mirror flipping up. If you choose this option, you have to press the Shutter button once to flip up the mirror, and then press it a second time to make the exposure.
13: AF point selection method	1: Multi-controller direct, or 2: Quick Control dial direct1 or 2	If you most often prefer to manually select the AF point, then this function eliminates the need to press the AF-point selection button to activate AF-point selection. If you choose option Option 2 to use the Quick Control dial, then you can set exposure compensation by pressing the AF-point selection button and turning the Main dial to set the compensation amount.
17: AF point activation area	1: Expanded1	This expands the center Spot-meter area to include the six invisible AF points and the center AF point. So in AI Servo AF focus mode, you'll get more accurate focus tracking of a bird or animal on the fly or on the run.
19: Lens AF stop button function	1: AF start, or 2: AE Lock while metering	With Option 1, you can use the AF stop button to initiate AF when the button is pressed, although this disables AF operation with the camera. Or if you choose Option 2, you can use the AF stop button to decouple focusing and metering by having the button initiate AE Lock when it's pressed.

3.1 Setting up a Custom Function set, much like the one described here, for the ceremony segment of this wedding allowed me to concentrate on shooting instead of adjusting camera settings. Exposure: ISO 320, f/3.2, 1/50 sec., using an EF 70-200mm, f/2.8L IS USM lens.

Registering Camera Settings

You can save your favorite or frequently used shooting and menu settings to the C mode, or the Camera Settings mode. C mode is a great way to spend less time adjusting camera settings and more time shooting.

The settings that you can register or save to C mode, detailed in Tables 3.25 and 3.26, include exposure modes and settings, white balance, exposure compensation and

bracketing, Picture Style, and metering and drive modes. Even after you register the modes and settings to C mode, you can make ad-hoc changes as you shoot without switching out of C mode. The changes you make are not retained unless you register them, essentially overwriting the previous registered settings.

You can take several approaches to registering camera settings. One approach is to use it for everyday shooting by registering the modes, options, and Custom Functions that you use most often. No matter what special situations you encounter that deviate from your standard settings, you can quickly return to your usual settings by switching to C mode.

Another approach is to register C mode setting for specific shooting venues such as studio portraits, weddings, shooting theater that you shoot in often, and so on. Or if you work in a multi-studio business, you could help ensure a consistent look and feel across the studios by registering all the 5D camera bodies to the same settings.

Or if you shoot weddings with multiple photographers, you can use C mode to ensure consistency across the 5D camera bodies used by different photographers. Alternately, if you use a tag-team approach, where certain photographers shoot the pre-wedding shots, others shoot the ceremony, and others shoot the reception and dance, then each camera body can be preset for the different light and requirements that each segment of the wedding shoot entails.

3.2 Much of my shooting day to day is flower photography. I have the custom functions and camera set up for that type of shooting. So regardless of the opportunities I encounter for nature shots, it's as easy as switching to C mode to begin shooting. Exposure: ISO 125, f/8, 1/100 sec. using an EF 24-70mm, f/2.8L USM lens.

Whichever scenario suits your work, there is no question that being able to quickly move to a preset group of settings saves a significant time.

When you register camera settings, the settings outlined in Tables 3.25 and 3.26 are saved and recalled when you set the Mode dial to C.

To register camera settings:

1. **Set all of the settings on the camera that you want to register.** In addition to shooting and menu settings, you can set Custom Functions for specific shooting scenarios as detailed in the previous section in this chapter.

2. **Press the Menu button, and then press the Jump button until the Set-up menu (yellow) is displayed.**

3. **Turn the Quick Control dial clockwise to highlight Register camera settings, and then press the Set button.** The camera displays the Register camera settings screen.

4. **Turn the Quick Control dial to select OK, and then press the Set button.** The camera displays the Set-up menu.

5. **Turn the Mode dial to C to shoot with the registered settings.**

Table 3.25
Shooting Settings Registered in C Mode

Shooting mode (any mode except Full Auto)	Exposure Settings: ISO, aperture, shutter speed	AF mode
AF-point selection method	Metering mode	Drive mode
Exposure compensation	Flash exposure compensation	White Balance

Table 3.26
Menu Settings Registered in C Mode

Image quality	Beep on or off	Shoot with or without a CF card
AEB	White Balance Shift/ Bracketing	Custom White Balance
Color temperature	Color space	Picture Style
Review time	AF points	Histogram
Auto power off	Auto rotate	LCD brightness
File numbering method	Custom Functions	

Tip *To check the registered camera settings, set the Mode dial to C and then press the INFO button. The camera displays the settings on the LCD.*

If you want to restore the registered settings to the 5D's default settings, follow these steps.

Note *All settings except Custom Functions are returned to the default settings shown in Tables 3.27 and 3.28. If you also want to restore default Custom Function settings follow the steps in the previous section.*

1. **Set the camera to any shooting mode except C or Full Auto.**

2. **Press the Menu button, and then press the Jump button until the Set-up (yellow) menu is displayed.**

3. **Turn the Quick Control dial to highlight Clear settings, and then press the Set button.** The camera displays the Clear settings screen.

4. **Turn the Quick Control dial to select Clear registered camera set.** The camera displays the Clear registered camera set. screen.

5. **Turn the Quick Control dial to select OK, and then press the Set button.** The camera returns the registered settings to the defaults shown in the following tables.

Note *The settings shown in these tables are also applied if you choose to clear all camera settings.*

Table 3.27
EOS 5D Default Shooting Settings

AF mode	One-shot AF
AF-point selection	Automatic AF-point selection
Metering mode	Evaluative
Drive mode	Single
Exposure compensation	None
AEB	Off
Flash exposure compensation	None
Custom Functions	Current settings retained

Table 3.28
EOS 5D Default Image Settings

Quality	Large/Fine JPEG
ISO	100
Color space	sRGB
White Balance	Auto White Balance (AWB)
Color Temperature	5200K
White-Balance Correction	Off
White-Balance Bracketing	Off
Picture Style	Standard

Lenses and Speedlites

P A R T

In This Part

Chapter 4
Selecting and Using
Lenses

Chapter 5
Working with Canon
EX Speedlites

Selecting and Using Lenses

Different cameras make different demands on lenses, and there is no question that the full-frame EOS 5D produces the best quality images with high-quality lenses such as Canon's L-series lenses. With a high-quality lens, pictures have stunning detail, high resolution, and snappy contrast. Conversely, low-quality optics tend to produce softened edges, particularly with wide-angle lenses, more chromatic aberrations, and distortion.

With the 5D's full-frame sensor, the need for good glass is especially important because at full-frame, any defects in the lens performance show up immediately in terms of soft corners. As most photographers know, over time the investment in lenses far exceeds the money invested in the camera body. For these reasons, making studied decisions on lens purchases pays off for years to come in getting great image sharpness and quality.

This chapter provides an overview of Canon lenses, what features to look for in buying lenses, and the advantages and disadvantages of zoom versus prime (single-focal length) lenses. It also provides the basics on lenses characteristics and various lens accessories.

Understanding Canon Lenses

The EOS 5D is compatible with Canon's EF-mount lenses, but not with the EF-S lenses designed for Canon's cropped sensor cameras. Of course, the 5D has a full-frame sensor, which means that it is equivalent to a 35mm film frame. There is no focal length multiplication factor so that wide-angle lenses are truly wide angle, and telephoto lenses are true to their focal length just as they would be on a 35mm film camera.

In This Chapter

Understanding Canon lenses

Prime versus Zoom Lenses

Using wide-angle lenses

Using telephoto lenses

Using normal lenses

Using macro lenses

Using tilt-and-shift lenses

Using image-stabilized lenses

Exploring lens accessories

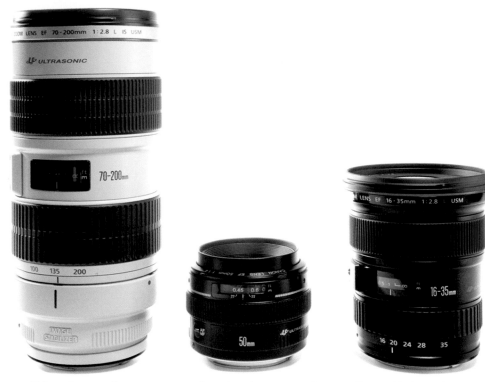

4.1 Although zoom lenses are versatile, prime lenses are often smaller and lighter. The Canon EF 50mm f/1.4 lens, shown in the center, is one of the lightest and sharpest lenses in Canon's lineup. This image shows the size comparison of the 50mm with the EF 70-200mm, f/2.8L IS USM lens, and the EF 16-35mm, f/2.8L USM lens.

While the 5D's full-frame sensor allows you to use the lens to its full extent, the cropped- or sub-frame sensors use lenses at their "sweet spot," allowing for very sharp frame corners depending on focal length and aperture. By contrast, on a full-frame camera, the optics must be superb to deliver the same edge-to-edge sharpness while minimizing chromatic aberrations, distortion, and vignetting.

When you shop for lenses, the terminology and technologies can be confusing. The next section reviews key lens designations and technologies.

EF lens mount

The designation EF (Electro-Focus) identifies the type of mount that the lens has. The EF lens mount provides not only quick mounting and removal of lenses, but it also provides the communication channel between the lens and the camera body. The EF mount is fully electronic and resists abrasion, shock, and play, and does not require lubrication as other lens mounts do. The EF system does a self-test using a built-in microcomputer so that you're alerted of possible malfunctions via the camera's LCD display. In addition, if you use lens extenders, exposure compensation is automatically calculated.

Ultrasonic Motor

Another designation that you often see is USM, an abbreviation for Ultrasonic Motor. A USM lens has an ultrasonic motor that is built into the lens on lenses with this designation. While the motor is powered by the camera, the internal focusing motor means that you get exceptionally fast focus. USM lenses use electronic vibrations created by piezoelectric ceramic elements to provide quick and quiet focusing action with almost instantaneous starts and stops.

In addition, lenses with a ring-type ultrasonic motor offer full-time manual focusing without the need to first switch the lens to manual focus. This design is offered in the large-aperture and super-telephoto lenses. A second design, the micro ultrasonic motor, provides the advantages of this technology in the less expensive EF lenses.

L-series lenses

Canon's L-series lenses feature a distinctive red ring on the outer barrel, or, in the case of telephoto and super-telephoto lenses, are distinguished by Canon's well-known white barrel material. The distinguishing characteristics of L-series lenses, in addition to their sobering price tags, are a combination of technologies that provide outstanding optical performance.

L-series lenses include one or more of the following technologies and features.

✦ **UD/fluorite elements.** Ultra-low dispersion, or UD, glass elements help minimize color fringing, or chromatic aberration. This glass also provides improved contrast and sharpness. UD elements are

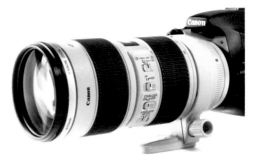

4.2 The popular EF 70-200mm, f/2.8L IS USM lens is only one of four Canon EF lenses of this focal length.

used, for example, in the EF 70-200mm f/2.8L IS USM and EF 300mm f/4L IS USM lenses. On the other hand, fluorite elements that are used in super telephoto L-series lenses reduce chromatic aberration. A single fluorite element has, according to Canon, roughly the corrective power of two UD-glass elements. Lenses with UD or fluorite elements are designated as CaF_2, UD, and/or S-UD.

✦ **Aspherical elements.** This technology is designed to help counteract spherical aberrations that occur when wide-angle and fast normal lenses cannot resolve light rays coming into the lens from the center with light rays coming into the lens from the edge into a sharp point of focus. The result is a blurred image. An aspherical element uses a varying curved surface to ensure that the entire image plane appears focused. These types of optics help correct curvilinear distortion in ultra-wide-angle lenses as well. Lenses with aspherical elements are designated as AL.

✦ **Dust, water-resistant construction.** The L-series EF telephoto lenses have rubber seals at the switch panels, exterior seams, drop-in filter compartments, and lens mounts to make them both dust and water resistant. Moving parts including the focusing ring and switches are also designed to keep out environmental contaminants. For any photographer who shoots in inclement weather, whether it's a wedding, editorial assignment, or sports event, having a lens with adequate weather sealing is critical.

Image Stabilization

You'll also see some lenses labeled as IS lenses — short for Image Stabilization. I cover Image Stabilization in detail later in this chapter, but the short story is that IS lenses allow you to handhold the camera at light levels that normally require a tripod. The amount of handholding latitude varies by lens and the photographer's ability to hold the lens steady, but you can generally count on one to four f-stops more stability than with a non-IS lens.

Macro

Finally, you'll see lenses with a macro designation. These lenses, covered in detail later in this chapter, enable close-up focusing with one-half to life-size subject magnification and a maximum aperture of f/25.

Full-time manual focusing

An advantage of Canon lenses is the ability to use autofocus, and then tweak focus manually using the lens' focusing ring without switching out of autofocus mode or changing the switch on the lens from the AF to MF setting. Full-time manual focusing comes in very handy with macro shots and when using extension tubes.

Inner and rear focusing

The lens' focusing groups can be located in front or behind the diaphragm, both of which allow for compact optical systems with fast autofocusing. As mentioned in Chapter 1, lenses with rear optical focusing, such as the EF 85mm f/1.8 USM, focus faster than lenses that move their entire optical system, such as the EF 85mm f/1.2L II USM. With both designs, the filter orientation doesn't change because the front of the lens does not rotate.

Floating system

In non-floating system lenses, optical aberrations are corrected only at commonly used focusing distances. At other focusing distances, particularly at close focusing distances, the aberrations appear and reduce image quality. Canon lenses use a floating system that dynamically varies the gap between key lens elements based on the focusing distance. As a result, aberrations are reduced or suppressed through the entire focusing range.

AF Stop button

The AF Stop button is available on several EF IS telephoto lenses, and pressing it stops focusing when an obstruction passes between the lens and the subject that can cause the focus to be thrown off. Once the obstruction passes, the focus remains on the subject provided that the subject hasn't moved so that you can resume shooting.

 Cross-Reference *The functioning of the AF Stop button can be changed using C.Fn-19 detailed in Chapter 3.*

Focus preset

This feature lets you program a focusing distance into the camera's memory. For example, if you shoot a bicycle race near the finish line, you can preset focus on the finish line. Then you can shoot normally as riders approach the finish line. When the racers near the finish line, you can turn a ring on the lens to instantly return to the preset focusing distance that is on the finish line.

Diffractive Optics

Diffractive Optics, abbreviated in lens designations as DO, is a process of bonding diffractive coatings to the surfaces of two or more lens elements. The elements are then combined to form a single multilayer DO element designed to cancel chromatic aberrations at various wavelengths when combined with conventional glass optics. Diffractive Optics results in smaller and shorter telephoto lenses without compromising image quality. For example, the EF 70-300mm, f/4.5-5.6 DO IS USM lens is 28 percent shorter than the EF 70-300mm, f/4.5-5.6 IS USM lens.

Prime versus Zoom Lenses

For many of today's newcomers to photography, prime lenses are an oddity at best. But prime lenses, or lenses that have a fixed focal length such as the venerable EF 50mm f/1.4, were once the staple in professional gear bags.

Classic prime lenses in Canon's lineup include the EF15mm f/2.8 Fisheye, a small lens weighing in at only 11.6 ounces that provides a whopping 180-degree view. Other prime lenses are the EF 24mm f/1.4L USM, EF 50mm, f/1.4 USM (or the new EF 50mm f/1.2L USM), EF 100mm, f/2.8 Macro USM, EF 135mm f/2L USM, and others. These lenses offer a wide range of choices for photographers who prefer prime lenses, or choose to have them alongside zoom lenses in their gear bags.

Single-focal-length lens advantages

Unlike zoom lenses, single-focal-length (prime) lenses tend to be fast with maximum apertures of f/2.8 or wider. Wide apertures allow fast shutter speeds and enable you to handhold the camera in low light and still get a sharp image. Compared to zoom lenses, single-focal-length lenses are noticeably lighter and smaller.

In addition, many photographers argue that single-focal-length lenses are sharper and provide better image quality overall than zoom lenses.

4.3 While most prime lenses are small and light, the EF 85mm, f/1.2L II USM lens is an exception, and despite its heft, this lens produces stunning images at both super-wide and standard apertures. This is the lens that I often pull out to shoot low-light music concerts as I did during this one. Exposure: ISO 400, f/1.8, 1/100 sec.

Single-focal-length lens disadvantages

Most prime lenses are lightweight, but you need more of them to cover the range of focal lengths needed for everyday photography, although some famous photographers including Henri Cartier-Bresson often used only one prime lens. Single-focal-length lenses also limit the options for on-the-fly composition changes that are possible with zoom lenses.

Zoom lenses

The versatility that zoom lenses provide is a major reason that prime lenses fell out of favor with photographers. Zoom lenses offer a range of, or variable, focal lengths within a single lens, allowing you the equivalent of having three, four, or more single-focal-length lenses in one lens. Zoom lenses are available in wide-angle and telephoto ranges.

With a zoom lens, part of the lens system moves along the optical axis to change the focal length while another part moves simultaneously to compensate for the resulting shift in focus. As a result, zoom lenses must have at least two lens groups that can move along the optical axis. The first group at the end of the lens compensates for focus shift and is referred to as a *compensator*. The second group is moved to change the focal length and is referred to as a *variator*. This group achieves focus by adjusting the focal point.

For example, in a wide-angle zoom lens with two lens groups, the first group has negative refraction (divergence), and the second group has positive refraction (convergence). The lens is designed with retrofocus construction. Further, to solve various limitations of this design, to keep the lens size compact, and to compensate for aberrations with fewer lens elements, most lenses use a multigroup zoom with three or more movable lens groups.

Some zoom lenses are slower than single-focal length lenses, and getting a fast zoom lens usually comes at a higher price. In addition, some zoom lenses have a variable aperture, which means that the lens' minimum aperture changes at different zoom settings.

Zoom lens advantages

The obvious advantage of a zoom lens is the ability to quickly change focal lengths and image composition, without changing lenses. In addition, you need only two or three zoom lenses to encompass the focal range you use most often for everyday shooting. For example, carrying a Canon EF 16-35mm, f/2.8L II USM lens and a Canon EF 70-200mm f/2.8L, IS USM lens, or a similar combination of lenses, provides the focal range needed for most shooting.

Of course, a zoom lens also offers the creative freedom of changing image composition with the turn of the zoom ring — all without changing your shooting position or changing lenses. Most mid-priced and more expensive zoom lenses offer high-quality optics that produce sharp images with excellent contrast.

4.4 A zoom lens like the very sharp EF 24-70mm, f/2.8L USM lens offers a good deal of versatility both on location and in the studio. I shot this and several variations at different focal lengths for stock. Exposure: ISO 100, f/22, 1/125 sec.

Zoom lens disadvantages

Although zoom lenses allow you to carry around fewer lenses, they tend to be heavier than their single-focal-length counterparts. Mid-priced fixed-aperture zoom lenses tend to be slow, meaning that with maximum apertures of only f/4.5 or f/5.6, they call for slower shutter speeds, which limit your ability to get sharp images when handholding the camera.

Some zoom lenses have variable apertures. If a variable-aperture f/4.5 to f/5.6 lens has an aperture of f/4.5 at the widest focal length, it has an aperture of f/5.6 at the telephoto end. Unless you use a tripod or your subject is stone still, your ability to get a crisp picture in lower light at f/5.6 will be questionable.

More expensive zoom lenses offer a fixed and fast maximum aperture, meaning that with maximum apertures of f/2.8, they allow faster shutter speeds that enhance your ability to get sharp images when handholding the camera. But the lens speed comes at a cost: The faster the lens is, the higher the price.

 Note *A complete list of Canon EF lenses available as of this writing appears later in this chapter.*

Using Wide-Angle Lenses

A wide-angle lens is great for capturing scenes ranging from large groups of people to sweeping landscapes, as well as for taking pictures in places where space is cramped. The distinguishing characteristic of wide-angle lenses is the range of the angle of view. Within the Canon lens line-up, you

Evaluating Bokeh Characteristics

As you are considering lenses, bokeh may be one consideration. *Bokeh* is derived from the Japanese word *boke* and means "fuzzy." The term refers to the way an out-of-focus point of light is rendered in an image.

Obviously, bokeh can make the out-of-focus areas aesthetically pleasing or visually obtrusive, and the interpretation is almost entirely subjective. In general, you want the out-of-focus points of light to be circular in shape and blend or transition nicely with other areas in the background, and the illumination is best if the center is light and the edges are dark and blurry.

In general, lenses with normal aperture diaphragms create polygonal shapes in the background. On the other hand, circular-aperture diaphragms optimize the shape of the blades to create circular blur because the point source is circular. Canon lenses that feature circular aperture diaphragms use curved blades to create a rounded opening when the lens is stopped down and maintain the circular appearance even in continuous shooting burst mode.

Ken Rockwell provides an article on bokeh with excellent examples at www.kenrockwell.com/tech/bokeh.htm.

can choose angles of view ranging from the fisheye lens which offers a 180-degree angle of view to the 35mm which offers a 63-degree angle of view.

When you shoot with a wide-angle lens, keep these lens characteristics in mind:

✦ **Extensive depth of field.** Particularly at small apertures such as f/8 or f/22 and without a close camera-to-subject shooting distance, the entire scene, front to back, will be in acceptably sharp focus. This characteristic gives you slightly more latitude for less-than-perfectly focused pictures.

✦ **Narrow, fast apertures.** Wide-angle lenses tend to be faster (meaning they have wide apertures) than telephoto lenses. As a result, these lenses are good choices for everyday shooting when the lighting conditions are not optimal.

✦ **Distortion.** Wide-angle lenses distort lines and objects in a scene, especially if you tilt the camera up or down when shooting. For example, if you tilt the camera up to photograph a group of skyscrapers, the lines of the buildings tend to converge and the buildings appear to fall backward (also called *keystoning*). You can use this wide-angle lens characteristic to creatively enhance a composition, or you can avoid it by moving back from the subject and keeping the camera parallel to the main subject, or by using a Tilt-and-Shift lens (discussed later in this chapter).

4.5 A moderate wide-angle setting of 46mm was used for this spring shot of tulips. Exposure: ISO 125, f/2.8, 1/1600th sec. using an EF 24-70mm, f/2.8L USM lens.

✦ **Perspective.** Wide-angle lenses make objects close to the camera appear disproportionately large. You can use this characteristic to move the closest object farther forward in the image, or you can move back from the closest object to reduce the effect. Wide-angle lenses are popular for portraits, but if you use a wide-angle lens for close-up portraiture, remember that the lens exaggerates the size of facial features closest to the lens, which is unflattering.

Tip *If you're shopping for a wide-angle lens, look for aspherical lenses. These lenses use a varying curved surface to keep the entire image plane in sharp focus to produce better edge-to-edge sharpness and reduce distortions.*

4.6 As most photographers know, a zoom lens is indispensable during wedding and event shooting. This candid shot of a groomsman was taken using an EF 70-200mm, f/2.8L IS USM lens. Exposure: ISO 320, f/2.8, 1/500 sec.

Using Telephoto Lenses

Choose a telephoto lens to take portraits and to capture distant subjects such as birds, buildings, wildlife, and landscapes. Telephoto lenses such as 85mm and 100mm lenses are ideal for portraits, while longer lenses (200mm to 800mm) allow you to photograph distant birds, wildlife, and athletes. When photographing wildlife, these lenses also allow you to maintain a safe distance from the wildlife.

When you shoot with a telephoto lens, keep these lens characteristics in mind:

✦ **Shallow depth of field.** Telephoto lenses magnify subjects and provide a limited range of acceptably sharp focus. At wide apertures,

such as f/4, you can render the background to a soft blur, but with extremely shallow depth of field, it's important to get tack-sharp focus. Canon lenses include full-time manual focusing that you can use to fine-tune the camera's auto-focus.

✦ **Narrow coverage of a scene.** Because the angle of view is narrow with a telephoto lens, much less of the scene is included in the image. You can use this characteristic to exclude distracting scene elements from the image.

✦ **Slow lenses.** Mid-priced and some expensive telephoto lenses tend to be slow; the widest aperture is often f/4.5 or f/5.6, which limits the ability to get sharp images without a tripod in all but the brightest light unless the lens has Image Stabilization. And because of the magnification, even the slightest movement is exaggerated.

✦ **Perspective.** Telephoto lenses tend to compress perspective, making objects in the scene appear stacked together.

If you're shopping for a telephoto lens, look for those with ultra low dispersion glass or fluorite elements that improve contrast and sharpness. Image Stabilization, detailed later in this chapter, further counteracts blur caused when you handhold the camera.

Using Normal Lenses

A normal, or 55mm, lens is perhaps the most often overlooked lens in the range of lenses. This lens, long the primary or only lens that photography greats of past decades used, remains a classic lens that provides outstanding sharpness and contrast. Normal lenses are small, light, most are affordably priced, and offer fast and super-fast apertures such as f/1.4 and faster.

When you shoot with a normal lens, keep these lens characteristics in mind:

✦ **Natural angle of view.** A 50mm lens closely replicates the sense of distance and perspective of the human eye. This means the final image will look much as you remember seeing it when you made the picture.

✦ **Little distortion.** Given the natural angle of view, the 50mm lens retains a "normal" sense of distance, especially when you balance the subject distance, perspective, and aperture.

✦ **Creative expression.** With planning and a good understanding of the 50mm lens, you can use it to simulate both wide-angle and medium telephoto lens effects. For example, by shooting at a narrow aperture and at a low or high angle shooting position, you can create the dynamic feeling of a wide-angle lens but without the distortion. On the other hand, a large aperture and a conventional shooting angle create results similar to that of a medium-telephoto lens.

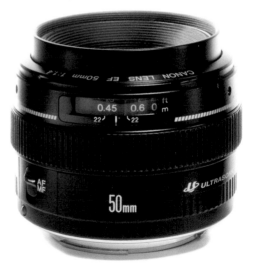

4.7 The Canon EF 50mm, f/1.4 USM lens is a very sharp lens with excellent contrast.

Using Macro Lenses

Macro lenses open a world of photographic possibilities by offering an extreme level of magnification. In addition, the reduced focusing distance allows beautiful, moderate close-ups as well as extreme close-ups of flowers and plants, animals, raindrops, and other subjects. You can further reduce the focusing distance by using extension tubes (detailed later in this chapter).

Both normal and telephoto lenses offer macro capability. Because these lenses can be used both at their normal focal length as well as for macro photography, they serve double duty. Macro lenses offer one-half to life-size magnification.

When you shoot with a macro lens, keep these characteristics in mind:

✦ **Extremely shallow depth of field.** At 1:1 magnification, the depth of field is less than 1mm at maximum aperture. The shallow depth of field makes focusing critical; even the slightest change to the focusing ring can throw the picture out of focus.

4.8 Of the two macro lenses that I use, the EF 100mm, f/2.8 USM lens is mounted on the camera most often. It is small and has a good focal length for not only macro shots, but also for much of my general shooting, including this spring rose. Exposure: ISO 100, f/5.6, 1/125 sec.

✦ **High magnification.** With extremely high magnification, any movement causes blur. Always use a tripod and cable release or remote to release the shutter.

✦ **Variety of working distances.** The working distance factors into your choice of macro lenses. For example, the 180mm f/3.5L Macro USM lens allows a longer working distance (measured from the tip of the lens to the subject) of 1.6 ft versus the 50mm, f/2.5 Compact Macro lens with a working distance of 0.8 ft.

Note A complete list of Canon lenses appears later in this chapter.

Using Tilt-and-Shift Lenses

Referred to as TS-E, tilt-and-shift lenses enable you to alter the angle of the plane of focus between the lens and sensor plane to provide a broad depth of field even at wide apertures and to correct or alter perspective at almost any angle. In short, TS-E lenses correct perspective distortion and control focusing range. These types of movements were previously possible only with medium- and large-format cameras.

Tilt movements allow you to bring an entire scene into focus, even at maximum apertures. By tilting the lens barrel, you can adjust the lens so that the plane of focus is uniform on the focal plane, thus changing the normally perpendicular relationship between the lens's optical axis and the camera's focal plane. Alternately, reversing the tilt has the opposite effect, greatly reducing the range of focusing.

Shift movements avoid the trapezoidal effect that results from using wide-angle lenses and pointing the camera up to take a picture of a building, for example. Keeping the camera's focal plane parallel to the surface of a wall, and then shifting the TS-E lens to raise the lens results in the perpendicular lines of the structure being rendered perpendicular and with the structure being rendered with a rectangular appearance.

TS-E lenses revolve within a range of plus/minus 90 degrees, making horizontal shift possible, and even useful in shooting a series of panoramic images. You can also use shifting to prevent having reflections of the camera or yourself in images that include reflective surfaces such as windows, car surfaces, and other reflective surfaces.

All of Canons' TS-E lenses are manual focus only. These lenses, depending on the focal length, are excellent for architectural, interior, merchandise, nature, and food photography.

Using Image-Stabilized Lenses

Image Stabilization (IS) is a technology that counteracts motion blur from handholding the camera. Whether IS belongs in the lens or in the camera is a matter of debate. But for Canon, the argument is that stabilization belongs in the lens because different lenses have different stabilization needs. If you've shopped for lenses lately, you know that IS comes at a premium price, but you gain from one to four f-stops of stability — and that means that you may be able to leave the tripod at home.

Canon offers a full complement of lenses with its Optical Image Stabilization (IS) technology that makes handholding the camera at slow shutter speeds and in low-light scenes more likely to produce a sharp image.

The rule of thumb for handholding the camera is 1/[focal length]. For example, the slowest shutter speed at which you can handhold a 200mm lens and avoid motion blur is 1/200 second. If the handholding limit is pushed, then shake from handholding the camera bends light rays coming from the subject into the lens relative to the optical axis, and the result is a blurry image.

With an IS lens, the built-in miniature sensors and a high-speed microcomputer analyzes vibrations and applies correction via a stabilizing lens group that shifts the image parallel to the focal plane to cancel camera shake. The lens detects camera motion via two gyro sensors — one for yaw and one for pitch. The sensors detect the angle and speed of shake. Then the lens shifts the OIS lens group to suit the degree of shake to steady the light rays reaching the focal plane.

Stabilization is particularly important with long lenses where the effect of shake increases as the focal length increases. And, as a result, the correction needed to cancel motion shake increases proportionately.

But how do IS lenses respond when you want to pan, or move the camera with the motion of a subject? IS detects panning as camera shake and the stabilization then interferes with framing the subject. To correct this, Canon offers two modes on IS lenses. Mode 1 is designed for stationary subjects. Mode 2 shuts off IS in the direction of movement when the lens detects large movements for a preset amount of time. So

when panning horizontally, horizontal IS stops but vertical IS continues to correct any vertical shake during the panning movement.

The question is whether IS is worth the premium prices for these lenses — and, of course, how much you hate schlepping around a tripod. Comparing the Canon EF 70-200mm, f/2.8L USM lens and the EF 70-200mm, f/2.8L IS USM, the price difference runs approximately $400 (US) more for an IS lens than for the same non-IS lens. Only you can decide, but for my shooting, IS is worth the price, particularly in low-light scenes such as weddings and music concerts where tripods are impractical.

4.9 For low-light editorial assignments, IS is vital. Here I shot at 200mm using an EF 70-200mm, f/2.8L IS USM lens at a shutter speed of 1/60 sec. The ISO was 400.

Table 4.1
Canon EF Wide, Standard, and Medium Telephoto Lenses

Ultra Wide Zoom	Wide-Angle	Standard Zoom	Telephoto Zoom	Standard and Medium Telephoto
EF 16-35mm, f/2.8L II USM	EF 14mm, f/2.8L II USM	EF 24-70mm, f/2.8L USM	EF 55-200mm, f/4.5-5.6 II USM	EF 50mm, f/1.2L USM
EF 17-40mm, F/4L USM	EF 14mm, f/2.8L USM	EF 24-85mm, f/3.5-4.5 USM	EF 70-200mm, f/2.8L IS USM	EF 50mm, f/1.4 USM
EF 20-35mm, f/3.5-4.5 USM	EF 15mm, f/2.8 Fisheye	EF 28-105mm, f/3.5-4.5 II USM	EF 70-200mm, f/2.8L USM	EF 50mm, f/1.8 II
	EF 20mm, f/2.8 USM	EF 28-105mm, f/4.0-5.6 USM	EF 70-200mm, f/4L IS USM	EF 85mm, f/1.2L II USM
	EF 24mm, f/1.4L USM	EF 24-105mm, f/4L IS USM	EF 70-200mm, f/4L USM	EF 85mm, f/1.8 USM
	EF 24mm, f/2.8	EF 28-135mm, f/3.5-5.6 IS USM	EF 70-300mm, f/4-5.6 IS USM	EF 100mm, f/2 USM
	EF 28mm, f/2.8	EF 28-200mm, f/3.5-5.6 USM	EF 70-300mm, f/4.5-5.6 DO IS USM	
	EF 35mm, f/1.4L USM	EF 28-300mm, f/3.5-5.6L IS USM	EF 80-200mm, f/4.5-5.6 II	
	EF 35mm, f/2	EF 28-80mm, f/3.5-5.6 II	EF 75-300mm, f/4-5.6 III USM	
	EF 28mm, f/1.8 USM	EF 28-90mm, f/4-5.6 II USM	EF 75-300mm, f/4-5.6 III	
			EF 100-300mm, f/4.5-5.6 USM	
			EF 100-400mm, f/4.5-5.6L IS USM	

Table 4.2
Canon EF Telephoto, Super Telephoto, Macro, and TS-E Lenses

Telephoto	Super Telephoto	Macro	Tilt-Shift
EF 135mm, f/2L USM	EF 300mm, f/2.8L IS USM	EF 50mm, f/2.5 Compact Macro Life-Size Converter EF	TS-E 24mm, f/3.5L
EF 135mm, f/2.8 with Softfocus	EF 400mm, f/2.8L IS USM		TS-E 45mm, f/2.8
EF 200mm, f/2.8L II USM	EF 400mm, f/4 DO IS USM	MP-E 65mm, f/2.8 1-5x Macro Photo	TS-E 90mm, f/2.8
EF 300mm, f/4L IS USM	EF 400mm, f/5.6L USM	EF 100mm, f/2.8 Macro USM	
	EF 500mm, f/4L IS USM	EF 180mm, f/3.5L Macro USM	
	EF 600mm, f/4L IS USM		

Exploring Lens Accessories

There are a variety of ways to increase the focal range and decrease the focusing distance to provide flexibility for the lenses you already own. These accessories are not only economical, but they also extend the range and creative options of existing and new lenses. Accessories can be as simple as a lens hood to avoid lens flare, adding a tripod mount to quickly change between vertical and horizontal shooting without changing the optical axis, or adding a drop-in or adapter-type gelatin filter holder. Other options include using extension tubes, extenders, and close-up lenses.

Extending the range of any lens with extenders

For relatively little cost, you can increase the focal length of any lens by using an extender. An extender is a lens set in a small ring mounted between the camera body and a regular lens. Canon offers two extenders, a 1.4× and 2×, that are compatible only with L-series Canon lenses. Extenders can also be combined to get even greater magnification.

For example, using the Canon EF 2× II extender with a 600mm lens doubles the lens's focal length to 1200mm. Using the Canon EF 1.4 II extender increases a 600mm lens to 840mm.

4.10 This is the 1.4 II extender with and EF 70-200mm, f/2.8L IS USM lens.

Extenders generally do not change camera operation in any way, but they do reduce the amount of light reaching the image sensor. The EF 1.4× II extender decreases the light by one f-stop, and the EF 2× II extender decreases the light by two f-stops. In addition to being lightweight, the obvious advantage of extenders is that they can reduce the number of telephoto lenses you carry.

The 1.4× extender can be used with fixed-focal length lenses of 135mm and longer (except the 135mm f/2.8 Softfocus lens), and the EF 70-200mm, f/2.8L, 70-200mm, f/2.8L IS, 70-200mm, f/4.0L, 70-200mm, f/4.0L IS USM, and 100-400mm, f/4.5-5.6L IS zoom lenses. With the EF 2× II, autofocus is possible if the lens has an f/2.8 or faster maximum aperture, and compatible IS lenses continue to provide stabilization.

Increasing magnification with extension tubes and close-up lenses

Extension tubes are close-up accessories that provide magnification from approximately 0.3 to 0.7 and can be used on many EF lenses, though there are exceptions. Extension tubes are placed between the camera body and lens and connect to the camera via eight electronic contact points. The function of the camera and lens is unchanged, and extension tubes can be combined for greater magnification.

Canon offers two extension tubes: the EF12 II and the EF25 II. Magnification differs by lens, but with the EF12 II and standard zoom lenses, it is approximately 0.7. With the EF25 II, magnification is 0.7. When combining tubes, you may need to focus manually.

Extension Tube EF25 II is not compatible with the EF 15mm, f/2.8 Fisheye; EF 14mm, f/2.8L USM; EF 20mm, f/2.8 USM; EF 24mm, f/1.4L USM; EF 20-35mm f/3.5-4.5 USM; EF 24-70mm, f/2.8L USM; MP-E 65mm, f/2.8 1-5× Macro Photo; or the TS-E 45mm, f/2.8lens.

Additionally, you can use screw-in close-up lenses. Canon offers three lenses that provide enhanced close-up photography. The 250D/500D series uses a double-element achromatic design for enhanced optical performance. The 500D series features single-element construction for economy. The working distance from the end of the lens is 25cm for the 250D, and 50cm for the 500D.

Working with Canon EX Speedlites

In This Chapter

Exploring E-TTL technology

Choosing a Canon EX-series Speedlite

Using Speedlites

A compendium of flash techniques

Countless scenes offer great opportunities for using one or more accessory Canon EX-series Speedlites, whether the scene is backlit or the subject and background are lit at different levels. And while using a flash is great for standard photography, it also offers creative opportunities for capturing everything from a drip of water to stroboscopic motion.

This chapter details choosing and using accessory Canon EX-series Speedlites. While it is not an exhaustive look at all the ways you can use Speedlites, it provides an overview of the technology, as well as some techniques that you can use with one or more Speedlites and the EOS 5D.

Exploring E-TTL Technology

The latest Canon's EX-series Speedlites employ E-TTL II technology. E-TTL stands for Evaluative Through-The-Lens flash exposure control. In simple terms, E-TTL II technology receives information from the camera, including the focal length of the lens, distance from the subject, exposure settings including aperture, and the camera's built-in evaluative metering system to balance subject exposure with the ambient light.

Note *While E-TTL II works with all lenses, not all Canon lenses communicate distance information that is used in the algorithm that calculates flash exposure. Generally, lenses with a ring-type Ultrasonic Motor (USM) return distance information. Lenses that don't offer full-time manual focus such as the EF 75-300mm, f/4-5.6 USM, do not return distance information, and lenses with arc form motors, such as the EF 50mm, f/1.8 and 24mm, f/2.8, 85mm, f/1.2L USM, and Tilt-and-Shift (full manual focus) lenses, also do not return distance information. Also, when the flash is not mounted on the camera, when wireless or bounce flash is used, and when macro flash is used, distance information is not communicated to the camera.*

In more specific terms, with E-TTL II, the camera's meter reads through the lens, but not off the focal plane. With the Speedlite mounted on the camera, after the Shutter button is fully pressed but before the reflex mirror goes up, the flash fires a preflash beam. Information from this preflash is sent to the camera and is combined with data from the evaluative metering system to analyze and compare ambient light exposure values with the amount of light needed to make a good exposure. Then the camera calculates and stores the flash output needed to illuminate the subject while maintaining a natural-looking balance with the ambient light in the background.

In a step-by-step fashion, here is the general sequence:

1. **Press the Shutter button halfway to set focus on the subject and determine the exposure needed given the amount of ambient light.**

2. **Press the Shutter button completely to fire a preflash so that the amount of light reflected off the subject can be measured.**

3. **The camera quickly compares and evaluates both the ambient and preflash readings and determines the proper subject and background exposure.**

4. **The reflex mirror flips up, the first shutter curtain opens, and the flash fires exposing the image on the sensor.** The second shutter curtain closes, and then the reflex mirror goes back down.

Regardless of the focal length of the lens you are using, the EX-series Speedlites automatically adjust the flash zoom mechanism for the best flash angle, and to illuminate only key areas of the scene, which conserves power.

E-TTL II technology also enables high-speed sync flash with Speedlites that allows flash sync with a shutter speed faster than the camera's x-sync speed of 1/200 second. As a result, you can open up the lens when shooting a backlit subject to blur the background.

 Note *High-speed sync extends the flash duration to make synchronization possible using fast shutter speeds that form a slit between the first and second curtains as the curtains travel. EOS-dedicated EX-series Speedlites offer this feature.*

When shooting with Speedlites, Canon's flash technology also allows wireless multiple flash to create studio-type lighting and to set light ratios. Wireless flash is even easier with the Speedllite Transmitter ST-E2 so that you can set up and identify up to three groups of Speedlites and designate a master and slave units.

Tip — *The Macro Ring Lite MR-14EX and Macro Twin Lite MT-24EX can also serve as master flash units.*

5.1 A 580EX Speedlite shooting into an umbrella combined with tungsten room light provided the lighting for this portrait. The flash created catchlights in the subjects' eyes that adds energy and vitality to the eyes. Exposure: ISO 100, f/2.8, 1/6 sec. using an EF 24-70mm, f/2.8L USM lens.

Choosing a Canon EX-series Speedlite

When choosing a Speedlite, it's important to evaluate your objectives and how you'll use the flash unit. Questions that you might ask yourself include: Do you need a portable studio for location assignments, do you want to enhance macro and other nature shooting, or do you need a Speedlite only for occasional use?

Why Flash Sync Speed Matters

Flash sync speed matters because if it isn't set correctly, only part of the image sensor has enough time to receive light while the shutter is open. The result is an unevenly exposed image. The EOS 5D doesn't allow you to set a shutter speed faster than 1/200 second but you can set a slower flash sync speed. Using Custom Function 03, C.Fn-03, you can also set whether the 5D sets the flash sync speed automatically (option 0) or always uses 1/200 second (option 1) when you're shooting in Av mode.

Custom functions are detailed in Chapter 3.

Additional considerations include the performance and power of the flash unit such as the guide number, power output, wide-angle to telephoto coverage, wireless and multi-Speedlite capability, recycle time, ability to maintain consistent color, power conservation, shutter curtain synchronization, custom functions, and the availability of a built-in PC terminal and external power packs.

Once you know your shooting objectives and the type of functionality and performance you need, you can evaluate Speedlites to see which model fits your needs best.

Evaluating EOS 5D-compatible Speedlites

At this writing, three Canon non-macro flash units, the 220EX, 430EX, and 580EX II are on the shelves and are compatible with the EOS 5D. For macro work, the Macro Ring Lite MR-14EX or Macro Twin Lite MT24EX are available and provide either shadowed or shadowless lighting. If you have an older Speedlite, such as the 580 or 550, for example, they perform nicely with the 5D and can be used wirelessly for multi-flash setups.

Here is an overview of the currently marketed Speedlites followed by a comparison of features in Tables 5.1 and 5.2.

✦ **580EX II.** This is currently the flagship Speedlite for non-macro photography. The 580EX II offers a metal foot for reliability and rigidity; a 20 percent improvement in recycling time and more weatherproofing than its predecessor, the 580EX; improved communication reliability through direct contacts; 180-degree swivel in either direction; and white-balance information communication with compatible cameras.

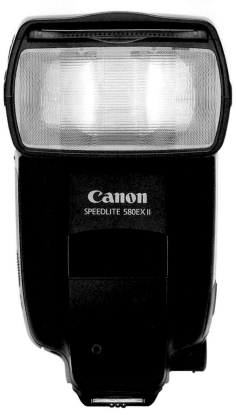

5.2 The Canon 580EX II Speedlite. Note that all product photos in this chapter are courtesy of Canon.

✦ **430EX Speedlite.** This compact flash unit includes manual flash mode; flash compensation that can be set on the 430; manual control of the flash zoom head; 40 percent faster recycling than its predecessor, the 420EX; and compatibility with wireless E-TTL. These features make the 430EX a good choice as a standalone unit or as a slave unit for multi-flash setups.

✦ **220EX Speedlite.** This flash unit offers only automatic operation. When used with certain film cameras, it provides E-TTL operation and FE Lock. But with other cameras, it offers TTL operation.

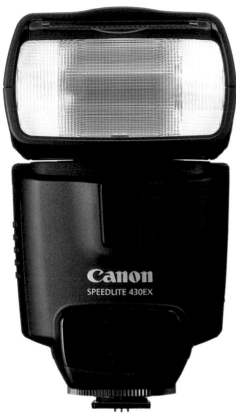

Figure 5.3 The Canon 430EX Speedlite

Figure 5.4 The Canon 220EX Speedlite

✦ **Macro Twin Lite MT-24EX.** This dual-light macro unit alleviates the flat lighting look that a single ring lite can create by providing two separate flash heads that you can move around the lens, aim separately, or remove from the holders and mount off-camera. The MT-24EX is E-TTL compatible with the 5D and allows wireless flash with one or more 550EX or 430EX as slave units. You can also control the lighting ratio of each flash head's output for more than a six-stop range.

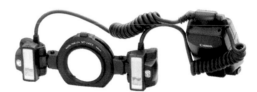

Figure 5.5 The Canon Macro Twin Lite MT-24EX Speedlite

✦ **Macro Ring Lite MR-14EX.** This flash unit is compatible with E-TTL and features two circular twin flash tubes that can fire at even power or be varied between them over a six-stop range. You can use compatible non-macro Speedlites such as the 550EX as wireless slaves. The controller has an illuminated LCD panel and accepts optional high-capacity battery packs.

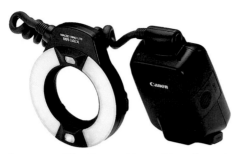

Figure 5.6 The Canon Macro Ring Lite MR-14EX Speedlite

Canon Speedlite Transmitter, ST-E2

In addition, Canon offers the Speedlite Transmitter, ST-E2, a small flash control unit that fits on the camera's hot shoe. The ST-E2 offers wireless control of multiple master and slave Speedlites, and it is as handy as a flash accessory can get.

Table 5.1
EOS 5D-Compatible Canon Speedlites (Non-macro)

	220EX*	**430EX****	**580EX II**
Type	E-TTL	Mode: E-TTL II, E-TTL, TTL	E-TTL operation with all EOS digital SLRs
Guide Number	72 ft/22 m (ISO 100)	141 ft/43 m (at ISO 100); flash head at 105mm zoom setting	190 (at ISO 100, ft)/ 58 (m); flash head at 105mm zoom setting
Number of Flashes	250 to 1700	Approx. 200 to 1,400, with fresh AA-size alkaline batteries or AA-size Ni-MH fully charged batteries	Approx. 100 to 700, with fresh AA-size alkaline batteries
Recycle Time	0.1 to 4.5 sec.	Approx. 0.1 to 3.7 sec. (AA-size alkaline batteries)/0.1 to 2 sec. (AA-size Ni-MH batteries)	Approx. 0.1 to 6 sec., with fresh AA-size alkaline batteries
Flash Range	2.3 ft/0.7 m to 63 ft/22 m (ISO 100)	At ISO 100, with EF 50mm f/1.4 For normal flash: approx. 2.3-79.7 ft/0.7 to 24.3 m; for high sync speed (EF flash): approx. 2.3 to 39.4 ft/0.7 to12 m	(At ISO 100, with 50mm f/1.4 lens at f/1.4) Approx. 1.6 to 98.4 ft/0.5 to 30 m

	*220EX**	*430EX***	*580EX II*
AF-assist Beam	Built-in (linked to center focusing point, 2.3 ft/0.7 m to 16.4 ft/5 m)	Built-in; covers all focus points in EOS cameras up to nine AF points; Effective range: At center: approx. 2.3 to32.8 ft/0.7 to10m; Periphery: approx. 2.3 to 16.4 ft./0.7 to 5 m (in total darkness).=	Built-in; covers all focus points in EOS cameras with 1, 3, 5, 7, 9, or 45 AF (autofocus) points; Distance range −2 to 32.8 ft (0.6 to 10 m) at center; 2 to 16.4 ft (0.6 to 5 m) at periphery
Custom Functions	Shoe lock provided	Six user-selectable Custom Functions built-in; set on SpeedliteSpeedlite's LCD panel	Fourteen Speedlite Custom Functions built-in; set on SpeedliteSpeedlite's LCD panel
Power Source	Four AA batteries (can use NiCd or lithium)	Four AA-size alkaline batteries (6V) or four AA-size Ni-MH (4.8V)	Four AA-size batteries: alkaline, lithium, or rechargeable Ni-MH usable
External Power Source	N/A	N/A	External power supply — compatible with Dust- and Water-Resistant External Power Pack, Canon battery pack CP-E3 and Transistor Pack E
Dimensions	2-9/16(W) x 3-5/8 (H) x 2-7/16 (D)	2.8 x 4.8 x 4.0 in./ 72 x 122 x 101mm	3.0 x 5.3 x 4.5 inches / 76 x 134 x 114mm
Weight (Without Batteries)	5.6 oz (160g)	11.6 oz/33 0 g	13.2 oz/375 g

* The 220EX supports up to 28mm coverage.
** Flash coverage: Fixed condenser lens with inner zoom: (1) Auto Zoom, (2) Manual Zoom, (3) Wide Panel. Zoom positions: 24mm, 28mm, 35mm, 50mm, 70mm, 80mm, 105mm; indicated by numerals on the LCD's focal length display.
Image Size Zoom Control: With cameras compatible with auto zoom, it zooms automatically to match the camera's image size.

Table 5.2
EOS 5D-Compatible Macro Speedlites

	Macro Twin Lite *MT-24EX*	*Macro Ring Lite* *MR-14EX*
Type	Macro flash unit with adjustable and removable twin straight flash heads; separate controller unit attaches to camera's hot shoe.	Ring Lite, twin circular flash tubes, and separate Controller Unit.
Guide Number	72 (ft)/22 (m), at ISO 100 (with both tubes firing at full power)	14 m/46.2 ft (ISO 100)
Flash Duration	Modeling Flash: One-second burst at 70Hz in E-TTL or Manual flash modes, showing ratios*; with C.Fn 4-1 (on MT-24EX), uniform one-second burst at 70Hz with any EOS body by pressing Controller Unit's test button.	Modeling Flash: (1) One-second burst at 70Hz in E-TTL or M flash mode, showing ratios (possible only with EOS-1v and EOS-3) (2) With CF 4-1, uniform one-second burst at 70Hz; works in TTL mode.
Flash Control System	Flash +/- exposure compensation, Flash Exposure Bracketing, FE Lock, FP sync, and Ratio Control of left:right (A:B) flash tubes over a six-stop range (8:1 ~ 1:8 lighting ratios), and wireless E-TTL with off-camera 550EX and/or 420EX slave units.	Controls in E-TTL mode: FP sync, FE Lock, Flash +/- compensation, Flash Exposure Bracketing. Controls in Manual mode: Flash +/- compensation, Flash Exposure Bracketing. Ratio Control in Manual mode: L:R tubes (A:B) in full steps over 1/1 ~ 1/64 range, full steps. Setting Method: LCD panel on Controller Unit (illuminated), similar to 550EX Speedlite.
Exposure Control Modes	Variable from full (1/1) ~ 1/64 power; Ratio Control of left:right (A:B) flash tubes from 1/1 to 1/64 power is possible	N/A
Custom Functions	Nine Custom Functions on MT-24EX, in addition to any in camera); set on MT-24EX Controller LCD panel.	Seven on the MR-14EX (in addition to any in camera), set on flash LCD.
Power Source	Four AA batteries in controller unit (alkaline, lithium, rechargeable Ni-Cd or Ni-MH AAs are okay).	Four AA batteries in Controller (alkaline, Ni-Cd, Lithium, and Ni-MH type AAs are okay).

	Macro Twin Lite *MT-24EX*	*Macro Ring Lite* *MR-14EX*
External Power Source	Compact Battery Pack E or E2, and Transistor Pack E	External battery packs, Compact Battery Pack CP-E2, Transistor Pack E
Weight	585 g/20.6 oz (excluding batteries)	430 g/15.1 oz (excluding batteries)

* A 72C Macro Lite Adapter is required when using the MT-24EX with the EF 180mm, f/3.5L Macro USM lens.

Here are some of the features of the ST-E2:

✦ **Control of up to three groups of Speedlites with the ability to control the slave unit's IDs.**

✦ **Modeling flash.** This fires at the flash ratio that you've set and is triggered by pressing the depth-of-field preview button on the camera.

✦ **An AF-assist beam that is compatible with 28mm and longer lens focal lengths.** The AF-assist beam has an effective range of approximately 0.6 to 10 m/2.0 to 16.5 ft along the periphery (in total darkness).

✦ **Flash ratio control and adjustment and channel control.** The flash ratio control for the A:B ratio is 1:8 to 8:1, in half- step increments or 13 steps.

✦ **FE Lock, Flash Exposure Bracketing, Flash Exposure Compensation, Stroboscopic flash, and high-speed sync (FP flash) in high-speed sync mode for flash synchronization at all shutter speeds.** Flash Exposure Confirmation during FE Lock is indicated when the flash exposure level icon is lit in the viewfinder. If the flash exposure is insufficient,

the icon blinks. After the flash fires, the ST-E2's flash confirmation lamp lights in green for 3 seconds.

✦ **Infrared pulse transmission system with a range of approximately 12 to 15 m/39.4 to 49.2 ft. indoors, and approximately 8 to 10 m/ 26.2 to 32.8 ft. outdoors.** The flash transmission coverage is +/-40 degrees horizontal and +/-30 degrees vertical.

For multiple Speedlite shooting, the ST-E2 is invaluable because it gives you cable-less operation and precise flash ratio control. The unit is powered by CR5 lithium batteries. I prefer to use rechargeable CR5s for the ST-E2 which provide approximately 1,000 to 1,500 transmissions per charge.

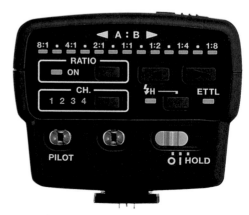

5.7 The Canon Speedlite Transmitter ST-E2

Using Speedlites

Depending on the Speedlite that you use, there are a variety of ways that you can control or modify flash exposure, either by making on-camera adjustments or by using the Speedlite controls. In addition, both the 5D and the Speedlite's Custom Functions enable you to customize various flash functions to suit your shooting needs.

Because Speedlites differ in functionality, I talk here in general about the ways in which you can control and modify flash exposure. For specific steps in setting exposure modification, see the instruction manual for the Speedlite(s) that you're using.

Flash Exposure Compensation

Flash Exposure Compensation is much like Auto Exposure Compensation in that you can set compensation for flash exposure up to +/- two stops in 1/3-stop increments. A positive compensation setting increases the flash output and vice versa. Flash Exposure Compensation helps reduce shadows in the background and balance unevenly lit scenes, among other things.

Generally, you can set compensation on either the camera or the Speedlite, or both. If you set it on both, then the Speedlite setting overrides the camera setting.

Flash Exposure Compensation can be combined with Auto Exposure Bracketing (AEB). If you're shooting a scene where one part of the scene is brightly lit and another part is much darker, for example, an interior room with a view to the outdoors, then setting AEB to -1 and setting the Flash Exposure Compensation to -1 makes the transition between the two differently lit areas more natural. This technique is illustrated later in this chapter.

 See the section on balancing lighting extremes later in this chapter for an example of using Flash Exposure Compensation.

Flash Exposure Bracketing

Flash Exposure Bracketing (FEB), like AEB, takes three shots with different flash output for each shot up to +/- three stops in 1/3-stop increments. On most Speedlites, FEB is cancelled after the three shots are taken. You can also combine FEB with Flash Exposure Compensation and FE Lock.

Flash Exposure Lock

Flash Exposure Lock (FE Lock) is much like Auto Exposure Lock (AE Lock). Flash Exposure Lock enables you to meter for and set the flash output for the area of critical exposure in the scene.

FE Lock can be used in a variety of ways. One technique is to identify the area of critical exposure in the scene, and then meter for that area and lock the flash exposure. In a food setup, for example, the critical exposure will be on the food as opposed to the background, so FE Lock is set on the food. The camera then balances the exposure with the background light.

High-speed sync

High-speed flash sync (FP flash) allows you to make flash images at any shutter speed rather than limiting the fastest shutter speed to the 5D's X-sync speed of 1/200 second. This means that you have more latitude in using wide apertures to blur backgrounds in outdoor and indoor portraits. With fast shutter speeds, the effective flash range will be shorter, and the range is shown on the Speedlite's LCD. When the Speedlite is set to high-speed sync flash, the stroboscopic flash can't be set.

In addition to setting flash exposure, you can control flash functions on the camera and on the flash. Custom functions for the flash unit vary by Speedlite and are detailed in the Speedlite manual. On the 5D, you can set the following flash-related Custom Functions.

✦ **C.Fn-03:** Sets the flash sync speed in Av mode to either automatic or 1/200 second fixed.

✦ **C.Fn-07:** Enables or disables external flash firing or non-Canon flash that is connected to the PC terminal.

✦ **C.Fn-14:** Sets either Evaluative or Average flash metering.

✦ **C.Fn-15:** Sets the flash curtain sync to first or second curtain.

5.8 In this image, using high-speed sync captured the motion of water dripping into a glass. Exposure: ISO 200, f/2.8, 1/2500 sec. using an EF 100mm, f/2.8 USM lens and a 580EX Speedlite.

Two Classic Flash Techniques

Two of the most frequently used flash techniques are bounce flash and creating a catchlight in the subject's eyes. Bounce flash softens hard flash shadows by diffusing the flash light. To use bounce flash, turn the flash head so that it points up diagonally toward the ceiling or a nearby wall so that the light hits the ceiling or wall and spreads the flash illumination. When the flash head is turned upward, the flash coverage is set to 50mm if the Speedlite is set to automatic coverage.

If the ceiling is so high that it will underexpose the image, I often use a silver reflector as a faux "ceiling," holding it above the flash head and bouncing the flash light into it. Using a silver or white reflector prevents a color cast in the image as well. If you want to create a sense of depth, bounce the flash off a wall to the left or right of the subject. The farther the ceiling or wall is from the flash, the softer the illumination.

To create a catchlight in the subject's eyes using the 580EX or 580EX II flashes, tilt the head up by 90 degrees, and then pull out the panels that are tucked into the flash head. One translucent is called the "wide" panel and is used with wide-angle lenses. There is a solid white panel behind the wide panel, and it is the catchlight panel. Push the wide panel back in but leave the catchlight panel out. Be sure not to turn the flash head; keep it straight on with the subject. Then take the image. The panel throws light into the eyes, creating catchlights that add a sense of vitality to the eyes. For best results, be within 5 feet of the subject.

A Compendium of Flash Techniques

Once you have one or more Speedlites, using them is not only a practical matter, but also one of imagination and creativity. Just as with studio lighting, using one or more Speedlites provides essentially the same creative lighting opportunities as traditional studio strobes. And when you need portable studio lighting for location portraits and assignments, it's hard to beat the small size and weight of multiple Speedlites, light stands, and a few light modifiers such as a softbox or umbrellas.

Combine the Speedlites with the ST-E2 Speedlite Transmitter, and you can avoid the hassle of cords altogether. In addition, the newer Speedlites come with stands that make it easy to place them around the set to suit the lighting scheme that you have in mind.

The examples in the following sections are only a few of the many different ways to use one or more Speedlites.

Using a Speedlite as an auxiliary light

Particularly with location photography, the ambient light must be evaluated carefully to determine if it is adequate to use as the main light source. The ambient light can provide a sense of the subject's environment that helps set the prevailing ambience, particularly in indoor locations. I try to make the most of ambient light and use it as the main light source when possible. As a result, I use Speedlites to bolster ambient light and to help define areas in the scene that are poorly lit.

In this portrait, a 580EX Speedlite provided auxiliary light in an office that was lit by indirect, late-afternoon light from windows that faced the subject. A window to camera right provided additional illumination.

To create a loop-light setup, I mounted the 580EX on a light stand shooting into a small silver umbrella and positioned to camera right at about a 40-degree angle. In addition, an assistant held a silver reflector to camera left to help fill shadows under the chin.

5.9 This environmental portrait was one in a series of church elders. Exposure: ISO 200, f/2.8, 1/15 sec. using an EF 24-70mm, f/2.8L USM lens.

Working with wireless multiple flash setups

There is perhaps no more fun in flash photography than when you use multiple wireless Speedlites. I use the ST-E2 Speedlite

Transmitter with two Speedlites and light modifiers (or not) depending on the subject. With wireless shooting, you have to ensure that the signal between the Speedlites is direct, but in an interior setting, you have a bit more flexibility in setting up the lights.

Here I used two EX-series Speedlites, a 580EX Speedlite mounted on the camera and bounced off a silver reflector held above the flash head as a "ceiling," and a 550EX Speedlite set up on a table behind the wine and glasses. The 550 was set up as a slave and fired wirelessly from the 580. Notice how the backlight illuminates the center of the bottle and the glasses and adds depth to the scene.

5.10 Exposure: ISO 100, f/5.6, 1/5 sec. using an EF 25-105mm, f/4L IS USM lens.

Balancing lighting extremes

A little creative use of exposure modification on both the 5D and a Speedlite can help balance disparate lighting, such as a dim indoor scene and a bright outdoor view. The trick is to blend the extremes. With Speedlites that allow manual adjustment, a negative compensation for both the camera exposure and the flash works to balance the differences in light in the room with the brighter outdoor light.

In figure 5.11, Auto Exposure Compensation of -1 provided the exposure for the window view to the outdoors without the details being lost to overexposure. A -1 Flash Exposure Compensation balanced the indoor lighting. The transition between lighting extremes is more subtle and natural as a result.

I also encourage you to explore the options that multiple Speedlites offer. And for detailed information on using Canon Speedlites, be sure to check out the *Canon Speedlite System Digital Field Guide* by J. Dennis Thomas (Wiley, 2007).

5.11 This dining room scene exposure was ISO 100, f/8, 1/13 sec. with -1 exposure compensation using a 580EX Speedlite set to -1 Flash Exposure Compensation.

Shooting with the EOS 5D

◆　　◆　　◆　　◆

In This Part

Chapter 6
Event Photography

Chapter 7
Nature, Landscape,
and Travel Photography

Chapter 8
Portrait Photography

Chapter 9
Stock and Editorial
Photography

Chapter 10
Wedding Photography

Chapter 11
Canon Programs,
Software, and
Firmware

◆　　◆　　◆　　◆

Event Photography

✦ ✦ ✦ ✦

In This Chapter

Overview and trends

Inspiration and creative
resources

Packing your gear bag

Shooting events

A compendium of
practical advice

✦ ✦ ✦ ✦

The area of event photography is as much a challenge as any when it comes to gaining mastery over demanding subjects and exposures. And with mastery comes rewards of one-of-a-kind images and the promise of continuing creative challenge — not to mention creating a good source of income with print sales or ongoing assignments.

Overview and Trends

With proper marketing or representation, the field of event photography is wide open — whether you're shooting on assignment for a company meeting, photographing a party or gala for a magazine or a Web site, or shooting recitals, sports events, or graduations. For local events, in particular, photographers who can take advantage of Web posting and printing services can begin generating revenue the day of the event or soon thereafter.

Many freelance event photographers find a niche that suits their personal interests and follow it throughout the season or the year. For example, some photographers follow the BMX racing circuit through the season, traveling and working from RVs most of the year. Riders become familiar with the photographers, and the familiarity with the photographer increases sales. Many photographers supplement event image sales by shooting portraits of riders before or after the event. The travel also affords the opportunity for side work in nature, landscape and stock photography.

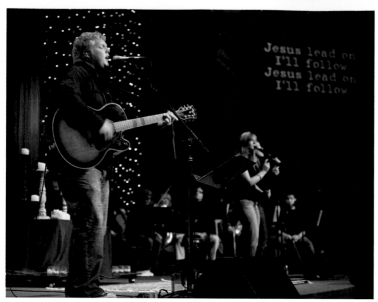

6.1 This image is an overall establishing shot for a concert assignment. Exposure: ISO 400, f/2.8, 1/20 sec. using an EF 70-200mm, f/2.8L IS USM lens.

A common approach to local event photography is to shoot the event, upload images to a Web site where event participants and fans enter a password to view, order, and receive prints by mail. Alternately, some photographers shoot, edit, display proofs, and print images on-site using their own or rented dye-sublimation printers or inkjet printers. To facilitate the fast turnaround of event shooting, a variety of software programs are available to enhance workflow for volume shooting with features to make pricing and tax calculations simple and quick.

Assignment photography ranges from shooting for private companies who contract for coverage of large conventions, awards ceremonies, musical groups in concert, and charity events. Whether you're shooting a private or commercial event, the objective is to show the energy and emotion – the decisive moments – of the event as well as capture high-energy shots of the key players in the event. In event shooting, creative approaches that show the subjects in new and interesting ways increase sales and on going assignment opportunities.

For event assignments, knowing the needs of the art director is crucial for delivering the range of images needed as well as for scheduling shooting time before, during, and after the event. For example, if the client wants overall establishing shots of the venue as background shots for Web site promotions, posters, and publications, you can take those early in the session. The same applies to speaker or performer portraits.

6.2 In addition to assignments and planned events, local and regional weather disasters such as this flood provide images for newspapers and television stations. Exposure: ISO 100, f/2.8, 1/60 sec. using an EF 70-200mm, f/2.8L IS USM lens.

Regardless of the event, you should arrange access and permits in advance, along with the shooting and working space, model releases, and property releases, if necessary.

Inspiration and Creative Resources

This section offers a variety of resources for event photographers including associations, Web sites, and photographer sites.

✦ **American Society of Media Photographers.** www.asmp.org. One of the premier photographic associations, membership in ASMP offers education, business resources, online forums, local chapters, legal resources, and publications.

✦ **Society of Sport and Event Photographers.** www.sep society.com/i4a/pages/index.cfm?p ageid=1. This association offers certification, resources, photographer directories, discounts on professional services, and articles.

6.3 Multicultural events such as this celebration provide a variety of opportunities for colorful images. Exposure: ISO 400, f/4.0, 1/60 sec.
© Peter Bryant

✦ **Model and property releases.** The American Society of Photographers Web site, www. asmp.org/commerce/legal/ releases, provides an overview of when you need releases. Doing a Web search on 'model release form, photography' nets many sites that offer sample releases as well as model releases that you can purchase. Be sure to review the forms before you use them to ensure that they cover all contingencies.

✦ **Event programs and Web sites.** Many event-oriented programs are available including Performer Software, www.performerpro.com/, which includes an online shopping cart, print ordering, order fulfillment, a Web ordering system, and more. Other products include Event Photography System, event photosystems.com/, Digital Railroad, marketplace.digital railroad.net/, More Photos, www.worldatmydoor.com/index. asp, Picasa, picasa.google.com/, Express Digital, www.express digital.com/products/contents-photographers.shtm, and Photo Reflect, photoreflect.com.

✦ **Plus.** www.useplus.com/about plus/system.asp. This system defines and categorizes image usage around the world, from granting and acquiring licenses to tracking and managing them well into the future.

✦ **Canon Digital Learning Center, Tips and Techniques.** www.usa. canon.com/dlc/controller? act=ArticleFilterAct& categoryID=-1&typeID=-1& productID=2&x=104&y=34. This section of the Learning Center offers a variety of articles and tips on using everything from the 5D to Canon lenses.

✦ **Canon Explorers of Light.** www.usa.canon.com/dlc/ controller?act=ArtistsList Act. This section of the Web site offers inspiring images from Canon's Explorers of Light.

Packing Your Gear Bag

Lenses ranging from wide-angle to tele-photo and at least two 5D camera bodies are a minimum for the fast pace and high volume of event shooting and for the variety of shooting needs of different types of events. While the 5D is capable of capturing 60 Large/Fine JPEG image per burst, it captures moderately fast action well, although it is not designed to perform with the speed of the faster EOS 1D Mark III.

Here are some general suggestions for event shooting, with an eye on the gear you'll want to have available when shooting a session that is local rather than long distance:

✦ **One or two EOS 5D camera bodies.** The best case scenario is having two 5D camera bodies, one with a wide-angle lens and one with a 200-400mm telephoto lens, depending on the event and your shooting proximity.

✦ **One or more wide-angle and telephoto zoom lenses.** I've found that the 24-70mm f/2.8L lens, and the 70-200mm, f/2.8L IS USM are very versatile. I also use the Extender EF1.4x II and Extender EF 2x II to increase the focal length. For sports and other fast-action events, an EF 300mm, f/2.8L IS USM or a similar lens is a good choice and can be combined with an extender. For outdoor events such as motocross, be sure to have lens cleaning cloths handy as well.

Cross-Reference *For details on Canon lenses, see Chapter 4.*

✦ **Tripod and monopod.** Having a light-weight but sturdy tripod is indispensable, particularly when you're shooting with long lenses. In addition, a versatile ball head with a sturdy quick-release plate increases the steadiness of shooting.

✦ **CF cards sufficient for the duration.** The number of CF cards that you carry depends on how many images you typically shoot and the length of the shooting session. High-volume shooting justifies the larger capacity CF cards as well as a portable storage device to offload images as time allows.

✦ **Spare camera batteries.** Even with the good life of the 5D battery, I have one or more charged spare batteries in my gear bag as insurance. Also if I know that I will have access to electricity, I sometimes bring along the battery charger for multiple day events.

✦ **Optionally, a laptop computer or portable storage device.** Backing up images on-site, either to a laptop or a handheld hard drive, is an essential part of the workflow, and if you're traveling for an event, you'll want to back up the shoot on a laptop or portable storage device. A laptop is handy if you upload images to a Web site and/or print images onsite.

✦ **EX-series flash, light stands, umbrella or lightbox, ST-E2 Speedlite transmitter.** When shooting portraits is part of the event or assignment, a handy portable studio might include one to three EX-series Speedlites mounted on stands with light

modifiers such as an umbrella or softbox, with the ST-E2 transmitter. This lighting setup, along with a couple of reflectors is completely wireless and the light ratios are easily controlled from the transmitter.

Cross-Reference *For details on EX-series flash, see Chapter 5.*

Additional handy items include the following:

✦ **Silver and gold reflectors.** Without question, reflectors of various sizes are indispensable for filling shadow areas and adding catchlights to the eyes if shooting individual participant portraits is part of the session.

✦ **Portable background and stands.** Whether it's a roll of white seamless paper or a painted board, having a clean background that's easy to assemble and tear down for portraits is exceptionally handy. Very often sales from events can be increased by offering individual portraits of some of the star participants.

✦ **Plastic painter's cloths.** For outdoor shooting, large plastic sheets come in handy for a variety of unexpected situations, including offering protection from a rain shower or wet grass, protecting camera and lighting equipment, or serving as a scrim for portrait sessions.

✦ **Leatherman tool.** Even for the "unhandy" person, this tool can solve all kinds of unexpected problems, including trimming back foliage in an outdoor setting.

6.4 A moment of strong emotion and gesturing made this a favorite shot with the art director. Exposure: ISO 400, f/2.8, 1/60 sec., -2 exposure compensation, using an EF 70-200mm, f/2.8L IS USM lens.

Shooting Events

Fortunately, the 5D offers versatility in shooting a broad range of events, and enough customization that you can set up the camera in advance for some types of events and begin shooting with little tweaking of exposure and Custom Function settings.

I'm a fan of C (Camera User Setting) mode on the 5D and use it as often as possible to preset the camera for upcoming assignments and events. I almost always arrive early to assess the lighting, take test shots, and set a Custom white balance, if that's the best option. Very often for music concerts, I use Automatic white balance, tweak the color in Adobe Camera Raw, and then apply the color correction as a batch to all the images shot under the same lighting.

For indoor music concerts with stage lighting, I find that the ambience of the gelled and colored stage lights retains the atmosphere of the concert, so I do only minor color adjustment in Adobe Camera Raw during processing.

The bigger challenge is establishing a base exposure that retains detail in the highlights of performers as they move in and out of strong spotlights on the stage. If possible, I find out when the rehearsal is scheduled, and attend at least part of it to establish the exposure.

At the rehearsal, I use Auto Exposure Lock, setting the exposure on the hottest highlight area of the performer's skin, and then register that setting to the C mode. Alternately, you can use the Spot meter to determine the exposure. For indoor events on a stage, I shoot wide open at the lowest ISO that I can set and still get 1/60 second at f/2.8.

6.5 A good vantage point and careful composition worked well in this shot of a local parade. Exposure: ISO 400, f/8, 1/250 sec.
© Rob Kleine, www.gentleye.com

I also shoot in RAW capture mode. Many photographers prefer to shoot JEPG at events for the faster workflow that it offers, and this approach makes sense for high-volume shooting scenarios when you're displaying and printing images on-site. In other cases, it makes sense to shoot RAW + JPEG, particularly if you anticipate that you'll want to spend more time editing selected images after the event.

However, even in high-volume event shooting, I prefer to have the latitude that RAW offers in post-processing, particularly in changeable light, such as on a stage or outdoors as participants move in and out of bright sunlight to overcast or shaded areas. I know that even if the images are slightly overexposed, I can pull back a minimum of one f-stop of highlight detail during RAW image conversion. And for assignment shooting such as music concerts, the RAW files offer more flexibility for providing files large enough for printing posters or small enough for CD jewel case inserts.

For outdoor events, I recommend using C mode to register both shooting and menu settings. As detailed in Chapter 2, you can set everything from the shooting mode and exposure to the AF point selection in advance, so that you're ready to begin shooting as soon as the event begins. And if conditions change, you can make on-the-fly adjustments to the settings of C mode, and as long as you don't register these changes, you can return to the original registered settings later.

Tip *If you've forgotten the settings you registered in C mode, just press the INFO button to display the settings on the LCD.*

Perhaps the worst event shooting circumstances are in conference rooms and auditoriums. The overhead light—usually

6.6 This image from the assignment for updating the church publications illustrates the contemporary look and feel of the service, which was one of the concepts that the art director wanted from the shoot. Exposure: ISO 400, f/2.8, 1/45 sec., -2 exposure compensation using an EF 70-200mm, f/2.8L IS USM lens.

fluorescent—is nothing short of ugly and unflattering. For events such as a conference, the best option that I've found is flash—either bounce or fill flash, provided that flash is allowed in the venue. For the best results, mount the flash on a bracket and diffuse it with a modifier such as a small softbox or diffusion panel and shoot in E-TTL II mode. In some cases, a skylight with a reflector or window light provides a happy alternative to overhead artificial light. Work with the event organizers ahead of time to coordinate the best shooting space, if possible.

6.7 There is no shortage of winter weather disasters in Washington state. During this wind storm, this was one of the first pictures from my area, and it was also used on a local television's Web site as part of a slide show. Exposure: ISO 100, f/2.8, 1/60 sec. using an EF 70-200mm, f/2.8L IS USM lens.

A Compendium of Practical Advice

Following are some of the techniques that you may find useful when shooting events.

✦ **Shoot both traditional shots and creative variations.** I once had a client reject what I thought was the best image from a family event. The client said simply, "We aren't artsy people." They chose the traditional images over an image that eventually placed in a photography competition. But if I hadn't taken both the traditional and the creative shots, I wouldn't have satisfied the client's expectations.

✦ **Ensure that you're on the same page as the art director.** In some cases, art directors use precious few words to describe their vision and expectations for the assignment.

Ask as many specific questions as possible and restate the answers in your own words to ensure that your vision syncs up with theirs.

✦ **Have backup gear.** Just as with wedding shooting, there are no second chances when shooting many types of events, so if the battery dies or if a lens suddenly refuses to focus, you need to be able to quickly switch to a backup 5D and lens to continue shooting without a hiccup.

✦ **Do your homework.** Know the key participants, know the rules of the game, know the schedule of events, know if the event is being videotaped and how that affects your ability to move around the stage or venue, know if any areas of the venue are off-limits to photographers, know where the best action will happen, and, of course, stake out a shooting area early.

6.8 This image from a family reunion shows a nine-day old baby in the hands of his 100-year-old great-great-grandmother. Exposure: ISO 200, f/2.8, 1/60 sec. using window light to the front of the subjects and a silver reflector to camera left. I used an EF 100mm, f/2.8 Macro USM lens for this shot.

✦ **Know the 5D.** Before you begin shooting events such as low-light music concerts, theatrical productions, and so on, shoot images on the 5D at high ISO settings, and then print the images at the sizes that the client might request. Evaluate the prints for digital noise and grain levels that become more evident at large print sizes. That gives you a yardstick for the highest ISO settings that you can use and get good prints. For example, I get lovely 13x19-inch prints at ISO 1600. At ISO 3200, 8x10 inches and smaller are appropriate from my experience.

✦ **Negotiating model releases.** Some companies routinely require that everyone who appears on the stage sign model releases prior to the event, but others do not. In the latter case, be sure that you discuss model releases with the art director for assigned event shooting and with the participants for other events. Also check with event organizers on whether work permits, proof of insurance, and registration are required. You can find model release forms on the Web, or you can hire an attorney to create one.

6.09 One of the challenges of shooting concerts is capturing the vocalist when she is pulled back from the microphone. But this performer was experienced with having a photographer present and pulled back often enough for me to capture suitable images. Exposure: ISO 400, f/2.8, 1/90 sec. using an EF 70-200mm, f/2.8L IS USM lens.

Nature, Landscape, and Travel Photography

CHAPTER 7

◆ ◆ ◆ ◆

In This Chapter

Overview and trends

Inspiration and creative resources

Packing your gear bag

Shooting nature, landscape, and travel images

A compendium of practical advice

◆ ◆ ◆ ◆

If photography is all about light, then nature, landscape, and travel photography is all about looking for the light — a stunning spectrum of light to define mood, texture, depth, and character of images.

Overview and Trends

Weather, global warming, endangered species, and the erosion of natural wonders such as coral reefs are hot buttons in the news now. Photographers who can deliver images illustrating these issues gain entry into expanded markets for supplying images not only in the traditional markets of stock, fine art, and galleries, but also to news and special-interest publications.

The field is not limited to strictly documentary and fine-art work. An increasing number of photographers work with tourism boards and advertising agencies for travel-related publications and advertising campaigns. This market is strong and expanding, and it incorporates aspects of fashion, lifestyle, glamour, and editorial shooting. Travel campaigns focus both on vacationers and business travelers. Shooting encompasses both indoor and outdoor venues with concepts that convey not only the beauty, but also the energy of the locale with iconic images.

7.1 The breathtaking sweep of clouds and color along with late-afternoon light across the forest drew me to this scene. Exposure: ISO 100, f/8, 1/45 sec. using an EF 70-200mm, f/2.8L IS USM lens.

Nature, landscape, and travel photographers often migrate to specialty areas, including aerial photography, storm chasing, and documenting specific locations such as Antarctica or the rain forests. Along the way, many photographers become experts in their areas of specialization.

Inspiration and Creative Resources

A wide variety of resources are available for nature, landscape, and travel photographers. Canon also provides resources and inspiration on the Canon Digital Learning Center Web site (www.usa.canon.com/ dlc/controller?act=HomePageAct). Here is a selection of Web sites, magazines, and programs that you can check out to enhance your nature, landscape, and travel photography.

✦ **Travels to the Edge with Art Wolfe.** www.usa.canon.com/ dlc/travels/index.jsp.

✦ **Nature Photographers Online Magazine.** www.naturephoto graphers.net.

✦ **Nature Photographer Magazine.** www.naturephotographermag.com.

✦ **Canon Explorers of Light.** www.usa.canon.com/dlc/

7.2 Aerial photography offers wonderful opportunities not only for capturing the massive sweep of the land, but also for showing environmental trends such as erosion, deforestation, animal migration patterns, and more. This is an aerial shot of the Great Salt Lake. Exposure ISO 100, f/9.5, 1/500 sec. using an EF 24-70mm, f/2.8L USM lens.

controller?act=ArtistsListAct. Includes Sam Able, Bruce Dorn, Don Emmerich, Darrell Gulin, Eric Meola, George Lepp, Art Wolfe, Roger Ressmeyer, Adam Jones, Lewis Kemper, Stephen Wilkes, Vincet Laforet, Jeff Schewe, and William Neill, among others.

✦ **North American Nature Photography Association**. www.nanpa.org.

✦ **National Geographic.** www.nationalgeographic.com.

✦ **National Geographic Traveler.** www.nationalgeographic.com/ traveler.

✦ **Photographer's Market.** photo graphersmarket.com.

✦ **Fred Miranda.** www.fredmiranda .com/software. Offers a variety of Photoshop actions, including Velvia Vision and Intellisharpen, to enhance image rendition and sharpening.

7.3 This image of Snohomish, a small farming community in Washington, provides the context of the farming valley in the shadow of the mountains. Exposure: ISO 100, f/22, 1/125 sec. usinig an EF 70-200 mm, f/2.8L USM lens.

Packing Your Gear Bag

Packing for nature, landscape, and travel shooting depends on where you're going, the length of the trip, and the weather conditions. For example, if you're shooting in an easily accessible location and can store extra gear in your vehicle, then you can take more varied gear without the worry about being slowed down by a seriously heavy backpack.

If you're traveling, then the selection of gear and the level of complexity increases, and for air travel you have to be more selective in packing multipurpose, versatile lenses, filters, and accessories. The mix of gear can change if you're travel domestically or internationally.

✦ **Carry-on regulations.** The first and most important step in preparing for airline travel is to check the carry-on guidelines for the specific airline or airlines that you're flying on. Some airlines are more restrictive than others. For an overview of domestic airline carry-on regulations, visit iFly.com (www.ifly.com/carry-on). For international flights, be sure to check the airline's Web site.

✦ **Security checkpoint regulations.** It also pays to check out the allowable carry-on items from the Transportation Security Administration (www.tsa.gov/) because they change frequently. Any information you can get in advance eases the entire travel process.

7.4 In this image, Peter captured not only the architecture but also a predominate cultural heritage of the San Diego, California, area. Exposure: ISO 1600, f/3.5, 1/60 sec. using an EF 16-35mmL II USM lens.
©*Peter Bryant*

Here are my minimum recommendations for packing gear for shooting where airline travel is not involved.

✦ **One or two EOS 5D camera bodies.** Ideally, you'll have a backup 5D with you in case anything goes wrong. This is especially important in inclement weather and in locations where the camera is exposed to blowing dust, sand, rain, or heavy moisture—all of which can wreak havoc with cameras. You may, of course, eschew the second body for local shooting. But if you spend any time packing, driving, and/or walking to a location only to experience a problem with the camera, your time and the trip is wasted.

✦ **Weather-proof camera and lens sleeves.** The EOS 5D lacks the extensive weather-proofing seals and gaskets of the 1D and 1Ds cameras, so it's important to have protection for the camera against environmental factors including moisture, sand, and dust. Some camera bags such as some from Lowepro include water-repellant bags and sleeves that fold compactly and attach to one of the camera bag's interior compartments. Alternately, you can buy a variety of weather-proof camera protectors from Storm Jacket (www.stormjacket.com).

7.5 Peter's composition of Balboa Park in San Diego, leaves room to the left so that editors who may license the image can insert text and graphics. Exposure: ISO 100, f/6.3, 1/60 sec. using an EF 28-135mm, f/3.5-5.6L IS USM lens.

©Peter Bryant

✦ **One or more wide-angle, macro, and telephoto zoom lenses.** For general outdoor shooting, I carry the EF 16-35mm, f/2.8L II USM, or alternately the 24-70mm f/2.8L lens, the 100-400mm f/4.5L IS USM or the 70-200mm, f/2.8L IS USM, and, depending on your budget, a 300mm or up to a 500mm lens is also a good addition. For macro nature images, I prefer the EF 100mm, f/2.8 Macro USM and the EF 180mm, f/3.5L Macro USM lenses.

✦ **Tripod and monopod.** Having a light-weight but sturdy tripod is indispensable. In addition, a versatile ball head with a sturdy quick-release plate increases the steadiness of shooting, particularly with long lenses.

✦ **Extenders and extension tubes.** I typically carry both the EF 1.4x II and the EF 2x II extenders to increase the focal range of telephoto lenses. The tele-extenders can be used with fixed focal length lenses 135mm and longer (except the 135mm f/2.8 Softfocus lens), and the EF 70-200mm, f/2.8L; 70-200mm, f/2.8L IS; 70-200mm, f/4.0L; 70-200mm, f/4.0L IS USM; and 100-400mm, f/4.5-5.6L IS zoom lenses.

The effective aperture is reduced by one f-stop for the 1.4x extender and two f-stops for the 2x extender. Autofocus is possible when combined with a lens having an f/4 or faster maximum aperture. The version II extenders offer enhanced weather-resistant construction, and improved anti-reflective surfaces in the barrel. Extension tubes, either from Canon or Kenko, allow you to get in close to capture the fine details of nature.

✦ **CF cards.** The number of CF cards that you carry depends on how many images you typically shoot and the length of the shooting session. I usually carry a variety of SanDisk Extreme III cards in sizes ranging from 1GB to 4GB.

✦ **Spare camera batteries.** Especially in cold weather that reduces the shooting time for the battery, it's important to have plenty of power available in the form of one or multiple spare and charged camera batteries. In cold weather, place the battery inside your jacket near your body to keep it warm.

✦ **Polarizer and neutral density filters.** A circular polarizer will enhance the saturation and color of blue skies as well as reduce reflections on reflective surfaces. Neutral density filters come in varying densities and allow you to hold back the bright sky by 1 to 3 f-stops to balance it with the foreground exposure.

✦ **TC-80 N3 Remote Controller.** This cable allows not only remote shutter firing, but also it has functions so that you can set the self-timer, use an intervalometer with the ability to set the length of time between shots, set bulb exposures from 1 second to 99 hours, 59 minutes, and 59 seconds, and set the number of exposures from 2 to 99.

✦ **Laptop computer or portable storage device.** Backing up images on-site, either to a laptop or a handheld hard drive, is an essential part of the workflow throughout the day. Unless I have to, I don't delete images from the CF cards after loading them onto the computer or handheld device so that I have two copies of the images at all times.

The lens selection, of course, depends on your budget and shooting preferences. Certainly Canon offers a good selection of super-telephoto lenses that serve well in the field.

Cross-Reference *For details on Canon lenses, see Chapter 4.*

Additional items to pack include the following:

✦ **Cell phone and/or location device.** Whether you're near home or far from home, a cell phone is indispensable for normal and emergency communication. And if you're hiking in mountain areas, check in with the ranger station to see if it has GPS location devices or electronic signal devices that enable rescuers to more easily find you in case of emergency.

✦ **Passport, driver's license, or other identification.** If you're staying in a hotel, be sure to carry the hotel's phone number or business card with you.

✦ **Notebook and pen.** Write down your impressions of the area, especially first impressions that will help you define your creative inspiration of the place, and subsequently your approach to shooting.

✦ **Plastic bags.** These bags are useful for storing anything and everything in inclement weather.

✦ **Gaffer's tape and florist's wire.** You can use these items to hold, secure, or repair almost anything.

✦ **Leatherman tool.** Even for the "unhandy" person, this tool can solve all kinds of unexpected problems in the field.

Shooting Nature, Landscape, and Travel Images

The EOS 5D offers ample creative control for expressing your photographic vision with the assurance that the final image resolution will be excellent. As Dave Etchells of Imaging-Resource (www.imaging-resource. com) reports, the camera has very high resolution that is beyond 2,000 lines of strong detail for excellent prints to 13x19 inches and larger. The strong performance of the 5D with low noise at high ISO settings also adds another dimension of creativity for low-light shooting. And with a usable dynamic range in both JPEG and RAW capture, the camera falls just below the top-of-the-line Canon EOS digital SLRs, and gives wide latitude for excellent exposure in a broad range of light.

Creative as well as technical control over the final image begins with the Picture Style that you choose or modify. Especially if you shoot RAW capture, the 5D allows you to control color saturation and look and feel so that you get the image rendition that you envision. As I mention in Chapter 3, the 5D's Standard Picture Style tends to oversaturate

Establishing a Creative Vision

Nature, landscape, and travel photographers bring to the table their unique inspiration for their work, and it's often as varied as the photographers themselves. Canon Explorer of Light, Stephen Wilkes, www.stephenwilkes.com/main.html, explained his approach to creative vision to me during an interview.

"The act of previsualizing is a wonderful thing — it is a gift. And with the technology today and the demand of business, it's important to be able to see things in your mind to a certain degree. But I think that photographers can get so focused on seeing what they want the picture to be that they don't see anything else; in fact, they don't see what's really there."

Wilkes said, "One of the things that I look for in photography is emotion. I respect and admire photographers who create images where their soul, their energy, is in the picture. You can feel them in their pictures. That's what style is to me — when I feel the soul in the work. I take a lot of pride in that. I work very hard. Someone once commented that I had a Zen master's approach to the way I look at things where intuitively I just feel things."

If Wilkes sounds Yoda-like, he says that it's taken years of observation, introspection, and study to reach that point. "I like to tell young photographers that I can save them a lot of money in therapy [just by telling them that] we don't have control of the weather."

7.6 The versatility of the EF 100mm, f/2.8 Macro USM lens makes it one of my favorite lenses, both for macro work and as a walk-around lens for grab shots such as this butterfly on a cone flower. Exposure: ISO 100, f/5.6, 1/125 sec.

reds, so it's important to modify the Picture Style or choose another style that is less likely to clip in the Red channel.

With some RAW-capture shooting and processing experience, you will soon learn to evaluate the differences among the Picture Styles. For example, if you compare RAW images shot with the Standard and Neutral styles in the Edit Image window of Canon's Digital Photo Professional (DPP) program, you'll begin to see how the style affects image quality. Of course, renderings are affected by ambient light, but in general, you can see the differences in how Sharpness, Contrast, Saturation (color saturation), and Color Tone (negative settings increase the blue/purple hue, and positive settings increase the yellow hue) affect the histogram. With a strong tonal curve such as is used for the Standard, Landscape, and Monochrome Picture Styles, you may experience clipping that blows out highlights. And with the color saturation parameter, anything above a +2 setting tends toward color channel clipping.

Like most photographers, I prefer to control the final rendition of images, and the best way to do that is to ensure that pixels are not clipped either in the camera as a result of the Picture Style parameter settings and the tonal curves, or in editing. For these reasons, I shoot with a modified Neutral Picture Style and I shoot only in RAW capture mode. If you shoot JPEG mode, then it's important that you make test shots using the Picture Styles that you find pleasing, and then evaluate the images in DPP, looking both for color-channel clipping and tonal curve differences.

 For details on using Canon Picture Styles, see Chapter 3.

Another creative advantage of the 5D is the C mode, where you can set and save your most-often-used shooting settings and return to them by switching the Mode dial to C.

The range of light and shooting situations that nature, landscape, and travel photographers encounter run the gamut from exceptionally stunning to stormy and dull. Regardless of the variety, the challenge that is common to outdoor shooting is getting the best exposure.

7.7 Overcast light and fog combined to create a moody, mysterious look for this lake scene. Exposure: ISO 100, F/4, 1/45 sec. using an EF 24-105mm, f/4L IS USM lens.

Using the characteristics of natural light

Natural light changes throughout the day. By knowing the predominant characteristics throughout the day, you can use the changing quality, color, and intensity of light to your advantage.

But getting the light is only half of the story. Exposing so that the light is rendered as it appears to the photographer's eye is the essential second half of the story, along with ensuring that the color is rendered accurately.

Presunrise and sunrise

In predawn hours, the cool blue and gray hues of the night sky dominate and create a soft, shadowless light. This is the time to capture subtle reflections of the landscape on a calm lake, or to capture the fog or mist that tends to hang low over valleys and water.

As the sun inches over the horizon, the light changes quickly and the landscape begins to reflect the warm gold and red hues of the low-angled sunlight with long shadows to reveal texture and detail that add depth to the image. During this time of day, the green color of grass, tree leaves, and other foliage is enhanced.

Contrast is low as the sun's rays are scattered by cutting through the atmosphere at a low angle. Landscape, fashion, and portrait photographers often use the light available during and immediately after sunrise. During sunrise, tall structures such as buildings and trees are lit by the sun while the rest of the landscape appears cool and shadows are filled in by light from the sky.

In broad terms, both sunrise and sunset register in approximately at 2,000 K. To get the best color, you can set a custom white balance, which is detailed in Chapter 3. If you are fortunate enough to have a color temperature meter, then setting the K white balance option to the color temperature meter reading provides the best results. If you are shooting RAW images, you also can adjust the color temperature after capture in Canon's Digital Photo Professional RAW conversion program.

7.8 This image was taken in early afternoon light and shows the mission bells in San Diego. Exposure: ISO 100, f/8, 1/320 sec.

Early morning to midday

As the sun rises in the sky on a typical clear day, the quality of light becomes more intense as the angle between the sun and earth increases, allowing more light rays to pass through the thinner atmosphere. The color temperature also rises and loses its warmth to become white as it heads toward 5,500K. The first two hours after sunrise typically provide ideal light for nature, landscape, and travel photography because the contrast isn't too extreme, the color temperature is still a bit warm, the sky is bluer because the sun is still close to the horizon, and long shadows reveal texture and depth in the landscape.

During midday hours, the warm and cool colors of light equalize to create a light the human eye sees as white or neutral. On a cloudless day, midday light often is considered too harsh and contrasty for landscape shooting and produces flat and lifeless results. However, midday light is effective for photographing images of graphic shadow patterns, flower petals, and plant leaves made translucent against the sun, and images of natural and man-made structures.

For midday pictures, the Daylight white balance setting on the EOS 5D is a good choice.

Presunset, sunset, and twilight

During the time just before, during, and just following sunset, the warmest and most intense color of natural light occurs. The predominantly red, yellow, and gold light creates vibrant colors, while the low angle of the sun creates soft contrasts that define and enhance textures and shapes. Sunset colors create rich landscape, cityscape, and wildlife photographs. The warmth of this time of day is different from sunrise because the sun is striking a warm rather than a cold landscape. As a result, shadow color is more neutral than the blue seen in early morning shadows.

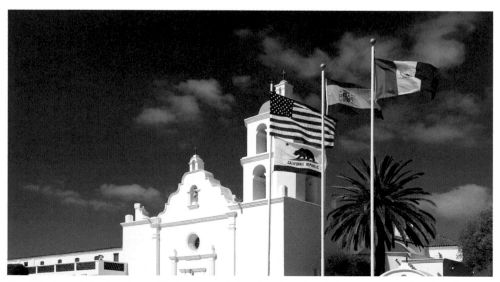

7.9 This travel shot makes effective use of the clouds to lead the eye upward to the flags. Exposure: ISO 100, f/10, 1/100 sec. using a using an EF 16-35mmL II USM lens.
©*Peter Bryan*

The last hour before sunset, the "Golden Hour," brings even lackluster scenes to life. Once again, long shadows stretch to reveal texture and detail particularly when the sun is at a right angle to the camera.

> **Tip** *To avoid flare, try this test. If you can look at the sun's orb without squinting, then you can include it in the image without risking flare. If you have to squint, wait a few minutes for the sun to sink lower on the horizon, and then try again.*

With the sun below the horizon, light is reflected onto the landscape from the sky. This is a good time to use long shutter speeds to record movement in the landscape area, whether the movement is water washing up to the shore, people passing by, or trees and grasses swaying in the breeze. The first 30 minutes after sunset is an ideal time to capture the soft pastel sky colors reflected in a still lake or on the ocean.

7.10 In this image, lens flare is evident along the side of the steeple. Exposure: ISO 125, f/2.8, 1/8000 sec., using an EF100mm, f/2.8 Macro USM lens.

7.11 Uneven polarization is evident in the sky. Adding a grad-ND filter would help avoid this. Exposure: ISO 100, f/13, 1/50 sec. using an EF 28-135mm, f/3.5-5.6 IS USM lens.
©Peter Bryan

Essential Filters

The most useful filters in nature, landscape, and travel — collectively referred to as "outdoor" photography — include the circular polarizer, neutral density or vari-neutral density filters, and warm-up filters. Here is a brief overview of each type of filter.

✦ **Polarizer.** Polarizers deepen blue skies, reduce glare on non-metallic surfaces to increase color saturation, and remove spectral reflections from water and other reflective surfaces. A circular polarizer attaches to the lens, and you rotate it to reduce reflected polarized light. Maximum polarization occurs when the lens is at right angles to the sun. With wide-angle lenses, uneven polarization can occur causing part of the sky to be darker than other areas of the sky. You can use a one- to two-stop neutral density graduation filter to tone down the lighter area of the sky by carefully positioning the grad-ND (Neutral Density) filter.

✦ **Variable neutral-density filters.** Singh-Ray's Vari-ND Variable Neutral Density Filter (www.singh-ray.com/varind.html) allows you to continuously control the amount of light passing through your lens up to 8 EV (Exposure Values), making it possible to use narrow apertures and slow shutter speeds even in more brightly lit scenes to show the fluid motion of a waterfall, the motion of clouds, or flying birds. The filter is pricey, but it is a handy addition to the gear bag.

✦ **Graduated neutral-density filters.** These filters allow you to hold back a bright sky from 1 to 3 f-stops to balance foreground exposure. Filters are available in hard or soft stop types and in different densities: 0.3 (one stop), 0.45 (one-and-one-half stops), 0.6 (two stops), and 0.9 (three stops). With this filter, you can darken the sky without changing its color; its brightness is similar to that of the landscape and it appears in the image as it appears to your eye.

✦ **Warm-up filters.** Originally designed to correct blue deficiencies in light or certain brands of film, warm-up filters correct the cool bias of the light, and you can use them to enhance the naturally warm light of early morning and late afternoon. Warm-up filters comes in different strengths, such as 81 (weakest); and 81A, B, C, D, and EF, with 81EF being the strongest. For greatest effect, combine a warm-up filter with a polarizer. You can also apply the warm-up effect during image editing in Photoshop.

Diffused light

On overcast or foggy days, the light is diffused, contrast is dramatically reduced, and shadows are weak while the color temperature tends toward the cool side of the scale. Light can be diffused by clouds; an overcast sky; atmospheric conditions, including fog, mist, dust, pollution, storms, and haze; or objects such as awnings or shade from trees or vegetation.

Particularly for nature, landscape, and travel shooting, clouds provide endlessly changing patterns of light and shade. Clouds also provide visual interest as the backdrop for all types of outdoor images as well as provide lovely reflections in lakes and ponds. In fact, clouds with their endless formations can be the focal point of compositions with a hint of land to provide both an anchor for the image and a sense of scale. At the extreme end of the cloud scale are heavy, dense overcast clouds that can make evocative black-and-white or toned images at high ISOs or long shutter speed.

Because overcast and cloudy conditions commonly are between 6,000 and 8,000 degrees K, the Cloudy, twilight, sunset white balance setting on the EOS 5D works adequately for overcast and cloudy conditions.

Tip *To learn more about light, visit Canon's Web site at www. canon.com/technology/s_labo/ light/003/01.html.*

Each of these types of light and the moods they create depend on the accuracy of the 5D to capture the color, the subtleties of the light plays in the scene.

For many nature photographers in particular, RAW capture is the only option that gives them the kind of control over the final image that they need and want. By setting the camera to either the Faithful or Neutral Picture Style, you can render colors faithfully and the camera applies a lower contrast tonal curve that, in turn, allows you ample latitude during RAW image conversion to increase contrast and color saturation to your liking, without clipping or blowing highlights in a conversion program such as Adobe Camera Raw. Of course, the downside is that the images on the LCD look a little flat.

7.12 A light overcast in this scene rendered a soft but colorful effect for these spring tulips. Exposure: ISO 125, f/8, 1/200 sec.

Exposure techniques for atypical scenes

Like most dSLRs, the EOS 5D has a very capable onboard reflective light meter. It is designed to measure light that is reflected off the subject or scene, and it's calibrated to correctly expose "average" scenes. An average scene reflects approximately 18 percent of the light falling onto it. Visually, this 18 percent is represented as mid-gray, referred to as 18 percent gray.

A good many scenes are "average," particularly scenes that are evenly lit, or where the sun is behind or to the side of the camera, and scenes where not too much of the sky or a dark foreground is in the frame to give a predominance of light or dark tones. Scenes such as snow, or a dark foreground or large dark expanse of water are prone to exposure error. And in scenes such as this, along with others such as a sunlit building framed by a large expanse of dark foreground or scenes where you include large expanses of bright sky, you can make full use of the 5D's metering options to get good exposures in non-average scenes.

7.13 Exposing for the glow of this balloon in the sunset sky was a bit tricky because every moment that I hesitated, the balloon drifted farther away. I metered on the balloon glow and fired off several frames using Auto Exposure (AE) Lock. This was the best frame from the series. Exposure: ISO 100, f/4, 1/45 sec.

The first step is to evaluate the scene you're shooting. If you determine that the scene has a predominance of dark or light tones that will fool the Evaluative metering system, then you can switch to Partial or Spot metering. Spot metering is weighted at the center 3.5 percent of the viewfinder while Partial metering, also weighted at the center, is 8 percent of the viewfinder area.

Once you've switched to Spot or Partial metering, you can then meter for the area that's critical for proper exposure. For example, if you're shooting a landscape scene under stormy skies where patches of light break through the clouds to light areas of the scene, then meter for the light areas. You can either use AE Lock to set the exposure and recompose, focus, and make the image, or you can switch to Manual mode using the exposure indicated with Spot metering. If you are using a graduated filter, the dark band across the top can cause a metering error. So take the meter reading without the filter, and then attach the filter before making the image.

Cross-Reference *For details on using AE Lock, Manual mode, and Exposure Compensation, see Chapter 1.*

Both Partial and Spot metering are reflective, and that means that you must meter from a mid-gray in the scene that has approximately 18 percent reflectance. In outdoor scenes, you can use green grass, a blue sky, or a stone—all of which have approximately 18 percent reflectance. Or you can carry a small gray card available at most camera stores and meter from it.

For quick switching between metering modes, you can set the C mode (detailed in Chapter 2) so that it is preset to Spot metering.

Another option is to use Exposure Compensation (detailed in Chapter 1). For scenes with a large expanse of sky, a positive compensation of 1 to 1.5 f-stops is generally adequate to compensate for the predominance of light in the scene. For large expanses of snow, a positive compensation of one to two stops will counteract the camera's underexposure and render snow white instead of gray.

Note *Another option is to bracket images, and then composite the images in an editing program such as Adobe Photoshop CS3. Bracketing, explained in Chapter 1, involves making a picture at the camera's ideal exposure, as well as pictures at exposures that are over and under that exposure. I bracket using shutter speed rather than aperture to ensure perfect registration of the composited images.*

Another function that you will doubtless want to set is Mirror Lockup with, of course, a tripod. By locking up the mirror before the shutter is fired, you can avoid any blur caused by the slap of the reflex mirror, particularly when you're shooting macro images and when you're using telephoto lenses. You can turn on Mirror Lockup using C.Fn-12. See Chapter 2 for how to set Custom Functions.

7.14 In this scene, I wanted to retain detail in the bright areas of the snow and icicles and keep the snow white. I metered for the ice and added a stop of compensation. Exposure: ISO 125, f/10, 1/250 sec., +1 compensation.

7.15 For this image, I wanted to create a purple haze of the background flowers, so I moved in very close and used the EF 85mm, f/1.2L II USM lens with an extension tube knowing that at a wide aperture, the bokeh would smooth the background details. Exposure: ISO 125, f/5.6, 1/60 sec.

Shooting in lowlight

Lowlight scenes, whether the subjects are landscapes, nature images, or travel shots, challenge your photography skills. Evening and night images not only expand your understanding of exposure, but they also open up a new world of creative challenge, enjoyment, and one-of-a-kind images. And the EOS 5D's excellent performance at high ISO settings allows you a great deal of creative freedom in these kinds of scenes.

Sunset and twilight are magical times to photograph city skylines, harbors, and the rising moon. During twilight, the artificial lights of cities and the light from the sky reach approximately the same intensity. This crossover time offers a unique opportunity to capture detail in a landscape or city skyline, as well as in the sky.

Lowlight and night photos offer an opportunity to use Manual mode on the 5D. Some starting metering recommendations are provided in Table 7.1.

A Compendium of Practical Advice

Tips and techniques for nature, landscape, and travel images abound. Here are some of the techniques that you can use when shooting outdoor images.

✦ **Focus one-third of the way into the scene.** This technique approximates hyperfocal focusing, and though it is not as accurate, it works reasonably well. For sweeping landscapes where there's no obvious center of interest such as a person, object, or an animal, focus the lens approximately a third of the way into the scene. The depth of field for distant subjects extends approximately twice as far beyond the point of focus as it does in front. At close focusing distances, however, the point of focus falls approximately in the center of the depth of field.

Table 7.1
Ideal Night, Evening, and Lowlight Exposures

Subject	ISO	Aperture	Shutter Speed
City skylines (shortly after sunset)	100 [400]	f/4 [f/8]	1/30 second
Full moon	100	f/11	1/125 second
Campfires	100	f/2.8	1/15 to 1/30 second
Fairs, amusement parks	100 [400]	f/2.8	1/8 to 1/15 second [1/30-1/60]
Lightning	100	f/5.6 [f/8]	Bulb; keep shutter open for several lightning flashes
Night sports games	400 to 800	f/2.8	1/250 second
Candlelit scenes	100 [200]	f/2.8 [f/4]	1/4 second
Neon signs	100 [200]	f/5.6	1/15 second [1/30]
Freeway lights	100	f/16	1/40 second

7.16 I focused a third of the way into this scene to maximize acceptable sharpness throughout the frame. Exposure: ISO 100, f/8, 1/90 sec. using an EF 70-200mm, f/2.8L IS USM lens.

Maximizing Depth of Field

Particularly in landscape photography, you want to maximize the depth of field. Certainly a narrow aperture is one part of ensuring maximum depth of field. In addition, you can use hyperfocal focusing to provide sharp focus from near to far in the frame. This is the way to get images with the best acceptable focus from the nearest point in the scene to infinity. The depth of field will extend from half the hyperfocal distance to infinity at any given aperture.

The easy way to set hyperfocal distance focusing is if you have a lens that has both a distance scale and a depth-of-field scale. If you have this type of lens, first focus the lens on infinity, and then check the depth-of-field scale to see what the nearest point of sharp focus is at the aperture you've set. Then focus the lens on the hyperfocal distance. For example, with the aperture set to f/11 and using the EF 28mm lens, the hyperfocal distance is just over 2 meters, which means that you would refocus the lens at a point in the scene just over 2 meters to get acceptable sharpness from half the hyperfocal distance, or approximately 5 feet, to infinity.

If your lens does not have a depth-of-field scale, and most newer lenses do not, then you may want to buy a hyperfocal focusing calculator. Alternately you can calculate the distance using this formula. The formula takes into account the *circle of confusion*, or the maximum size of points on an image that are well defined — that is — acceptably sharp, when a 8x10-inch print is viewed at a normal viewing distance of 2 to 3 ft. For 35mm, that circle size is 0.036mm.

To calculate the hyperfocal distance, you can use this equation:

$$H=(F \times F)/(f \times c)$$

where H is hyperfocal distance, F is lens focal length, f is aperture, c is circle of confusion.

So a 28mm lens set to f/16 produces:

$H=(28 \times 28)/(16 \times 0.036)$, or $H=1361$mm or 1.36 meters. To ensure maximum depth of field, you would focus the lens on a point in the scene that is just less than 1.5 meters from the camera.

✦ **Previsualize the image.** If you're shooting a sunset scene, decide if you want to capture foreground detail or show trees, hills, and buildings as silhouettes. If you want to show foreground detail, then meter the foreground directly by excluding the sky and sun from the viewfinder, and then use a neutral density graduated filter to tone down the sky so that it isn't blown out. If you decide to let the foreground go to silhouette, include less foreground in the frame by tilting the camera upward slightly to feature more sky. Or switch to a telephoto lens, and pick out one or two elements, such as trees or a building, to silhouette.

✦ **Research before you go.** Most travel photographers agree that you can never do too much research on the place you're traveling to before you leave. The more you know about the area, what its defining characteristics are, and what areas the locals frequent, the better the chances that you will come away with unique images that capture the spirit of the locale.

✦ **Photographing rainbows.** To capture the strongest color of a rainbow, position the rainbow against a dark background such as stormy clouds, a hill, or trees. You can underexpose the image by about one-third or one-half f-stop to increase the intensity of the colors.

✦ **Use side- or cross-lighting.** Frontal lighting is often chosen by inexperienced photographers, but creates images that lack texture and depth because the shadows fall away from the camera and out of view. Instead shoot so that the sun is on one side of the camera with light striking the scene at a right angle. Side-lighting provides the strongest effect for polarizing filters given maximum polarization occurs in areas of the sky that are at right angles to the sun.

✦ **Use the Self-timer mode.** For low-light and night scenes, you can use the Self-timer mode to ensure that there is no camera shake as a result of pressing the shutter button with your finger.

7.17 Side-light provided strong shadow patterns in this fall scene. Exposure: ISO 100, f/3.5, 1/350 sec. using an EF 70-200mm, f/2.8L IS USM lens.

✦ **Include people in travel images.** People define the locale and the locale defines the people. As a result, it's difficult to capture the spirit of place without including people in your images. If you don't speak the language, use hand gestures to ask permission before you photograph people.

✦ **Find new ways to capture iconic landmarks.** Some landmarks such as the Eiffel Tower have been photographed at every angle, with every lens, and in every light possible. Spend time thinking about how to get a fresh take on iconic landmarks to make your images distinctive.

✦ **Use a lens hood.** You can avoid lens flare by keeping lenses squeaky clean and using a lens hood to prevent stray light from striking the front lens element.

✦ **Use selective focusing for creative effect.** At the opposite end of the spectrum of maximum depth of field is choosing to render only a small part of the scene in sharp focus using limited depth of field. This technique is effective with a 200-300mm lens set to a wide aperture with a single tree or a small group of people as the point of sharp focus while the rest of the scene is thrown well out of focus. The fall-off of sharpness is increased as the focal length increases and the aperture gets wider.

✦ **Metering a bright sky.** To get a proper exposure for a bright sky, meter the light on the brightest part of the clouds using the 5D's Spot meter. If the sun is above the horizon, take the meter reading without the sun in the frame, and from an area of the sky that is next to the sun.

7.18 A wide aperture, telephoto, macro lens, and a close camera-to-subject distance renders a very specific area of sharp focus in this image. Exposure: ISO 125, f/2.8, 1/500 sec. using an EF 100mm, f/2.8 Macro USM lens.

Portait Photography

In This Chapter

Overview and trends

Inspiration and creative resources

Packing the gear bag

Shooting portraits

A compendium of practical advice

Portraiture is an amazing and unique entrée into another person's life. It is all about encapsulating the spirit of the subject. Certainly, this concept is hackneyed, but any photographer who has photographed a fair number of people knows that it is true. Capturing the singular energy of the subject is what brings the subject up and off the photographic paper and into the hearts of those who view the portrait.

Capturing the person's spirit begins by having a bond, a connection with the subject. Ultimately it's the photographer's responsibility to ensure that the bond is established.

But what about portraits where the shooting time is limited to 10 or 15 minutes? That's rarely enough time to create a bond, and it's barely enough time to make the images. Even in those situations, the photographer's experience and knowledge of the subject — perhaps from previous conversations or research on the person — combines with using the lens like a divining rod to quickly hone in on the essence of the subject.

Overview and Trends

Portraiture is a field that crosses many other areas of photography including weddings, fashion, stock, travel, editorial, photojournalism, sports, and commercial shooting. And within each of the areas, various trends abound and change frequently. For the traditional portrait photographer, styles in studio and location shooting for single, family, executive, and high-school senior portraits also change often, and are influenced by current trends in everything from fashion to music photography.

8.1 Regardless of how reluctant or how playful your subjects are, having fun with them is as important as getting a technically perfect shot. This little girl was throwing rocks into a lake and enjoyed being the center of attention with the camera. Exposure: ISO 100, f/1.2, 1/8000 sec. using an EF 85mm, f/1.2L II USM lens.

If there is a single trend in studio and location portraiture, it's considered a lifestyle approach. Lifestyle shooting differs from environmental photography because it shows subjects in the context of how they think of themselves rather than simply in the context of their environment. Lifestyle portraiture tends to reflect the subjects' interests, their views of themselves, and their values.

More than ever before, the portrait occurs in settings that allow subjects to interact naturally with their surroundings and with each other. In other areas, such as high-school senior portraiture, fashion and music photography, trends have a strong influence. Today's senior portrait is as likely to have subjects half submerged in reflecting pools,

8.2 Lifestyle shooting for model portfolios or for portrait sessions is especially popular with young clients, such as this image with the young woman learning to play pool. Side and top light, plus a silver reflector lit this scene. Exposure: ISO 160, f/2.8, 1/20 sec., -1/3 exposure compensation using an EF 100mm, f/2.8 Macro USM lens.

or feature them skiing, dancing, or playing a musical instrument, as it is to have the traditional studio shot against white seamless or muslin background. In short, many adults and young clients want to mimic what they see in magazines and on music videos in their portrait sessions.

As a result, the photographer who does not reinvent himself or herself runs the risk of losing clients who no longer see themselves in traditional studio shots. The same applies to the selection of products that the photographer offers to clients. Whether the photo package includes DVDs, posters, or more traditional image packages, portrait clients clearly expect more than ever before. Many of the trends described in chapter 10 are also used by portrait photographers to increase the range of products that they offer clients as well as increase sales per session.

In the commercial arena, where editors and creative directors can make or break a photographer's career, clients look for people photography that is not only edgy, but also beautiful imagery, and imagery that is right for the vision of the campaign or the brand. *Photo District News (PDN)* offers a look at recent trends in their "Fashion and Portraiture" issue, where commonly used descriptive words include honest, beautiful, elegant, and classic but contemporary. The prevailing sentiment might be summarized as classically beautiful photography with a fresh and honest style.

Obviously, good photography never goes out of style, but a vision and a unique style go a long way toward getting both assignments and clients regardless of whether you're shooting for private or commercial clients.

8.3 Window light directly in front of the woman illuminated this simple portrait. Exposure: ISO 200, f/4, 1/13 sec. using an EF70-200mm, f/2.8L IS USM lens.

Inspiration and Creative Resources

Here is a selection of associations, photographers, and online courses that you can check out to inspire and enhance your portrait shooting.

✦ **Society of Wedding and Portrait Photographers.** www.swpp.co.uk. A range of educational seminars by inspirational speakers and they provide training and mentoring.

8.4 When I travel, people see my camera and often ask me to take their picture. That was the case with this man at an airport in Oklahoma City. The strong backlight resulted from large windows on the left and right of the camera. I also softened the background in Photoshop during image editing. Exposure: ISO 100, f/4, 1/45 sec. using an EF 24-70mm, f/2.8L USM lens.

✦ **Professional Photographers of America (PPA).** www.ppa.com/i4a/pages/index.cfm?pageid=3. PPA is the world's largest not-for-profit association for professional photographers, with more than 18,000 members in 64 countries. It is an association that seeks to increase its members' business savvy as well as broaden their creative scope. PPA also publishes a magazine that features articles and news for portrait photographers.

✦ **Canon Explorers of Light.** www.usa.canon.com/dlc/controller?act=ArtistsListAct. Includes Rod Evans, Eddie Tapp, Bruce Dorn, Nick Vedros, Jack Reznicki, John Huba, Michele Celentano, Fran Reisner, Paul Aresu, Stephen Eastwood, Joyce Tenneson, Gregory Heisler, Monte Zucker, Harry Benson, Jane Connerziser, Greg Gorman, Clay Blackmore, Michael Grecco, and Melvin Sokolsky, among others.

✦ **BetterPhoto.com.** www.betterphoto.com/home.asp. Offers several online portrait and portrait lighting classes.

Packing Your Gear Bag

If you're shooting in a studio, you'll have the gear you need on hand. Packing gear becomes important for location shooting. If you're shooting locally, you'll obviously have more flexibility to include a larger selection of lenses, strobes, light modifiers, and accessories. If you're traveling by air to a location or studio session, then the selection may be more limited.

Another factor that influences the lens selection is whether you're shooting a large group of people or small groups of two or three subjects. I've found that even with large groups, clients often want shots of smaller groupings such as family members or work groups within an office setting. Additionally, individuals within the group often request single portraits. As a result, I carry a selection of lenses that will also cover these kinds of requests.

Here are some basic recommendations for packing gear for portrait sessions, with an eye on the gear you'll want to have available when shooting a session that is local rather than long distance.

✦ **One or two EOS 5D camera bodies.** The optimal solution is to have two 5D camera bodies, one with a wide-angle lens and one with a medium telephoto lens.

✦ **One or more wide-angle and medium telephoto zoom lenses.** I've found that the 24-70mm, f/2.8L lens and the 70-200mm, f/2.8L IS USM cover most all portrait shooting needs. I'm especially fond of the EF 85mm, f/1.2L II USM lens for portraits not only because it is super-fast glass, but also for the excellent contrast and sharpness it provides.

Tip *A telephoto lens is great to use particularly at the beginning of a portrait session when the subject may be uncomfortable with close shooting distances. With the telephoto lens, you can stay within a distance that allows you to talk with the subject as you shoot, but also far enough away to keep the subject comfortable.*

✦ **Tripod and monopod.** Having a light-weight but sturdy tripod is indispensable. In addition, a versatile ball head with a sturdy quick-release plate increases the steadiness of shooting, particularly with long lenses.

✦ **CF cards sufficient for the duration.** The number of Compact Flash (CF) cards that you carry depends on how many images you typically shoot and the length of

the shooting session. I carry a variety of SanDisk Extreme III cards in sizes ranging from 1GB to 4GB.

✦ **Silver and gold reflectors.** Reflectors of various sizes are indispensable indoors and outdoors for filling shadow areas and adding catchlights to the eyes. Before pulling out a flash for outdoor portraits, I first try to bring up the light on the subject's face with one or more reflectors. Reflectors are easier to manipulate than flash, and they provide just enough light to brighten the subject while retaining the overall natural color of the ambient light in the scene. Reflectors are also indispensable for studio portraiture as well.

✦ **Spare camera batteries.** Even with the good life of the 5D battery, I have one or more charged spare batteries in my gear bag as insurance.

✦ **EX-series flash, light stands, umbrella or lightbox, ST-E2 Speedlite transmitter.** It is certainly possible to create fine portraits with a single flash unit mounted on a flash bracket. However, for more creative control, I've found nothing that is easier to carry and more versatile than one to three EX-series Speedlites mounted on stands with light modifiers such as an umbrella or softbox, and with the ST-E2 transmitter. This lighting setup is completely wireless and the light ratios are easily controlled from the transmitter. All in all, this is a seriously cool portable studio setup.

Cross-Reference *For details on EX-series flash, see Chapter 5.*

8.5 I used an EX 550 Speedlite shooting into a silver umbrella plus tungsten household light for this portrait. I added a strong vignette during image-editing in Photoshop to help eliminate the detail in the background drapes. Exposure: ISO 125, f/2.8, 1/6 sec. using an EF 24-70mm, f/2.8L USM lens.

✦ **A laptop computer or portable storage device.** Backing up images on-site, either to a laptop or a handheld hard drive, is an essential part of the workflow, and if you're traveling for a portrait session, you'll want to backup the shoot on a laptop or portable storage device.

Additional handy items include the following.

✦ **Brush, combs, cosmetic blotters, lip gloss, concealer, safety pins.** Particularly for family shooting, touch-ups of hair between shots are often necessary. Cosmetic blotters come in handy to reduce the shine from facial oil and a neutral-tone lip gloss adds shine to the lips while concealer hides blemishes.

✦ **Plastic painter's cloths.** For outdoor shooting, the large plastic sheets come in handy for a variety of unexpected situations including protecting camera, lighting equipment, and subjects from a rain shower or wet grass, and, in a pinch, several layers of the plastic can serve as a scrim.

✦ **Leatherman tool.** Even for the "unhandy" person, this tool can solve all kinds of unexpected problems, including trimming back foliage in an outdoor setting.

Shooting Portraits

Hundreds of books have been written on photographing people, lighting techniques, and posing. This section of the book isn't intended to summarize all techniques for all situations. Rather it is intended to illustrate what the 5D can do both in the field and in the studio, and to serve as a starting point for photographers who are new to the 5D and/or new to portraiture with the 5D.

Making outdoor portraits

As with any portrait, the first concern is to capture the personality of the subject. And as you get acquainted with the person, you can use and modify the lighting to underscore the subject's personality and spirit.

Unlike in the studio, outdoor lighting presents many challenges, including that you can't just move the sun as you would a strobe head in the studio. Regardless, the lighting must provide beautiful facial illumination and be appropriate for the subject's

face and personality. I can think of few if any subjects who look best in bright, direct, mid-day sunlight with harsh light and dark shad-ows under the eye sockets, nose, and chin. If you have no alternative to shooting during bright sunlight, then find an area where the subject is shaded from the top such as by the roof of a building, an awning, or a tree. These areas soften the light on the face and keep the subject from squinting in the bright light. Then use a reflector to bounce light into the face.

Also, if you're shooting in bright sunlight, you can place the sun to the back of the subject, and then use a silver or white reflector to bounce the light into the subject's face at the angle you want. For softer light in this situa-tion, use a matte white reflector, which soft-ens shadows and reduces contrast. In fact,

you can use two reflectors to mimic studio light patterns.

Perhaps the ideal outdoor portrait light is the light of an overcast day. This light is dif-fused naturally by the clouds to provide a naturally soft light source. While flattering for all types of subjects, overcast light is especially flattering for portraits of senior cit-izens, women, and children. The downside is that you may not get catchlights in the eyes and shadows under the eyes can appear. But a simple silver reflector will both fill shadows and add catchlights to the eyes.

Alternately, open shade produced by large areas of sky on a sunlit day, where the light is obstructed by an object such as a building or a tree, also provides soft light. When

8.6 I waited until late afternoon to make this five-generation portrait. The sun hitting the back of the trees provided nice rim light on the trees, and the subjects, including the 100-year-old woman on the right and the 9-day-old baby in the front, were comfortable in the subdued light. My assistant held a large silver reflector low and in front of the group to fill shadows. Exposure: ISO 200, f/6.7, 1/250 sec. using an EF 24-70mm, f/2.8L USM lens.

using open shade, be sure that the subject facial illumination is from a high-enough angle to provide light to the frontal plane of the face. Then to provide modeling to facial features, you can move the subject as necessary and supplement with a reflector.

If you're new to this type of shooting, a guideline that you can follow is to move the subject or the reflector so that the light angle is slightly above the height of the subject's eyes, approximately 45 degrees above the eyes. Also watch the shadow under the nose. Ideally, you do not want the shadow to touch or cross the subject's upper lip. Particularly for women, a clean lip line is most attractive.

Tip *If you're photographing a subject in open shade with a bright background, be sure to move in close to the subject's face and meter on the face (with the reflector in place), and then use the exposure from this reading to make the image.*

The best times for outdoor portraits are sunrise and the Golden Hour, the hour before sunset. The low angle of the sun strikes the subject's face providing dramatic and warm illumination. Again, you can use reflectors to fill in the shadow side of the face.

Getting the best color

With the subject in a shaded area, the light either is very cool and/or reflects the color of the shading; for example, a slight green hue is reflected from a subject positioned under a tree and standing in grass. While you can color-correct the image during conversion or editing, I prefer to set a Custom White Balance. While this takes a bit of time before shooting, it is worthwhile because I know that I'll shoot a long series of shots in the same light and location before moving on. Alternately, you can shoot a gray card for the first image, and then color correct during RAW image conversion.

Reflective Versus Incident Light Meters

The EOS 5D offers a variety of light metering options including Evaluative and Spot meters, detailed in Chapter 1. Regardless of the metering option you choose, if the meter is reflective, it measures the light reflected by the subject. While reflective light meters are generally accurate, they can cause exposure errors in scenes where glare and extraneous light figure in.

An alternative to the onboard reflective meter is using a handheld incident light meter. An incident meter, which is more precise and accurate than reflective meters, reads the amount of light falling onto the subject. Incident meters have a plastic hemisphere over the light sensor. To use the incident meter, you set the ISO that you're using on the 5D in the meter, and then take the meter reading at the subject's position with the hemisphere pointed toward the light. When you push the metering button, the meter displays a readout showing the exposure settings based on the scene illumination and the ISO.

Many photographers prefer using the handheld incident meter as it's more accurate. Regardless of the type of meter you use, meter readings are a starting point for exposure settings. It's still the photographer's job to evaluate extraneous light and reflective objects that can affect the exposure as well as contrast levels between the subject and the background.

8.7 This family photo session was dominated as much by the antics of the young children as by the adults. The great-grandmother took it all in stride as she cared for the newest member of the family. Exposure: ISO 125, f/3.5, 1/45 sec. using an EF 24-70mm, f/2.8L USM lens.

Use C mode

To make the 5D work for you, set up the C mode in advance with your anticipated settings, or arrive early and evaluate the scene, and then set up C mode. For example, I typically set up Spot metering, Av shooting mode, Continuous drive mode, and set the Picture Style to my own custom style based on the Neutral style. I then set the ISO based on the available light.

8.8 Overcast light was a subtle complement to the affection between this brother and sister who were each seated in a prized antique chair. Exposure: ISO 125, f/3.5, 1/45 sec. using an EF 24-70mm, f/2.8L USM lens.

This is also a good time to run through the Custom Functions to reset any that do not apply to the current session and set functions that you want to use for this session.

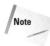

Note *Be sure that you fully test Custom Functions before a photo session begins to ensure that there are no conflicts in the camera, and that you're familiar with any button functionality changes resulting from a change to Custom Functions.*

Making indoor portraits

Indoor portrait light runs the gamut from household light of all types to window light and electronic flash. Of all the options for lighting indoor portraits, the most beautiful illumination is window light because it tends to be soft and yet directional, and you can control it using reflectors, scrims, and/or electronic flash. While window light is the best, the range of indoor ambient light can vary from a windowless conference room to stage lighting. While the range of all lighting is too extensive for me to discuss in detail here, I'll look at shooting with the 5D in some common ambient light scenarios.

Window light

While window light is the most beautiful of ambient indoor light, it is directional, which means that you'll want to fill shadows using either reflectors or fill flash. I prefer using reflectors because they retain the natural color and quality of the light. If the light is cool, using a gold reflector can warm up the scene, but in most cases, I use either a silver or white reflector.

One of the advantages of window light is that you can decrease the light by moving the subject farther from the window. If the window is relatively far from the wall that is behind the subject, separation between the subject and the background can fall off to the point that the subject appears to merge with the background. To prevent this, you can set up a portable background. I have a white sectional room divider that I use most often as an impromptu background. But seamless paper on background stands works well, too.

To get the facial modeling you want with the window light, you can move the subject, the camera, the reflector, and the background relative to the window. Typically having the subject at a 45-degree angle to the window is a good starting place. Then you can use the reflector on the shadow side of the subject to bounce light into the shadows.

To meter window light, it's important to expose for the skin, and, in particular, to meter for facial highlights, which are the areas of critical exposure. While Evaluative metering will give a generally good exposure, you can get a more precise reading using the 5D's Spot meter. Just come in close to the subject and meter the highlight area. Then you can use either AE Lock or switch to Manual mode to use the resulting exposure settings. It's also a good idea to meter the shadow side of the face so you know the difference in f-stops between the highlights and the shadows. If the difference is too high, the image will render the shadow side as very dark. You can move the subject farther from the window to decrease the difference between the shadow and highlight meter readings. Of course, the contrast also depends on the subject. High contrast between the highlight and shadow side of the face works well for portraits of men, but it is not as flattering for portraits of women and children.

8.9 Lovely late-afternoon window light provided the illumination for this informal portrait of the grandmother of a bride. Exposure: ISO 320, f/2.8, 1/60 sec. using an EF 70-200mm, f/2.8L IS USM lens.

Another option for bright window light is to lessen the intensity by covering the window with a translucent material such as tracing paper or a light-weight fabric such as a bed sheet or a sheer curtain.

8.10 Strong window light and a silver reflector to camera right provided light modeling on Chelsie's face in this portrait. Exposure: ISO 160, f/2.8, 1/25 sec. using an EF 100mm, f/2.8 Macro USM lens.

Ambient interior and mixed light

Many of the principles of using window light apply when shooting with main light sources such as a tungsten lamp that is placed to one side of the subject. In overhead lighted rooms such as conference rooms, the challenges are similar to working with direct overhead sunlight that creates shadows under the eye sockets, nose, and chin. In these situations, using either reflectors or electronic fill or bounce flash comes in handy to reduce the shadows and bring up the facial brightness. If you have only a reflector, ask the subject to hold a reflector at waist level and angled so that it reduces facial shadows.

8.11 A mix of fluorescent and window light illuminated this portrait. I didn't have time to set a Custom white balance, and color correction was a challenge. More work could be done to neutralize the color cast on the woman's hair. Exposure: ISO 320, f/2.8, 1/60 sec., using an EF 70-200mm, f/2.8L IS USM lens.

Particularly with tungsten household light, setting a Custom white balance produces the best color. The Tungsten white balance setting has an excessively yellow cast. Certainly one option is to use White-Balance Correction (detailed in Chapter 3) the same way that you would use a color correction filter in traditional film photography. But unless you shoot in the same tungsten light on a regular basis, it is easier to set a Custom white balance. Likewise with fluorescent light, there are so many different types of fluorescent light, that it's hard to make a specific recommendation other than setting a Custom white balance.

And in mixed light scenes, a Custom white balance avoids time spent color correcting images on the computer. You can opt to set the white balance for the strongest light source, but there will be evidence of the other light sources as color casts in the image, making color correction a potential nightmare provided that you want a neutral image.

8.12 Window light to the right of the subject, an EX 550 Speedlite shooting into a silver umbrella, and a silver reflector to camera right illuminated this environmental portrait. A second EX Speedlite should have been set up in the background to provide separation of the subject from the background. Exposure: ISO 200, f/2.8, 1/15 sec. using an EF 24-70mm, f/2.8L USM lens.

Studio lighting

Whether you have only one or multiple studio lights, and whether the system is studio flash or continuous HMI lighting, studio lighting gives you a great deal of control over portrait lighting. And when combined with modifiers such as umbrellas, softboxes, barn doors, snoots, beauty dishes, flags, and reflectors, studio lighting can enable you to produce a range of lighting effects.

Without going into the advantages and disadvantages of each type of lighting system, I'll take a brief look at controlling light with an eye toward those of you who are just getting into studio portraiture.

Just as you can create a variety of lighting effects with a single light source, the sun, you can do the same with a single studio light, but with the huge advantage of being able to move and place the light, plus you can control and count on constant intensity

making exposure control much easier. Also much the same amount of control applies if you're using an EX-Speedlite system. As I discuss in Chapter 5, with the addition of light stands, umbrellas, and softboxes, and the ST-E2 Speedlite Transmitter, you can use one or more Speedlites in the same way as a studio lighting system.

Regardless of the studio setup, the 5D performs like a champ in the studio. With large studio systems, use the PC sync terminal and sync at 1/125 second or slower. It's a good idea to test the sync speed with the system first, but I've had no problem using 1/125 second with my 4-strobe Photoflex system.

It takes only one or two studio sessions to determine the light temperature. If the lighting system doesn't specify the light temperature, then it's easy to shoot some RAW images, and then use the White Balance tool in Adobe Camera Raw to determine

Basic One-Light Setup

The main light provides the modeling on the subject's face and form. You can combine key light with an umbrella (silver, gold, or shoot-through) or softbox. Then place the light at a 45-degree angle to the right of the camera with the light pointed slightly down so that it creates a shadow between the end of the nose and the lip. Place a large silver reflector to the left of the camera to soften the shadow created by the key light. Adjust the placement of the key light, watching how the shadow changes as you adjust it.

For classic loop lighting, the key light should be placed so that it throws a nose shadow that follows the lower curve of the cheek on the opposite side of the light. The shadow from the key light should cover the unlit side of the nose without the shadow extending onto the subject's cheek. You can adjust the height of the key light to change the curve under the cheekbone. Also be sure that the areas under the eyebrows and the top of the eyelids are well lit. Then you can adjust the reflector position to soften the shadow.

While this book cannot cover the variety of lighting styles, a plethora of fine books are available to teach you classic and creative lighting styles and ratios. And as you increase the number of lights, you have even more creative options to light the background separately, add hair lights, and control the overall light ratios precisely.

8.13 With elderly subjects, particularly those who are battling diseases such as Alzheimer's, it's important to keep the portrait sessions short and to the point. This portrait of my mother on her eightieth birthday is one that I treasure most. Exposure: ISO 100, f/5.6, 1/125 sec. using three Photogenic strobes, two to light the background, one to camera right with a gold reflector to camera left. I added blur selectively during image editing.

what the neutral temperature is for the system. Then you can use the K white balance setting to dial in the specific temperature for studio shooting. In some cases, the Flash white balance setting provides relatively neutral renderings, but it really depends on the light system.

Also you can set up the shooting mode, sync speed, and white balance, and then register them as the C mode settings. This is a good idea if you do a lot of studio work as it provides an instant setup for the most common settings.

A Compendium of Practical Advice

Here are some of the techniques that I find most useful in shooting portrait images:

✦ **Focus on the eyes.** The eyes are the windows to the soul, and they are also the most dramatic feature in portraits. The goal is to capture the vibrancy and spirit of the person. Composition, using the *golden mean*, provides the starting point for composition. (In simple terms, the golden mean divides the 35mm frame so that it looks like a tic-tac-toe board.) Placing the subject's eyes at any of the four points of intersection provides strong visual impact. And, of course, the point of sharpest focus in the image must be on the subject's eyes.

✦ **Maintain proportions for kid shots.** Keeping a sense of scale helps keep children from appearing to be too large in the frame. Plan the background and props in pictures of children so that they provide a frame of reference for spatial relationships.

✦ **Pose groups of people as you'd arrange flowers.** In this easy-to-remember analogy, you begin by placing the first person, then the next with an eye toward creating a pleasing blend of shapes and sizes within the frame. Create a natural flow from person to person in the group as if the viewer is following a visual map. Use hands and arms to connect subjects and use classic shapes such as the S curve and triangle. Shoot at the smallest aperture possible to ensure extensive depth of field so that the faces have equal sharpness. Also try to keep the subjects close to the same plane perpendicular to the lens axis to maintain sharpness.

✦ **Minimize signs of aging.** To de-emphasize the wrinkles and loose skin of older male subjects, have them stand and place one foot on a chair or stool. Then have the subject lean toward you by extending his neck to stretch the skin and smooth the jaw line.

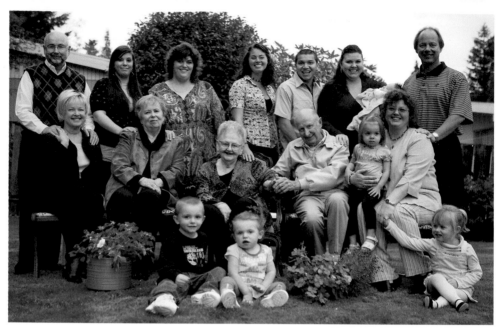

8.14 To arrange this large family portrait, I began with the 90-year-old birthday grandmother and her brother, then arranged other family members around them, and then placed the children last. Right after this image was made, the children ran off to play. Minutes later, I heard them screaming behind me. Angry wasps were attacking with a vengeance. It was a shooting session none of us will ever forget. Now I carry bug spray in my gear bag when I shoot outdoor family portraits. Exposure: ISO 125, f/3.5, 1/60 sec. using and EF 24-70mm, f/2.8L USM lens.

✦ **Use contrast for composition strength.** The viewer's eye is drawn to contrast — a light subject against a dark field and vice versa. In addition, the sense of sharpness of a photograph is increased by the skillful use of contrast. In short, put the subject against a complementary background tone.

✦ **Engage with the subject(s).** A primary means of human communication is with the eyes. If you're buried behind the camera, you lose connection with the subject. I get the shot set up, then I step from behind the camera to show the subject what I have in mind or just to chat a bit to help the subject become more comfortable. Then I go back to the camera to focus as we continue to chat.

✦ **Remember kids rule.** The wise photographer works with the mood, energy, and flow of young subjects rather than against them. One toddler came close to tearing down light stands, backgrounds, and props in my studio. By the middle of the session, lights were askew at every angle. I shot with whatever light I could get as the boy raced through the set. I held my breath and kept shooting. The exercise paid off with images that showed a wonderful twinkle in the child's eyes.

✦ **Work with the art director.** In the best of assignments, working with the art director, make-up artist, and stylist is a collaborative project. But in situations where the art director wants compositions and setups that do not work visually, my philosophy is to shoot the images as the art director wants, and then show her or him the images on the LCD or computer and discuss aspects that might work better visually.

✦ **Set the mood.** The ambience and hospitality that your studio offers is directly reflected in the images. Having refreshments, comfortable seating, and music sets the energy and mood of the shoot, so paying attention to these details pays big dividends.

✦ **In group shots, position the children last.** Kids are much less patient if they have to wait for you to complete the arrangement of people in groups — especially large family groups. I typically put the children in front on stools or on the ground where they can feel more comfortable.

✦ **Show instead of telling.** Instead of describing what you want the subject to do, move to the subject position and assume the pose or position that you want them to mimic. Portraits are a two-way street, so as you demonstrate, talk about your goals and ask for the subject's ideas as well.

Paul Aresu Talks about Portrait Photography

In portraiture, creative vision sets the energy, the style, and the mood of each session. For commercial photographer and Canon Explorer of Light, Paul Aresu, portraiture comprises much of his personal work, and he sees it as a unique opportunity.

In an interview, Aresu said, "I love to shoot portraits, to get inside people's lives. I am like an interviewer — I love talking to people about their lives. Photography is to me is like a license to get into people's lives. I have a driver's license into peoples' personal lives. And it has allowed me to meet the most interesting sports celebrities, actors, all kinds of writers and artists. So photography has brought me to a point I couldn't get to in ordinary life."

Whether he's shooting portraits or commercial assignment, Aresu constantly reinvents his photography — something that he sees as a necessary component to staying at the top of the field. "It's your imagination. If you have a really good imagination, you'll never be stagnant. It seems like my imagination is still working for me, and as long as that's still going, I'm going to continue to create good pictures."

Stock and Editorial Photography

CHAPTER

9

In This Chapter

Overview and trends

Inspiration and creative resources

Packing your gear bag

Shooting stock and editorial images

A compendium of practical advice

Nowadays, the line separating stock and editorial photography is blurring as stock agencies initiate news- and feature-related photography assignments, and as editorial photographers market outtakes to stock houses.

Regardless of where the image originates — shooting for stock or shooting on editorial assignment — the shooting techniques and subjects are often similar, and both areas represent a continuing source of income for photographers. Of all the areas into which photographers migrate, stock and editorial assignment shooting are perhaps the areas where change is the norm, and are the subject of heated debate. Changes in the stock industry during the past five years — everything from on-demand assignment shooting to "dollar," or micro stock — has put new perspectives on rights management and income expectations. Editorial shooting, like stock, is ever changing, but it remains a solid starting point for photographers. Editorial photography, in particular, offers an opportunity for creative storytelling that is unique among the specialty areas.

Overview and Trends

For stock photographers, change is the name of the game, both in terms of image content and in modifications to strategies for dealing with stock houses. In past years, the shift in content has gone from nature, landscape, and still-life shooting to lifestyle images. Predictably, the focus further subdivided into the current demand for ethnic diversity lifestyle images. Today, stock agencies look for an innovative conceptual approach with strong appeal across markets. Many of the best-selling images embody traditional concepts such as love,

9.1 Photographing editorial assignments can present lighting challenges. In this venue, the stage lighting was relatively low, so I took advantage of the 5D's excellent low-noise performance and set the ISO to 1600. There can be a sacrifice in color fidelity at high ISO settings, but the 8x10-inch print from this image was excellent. Exposure: ISO 1600, f/4, 1/30 sec. using an EF 24-105mm, f/4L IS USM lens.

as well as contemporary topics including health, the environment, pop culture, technology trends, exclusive locations, celebrities, and weather events. But the trends change frequently, and it pays to look at the latest offerings by major stock agencies including Getty Images (www.gettyimages. com), Corbis (www.Corbis.com), Alamy (www.alamy.com), and others.

Niche content can also set photographers apart from the ever-growing crowd of established and hopeful stock photographers. Jim Reed's weather photography (www.jim reedphoto.com) is a great example of successful niche content. Reed is an expert in

severe weather photography and has spent years honing the art of storm chasing and storm shooting. Reed's work has grown from modest beginnings and is now featured in major stock collections and on television programs as well as his newest book. Other niche areas include underwater, aviation, and ethnic diversity.

For photographers looking to break into magazine and publication shooting, the trend is toward not only print usage, but also online use and use with multimedia elements. In the print arena, local and regional magazines offer a fast-growing segment of opportunity for photographers, although the

9.2 Photographing local events such as this flood in western Washington state provides both the opportunity for stock sales and an entrée into publication shooting. This image was used on a local television station's Web site as part of a slide show showing the effect of the flooding. Exposure: ISO 100, f/2.8, 11/180sec. using an EF 70-200mm, f/2.8L IS USM lens.

rates remain relatively low compared to national publication rates. On the other hand, local and regional editorial photography allows creative freedom, helps photographers build their portfolios, and provides exposure. For photographers looking to move into editorial shooting, local and regional publications are a good first step.

As revenues for online versions of news and general interest Web sites grow, photographers are increasingly being asked to expand their skills so that they can create multimedia Web stories that feature still images as well as video and audio content. To remain competitive, photographers are brushing up on multimedia tools including Soundslides and Apple's Final Cut Pro video editing program.

A common element of both stock and editorial shooting is the assignment aspect. Stock agencies send photographers on assignment with the same goals editors have when they send photographers out on assignment. The common denominator is the photographer's ability to tell a good story.

Inspiration and Creative Resources

A wealth of resources for stock and editorial photographers is available, including books, workshops, Web sites, and photography associations. Following are selected resources from among hundreds.

✦ **American Society of Media Photographers,** www.asmp.org. One of the premier photographic associations, membership in ASMP offers education, business resources, online forums, local chapters, legal resources, and publications.

✦ **American Society of Picture Professionals,** www.aspp.com. A nonprofit community of image experts committed to sharing experience and knowledge throughout the industry.

✦ **Creative Eye,** http://creativeeye coop.com/pages/overview.html. A worldwide cooperative of photographers and illustrators dedicated to addressing such concerns as market standards, licensing methods, rights protection, and licensing fees for the reuse of their images.

✦ **The Digital Journalist,** www. digitaljournalist.org. Photojournalist Dirck Halstead's online publication covering news, trends, and commentary on photojournalism and editorial photography as well as technical tips.

✦ **Editorial Photographers (EP),** www.editorialphoto.com. An organization whose goal is the education of both photographers and photo

9.3 Simple concepts with clean treatments, as shown with this alarm clock, are also good stock entries. This image is cropped, but the original image has space at the top and sides to allow room for text and graphics. Exposure: ISO 100, f/16, 1/125 sec. using an EF 24-70mm, f/2.8L USM lens.

editors in the editorial marketplace. The EP board members often serve as liaisons between the various trade organizations and working groups, and they act as point people when issues critical to photographers arise.

✦ **National Press Photographers Association,** www.nppa.org. Dedicated to the advancement of photojournalism — its creation, editing, and distribution in all news media — and offers education and a community for photographers.

✦ **Stock Artists Alliance,** www.stock artistsalliance.org. Offers photographer directories, discounts on professional services, advocacy for stock photographers, and news and articles pertaining to the stock industry.

✦ **Stock Photo Price Calculator,** http://photographersindex.com/ stockprice.htm. Offers a handy way to estimate stock photo use pricing.

✦ **US Copyright Office,** www.copy right.gov. Offers forms, instructions, questions and answers on copyright applications, and news bulletins about registering copyrights in the United States.

Packing Your Gear Bag

What you pack in your gear bag will doubtless reflect the specific nature of the stock shoot or editorial assignment. Particularly for editorial shooting outdoors, it's important to have protection for the camera in inclement weather. The 5D doesn't have extensive weather sealing, and moisture is always one of the worst enemies of cameras. Storm Jacket (www.stormjacket.com) offers a variety of weatherproof sleeves for camera and lenses.

9.4 A detail image like this one shows the effect of weather and storms and puts the event in perspective. Exposure: ISO 100, f/4, 1/45 sec. using an EF 24-70mm, f/2.8L USM lens.

Here are basic recommendations for packing gear for stock and editorial shooting:

✦ **One or two EOS 5D camera bodies.** The optimal solution is to have two 5D camera bodies, each with a lens mounted that suits the assignment or stock shoot. Particularly with assignment shooting, often you get no second chance to capture the moment, so having a backup camera that is ready to shoot is critical if you want to ensure continuous shooting.

✦ **One or more wide-angle and telephoto zoom lenses.** My standard lenses are the EF 24-70mm, f/2.8L lens, and the EF 70-200mm, f/2.8L IS USM. I also carry the Extender EF1.4× II and Extender EF 2× II to increase the focal length. Depending on the assignment or stock subject, having a very fast lens is also invaluable. Good fast-lens candidates include the EF 50mm, f/1.4 USM, and the EF 85mm, f/1.2L II USM.

✦ **Tripod and monopod.** Having a lightweight but sturdy tripod is essential. In addition, a versatile ball head with a sturdy quick-release plate increases the steadiness of shooting, particularly with long lenses.

✦ **CompactFlash (CF) cards sufficient for the duration.** The number of CF cards that you carry depends on how many images you typically shoot and the length of the shooting session. I carry a variety of SanDisk Extreme III cards in sizes ranging from 1GB to 4GB.

✦ **Silver and gold reflectors.** Without question, reflectors of various sizes come in handy for filling shadow areas and adding catchlights to the eyes when shooting individual participant portraits is part of the session.

✦ **Spare camera batteries.** Even with the good life of the 5D battery, I have one or more charged spare batteries in my gear bag as insurance.

✦ **A laptop computer or portable storage device.** Backing up images on site either to a laptop or a handheld hard drive is an essential part of the workflow, and if you're traveling for an extended assignment, you'll want to backup the shoot on a laptop or portable storage device.

✦ **EX-series flash, light stands, an umbrella or lightbox, a ST-E2 Speedlite transmitter.** If shooting portraits is part of the assignment or stock session, I've found that one to three EX-series Speedlites mounted on stands with light modifiers such as an umbrella or a softbox with the ST-E2 transmitter are amazingly portable and offer excellent results. This lighting setup is completely wireless and the light ratios are easily controlled from the transmitter. For details on EX-series flash, see Chapter 5.

Additional handy items include the following:

✦ **Portable background and stands.** Whether it's a roll of white seamless paper or a painted board, having a clean background that's easy to assemble and tear down for portraits is exceptionally handy.

✦ **Plastic painter's cloths.** For outdoor shooting, these large plastic sheets come in handy for a variety of unexpected situations, including providing protection from a rain shower or wet grass, protecting camera and lighting equipment, or serving as a scrim for portraits.

✦ **Leatherman tool.** Even for the "unhandy" person, this tool can solve all kinds of unexpected problems, including trimming back foliage in an outdoor setting.

Shooting Stock and Editorial Images

The EOS 5D is an exceptionally versatile camera, particularly because you can shoot at high ISO settings in low-light scenes and get excellent results. That fact alone extends the range of the camera to virtually any shooting assignment except perhaps sports, where the camera is not as speedy as other models.

C mode on the 5D is exceptionally handy because it allows you to set the camera in advance for the shooting mode, exposure settings, drive mode, and so on that you anticipate that you'll need. Plus, once you begin shooting the session, you can tweak settings on the fly. After you make a quick assessment of the lighting for the session, you can determine what ISO to set, and set a custom white balance provided that the light remains constant over a series of shots, or use a preset white balance. Again, the custom white balance costs a few minutes to set up, but it saves a lot of time during image processing.

9.5 An image similar to this one sold as stock for a greeting card company. Exposure: ISO 100, f/2.8, 1/4 sec. using an EF 24-70mm, f/2.8L USM lens.

RAW capture mode is my preference although JPEG or RAW + JPEG may be more suitable if you need to show the editor images from the assignments immediately. It's really important to have a good workflow set up in advance for editorial shooting. Arrange with the editor in advance how and when you'll show proofs from the shoot. If you're shooting RAW+JPEG, it's easy to upload the images from the shoot to your Web site for the client to pick images for processing. Then you can process the RAW images that the editor selects from the proofs for final delivery.

Whether for stock or on editorial assignment, shoot with an eye to tell the story, and the entire story. Very often detail shots hone in on aspects of the story where wider shots cannot convey the intimate details that evoke emotion and resonate with the editor and viewer. For this reason, I also carry an EF 180mm, f/3.5L Macro USM or an EF 100mm, f/2.8 Macro USM lens specifically to capture detail shots.

If you're new to stock and editorial shooting, consider shooting local events that have a news edge. Photographing floods, tornado

9.6 Images that illustrate concepts such as the contemplation of a child shown in this image do not require model releases, and are generic enough that stock buyers from a variety of markets can use them. Exposure: ISO 100, f/1.2, 1/8000 sec. using an EF 85mm, f/1.2L II USM lens.

Lauren Greenfield Talks about Editorial Shooting

Lauren Greenfield, www.laurengreenfield.com, acclaimed editorial photographer and Canon Explorer of Light, is on the top call list of several publications, including the *New Yorker, Elle, Harper's Time, Life,* and *National Geographic.* She believes that strong editorial shooting is the key to success. "In photography, your work is your ticket. There are enough opportunities in this industry that if you have strong work, you can get it seen by picture editors from magazines, or you can get a book published. If you have strong work, if you have a strong photo essay, you can get it published."

"The most important thing for young photographers is to do personal projects," Greenfield said. 'No matter what your work is or what you do to make money—always have a personal project because that's how you find your own voice, and that's how you show other people your voice and what your mission is. And ultimately, that's how you're going to do the work that's most meaningful and that's going to be the strongest."

damage, rallies, and the like can often lead to selling images to local newspapers and television channels that use still images from areas where they did not have a news crew in place.

Without question, whether using editorial or stock, editors look for clean, well-composed images with a strong story-telling component.

A Compendium of Practical Advice

Here are some of the techniques that I find most useful in shooting event images.

✦ **Leave space for text.** For both stock and editorial assignments, leave space at the top and to one side so that editors who use the image can place text and logos. And given that magazines are vertical, a good assortment of vertical shots increases the usability of images in magazines as covers and full-page images.

✦ **Ensure that you're in sync with the editor.** While there is a good deal of creative freedom given to assignment photographers, you still have to have clear expectations that are outlined and agreed upon before the shooting begins. If you haven't worked with the editor before, ask lots of questions, ensure that you understand the editor's expectations and needs, and deliver the images on time.

9.7 Concepts such as spirituality, religion, and church are keywords that can be used with this image for stock use. Exposure: ISO 100, f/19, 1/250 sec., -0.5 exposure compensation to retain detail in the highlights of the clouds. I used an EF 70-200mm, f/2.8L IS USM lens for this shot.

✦ **Have backup gear.** To best illustrate this advice, I recall the story of a top editorial and fashion photographer who went to a remote desert location to shoot an editorial assignment. He brought multiple trunks of gear including backup camera bodies, multiple and duplicate lenses, fans, flash gear, and more. However, after the first few days of shooting, the sand took a toll on the cameras, and they failed one after another. With cameras falling like flies, the photographer resorted to completing the shoot with a 35mm film camera that he borrowed from one of his production assistants. The moral to the story is that you can't predict the unpredictable, and it pays to have backup.

✦ **Get model releases.** Discuss model releases with the editor for assignments before the shoot. You may also need property releases. If children are in the images, get parent or guardian signatures. It also is important to track how images of children are used in stock sales. If the usage is sensitive, then a special release is required if the parent or guardian agrees.

9.8 Generic shots like this one of a garlic with individual cloves can have a broad appeal for stock. Exposure: ISO 100, f/22, 1/180 sec. using an EF 24-70mm, f/2.8L USM lens.

✦ **Know the 5D.** Before you begin shooting at high ISO settings, take test shots and print the images at the sizes that the client might request or print them at in the publication. Evaluate the prints for digital noise and grain levels that become evident at large print sizes. By doing this, you have a yardstick for the highest ISO settings that you can use on the 5D and still get good reproduction.

✦ **Know the current rates.** Negotiation is the name of the game to be competitive in editorial and stock shooting, and the game rules change often. Stay current with the going day rates for both national and regional publications, and negotiate use of images on the publication's online Web site. Various photo associations such as those listed earlier in this chapter provide members with current day-rate information and pricing calculators for stock and online usage.

9.9 I've learned that in stock shooting, humor sells. I take advantage of my miniature Schnauzer's amazing patience to create unusual pet shots such as this. Exposure: ISO 100, f/10, 1/125 sec. using an EF 24-70mm, f/2.8L USM lens.

Wedding Photography

Wedding photography is one of the most demanding and rewarding fields that a photographer can choose. The work is multifaceted, technically and creatively challenging, and extends well beyond the wedding day to deliver proof books, prints, online and DVD slideshows and albums, and books for the newlyweds.

The work of wedding photography begins well in advance of the vows as the photographer gets acquainted with the couple to learn about the wedding location, guests, and the couple's expectations. But doubtless, the day of the wedding is the high point for the couple and the photographer.

For the wedding photographer, the day's work includes directing a cast of disparate people, cajoling and smoothing ruffled feelings, providing safety pins on cue, searching diligently for faint glimmers of lights in an otherwise romantically dark chapel, and, of course, making stunning and stylistic artful images that the family will enjoy for decades to come.

For anyone who shoots weddings on a regular basis, it's hardly a piece of cake, but they also know that part of the work is to make the work and the images look easy and effortless.

In This Chapter

Overview and trends

Inspiration and creative resources

Packing your gear bag

Shooting weddings

A compendium of practical advice

Overview and Trends

Since the early 1990s, when wedding photography was considered the lowliest of photography specialty areas, wedding photography rose to respectability on the shoulders of a handful of top-notch photographers who envisioned wedding photography as more than a series of formulaic poses. They saw the wedding day as an opportunity for visual story-telling

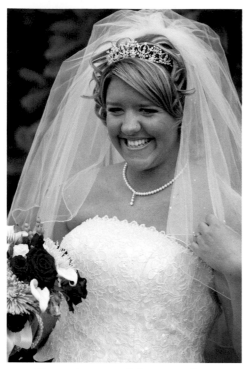

10.1 The excitement of the upcoming ceremony shows in the face of this bride. Exposure: ISO 320, f/4.5, 1/500 sec. using an EF 70-200mm, f/2.8L IS USM lens.

Artistic vision is a primary part of the equation of successful wedding photography, but current trends also play a large part in success as well as effective marketing.

Reading bridal magazines is an essential step in staying current with what brides expect from wedding photographers. Magazines feature the latest and most chic of wedding styles and trends, and they set, in large part, the expectation of brides for the look of not only the wedding, but also for the photography. Certainly the photographer has plenty of room to inject personal vision and style, but it pays to realize that brides are influenced by what they see in magazines and consider the current trends.

For anyone who follows trends closely, the most obvious recent shift is from a photojournalism style of covering the wedding to shooting that includes a mix of editorial, travel, glamour, portraiture, and fashion styles. Some brides, for example, contract for a boudoir photo session in advance of the wedding day and give the images to the groom as a gift. And just as high-school seniors expect exotic venues and a fashion look for their graduation pictures, brides also expect the edgy, contemporary look of fashion photography for their wedding images. Perhaps now, more than ever, photographers who have a varied background in many artistic disciplines are best prepared to compete successfully in a market that is filled to the brim with photographers.

in the highest sense. Soon they were joined by notable photojournalists who left the news ranks to apply their classic visual storytelling skills to weddings of friends and family. These pioneers blazed the trail for making photojournalism the style du jour for most of the 1990s and early 2000s.

It takes more than a camera and a declaration of intent to deliver professional-quality wedding images. Now, as always, there is a demand for quality and artful images that come only with vision, expertise, and experience. The goal of making images that stand the test of time as classic, artful photography is the unchanging objective.

Certainly not all photographers follow the current trends, opting instead for a distinctive fine-art or reportage look. So at the end of the day, your past work builds the bridge to your future assignments regardless of whether you've been published in national magazines.

10.2 Preceremony times with parents provide ample opportunities for intimate images such as this image of the bride with her father's arm in hers and her mother's hand on the bride's arm. Exposure: ISO 320, f/45, 1/1000 sec. using an EF 70-200mm, f/2.8L IS USM lens.

10.3 This is one of my favorite wedding images, and it doubtless has something to do with the fact that this groomsman is my grandson, Dalton. The twinkle in his eye is priceless. This image was also a favorite of the bride and groom. Exposure: ISO 250, f/2.8, 1/250 sec. using an EF 70-200mm, f/2.8L IS USM lens.

Another vital aspect of marketing centers in the package of services and deliverables that photographers offer clients. The gamut of services range from handing the client an "image dump" of hundreds if not thousands of wedding images unceremoniously piled onto DVDs, to hand-bound wedding books, multimedia photo stories, and iPod-downloadable images.

It is important to understand the expectations that couples have in a digital age. Many couples want and expect to receive a DVD of all images shot during the wedding festivities. Some couples, in an effort to keep costs down, request receiving only a DVD of images. While the couple may want all of the images, in my experience, few couples have the expertise, patience, or time to create a meaningful and lasting album or book from a plethora of digital images. As a result, like the proverbial shoebox, wedding images remain on DVDs in no meaningful order, much less in an attractive presentation. Few clients know how to professionally edit, size, and sharpen images for printing, and they seldom know what to look for in a good print. Regardless how computer literate the couple happens to be, I discourage clients from requesting the DVD image-dump option because it does not honor the day or the couple and their family and friends.

The advent of digital offers new opportunities for creatively presenting and distributing wedding images, and, of course, for additional studio profits. We live in a wired, instant-gratification, multimedia world and that is no less true for brides and grooms. They often expect to have on-site computerized slideshows that showcase wedding images taken only minutes before. Some couples may also want prints to hand out to guests at the reception. Photographers competing for clients see these services as a way to distinguish their work and bring value to the wedding that other photographers don't bring.

To address the need for almost instant image viewing and delivery in one form or another, many photographers take advantage of RAW + JPEG shooting, using the JPEG images as pre-edited versions that combine quickly for a live slide show or for small reception "favor" prints. Then the RAW images are converted and edited to create an image-plus-music slideshow hosted on the photographer's Web site. Many couples appreciate this type of quick turnaround, and it helps alleviate the anxious waiting for the final wedding proof images to be delivered.

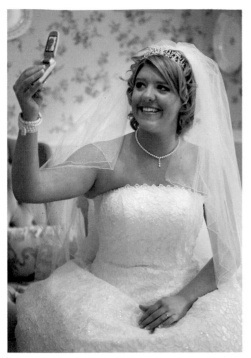

10.4 I found this bride filling time before the ceremony by snapping pictures of herself on her cell phone and sending them to friends across the street who were waiting for the ceremony to begin. Exposure: ISO 320, f/2.8, 1/45 sec. using an EF 70-200mm, f/2.8L IS USM lens.

Inspiration and Creative Resources

While producing image-sound-interview multimedia shows may not be your forte, several programs, some produced by photographers, can make the job easier. It also pays to think through the sequence of the slideshow ahead of time, and having a template speeds up on-site production.

Slideshows and DVDs

✦ **Showit Web,** www.showitfast.com. This Flash-based program, along with a suite of image effects, royalty-free music, and photo borders, was created by David Jay. You can choose between a light and full version of Showit Web, and the site also includes instructions for using the product. The product allows you to select the images for the slideshow, order and time the images, and add a music soundtrack, and then upload it to the Web.

✦ **Soundslides,** www.soundslides .com. Bills itself as a rapid production tool for still and audio Web presentations. Created by photojournalist Joe Weiss, the program works on the basis of creating a project, where you can add images, use a template, time each image, and include captions, transitions, and thumbnails.

✦ **FotoMagico,** www.boinx.com/ fotomagico/overview. From Boinx Software, this was developed by Peter Baumgartner, a computer engineer and passionate photographer, to make digital slideshows that you can use online and burn to DVD provided that you are a Mac user. You can drag images into FotoMagico's storyboard to order and reorder them. You can then add transitions from the Transition menu and drag songs from your iTunes library below the image that you want to sync to in the storyboard. The product integrates iPhoto and Aperture Library. An Express and Pro version are available.

✦ **The Slideshow Company,** www. theslideshowcompany.net. Produces one-of-a-kind photo slideshows with original music composition from their music library and Hollywood-type cinematics. Each DVD show includes a Web version to share with clients and prospects.

✦ **iDVD,** www.apple.com/ilife/idvd. From Apple, this allows you to use predesigned animated themes for DVD shows that may include video with still images in 16:9 and 4:3 formats with encoding and quality choices.

For those on a limited budget, you can get into the Web slideshow and multimedia wedding foray with products such as Google's Picasa (http://picasa.google.com/index.html), which offers slideshow production with the option to burn it to DVD and post it on the Web. Another shareware click-through program is JAlbum (http://jalbum.net), a downloadable program that offers easy-to-use drag-and-drop Web album creation with several different skins.

But the range of service doesn't end with online images. Photographers can now more easily create customized albums and bound photo books as well as the traditional enlargements.

Printed and bound albums

In addition to the traditional wedding album options, the option to have a bound printed album appeals to many photographers and couples alike. Virtually all of the major online photo labs, from Kodak and Apple iPhoto to MyPublisher and Shutterfly, offer printed books. But if you're looking for a product with a definite edge of quality, try a company like AsukaBook (www.asukabook.com), which offers a variety of hardcover printed wedding albums in a range of sizes and finishes. The process is you create the pages in Photoshop using the company's blank template, then create a PDF file, and then upload the file for printing.

Packing Your Gear Bag

If there is a single rule for wedding photographers concerning equipment, it's to have backup for everything—and that means backup camera bodies, tripods, tripod heads, lenses, batteries, and CompactFlash (CF) cards. In a sentence: Hope for the best, and plan for the worst. There are no second chances to capture defining wedding moments as they happen.

Among wedding photographers, stories abound of cameras that suddenly freeze up or refuse to focus, of broken tripods and ball heads, and of lenses and flash units that misbehave just as the couple walks down the aisle. Regardless of how well your gear has performed in the past, there is a first time for everything, and you want to be able to quickly grab another piece of gear to keep shooting without missing a beat.

For photographers who are just breaking into wedding photography, the cost of having duplicate camera bodies and lenses can be prohibitive. A good option is to rent gear for the wedding. This option has the added benefit that you can try various lenses before you buy, and the cost of rental should be built into the charges for the wedding photography.

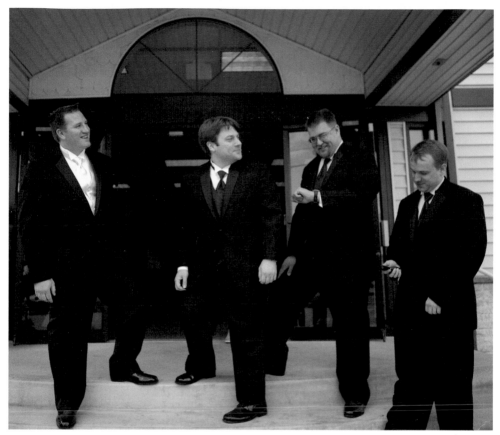

10.5 This image of the groom and groomsmen waiting for the best man seems like a setup shot, but, in fact, the best man was late and arrived minutes before the ceremony began. Exposure: ISO 350, f/2.8, 1/350 sec. using an EF 24-70mm, f/2.8L USM lens.

Many wedding photographers routinely bring two or more camera bodies at a minimum. After checking out the area, I usually have one camera with a wide-angle lens sitting at the front of the venue and another with a telephoto lens at the back of the venue. If I don't have an assistant, I recruit one of the guests to keep an eye on the camera that I'm not using at the moment.

Note *In addition to having backup gear, it's also important that all of your camera equipment is insured. Several professional photographer associations, such as Professional Photographers of America, offer access to such services.*

What you pack in the gear bag depends on many factors, including your personal shooting preferences and the duration of the shooting. For venues that require you to travel, you have the advantage of not checking film through hand-checks at airport security checkpoints.

Here are my minimum recommendations for shooting a wedding:

✦ **Two EOS 5D camera bodies.** You may also want a third camera body such as an EOS 40D, which offers exceedingly fast performance — handy for processionals, recessionals, and reception activities.

✦ **One or more wide-angle, normal, macro, and telephoto zoom lenses.** My preferences are the EF 24-70mm, or alternately the 24-105mm, f/4 IS lens; the 70-200mm, f/2.8L IS; the 100mm, f/2.8 Macro; and the EF 50mm, f/1.4 lens.

✦ **Tripod and monopod.** Have both a tripod and monopod with the same quick release plates.

✦ **Flash units and brackets.** I typically bring the EX 550 and 580 flash units and plenty of spare AA batteries. A better solution is to use the Compact Battery Pack CP-E4, which shortens flash recycle times and provides more firings before batteries need to be replaced. A flash bracket allows you to get the flash unit off the camera. Optionally, you may want to include flash modifiers such as a softbox or snap-on diffuser.

Cross-Reference *For more information on using Canon Ex-series Speedlites, see Chapter 5.*

✦ **CF cards sufficient for the duration.** The number of CF cards that you carry depends on how many images you typically shoot and the length of the shooting session. I usually carry a variety of SanDisk Extreme III cards in sizes ranging from 1GB to 4GB. I also use color-coded CF card holders to separate cards that have been exposed from those that are ready for use.

✦ **A laptop computer or portable storage device.** Backing up images on-site, either to a laptop or a handheld hard drive, is an essential part of the workflow throughout the day. Unless I have to, I don't erase images off the CF cards after loading them onto the computer or handheld device so that I have two copies of the images at all times. If you plan to do on-site slideshows, the laptop is, of course, necessary.

Additional handy gear includes light stands, umbrellas or softboxes for flash units, a stepladder, a circular polarizer, and a camera rotation device such as the Really Right Stuff Pro Flash Bracket WPF-1 (www.really rightstuff.com/flash/04.html). When I set up multiple Canon EX-series flash units for portraits, I depend on the Canon Speedlite Transmitter ST-E2 to drive the flashes and control the light ratios among the flash groups.

Shooting Weddings

Wedding photography and weddings themselves are as different as the photographers and couples who are involved in them. The techniques and approaches to wedding photography vary widely as well. This section provides an overview of wedding workflow, challenges, and options when shooting with the 5D.

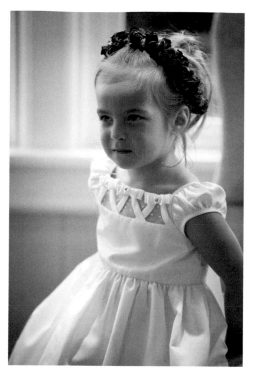

10.6 A candid shot of one of the flower girls. Exposure: ISO 320, f/2.8, 1/60 sec. using an EF 70-200mm, f/2.8L IS USM lens.

Getting ready

The day begins hours in advance of the vows with the bride and attendants getting ready. This is a time when you can capture the anticipation, excitement, and nervousness of the bride. The 5D performs beautifully in all types of light, indoor for dressing and outdoor as the bride gathers with family members and friends.

For the windowless dressing rooms with tungsten or fluorescent light, I recommend setting a custom white balance simply to avoid post-production work in color correction or shooting a white or gray card, if you are shooting RAW capture.

Of course, you can break old molds with unconventional approaches. For example, during two recent weddings, I divided my time between shooting the bride's preparation and the groom's preparation. Normally, most of my time is devoted to the bride getting ready for the ceremony. But by dividing the time, I learned that the groom's dressing time opens windows into family relationships that are intimate and touching — moments that I had previously overlooked by favoring the bride instead. While it's true that weddings are all about the bride, I've found that covering the groom with the same dedication adds an insightful balance in telling the couple's story.

I also learned the difference between the bride's dressing room and the groom's dressing room. In fact, the groom's was in the attic — a small room with bright green walls and an equally green ceiling. Two anemic tungsten ceiling lights were the sole illumination. I knew that the green walls would reflect a green tint into every shadow area. And using a bounce flash would create the same problem. I chose to shoot without flash, setting the ISO to 200, and shooting at 1/60 seconds for the series. Later, I converted the images to monochrome in Digital Photo Professional. Rendering the series in monochrome has the advantage of focusing the eye on the interaction between the mother and son rather than on the ugly green walls.

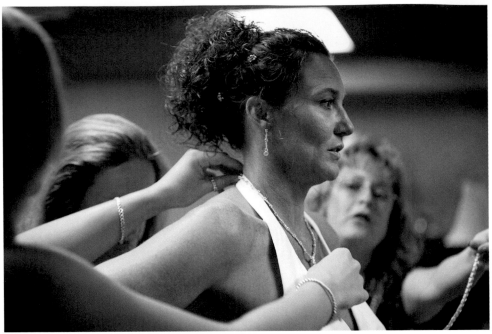

10.7 This is typical of the last-minute rush of the bride getting ready. The image shows the pre-ceremony nervousness as well as the support of the bride's family just minutes before she walks down the aisle. Exposure: ISO 400, f/2.8, 1/30 sec. using an EF 70-200mm, f/2.8L IS USM lens.

Meg Smith on Wedding Photography

With years of experience as one of the nation's top wedding photographers, Meg Smith, www.megsmith.com, concentrates on delivering wedding photos that stand the test of time as fine photography. "I try to make sure that every photograph is very good — not just okay, and not just to know that I got a shot of it — I want to make sure that I got a really good shot of it. In other words, I don't want to do just good wedding photography; I want to do good photography."

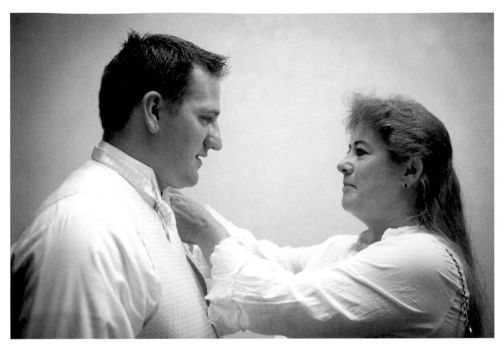

10.8 This groom was surprised to see me photographing him, but he soon warmed up to the idea. The groom ran into problems attaching the button covers and cufflinks, and his interaction with his mom provided a lovely series of images. Exposure: ISO 200, f/2.8, 1/60 sec. using an EF24-70mm, f/2.8L USM lens.

Capturing the ceremony

Of all the shooting during the wedding, the ceremony is the single time where if you miss a shot, it's gone forever. With the reliability of the 5D, you can shoot with confidence and with enough speed to capture the action of the processional and recessional, and certainly the definitive moments during the exchange of vows.

Tip *Well before the wedding, ask if flash is allowed in the church, and/or during the ceremony, and plan your gear accordingly.*

I typically choose to retain the ambience of the light for indoor ceremonies rather than to neutralize it by setting a Custom white balance. That sometimes means a bit of color tweaking during RAW image conversion. If you're shooting RAW + JPEG, and you are displaying the JPEG images as a slideshow during the reception, you'll get the best color in JPEGs if you set a custom white balance. At the least, be sure that the white balance setting on the 5D matches the light in the scene.

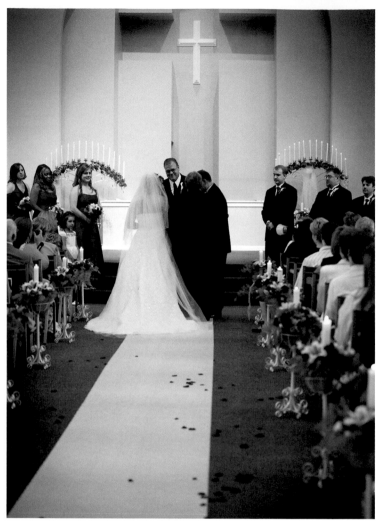

10.9 A long view at the beginning of the ceremony provides a glimpse of what's left of the flower petals. Exposure: ISO 320, f/2.8, 1/60 sec. using an EF24-70mm, f/2.8L USM lens.

During the ceremony, I typically have the 5D set to Single drive mode, Av, and then I shoot wide open because the light is inevitably low. I shoot in Single drive mode to avoid disrupting the ceremony with the sound of rapid shutter firings. But as the ceremony wraps up, I switch to Continuous drive mode to capture the couple coming down the aisle.

I've had mixed results using AI Servo AF. If you choose to use AI Servo AF for action sequences, be sure to shoot lots of images because some will inevitably have the wrong point of sharpest focus and some will be out of focus. Also don't be afraid to show motion blur as a creative alternative for the action sequences.

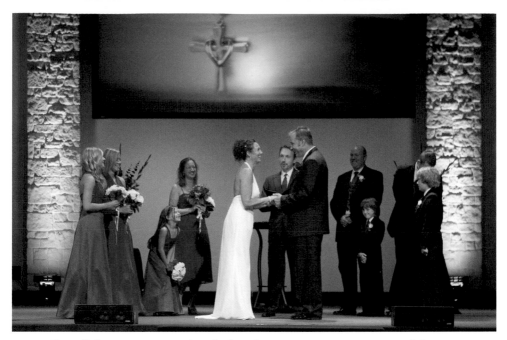

10.10 After all the tense preparations before the ceremony, I try to capture light moments of laughter during the ceremony as well as more solemn moments. Exposure: ISO 200, f/2.8, 1/50 sec., using an EF 24-70mm, f/2.8L USM lens.

Without question, you'll want an overall establishing shot of the ceremony venue after the lights go down for interior ceremonies, or before the wedding begins for outdoor ceremonies. This is also a good time to get images of guests arriving and greeting the groom and other family members.

During the ceremony, have both wide-angle and telephoto lenses, preferably on individual 5D camera bodies. Before the activity begins, reserve a chair or seat near the aisle in the mid-ground area of the audience. You can put one camera on the chair and switch to it after taking wide-angle shots early in the ceremony.

Focus on the details, portraits, and the reception

While the couple breathes a sigh of relief that the ceremony is over, the photographer simply shifts into gear for the next phase of shooting. This includes capturing the details, portraits — both candid and formal — and the reception.

Details

The opportunities for capturing detail images of the decorations and wedding attire present themselves through all phases of the wedding, and it takes only a good eye to make the most of them.

10.11 The happily and newly married couple head down the aisle hand in hand. Exposure: ISO 320, f/2.8, 1/60 sec. using an EF24-70mm, f/2.8L USM lens.

As with detail shots, portrait opportunities abound throughout the ceremony. Certainly formal shots are key to the portrait opportunities. Whether the couple provides a list of "must-have" family shots or you provide the list, this phase can occur either before or after the ceremony or be divided between those times.

Portraits

If the couple opts to not see each other before the ceremony, then some photographers photograph the bride, bride and attendants, and bride and family shots and likewise for the groom before the ceremony. With this approach, it's important to ensure that time for the sessions is scheduled and that family members and attendants are present well before the ceremony.

Another option is taking formal portraits following the ceremony. This option often makes the wedding flow more efficiently because guests can proceed to the reception while the wedding party remains at the site of the ceremony for a photo session.

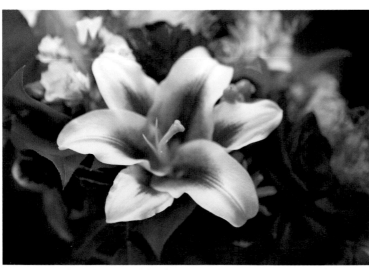

10.12 One of many aisle bouquets. Exposure: ISO 320, f/2.8, 1/80 sec. using an EF24-70mm, f/2.8L USM lens.

To save time when switching between the events of the wedding to the portrait session, you can set up the C mode, or Custom User Setting mode, to your favorite portrait exposure settings; shooting, drive, and autofocus modes; and then simply change the Mode dial when you're ready to begin shooting. I typically set the C mode in advance to Av mode, Continuous drive mode, and One-shot autofocus. Exposure settings vary according to the light and location, but these can be set on the fly and saved quickly.

Depending on the location and light, this is a good time to use one or multiple EX Speedlites, both indoors and outdoors. This is also where a ladder, reflectors, and Speedlite modifiers such as a small softbox or umbrella are invaluable. As soon as the last guest leaves after the ceremony, you can set up the lighting. If you're using multiple Speedlites, it goes without saying that you need to test the setup before the couple and family are called in for the portrait session. I try to find a clergyman or a musician who is willing to do one or two quick test shots.

The reception

Once the stress of the ceremony is over, the entire wedding takes on a very different spirit and the photographer's work is to capture the carefree celebration. The sequence of events for post-ceremony activities varies widely and brides feel free to customize the activities to their personal preferences. For this reason, I talk to the couple well before the wedding and prepare a basic shooting list to ensure that all milestone events are captured.

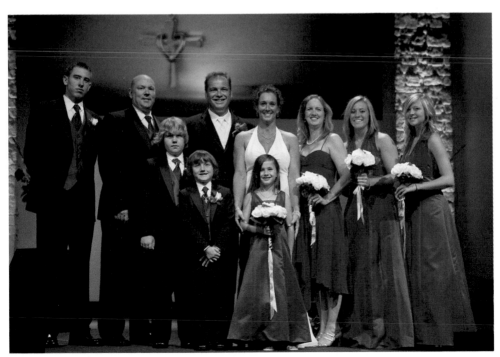

10.13 A traditional wedding party photograph. Exposure: ISO 200, f/3.5, 1/50 sec. using an EF24-70mm, f/2.8L USM lens.

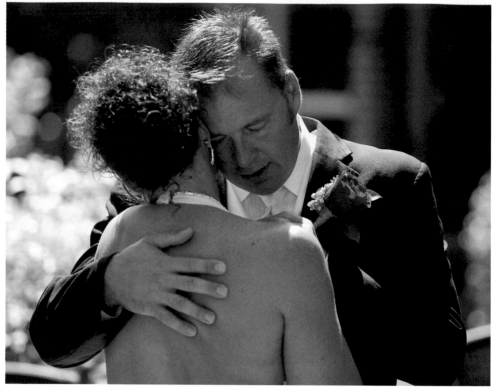

10.14 This was an emotional first dance for my son and his new wife. Exposure: ISO 250, f/2.8, 1/1000 sec. using an EF70-200mm, f/2.8L IS USM lens.

During the post-vow phase, the light, location, activities, and people run the gamut. For this reason, I typically set the 5D to Av mode, Continuous drive mode, and, in low-light scenes, I set the ISO to 800 or 1600, knowing that the images won't be ruined by excessive digital noise. This is a good time to watch for budding relationships among the wedding party members, attendants, and guests, which can make fun and endearing images.

A Compendium of Practical Advice

One of the beautiful aspects of photography is that photographers so willingly share advice with each other. And this is no less true of wedding photographers. Here are some tidbits of advice that you may have heard already, and if not, that you can use for the next wedding that you shoot.

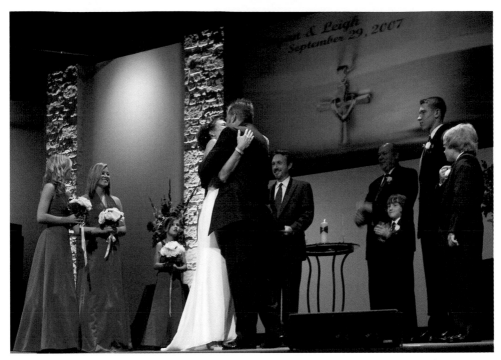

10.15 Sealed with a kiss. Exposure: ISO 320, f/3.2, 1/400 sec. using an EF 24-70mm, f/2.8L USM lens.

✦ **Get to know the couple ahead of the wedding.** Every minute you spend getting to know the couple in advance of the wedding pays off in wedding images that reflect their unique personalities and their hopes and dreams for the life they are beginning together. By the time of the wedding day, the couple should know you well enough to think of you as a new or old friend who they welcome.

✦ **Clearly set the expectations for shooting duration well before the ceremony.** If your fee covers six hours of shooting, the wedding planner needs to know that so that key events can be scheduled during the shooting time. Also clearly state your charges for time spent over the contracted shooting time.

✦ **Give the bride breaks where she can relax her smile for a few minutes.** This is also a good time to get more candid images of her kicking back and reflecting on the events of the day.

✦ **In addition to a gear bag, consider including a second bag packed with anything that the wedding party members may forget.** Handy gadget-bag items include hairspray, stick-on Velcro strips, makeup brushes, tissues (for tears or stuffing), mascara, florist wire, a Swiss Army knife, a nail file, a brush, a sewing kit, plastic tarps, bug spray, aspirin, and glue. One photographer carries a stack of one-dollar bills and pays kids to clean up pet droppings from the grass at outdoor receptions.

✦ **Know your audience.** Before the wedding ask the couple about any touchy relationships such as family feuds, divorced parents, and children, and have the couple decide how they want you to arrange the portraits in regard to these relationships. The last thing that you want to do is put a jilted mother-of-the-bride with her ex-husband and his 20-years-younger new wife for the family shot.

✦ **Regardless of what happens, put on a happy face and be part of the solution, not part of the problem.** At the beginning of a recent wedding, the bride's mother and the groom's mother disagreed about a small detail. But the argument heated up, and all the stress of preparation flooded out. I worked to calm both sides as I shot and used humor to help ease the strained emotions. Smoothing out the frayed emotions is all part of the job, and the photographer is often in a unique neutral position to be a sea of calm in turbulent waters.

✦ **Have backup at all points in the workflow.** Backing up includes having second and third bodies, lenses, and CF cards, but also backing up images on location, and when you return to the studio.

✦ **Take the high road when guests offer photography advice.** Nowadays, everyone seems to know something about photography, and a good number of them are anxious to show off their knowledge. Be kind, be patient, and keep shooting — your way.

10.16 Once the key shots are taken at the reception, take a cue from this groomsman and enjoy the festivities. Exposure: ISO 320, f/3.2, 1/400 sec. using EF 70-200mm, f/2.8L IS USM lens.

✦ **Bring your own refreshments.** I spent six hours shooting a wedding in 100-degree plus California heat, and I could not persuade the caterer to give me a bottle of water because I was not a wedding guest. This is just another example of the wisdom of being totally self-reliant.

✦ **Don't hold pictures hostage.** Even if you opt not to have an on-site slideshow, get a selection of pictures to the couple as quickly as possible. And most photographers agree that showing the final proofs is better done in person than on the Web or through the mail.

Canon Programs, Software, and Firmware

In This Chapter

Characteristics of RAW images

Choosing a RAW conversion program

Sample RAW image conversion

Creating an efficient workflow

Updating the 5D firmware

By now, few digital photographers are new to RAW image capture, but for those who are, the advantages of RAW capture can't be overstated. Many digital photography professionals see RAW capture as the gold standard for creating images that not only provide all that the 5D image sensor offers, but also act as the gateway to greater creative expression and control over the final image.

If you're new to RAW capture, a brief overview is helpful. RAW capture allows you to save the data that comes off the image sensor with virtually no internal camera processing. Because the camera settings have been "noted" but not applied in the camera, you have the opportunity to make changes to key settings such as image brightness, white balance, contrast, and saturation after the capture is made. The only camera settings that the camera applies to a RAW image are ISO, shutter speed, and aperture. During RAW image conversion, you can make significant adjustments to exposure, color, and contrast. In addition to the RAW image data, the RAW file also includes information, called *metadata*, about how the image was shot, the camera and lens used, and other description fields.

RAW capture mode offers advantages that are akin to traditional film photography. For example, in some cases, you can push digital RAW exposures during shooting by 1/2 to a full f-stop, and then pull back the exposure during RAW conversion.

The ability to push an exposure can, of course, make a noticeable difference in low-light shooting when you need to handhold the camera. While pushing exposures isn't recommended, it's mentioned here only as a possibility in especially challenging shooting situations.

Characteristics of RAW Images

An important characteristic of RAW capture is that it offers more latitude and file stability in making edits than is possible with a JPEG file. With JPEG images, large amounts of image data are discarded in the conversion to 8-bit mode, and then the data is further reduced by JPEG compression algorithms. As a result, the image leaves precious little, if any, wiggle room to correct tonal range, white balance, contrast, and saturation during image editing. Ultimately, this means that if the highlights are blown, then they're blown for good. If the shadows are blocked up, then they will remain blocked up. It may be possible to make improvements in Photoshop, but the edits make the final image susceptible to posterization and banding.

On the other hand, RAW images with rich data depth allow far more bits to work with during conversion and subsequent image editing. In addition, RAW files are more forgiving if you need to recover highlight detail. Table 11.1 illustrates the general differences in file richness between a RAW image and a JPEG image from a typical digital SLR camera. Note that this table assumes a five-stop dynamic range for an exposure.

The differences shown here translate directly to editing leeway. And having a good amount of editing leeway is important because all image editing after RAW conversion is destructive.

Proper exposure is important with any image, and it is no less so with RAW images. With RAW images, exposure is important in part because it pertains to the distribution of brightness levels in the linear capture. Linear capture can be contrasted with how the human eye adjusts to differences in light levels. When you go from one room to another room that is twice as light, your eyes automatically compress the differences in light so that you don't perceive the difference to be twice as bright, but only brighter. By contrast, the camera makes no such distinction. Rather, the camera simply counts photons hitting the sensor. It records the tonal levels exactly to the number of photons captured. As Table 11.1 shows, linear capture has significant implications for digital exposure.

Underexposure of an image sacrifices valuable bits of data that could have been — and need to be — captured in the image. And underexposure increases the likelihood that the few levels of brightness that are devoted to dark tones will be riddled with noise at all ISO settings. With a miscalculation of one f-stop of brightness, half of the possible tonal levels are missing and the few dark levels that are captured must then be redistributed between tonal levels causing gaps appear.

Using the histogram as a reference, expose to the right so that the highlight pixels just touch the right side of the histogram with a RAW image; this delivers all the tonal levels that the camera is capable of providing,

Table 11.1
Comparison of Brightness Levels

F-stop	Brightness Levels Available	
	12-bit RAW file	8-bit JPEG file
First f-stop (brightest tones)	2,048	69
Second f-stop (bright tones)	1,024	50
Third f-stop (midtones)	512	37
Fourth f-stop (dark tones)	256	27
Fifth f-stop (darkest tones)	128	20

What Is Bit Depth?

A digital image is made up of pixels. Each pixel is made up of a group of bits. A bit is the smallest unit of information that a computer can handle. In digital images, each bit stores information that, when aggregated with other pixels and color information, provides an accurate representation of the picture.

Because digital images are based on the Red, Green, Blue (RGB) color model, an 8-bit digital image has eight bits of color information for red, eight bits for green, and eight bits for blue for a total of 24 bits of data per pixel (8 bits × 3 color channels). Because each bit can be one of two values, either 0 or 1, the total number of possible values is 2 to the 8th power, or 256 colors per channel.

In the RGB color model, the range of colors is represented on a continuum from 0 (black) to 255 (white). On the continuum, an area of an image that is white is represented by 255R, 255G, and 255B. An area of the image that is black is represented by 0R, 0G, 0B.

A 16-bit file provides 65,000 colors per channel, and a 24-bit file (common on some film scanners) provides 16.7 million colors per channel. There is, of course, an upper limit on bit-depth given the human eye, with its non-linear response to light, can detect hundreds of thousands of colors while printers can reproduce far fewer distinguishable colors. As a result, high bit-depth images offer more subtle tonal gradations and a higher dynamic range than low bit-depth images. High bit-depth images also provide much more latitude in editing images.

Note that the RBG color model adds varying amounts of red, green, and blue to achieve a very wide gamut of different colors. This type of model is called an *additive color model*. Note that different RGB devices, such as monitors, scanners, and printers, have their own color spaces and gamuts.

including the first f-stop of brightness that accounts for half the total tonal levels in the image. And when tone-mapping is applied, significantly more bits can be redistributed down the line to the midtones and darker tones — areas where the human eye is most sensitive to changes. In short, exposing to the right side of the histogram gives you the best image that the EOS 5D can produce.

Choosing a RAW Conversion Program

RAW image data is stored in proprietary format, which means that the RAW images can be viewed and converted using the camera manufacturer's RAW conversion program, such as Canon's Digital Professional Pro conversion program, or a third-party RAW conversion program such as Adobe's Camera Raw plug-in or Adobe Lightroom.

Unlike standard TIFF and JPEG files, RAW files are not portable. They cannot be moved from computer to computer with the assurance that any system can display them. That means that you must first convert RAW files to a more universal file format or verify that clients have an operating system and conversion program that allows them to display RAW images before you hand off images. And unless the client has a third-party program such as Adobe Camera Raw, they must install and stay up to date with conversion programs from the camera manufacturer. Granted, few photographers hand off RAW images to clients, but as workflow and RAW capture matures, RAW image handoff could become a common part of the handoff process.

 Note *Images captured in RAW mode include unique filename extensions such as .CR2 for Canon 5D RAW files.*

Although RAW conversion programs continue to offer more image-editing tools with each new release, you won't find some familiar image-editing tools in RAW conversion programs, including healing, history brushes, or the ability to work with layers in the traditional sense. Most conversion programs rightly focus on basic image conversion tasks, including white balance, exposure, shadow control, brightness, contrast, saturation, sharpness, noise reduction, and so on.

Choosing a RAW conversion program is a matter of personal preference in many cases. Canon's Digital Photo Professional (DPP) is included with the 5D, and updates to it are offered free of charge. Third-party programs, however, often have a lag time between the time that the camera is available for sale and the time that the program supports the new camera. For example, there was approximately a six-week lag time between when the 5D was available and the time when Adobe Camera Raw supported 5D files, although the lag times are diminishing. Some photographers use the Canon conversion program during the lag time, while others use only the Canon program or wait for a third-party program to support the new camera. Arguments can be made for using either the manufacturer's or a third-party program. The most often cited argument for using Canon's program is that because Canon knows the image data best, it is most likely to provide the highest quality RAW conversion. At the same time, many photographers have tested the conversion

11.1 This figure shows Canon's Digital Photo Professional's main window with the toolbar for quick access to commonly accessed tasks.

results from Canon's program and Adobe's Camera Raw plug-in, and they report no difference in conversion quality.

Assuming that there is parity in image conversion quality, the choice of conversion programs boils down to which program offers the ease of use and features that you want and need. Certainly a company like Adobe has years of experience building feature-rich programs for photographers within an interface that is familiar and relatively easy to use. Canon, on the other hand, has less experience in designing features and user interfaces for software.

Because both DPP and Adobe Camera Raw are free (provided that you have Photoshop CS3), you should try both programs and any other conversion software that offers free trials. Then decide which one best suits your needs. I often switch between using Canon's DPP program and Adobe Camera Raw. When I want to apply a Picture Style from Canon to a RAW image or when I want to convert a RAW image to monochrome and apply a color filter, I use DPP. For most everyday processing, however, I use Adobe Camera Raw as a matter of personal preference.

11.2 By way of contrast, Adobe presents images in Bridge, and from Bridge or Photoshop you can open RAW images in Camera Raw for conversion.

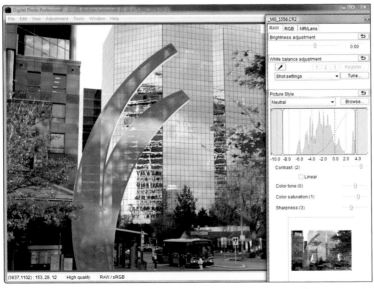

11.3 This figure shows the RAW image adjustment controls in Canon's Digital Photo Professional. Note that you can apply a Picture Style after capture.

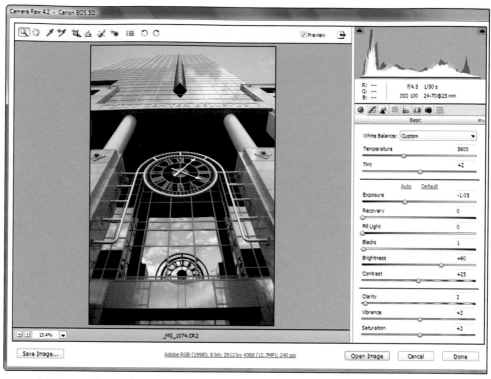

11.4 This figure shows the Adobe Camera Raw dialog box opened to the Basic tab where color, exposure, tone, contrast, and saturation adjustments are made.

Another consideration is which program offers the most and best batch features. DPP allows you to apply conversion settings from one photo to others in the folder, as does Camera Raw. Camera Raw also has the advantage of applying Camera Raw settings to batches of images.

Whatever conversion program you choose, be sure to explore the full capabilities of the program. Remember also that one of the advantages of RAW conversion is that as the conversion programs improve, you'll have the opportunity to go back to previous RAW image files and reconvert them using the improved conversion program.

Sample RAW Image Conversion

Although RAW image conversion adds a step to the processing workflow, this important step is well worth the time spent processing images. To illustrate the process, here is a high-level task flow for converting a 5D RAW image using Digital Photo Professional.

1. **Start Digital Photo Professional.** The program opens with the images in the currently selected folder displayed. RAW images are marked with a camera icon and the word RAW in the lower left of the thumbnail. On the left of the window, you can select a different directory and folder.

2. **Double-click the image you want to process.** The RAW image adjustment tool palette opens. In this mode, you can

 - Drag the Brightness slider to tweak the exposure to a negative or positive setting.

 - Use the White balance adjustment controls to adjust color. You can click the Eyedropper button, and then click an area that is white in the image to set white balance, choose one of the preset white-balance settings from the Shot Setting drop-down menu, or click the Tune button to adjust the white balance using a color wheel.

 - Choose a different Picture Style by clicking the drop-down arrow next to Standard and selecting a Picture Style from the list. The Picture Styles are the same as those offered on the menu on the EOS 5D. When you change the Picture Style in DPP, the thumbnail updates to show the change. You can adjust the curve, color tone, and saturation and sharpness. If you don't like the results, you can click the Reset button (depicted by a U-turn arrow) to change back to the original Picture Style.

 - Adjust the black and white points on the image histogram by moving the mouse pointer over the bar at the far left or right of the histogram and dragging it toward the center. By dragging the slider under the histogram, you can adjust the tonal curve.

 - Adjust the Color tone, Color saturation, and Sharpness by dragging the sliders. Dragging the Color tone slider to the right increases the green tone, and dragging it to the left increases the magenta tone. Dragging the Color saturation to the right increases the saturation, and vice versa. Dragging the Sharpness slider to the right increases the sharpness.

3. **Click the RGB image adjustment tab.** Here you can apply a more traditional RGB curve and apply separate curves in each of the three color channels: Red, Green, and Blue. You can also adjust the following:

 - Drag the Brightness slider to the left to darken the image or to the right to brighten it. The changes you make are shown on the RGB histogram as you make them.

 - Drag the Contrast slider to the left to decrease contrast or to the right to increase contrast.

 - Drag the Color tone, Color saturation, and Sharpness sliders to make the appropriate adjustments.

4. **In the preview window, choose File/Convert and save.** The Convert and Save dialog box appears. In the Convert and Save dialog box, you can set the bit-depth at which you want to save the image, set the Output resolution, choose to embed the color profile, or resize the image. You can also click the arrow next to Save as type, and then choose

16-bit TIFF or TIFF 16-bit and Exif-JPEG format, or you can choose 8-bit Exif-JPEG and TIFF formats.

Note *The File menu also enables you to save the current image's conversion settings as a recipe. Then you can apply the recipe to other images in the folder.*

5. **Click Save.** DPP displays the Digital Photo Professional dialog box until the file is converted. DPP saves the image in the location and format that you choose.

Creating an Efficient Workflow

When workflow became a buzzword several years ago, it typically encompassed the process of converting and editing images one at a time or several at a time. Since then, however, the concept of workflow has expanded to include the process from image capture to client handoff, often including pre-press settings, which ensure image quality and consistent settings that meet the client's needs and specifications.

While workflow varies depending on your needs or the requirements of the client, here are some general steps that you can consider as you create your workflow strategy.

✦ **Back up images.** The first workflow step is backing up original images to a separate hard drive or to DVD. Whether you do this step now or later, backing up is a critical aspect of any workflow.

✦ **Batch file rename.** Batch file renaming allows you to identify groups of images by subject, assignment, location, date, or all these elements. Programs such as DPP and Adobe Bridge offer tools for batch renaming that save time in the workflow.

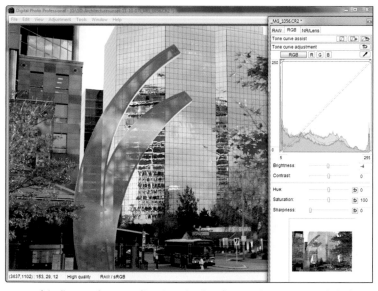

11.5 This figure shows adjusting the brightness in Canon's Digital Photo Professional RAW conversion window.

✦ **Create a standard IPTC template.** This should have your name, address, phone number, and important information about the image. Then you can use the Tools ➪ Append Metadata command in Adobe Bridge to apply the template to all the images in a folder.

✦ **Select and reject images.** Programs such as Adobe Bridge and Digital Photo Professional provide tools to rate images and then sort them to display top-rated images to process.

✦ **Convert images in groups or all at once.** If you're processing RAW images, you can open the selected images in groups or all at once for conversion, depending on the RAW conversion program you're using. In some programs, you can select similar images, process one image, and then apply all or part of that image's conversion settings to similar images. Then you can save the images or open them in Photoshop for additional editing.

✦ **Use a batch action.** If you create JPEG versions of the images for client selection on your Web site, you can use a batch action in Photoshop to make and automatically size images for the Web and save the images in a separate subfolder.

✦ **Create subfolders, maintain databases, and use tracking sheets.** If your workflow includes client selection, you can create subfolders for selected images and move non-selected images to other subfolders. This is a good time to

add JPEG versions of the images to a main database of images, if you maintain that type of database. A good practice is to maintain tracking sheets of images that you update during each stage of the process of handing off images to clients, or for your own records for personal images.

✦ **Register images with the Library of Congress.** Registering protects the copyright to your images and is an important part of the workflow. You can create a 4x6-inch contact sheet with approximately 12 images per sheet in Adobe Bridge of the images that you want to register. Be sure to leave space on the contact sheet to add your name and contact information.

Tip *The copyright gives you the right to control use of your images for your lifetime plus 70 years. The annual fee for bulk image registration is provided on www.copyright.gov.*

✦ **Image processing.** With the final selections made, you can do the final image processing in Photoshop according to the client's specifications.

✦ **Store final images safely.** When the final images are ready, you can burn a DVD or you can send images via FTP to the client or to your personal archives. Having a fire-safe and flood-safe place to archive hard drives and DVDs is important. Some photographers have a safety deposit box or other off-site location for storage.

The steps you incorporate into your workflow often depend on whether you're shooting for clients or for personal work, but these broad suggestions provide an overview of steps that you can consider for your workflow.

Updating the 5D Firmware

One of the greatest advantages of owning a digital camera such as the EOS 5D is that Canon often posts updates to the firmware (the internal instructions) for the camera to its Web site. New firmware releases can add improved functionality to existing features and, in some cases, fix reported problems with the camera.

New firmware along with ever-improving software keeps your camera and your ability to process images current as technology improves. To determine if you need to update firmware, you can compare the firmware version number installed on your EOS 5D to the latest release from Canon on its Web site.

To check the current firmware version installed on your camera, follow these steps:

1. **Press the Menu button.**

2. **Press the JUMP button to access the Set-up (yellow) menu.**

3. **Rotate the Quick Control dial until you see the Firmware Ver., and then write down the number.** If the firmware installed on your camera is older than the firmware offered on the Web site, then your camera needs updating.

Note *And you can check for other software updates and product notices on the Canon Web site's support area at www.usa .canon.com/consumer/ controller?act=ModelInfoAct& tabact=DownloadDetailTab Actfcategoryid=314&mode lid=11933. You can also check www.robgalbraith.com and search the news section for announcements of the latest firmware updates.*

Before installing firmware updates, be sure that the camera battery has a full charge, or use the AC Adapter Kit ACK-E2 to power the camera. If the camera loses power during the firmware update, it can become inoperable.

Also have a freshly formatted CompactFlash card available on which to copy the firmware update. Or you can connect the camera to your computer with a USB cable, and then copy the firmware file onto the CF card in the camera.

Tip *To download the latest version of firmware, go to the Canon Web site at http://web.canon .jp/imaging/eos5d/eos5d_firm ware-e.html.*

As you install the new firmware, ensure that you do not turn off the power switch or open the CF card door. To download firmware updates and install them on the EOS 5D, follow these steps:

1. **Insert the CF card in a card reader attached to your computer.**

2. **Scroll down on the Canon Web page (http://web.canon.jp/ imaging/eos5d/eos5d_firm ware-e.html) to the License Agreement and click I agree and download.** The Web page includes extensive instructions on downloading and installing the firmware.

3. **Click the Files for Firmware Update link that matches your computer's operating system, either for Windows extraction or for Mac OS extraction.**

4. **Click Run if a File Security dialog box appears.** If a window appears saying that Publisher cannot be verified, click Run. A window appears notifying you that this is a self-extracting file.

5. **Click OK.** A Self-extracting archive window appears.

6. **Click Browse, navigate to the CF card location, and click OK.** The Self-extracting archive window is displayed again.

7. **Click OK.** A progress window appears. The firmware appears on the CF card as a file.

8. **Insert the CF card into the camera and turn the camera on.** The firmware update program starts and displays an Execute Upgrade screen. Rotate the Quick Control dial to select OK, and press the Set button. A Checking Firmware

screen appears. Then a Replace Firmware screen appears listing the existing and new firmware version numbers.

If the firmware update program does not automatically start, press the Menu button, and then press the Jump button until the Set up (yellow) menu displays. Turn the Quick Control dial to select Firmware Ver., and then press the Set button. The Firmware update screen appears. Turn the Quick Control dial to select OK, and then press the Set button. The Firmware update program screen appears. If the version you downloaded to the CF card is the same version that is currently installed on the camera, press the Menu button to cancel the installation because you cannot overwrite the existing version with the same version.

9. **Rotate the Quick Control dial to select OK, and press the Set button.** A Re-writing Firmware screen appears with a progress bar. When the update is complete, a Firmware Replaced Successfully screen appears. As the update progresses, do not press any buttons on the camera, open the CF card door, or turn off the camera.

10. **Press the Set button to complete the firmware update.** Then be sure to format the CF card before using it again.

Appendixes

P A R T

IV

◆ ◆ ◆ ◆

In This Part

Appendix A
Canon CMOS Sensors
and Image Processors

Appendix B
EOS 5D Specifications

Glossary

◆ ◆ ◆ ◆

Canon CMOS Sensors and Image Processors

◆ ◆ ◆ ◆

In This Appendix

Canon-produced
CMOS Sensors

DiG!C II Image
Processor

◆ ◆ ◆ ◆

As Canon's ongoing research and development continues to refine camera features, Canon has progressively applied new and improved technologies throughout its camera lineup. As a result, photographers can rely on a consistently high level of quality, and this is certainly true in the EOS 5D.

As one of the finest cameras in the EOS line-up, the 5D reflects Canon's pioneering work in the field of CMOS (Complementary Metal Oxide Semiconductor) imaging sensors — work that continues today with the evolution of CMOS sensors in the latest EOS digital SLRs. An understanding of both the sensor technology and the internal processor is beneficial to better understand the camera and the image files that it produces.

Canon-produced CMOS Sensors

The EOS 5D, along with all of Canon's dSLRs, features a Canon-produced CMOS image sensor. While Canon isn't the only camera manufacturer that uses CMOS sensors, it is the only company, at the time of this writing, that produces and markets full-frame, 35mm-size image sensors — sensors that are used in the EOS 1Ds Mark III and the EOS 5D. Canon is also one of the few companies that designs and manufacturers its sensors in-house for all of its dSLRs.

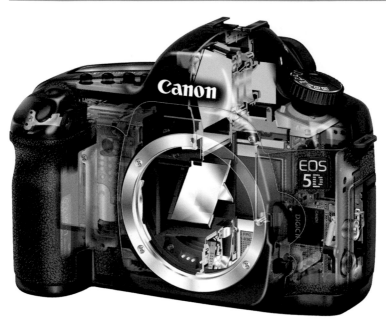

A.1 A look inside the Canon EOS 5D

Sensors are, of course, at the heart of digital photography. Digital cameras use either CMOS or CCD (Charge-Coupled Device) image sensors. Here is a brief background on both and the advantages and limitations.

CCD sensors

CCDs, invented in 1969 by Bell Lab researchers Willard S. Boyle and George E. Smith, were used exclusively in digital cameras in the early days of digital photography. CCDs are comprised of a matrix of photodiodes, which are semiconductors. CCDs are uniquely well suited for photography because of their capability to accumulate electrical charge in direct proportion to the amount of light striking them. When light, or photons, strikes the sensor, photons are absorbed at different depths in the silicon depending on their wavelengths. The brighter the light that strikes the photodiode, the greater the electrical charge that accumulates in the photodiode.

The matrix of photodiodes converts the light into electrons that are stored in a charge well and they are subsequently transferred out along charge transfer regions, arranged as columns next to each row of photodiodes. A series of pulses are then applied to relay the photodiode charges in sequential, bucket-brigade fashion down the rows of photodiodes to the edge of the CCD and off to an amplifier.

While CCDs are proven technology and offer generally low image noise, they have inherent limits. The sequential processing of electrical charges limits the speed at which CCDs can process images. Also, the voltages needed to initiate the relay of charges across the CCD require, by some estimates,

more than 50 percent more power for an APS-C-size sensor than CMOS sensors. This need for more power at longer shutter speeds creates more heat and, subsequently, increases the amount of noise in the image. In addition, battery packs tend to be larger and have longer recharge times.

CMOS sensors

CMOS sensors are also semiconductor light sensors and also contain rows of photodiodes, and the CMOS photodiodes also have individual amplifiers to increase the electrical signal and a converter to convert the charge to voltage. Transferring voltage, as compared to transferring the charge of each photodiode on a CCD, requires minimal power. In addition, because the signal is amplified at each photodiode, the rows of photodiodes can be read separately and multiple channels of data can quickly be read out simultaneously — all of which results in high-speed image processing. The bigger the sensor, the bigger the difference in power consumption compared to CCDs. The CMOS sensor's lower power consumption also means that battery packs are smaller, recharge time is quicker, and batteries maintain their working voltages longer.

While CMOS offers the advantages of low power consumption and high speed, the technology has inherent disadvantages, including fixed-pattern and random noise — problems that Canon has, over the course of several years, developed technologies to suppress.

Fixed-pattern noise appears on the same pixels at different times when images are taken. Because CMOS offers the advantage of relatively easily adding on-chip circuitry, Canon developed on-chip noise-reduction circuitry

that records the noise of each photodiode before exposure and automatically subtracts the noise when the image is captured.

Random noise appears on different pixels at different times and is caused by flickering light or thermal effects. To suppress random noise, Canon developed complete electronic charge transfer technology. Canon designed the photodiode and signal reader separately so that the sensor completely resets the photodiodes that store electrical charges. To suppress noise, the sensor transfers the residual light and noise to the signal reader, and then resets the diode while reading and holding the noise data. When the optical signal and noise data have been read, the initial noise data is used to remove the remaining noise from the photodiode to suppress random noise.

Because random noise increases with fast signal processing, Canon's technology also amplifies signals according to the sensitivity level generated as they are read. Signals with high optical signal-to-noise ratios are directed to a high-speed amplifier so that low-noise sensors can function well when shooting at high ISO speeds and during long exposures.

Additional engineering techniques such as the spacing of microlenses over each pixel help increase the light gathering efficiency of Canon's CMOS sensors' surfaces, even at higher pixel densities, to expand the signal output range at high ISO settings. CMOS sensors also have a multilayer low-pass filter positioned in front of the sensor to isolate false colors, or colors outside the visible portion of the electromagnetic spectrum, detected by the sensor. Then the DiG!C II Image Processor eliminates the colors from the image while retaining image detail. Through the years, Canon developed

sophisticated CMOS manufacturing and post-production facilities including clean rooms, flat glass handling, and specialized packaging equipment specifically designed to handle imaging devices.

DiG!C II Image Processor

Between the capture and recording stages is image processing that determines how the signals from the sensor are translated into a viewable image. In Canon dSLRs, the processing function is performed by the DiG!C II Image Processing chip. This processor uses proprietary signal-processing algorithms to process multiple channel signals from the sensor and write image data to and from the high-speed Double Data Rate Synchronous Dynamic Random Access Memory (DDR-SDRAM) buffer — all without sacrificing image optimization or slowing camera operation. While some cameras use built-in software to process images, Canon uses a dedicated hardware chip that is built into the camera circuitry. The result is additional processing power that can handle multiple functions that would otherwise require separate processing units.

Canon's single-chip DiG!C II processor, the follow-on to the original three-chip DiG!C system, also factors into the speedy operation of camera controls, autofocus, camera start-up time, faster frame rates with increased burst rates, and direct printing and data transfer rates.

DiG!C II algorithms are responsible for rendering color accurately, including the natural reproduction of bright, highly saturated subjects; white balance, including intelligent scene evaluation for calculating automatic white balance and the dynamic range in highlight areas; and metering. In addition, the second-generation DiG!C system provides improved color accuracy and noise reduction in low-light scenes.

Taken as a whole, the DiG!C II Image processor provides quick but high-quality image processing, compression, display and write times, as well as enhanced color and white balance, and optimized camera performance — all with relatively low power requirements.

EOS 5D Specifications

Type

- **Type:** Digital AF/AE single lens reflex
- **Recording Medium:** CompactFlash (CF) Card Type I and II
- **Image Format:** 1.41x0.94 in/35.8x23.9mm
- **Compatible Lenses:** Canon EF lenses (except EF-S lenses)
- **Lens Mount:** Canon EF mount
- **Lens Focal Length Conversion Factor:** 1.0×

Image Sensor

- **Type:** High-sensitivity, high-resolution, single-plate CMOS (Complementary Metal Oxide Semiconductor) Sensor
- **Pixels:** Approx. 12.8 megapixels
- **Total Pixels:** Approx. 13.3 megapixels
- **Aspect Ratio:** 3:2 (Horizontal:Vertical)
- **Color Filter System:** RGB primary color filters
- **Low-pass Filter:** Fixed position in front of the image sensor

In This Appendix

Type

Image sensor

Recording system

White balance

Viewfinder

Autofocus

Exposure control

Shutter

External Speedlite

Drive system

LCD monitor

Playback

Image protection and erase

Power source

Dimensions and weight

Operating environment

Recording System

✦ **Recording Format:** JPEG, RAW, and RAW+JPEG simultaneous recording provided. Backup image recording enabled (same image recordable on CF card standards).

✦ **Image Format:** JPEG, RAW

✦ **File Size:**
 • (1) Large/Fine: Approx. 4.6 MB (4,368 x 2,912)
 • (2) Large/Normal 2.3 MB (4,368 x 2,912)
 • (3) Medium/Fine: Approx. 2.7 MB (3,168 x 2,112)
 • (4) Medium/Normal: Approx. 1.4 MB (3,168 x 2,112)
 • (5) Small/Fine: Approx. 2.0 MB (2,496 x 1,664)
 • (6) Small/Normal: Approx. 1.0 MB (2,496 x 1,664)
 • (7) RAW: Approx. 12.9 MB (4,368 x 2,912)

✦ **Folders:** Folder creation/selection enabled

✦ **File Numbering:**
 • (1) Continuous numbering
 • (2) Auto reset
 • (3) Manual reset

✦ **Color Space:** Selectable between sRGB and Adobe RGB

✦ **Image-processing Parameters:** Six preset Picture Style settings plus three user-defined custom Picture Styles function with individual adjustments for sharpness, contrast, saturation, and color tone

✦ **Interface:** USB 2.0 Hi-Speed, NTSC/PAL for video output

White Balance

✦ **Settings:**
 • Auto
 • Preset (Daylight, Shade, Cloudy/Twilight/Sunset, Tungsten Light, White Fluorescent Light, Flash)
 • Manual (Custom, Color Temperature)

✦ **Auto White Balance:** Auto white balance with the image sensor

✦ **Color Temperature Compensation:**
 • White Balance Bracketing: +/-3 stops in full-stop increments
 • White Balance Correction: Blue/Amber bias +/- 9 levels, Magenta/Green bias +/- 9 levels

 Note *Blue/Amber bias and Magenta/Green bias cannot be set together during White Balance Bracketing.*

Viewfinder

✦ **Type:** Eye-level SLR with fixed pentaprism

✦ **Coverage:** Approx. 96% horizontally and vertically (coverage against JPEG Large)

✦ **Magnification:** 0.71× (-1 dpt with 50mm lens at infinity)

✦ **Eyepoint:** 20mm

✦ **Dioptric Adjustment Correction:** −3.0 to +1.0 diopter

✦ **Focusing Screen:** Standard focusing screen: Ee-A

✦ **Mirror:** Quick-return half mirror (Transmission: reflection ratio of 40:60, no mirror cut-off with EF 600mm f/4 or shorter lens)

✦ **Viewfinder Information:**

- AF (AF points, focus confirmation light)

- Exposure (shutter speed, aperture, spot metering circle, exposure level, AE Lock, exposure compensation, AEB level)

- Flash (flash ready, red-eye reduction lamp on, high-speed sync, FE Lock, FEB shooting, flash exposure compensation, insufficient flash warning during FE Lock)

- White Balance Correction

- Maximum burst

- CF card full warning

- CF card error warning

- No CF card warning

✦ **Depth-of-Field Preview:** Enabled with depth-of-field preview button

Note *With Speedlite 580EX, 550EX, 430EX, MR-14EX, or MT-24EX, pressing the depth-of-field preview button fires a modeling flash.*

✦ **Eyepiece Shutter:** None (eyepiece cover provided on strap)

Autofocus

✦ **Type:** TTL-CT-SIR AF-dedicated CMOS Sensor

✦ **AF Points:** 9 AF points (plus 6 invisible Supplemental AF points)

✦ **AF Working Range:** EV −0.5-18 (at ISO 100 at 20°C/68°F)

✦ **Focusing Modes:**

- Autofocus, (One-Shot AF, Predictive AI Servo AF, AI Focus AF [automatic switching between One-Shot/Predictive AI Servo AF])

- Manual Focus (MF)

✦ **AF Point Selection:** Manual selection, Automatic selection

✦ **Selected AF Point Display:** Superimposed in viewfinder and indicated on LCD screen

✦ **AF-assist Beam:** Emitted by the dedicated Speedlite

Exposure Control

✦ **Metering Modes:** Max. aperture TTL (Through-The-Lens) metering with 35-zone SPC

- (1) Evaluative metering (link to all AF points)

- (2) Partial metering (approx. 8% of viewfinder)

- (3) Spot metering (approx. 3.5% of viewfinder)

- (4) Center-weighted average metering

✦ **Metering Range:** EV 1-20 (at 68°F/20°C with 50mm f/1.4 lens, ISO 100)

✦ **Exposure Control Systems:**

- Program AE (Shiftable)

- Shutter-Speed-Priority AE

- Aperture-Priority AE

- Full Auto

- E-TTL II autoflash program AE

- Manual exposure

✦ **ISO Speed Range:** Equivalent to ISO 100-1600 (in 1/3-stop increments), ISO speed can be expanded to ISO 50 and 3200

✦ **Exposure Compensation:**

- (1) Manual

- (2) AEB range: +/-2 stops in 1/2- or 1/3-stop increments

✦ **AE Lock:**

- Auto: Applied in One-Shot AF mode with evaluative metering when focus is achieved

- Manual: By AE Lock button

Shutter

✦ **Type:** Vertical-travel, mechanical, focal-plane shutter with all speeds electronically-controlled

✦ **Shutter Speeds:** 1/8000 to 30 sec. (1/3-stop increments), X-sync at 1/200 sec.

✦ **Shutter Release:** Soft-touch electromagnetic release

✦ **Self-timer:** 10 sec. delay

✦ **Remote Control:** Remote control with N3 type terminal

External Speedlite

✦ **EOS External Flash or Dedicated Speedlites:** E-TTL II autoflash with EX-series Speedlite

✦ **PC Terminal:** Provided

Drive System

✦ **Drive Modes:** Single, Continuous (approx. 3 frames per second [fps]), Self-timer

✦ **Continuous Shooting Speed:** Approx. 3 fps (at 1/250 sec. or faster for all recording quality settings)

✦ **Max. Burst During Continuous Shooting:** JPEG: Approx. 60 frames (JPEG/Large)

✦ **RAW:** Approx. 17 frames

✦ **RAW+JPEG:** Approx. 12 frames

LCD Monitor

✦ **Type:** TFT color liquid-crystal monitor

✦ **Screen Monitor size:** 2.5 in

✦ **Pixels:** Approx. 230,000

✦ **Coverage:** 100% for JPEG images

✦ **Brightness Control:** 5 levels provided

Playback

✦ **Image Display Format:**

- Single image

- 9-image index

- Magnified zoom (approx. 1.5× to 10×)

- Auto play

- Auto play right after shooting

- Rotated

- Jump

✦ **Highlight Alert:** In the single image (INFO) mode, the highlight portions containing no image information will blink

Image Protection and Erase

✦ **Protection:** A single image can be protected or unprotected

✦ **Erase:** A single image or all images stored in a CF card can be erased if they are unprotected

✦ **Direct Printing from the Camera:** Enabled

✦ **Compatible Printers:** CP Direct, Inkjet Direct, and PictBridge-compatible printers

✦ **Settings:Printable images:** JPEG images (Print ordering enabled with DPOF version 1.1)

Power Source

✦ **Battery:** One Battery Pack BP-511A/BP-514/BP-511/BP-512

✦ **Number of Shots:**

• Approx. 800 (68°F/20°C)

• Approx. 400 (32°F/0°C)

 The above figures comply with CIPA standard and apply when a fully-charged Battery Pack BP-511A is used.

✦ **Battery Check:** Automatic

✦ **Power Saving:** Provided. Power turns off after 1, 2, 4, 8, 15, 30 min

✦ **Back-up Battery:** One CR2016 Lithium Battery

Dimensions and Weight

✦ **Dimensions (W x H x D):** 6.0 × 4.4 × 3.0 in/152 × 113 × 75mm

✦ **Weight:** 28.6 oz/810 g (Body only. Battery: 2.9 oz/82 g)

Operating Environment

✦ **Operating Temperature Range:** 32-104°F/0-40°C

✦ **Operating Humidity Range:** 85% or less

Glossary

A **E** Automatic exposure.

AE Lock Auto Exposure Lock. A camera mode that lets the photographer lock the exposure from a meter reading. After the exposure is locked, the photographer can then recompose the image.

AF Lock Auto Focus Lock. A camera mode that locks the focus on a subject and allows the photographer to recompose the image without the focus changing. Usually activated by pressing the Shutter button halfway down.

Ambient light The natural or artificial light within a scene. Also called available light.

Angle of view The amount or area seen by a lens or viewfinder, measured in degrees. Shorter or wide-angle lenses and zoom settings have a greater angle of view. Longer or telephoto lenses and zoom settings have a narrower angle of view.

Aperture The lens opening through which light passes. Aperture size is adjusted by opening or closing the diaphragm. Aperture is expressed in f/numbers such as f/8, f/5.6, and so on.

Aperture-Priority (Av Aperture-Priority AE) A semiautomatic camera mode in which the photographer sets the aperture (f-stop), and the camera automatically sets the shutter speed for correct exposure.

Artifact An unintentional or unwanted element in an image caused by an imaging device or appearing as a byproduct of software processing such as compression, flaws from compression, color flecks, and digital noise.

Artificial light The light from an electric light or flash unit. The opposite of natural light.

Autofocus The camera automatically focuses on the subject using the selected autofocus point shown in the viewfinder, or tracks a subject in motion and creates a picture with the subject in sharp focus. Pressing the Shutter button halfway down activates autofocus.

Automatic exposure The camera meters the light in the scene and automatically sets the shutter speed (ISO) and aperture necessary to make a properly exposed picture.

Automatic flash When the camera determines that the existing light is too low to get either a good exposure or a sharp image, it automatically fires the built-in flash unit.

Av Abbreviation for Aperture Value that indicates f-stops. Also used to indicate Aperture-Priority mode.

AWB (Automatic White Balance) A White Balance setting where the camera determines the color temperature automatically.

Axial chromatic aberration A lens phenomena that bends different color light rays at different angles, thereby focusing them on different planes. Axial chromatic aberration shows up as color blur or flare.

Backlighting Light that is behind and pointing to the back of the subject.

Barrel distortion A lens aberration resulting in a bowing of straight lines outward from the center.

Bit depth The number of bits (the smallest unit of information used by computers) used to represent each pixel in an image that determines the image's color and tonal range.

Blocked up Describes areas of an image lacking detail due to excess contrast.

Blooming Bright edges or halos in digital images around light sources, and bright reflections caused by an oversaturation of image sensor photosites.

Bokeh The shape and illumination characteristics of the out-of-focus area in an image.

Bounce light Light that is directed toward an object such as a wall or ceiling so that it reflects (or bounces) light back onto the subject.

Bracket To make multiple exposures, some above and some below the average exposure calculated by the light meter for the scene. Some digital cameras can also bracket white balance to produce variations from the average white balance calculated by the camera.

Brightness The perception of the light reflected or emitted by a source. The lightness of an object or image. See also *Luminance*.

Buffer Temporary storage for data in a camera or computer.

Bulb A shutter speed setting that keeps the shutter open as long as the Shutter button is fully depressed.

Cable release An accessory that connects to the camera and allows you to trip the shutter by using the cable instead of by pressing the Shutter button.

Calibration In hardware, a method of changing the behavior of a device to match established standards, such as changing the

contrast and brightness on a monitor. In software, calibration corrects the color cast in shadows and allows adjustment of non-neutral colors that differ between an individual camera and the camera's profile used by Camera Raw.

Camera profile A process of describing and saving the colors that a specific digital camera produces so that colors can be corrected by assigning the camera profile to an image. Camera profiles are especially useful for photographers who often shoot under the same lighting conditions, such as in a studio.

Chroma noise Extraneous, unwanted color artifacts in an image.

Chromatic aberration A lens phenomena that bends different color light rays at different angles, thereby focusing them on different planes. Two types of chromatic aberration exist. Axial chromatic aberration shows up as color blur or flare. Chromatic difference of magnification appears as color fringing along high-contrast edges.

Chromatic difference of magnification Chromatic aberration that appears as color fringing where high-contrast edges show a line of color along their borders. The effect of chromatic aberration increases at longer focal lengths.

CMOS (Complementary Metal Oxide Semiconductor) The type of imaging sensor used in 5D to record images. CMOS sensors are chips that use power more efficiently than other types of recording mediums.

Color balance The color reproduction fidelity of a digital camera's image sensor and of the lens. In a digital camera, color balance is achieved by setting the white balance to match the scene's primary light source. You can adjust color balance in image-editing programs using the color Temperature and Tint controls.

Color cast The presence of one color in other colors of an image. A color cast appears as an incorrect overall color shift often caused by an incorrect white-balance setting.

Color space In the spectrum of colors, a subset of colors included in the chosen space. Different color spaces include more or fewer colors.

Color/light temperature A numerical description of the color of light measured in degrees Kelvin. Warm, late-day light has a lower color temperature. Cool, early-day light has a higher temperature. Midday light is often considered to be white light (5,000 K). Flash units are often calibrated to 5,000 K.

Compression A means of reducing file size. Lossy compression permanently discards information from the original file. Lossless compression does not discard information from the original file and allows you to re-create an exact copy of the original file without any data loss.

Contrast The range of tones from light to dark in an image or scene.

Contrasty A term used to describe a scene or image with great differences in brightness between light and dark areas.

Cool Describes the bluish color associated with higher color temperatures. Also used to describe editing techniques that result in an overall bluish tint.

Crop To trim or discard one or more edges of an image. You can crop when taking a picture by changing position (moving closer or farther away) to exclude parts of a scene, by zooming in with a zoom lens, or by using an image-editing program.

Daylight-balance General term used to describe the color of light at approximately 5,500 K — such as midday sunlight or an electronic flash.

Dedicated flash A method in which the camera measures the ambient light and determines the flash output accordingly. Also known as TTL, or Through The Lens.

Depth of field The zone of acceptable sharpness in a photo extending in front of and behind the primary plane of focus.

Diaphragm Adjustable blades inside the lens that determine the aperture.

Diffuser Material such as fabric or paper that is placed over the light source to soften the light.

DPI (Dots Per Inch) A measure of printing resolution.

Dynamic range The difference between the lightest and darkest values in an image. A camera that can hold detail in both highlight and shadow areas over a broad range of values is said to have a high dynamic range.

Exposure The amount of light reaching the light-sensitive medium — the film or an image sensor. It is the result of the intensity of light multiplied by the length of time the light strikes the medium.

Exposure compensation A camera control that allows the photographer to overexpose (the plus [+] setting) or underexpose (the minus [–] setting) images by a specified amount from the metered exposure.

Exposure meter A built-in light meter that measures the amount of light on the subject. EOS cameras use reflective meters. The exposure is shown in the viewfinder and on the LCD panel as a scale with a tick mark under it that indicates ideal exposure, overexposure, and underexposure.

Extender An attachment that fits between the camera body and the lens to increase the focal distance of the lens.

Extension tube A hollow ring attached between the camera lens mount and the lens that increases the distance between the optical center of the lens and the sensor, and decreases the minimum focusing distance.

F-number A number representing the maximum light-gathering ability of a lens or the aperture setting at which a photo is taken. It is calculated by dividing the focal length of the lens by its diameter. Wide apertures are designated with small numbers, such as f/2.8. Narrow apertures are designated with large numbers, such as f/22. See also *Aperture*.

F-stop See *F-number* and *Aperture*.

Fast Refers to film, digital camera settings, and photographic paper that have high sensitivity to light. Also refers to lenses that offer a very wide aperture, such as f/1.4, and to a short shutter speed.

File format The form (data structure) in which digital images are stored, such as JPEG, TIFF, RAW, and so on.

Filter A piece of glass or plastic that is usually attached to the front of the lens to alter the color, intensity, or quality of the light. Filters also are used to alter the rendition of tones, reduce haze and glare, and create special effects such as soft focus and star effects.

Fisheye lens A lens with a 180-degree angle of view.

Flare Unwanted light reflecting and scattering inside the lens, causing a loss of contrast and sharpness and/or artifacts in the image.

Flat Describes a scene, light, photograph, or negative that displays little difference between dark and light tones. The opposite of contrasty.

Fluorite A lens material with an extremely low index of refraction and dispersion when compared to optical glass. Fluorite features special partial dispersion characteristics that allow almost idea correction of chromatic aberrations when combined with optical glass.

Focal length The distance from the optical center of the lens to the focal plane when the lens is focused on infinity. The longer the focal length is, the greater the magnification.

Focal point The point on a focused image where rays of light intersect after reflecting from a single point on a subject.

Focus The point at which light rays from the lens converge to form a sharp image. Also the sharpest point in an image achieved by adjusting the distance between the lens and image.

Frame Used to indicate a single exposure or image. Also refers to the edges around the image.

Front light Light that comes from behind or beside the camera to strike the front of the subject.

Ghosting A type of flare that causes a clearly defined reflection to appear in the image symmetrically opposite to the light source, creating a ghost-like appearance. Ghosting is caused when the sun or a strong light source is included in the scene and a complex series of reflections among the lens surfaces occurs.

Gigabyte The usual measure of the capacity of digital mass storage devices; slightly more than 1 billion bytes.

Grain See *Noise*.

Gray-balanced The property of a color model or color profile where equal values of red, green, and blue correspond to a neutral gray value.

Gray card A card that reflects a known percentage of the light that falls on it. Typical grayscale cards reflect 18 percent of the light. Gray cards are standard for taking accurate exposure-meter readings and for providing a consistent target for color balancing during the color correction process using an image-editing program.

Grayscale A scale that shows the progression of tones from black to white using tones of gray. Also refers to rendering a digital image in black, white, and tones of gray. Also known as monochrome.

Highlight A term describing a light or bright area in a scene, or the lightest area in a scene.

Histogram A graph that shows the distribution of tones in an image.

Hot shoe A camera mount that accommodates a separate external flash unit. Inside the mount are contacts that transmit information between the camera and the flash unit and that trigger the flash when the Shutter button is pressed.

Hue The dominant wavelength of a color. A color system measures color by hue, saturation, and luminance. The hue is the predominant color.

ICC profile A standard format data file defined by the ICC (International Color Consortium) describing the color behavior of a specific device. ICC profiles maintain consistent color throughout a color-managed workflow and across computer platforms.

Image Stabilization A technology that counteracts hand motion when handholding the camera at slow shutter speeds or when using long lenses.

Infinity The farthest position on the distance scale of a lens (approximately 50 feet and beyond).

ISO (International Organization for Standardization) A rating that describes the sensitivity to light of film or an image sensor. ISO in digital cameras refers to the amplification of the signal at the photosites. Also commonly referred to as film speed. ISO is expressed in numbers, such as ISO 125. The ISO rating doubles as the sensitivity to light doubles. ISO 200 is twice as sensitive to light as ISO 100.

JPEG (Joint Photographic Experts Group) A lossy file format that compresses data by discarding information from the original file.

Kelvin A scale for measuring temperature based around absolute zero. The scale is used in photography to quantify the color temperature of light.

LCD (Liquid Crystal Display) Commonly used to describe the image screen on digital cameras.

Lightness A measure of the amount of light reflected or emitted. See also *Brightness* and *Luminance*.

Linear A relationship where doubling the intensity of light produces double the response, as in digital images. The human eye does not respond to light in a linear fashion. See also *Nonlinear*.

Lossless A term that refers to file compression that discards no image data. TIFF is a lossless file format.

Lossy A term that refers to compression algorithms that discard image data, often in the process of compressing image data to a smaller size. The higher the compression rate, the more data that's discarded and the lower the image quality. JPEG is a lossy file format.

Luminance The light reflected or produced by an area of the subject in a specific direction and measurable by a reflected light meter.

Manual mode A camera mode in which you set both the aperture and the shutter speed.

Megabyte Slightly more than 1 million bytes.

Megapixel A measure of the capacity of a digital image sensor. One million pixels.

Memory card In digital photography, removable media that stores digital images, such as the CompactFlash media used to store 5D images.

Metadata Data about data, or more specifically, information about a file. Data embedded in image files by the camera includes aperture, shutter speed, ISO, focal length, date of capture, and other technical information. Photographers can add additional metadata in image-editing programs, including name, address, copyright, and so on.

Middle gray A shade of gray that has 18 percent reflectance.

Midtone An area of medium brightness; a medium gray tone in a photographic print. A midtone is neither a dark shadow nor a bright highlight.

Mode dial The large dial on the top right of the camera that allows you to select shooting modes in the Basic and Creative Zones.

Moiré Bands of diagonal distortions in an image caused by interference between two geometrically regular patterns in a scene or between the pattern in a scene and the image sensor grid.

Neutral density filter A filter attached to the lens or light source to reduce the required exposure.

Noise Extraneous visible artifacts that degrade digital image quality. In digital images, noise appears as multicolored flecks, also referred to as grain. Grain is most visible in high-speed digital images captured at high ISO settings.

Nonlinear A relationship where a change in stimulus does not always produce a corresponding change in response. For example, if the light in a room is doubled, the room is not perceived as being twice as bright. See also *Linear*.

Normal lens or zoom setting A lens or zoom setting whose focal length is approximately the same as the diagonal measurement of the film or image sensor used. In 35mm format, a 50 to 60mm lens is considered to be a normal lens. A normal lens more closely represents the perspective of normal human vision.

Open up To switch to a lower f-stop, which increases the size of the diaphragm opening.

Optical zoom Subject magnification that results from adjusting the optical elements in the lens.

Overexposure Exposing film or an image sensor to more light than is required to make an acceptable exposure. The resulting picture is too light.

Panning A technique of moving the camera horizontally to follow a moving subject, which keeps the subject sharp but creates a creative blur of background details.

Photosite The place on the image sensor that captures and stores the brightness value for one pixel in the image.

Pincushion distortion A lens aberration causing straight lines to bow inward toward the center of the image.

Pixel The smallest unit of information in a digital image. Pixels contain tone and color that can be modified. The human eye merges very small pixels so they appear as continuous tones.

Plane of critical focus The most sharply focused part of a scene. Also referred to as the point of sharpest focus.

Polarizing filter A filter that reduces glare from reflective surfaces such as glass or water at certain angles.

PPI (Pixels Per Inch) The number of pixels per linear inch on a monitor or image file. Used to describe overall display quality or resolution.

Prime lens A lens with a fixed focal length.

RAM (Random Access Memory) The memory in a computer that temporarily stores information for rapid access.

RAW A proprietary file format that has little or no in-camera processing. Processing RAW files requires special image-conversion software such as Adobe Camera Raw. Because image data has not been processed, you can change key camera settings, including exposure and white balance, in the conversion program after the picture is taken.

Reflected light meter A device—usually a built-in camera meter—that measures light emitted by a photographic subject.

Reflector A surface, such as white cardboard, used to redirect light into shadow areas of a scene or subject.

Resampling A method of averaging surrounding pixels to add to the number of pixels in a digital image. Sometimes used to increase resolution of an image in an image-editing program to make a larger print from the image.

Resolution The number of pixels in a linear inch. Resolution is the amount of information present in an image to represent detail in a digital image. Also the resolution of a lens that indicates the capacity of reproduction of a subject point of the lens. Lens resolution is expressed as a numerical value

such as 50 or 100 lines, which indicates the number of lines per millimeter of the smallest black and white line pattern that can be clearly recorded.

RGB (Red, Green, Blue) A color model based on additive primary colors of red, green, and blue. This model is used to represent colors based on how much light from each color is required to produce a given color.

Ring flash A flash unit with a circular light that fits around the lens or to the side and produces virtually shadowless lighting.

Saturation As it pertains to color, a strong pure hue undiluted by the presence of white, black, or other colors. The higher the color purity is, the more vibrant the color.

Sharp The point in an image at which fine detail and textures are clear and well defined.

Sharpen A method in image editing of enhancing the definition of edges in an image to make it appear sharper. See also *Unsharp mask*.

Shutter A mechanism that regulates the amount of time during which light is let into the camera to make an exposure. Shutter time or shutter speed is expressed in seconds and fractions of seconds such as 1/30 second.

Shutter-Priority (Tv Shutter-Priority AE) A semiautomatic camera mode that allows the photographer to set the shutter speed and the camera to automatically set the aperture (f-number) for correct exposure.

Side lighting Light that strikes the subject from the side.

Silhouette A scene where the background is much more brightly lit than the subject.

Slave A means of synchronizing one flash unit to another so that one controls the other.

Slow Refers to film, digital camera settings, and photographic paper that have low sensitivity to light, requiring relatively more light to achieve accurate exposure. Also refers to lenses that have a relatively wide aperture, such as f/3.5 or f/5.6, and to a long shutter speed.

SLR (Single Lens Reflex) A type of camera that enables the photographer to see the scene through the lens that takes the picture. A reflex mirror reflects the scene through the viewfinder. The mirror retracts when the Shutter button is pressed.

Speed Refers to the relative sensitivity to light of photographic materials such as film, digital camera sensors, and photo paper. Also refers to the ISO setting, and the ability of a lens to let in more light by opening the lens to a wider aperture.

Spot meter A device that measures reflected light or brightness from a small portion of a subject.

sRGB A color space that encompasses a typical computer monitor.

Stop See *Aperture*.

Stop down To switch to a higher f-stop, thereby reducing the size of the diaphragm opening.

Telephoto A lens or zoom setting with a focal length longer than 50 to 60mm in 35mm format.

Telephoto effect The effect a telephoto lens creates that makes objects appear to be closer to the camera and to each other than they really are.

TIFF (Tagged Image File Format) A universal file format that most operating systems and image-editing applications can read. Commonly used for images, TIFF supports 16.8 million colors and offers lossless compression to preserve all the original file information.

Tonal range The range from the lightest to the darkest tones in an image.

Top lighting Light, such as sunlight at midday, that strikes a subject from above.

TTL (Through The Lens) A system that reads the light passing through a lens that will expose film or strike an image sensor.

Tungsten lighting Common household lighting that uses tungsten filaments. Without filtering or adjusting to the correct white-balance settings, pictures taken under tungsten light display a yellow-orange color cast.

UD (Ultra-low dispersion) lens A lens made of special optical glass processing optical characteristics similar to fluorite. UD lenses are effective in correcting chromatic aberrations in super-telephoto lenses.

Underexposure Exposing film or an image sensor to less light than required to make an accurate exposure. The picture is too dark.

Unsharp mask In digital image editing, a filter that increases the apparent sharpness of the image. The Unsharp mask filter cannot correct an out-of-focus image. See also *Sharpen*.

Value The relative lightness or darkness of an area. Dark areas have low values, and light areas have high values.

Viewfinder A viewing system that allows the photographer to see all or part of the scene that will be included in the final picture. Some viewfinders show the scene as the lens sees it. Others show approximately the area that will be captured in the image.

Vignetting Darkening of edges on an image that can be caused by lens distortion, using a filter, or using the wrong lens hood. Also used creatively in image editing to draw the viewer's eye toward the center of the image.

Warm Reddish colors often associated with lower color temperatures. See also *Kelvin*.

White balance The relative intensity of red, green, and blue in a light source. On a digital camera, white balance compensates for light that is different from daylight to create correct color balance.

Wide angle Describes a lens with a focal length shorter than 50 to 60mm in full-frame 35mm format.

Index

NUMBERS

8-bit images, 17–18, 20–21, 235
12-bit images, 20–21, 235
16-bit images, 18–21, 235
24-bit images, 235
32-bit images, HDR imaging, 46–47
35-zone TTL, metering mode, 38
220EX Speedlite, 134–137
430EX Speedlite, 134–137
580EX II Speedlite, 134, 136–137, 142

A

AC Adapter Kit (ACK-E2), 9–10, 243
Access lamp, rear panel control, 8
accessories
 event photography gear, 151–152
 EX-series Speedlites, 131–144
 lens, 128–129
 nature/landscape/travel photography gear,
 162–166
 portrait photography gear, 187–189
 stock/editorial photography gear, 207–209
 wedding photography gear, 220–222, 231
Add original decision data (C.Fn-20), 99–100
additive color model, bit depth, 235
Adobe Bridge
 IPTC templates, 242
 metadata, 16
 RAW format, 238
Adobe Lightroom, RAW format conversion, 236
Adobe RGB color space, 67–69
Adobe's Camera RAW, 236–239
advertising campaigns, 159
AE (Automatic Exposure), 8–9, 257
AE Bracketing (AEB), viewfinder display, 13–14
AE Lock (Auto Exposure Lock)
 event photography, 153
 pros/cons, 43–45
 viewfinder display element, 13–14
AE Lock button
 AE Lock enabling, 45
 rear panel control, 8–9
AE Lock/FE Lock/Index button, 61
AEB (AutoExposure Bracketing), 13–14, 45–47
aerial shots, nature/landscape/travel
 photography, 160

AF assist beam (C.Fn-05), 92–93
AF Lock (Auto Focus Lock), 257
AF mode/White balance button, 5, 7
AF point activation area (C.Fn-17), 98–99
AF point selection button, 7, 8–9
AF point selection method (C.Fn-13), 96–97
AF point selection, Shutter button, 7
AF point selection/Enlarge button, 32–34, 60
AF points
 35-zone TTL metering, 38
 AF performance enhancements, 37
 cross-type, 33
 Full Auto mode settings, 24–25
 manually selecting, 32–34
 viewfinder display element, 13–14
AF Stop button, EF IS telephoto lenses, 117
AF/MF (Autofocus/Manual Focus) switch, lens
 control, 11–12
AF-WB button
 color temperature settings, 73–74
 custom white balance settings, 77
 preset white balance settings, 73
 specifying a color temperature, 80–81
AI Focus AF mode, autofocus mode, 34–35
AI Focus, Full Auto mode settings, 24
AI Servo AF mode, autofocus mode, 34–35
airlines, carry-on regulations, 162
AL (aspherical elements), lens designation, 115
albums, wedding photography, 220
ambient light, 195–196, 257
angle of view
 defined, 257
 normal lens, 123
 wide-angle lens, 120–121
Aperture Value (Av), 258
Aperture-Priority (Av Aperture-Priority AE)
 defined, 257
 semiautomatic mode, 23, 29–30
apertures
 AF performance enhancements, 37
 Av (Aperture-Priority AE) mode, 29–30
 defined, 257
 depth-of-field previews, 9–10
 viewfinder display element, 13–14
 wide-angle lens, 121
Apple iPhoto, wedding albums, 220

artifacts, 257
artificial light, 257
aspherical elements (AL), L-series lenses, 115
AsukaBook, wedding albums, 220
auditoriums, event photography, 154
auto bracketing, white balance, 77–78
Auto Exposure (AE), AE Lock button, 8–9
Auto Exposure Lock (AE Lock)
　　event photography, 153
　　JPEG format, 43
　　pros/cons, 43–45
Auto Focus Lock (AF Lock), 257
Auto Playback, image slide show, 61
Auto Reset, file numbering system, 21–22
AutoExposure Bracketing (AEB), 45–47
autofocus, 36–37, 258
autofocus modes, 34–35
auto-ISO, Full Auto mode settings, 24
Automatic Exposure (AE), 257
automatic exposure, 258
Automatic White Balance (AWB), 73, 258
auxiliary lights, Speedlite use, 142–143
Av (Aperture Value), 258
Av (Aperture-Priority AE) mode, 23, 29–30
Av, Mode dial control, 5
award ceremony, event photography, 148
AWB (Automatic White Balance), 34, 73, 258
axial chromatic aberration, 258

B

B (Bulb) mode, use guidelines, 23, 30–31
B&H Photo Video, focusing screens, 34–36
backfocusing, 37
backgrounds, 152, 208
backlighting, 258
backlights, LCD panel illumination, 5
backups, image workflow element, 241
banding noise, 51
barrel distortion, 258
batteries
　　CR2016, 11
　　date/time, 11–12
　　event photography, 151
　　firmware update, 243–244
　　nature/travel/landscape photography, 165
　　portrait photography, 188
　　sensor cleaning, 65
　　stock/editorial photography, 208
　　wedding photography, 222
battery compartment, 9–12
bit depth
　　defined, 20–21, 258
　　RGB color model, 235

blocked up, 258
blooming, 258
bokeh, 120, 258
bottom panel controls, 11–12
bounce flash, 142, 154
bounce light, 258
bound albums, wedding photography, 220
Bracket sequence/Auto cancel (C.Fn-09), 94–95
bracket, 258
bracketing, AEB (AutoExposure Bracketing), 45–47
bridal magazines, wedding photography, 216
brightness, 258
brightness histogram, exposure evaluation, 40–41
brightness levels, 8-bit/12-bit image comparison, 235
brushes, 189, 231
Bubble Jet Direct, printer support, 11
buffer, 258
Bulb (B) mode, use guidelines, 23, 30–31
bulb, 258

C

C (Camera Settings) mode
　　customizable mode, 23, 31
　　event photography, 153–154
　　Mode dial control, 5
　　nature/travel/landscape photography, 168
　　portrait photography, 192
　　registering camera settings, 105–108
　　stock/editorial photography, 209–210
C.Fn-00: Focusing screen, 101
C.Fn-01: Set function when shooting, 90
C.Fn-02: Long exp. noise reduction, 91
C.Fn-03: Flash sync speed in Av mode, 91, 141
C.Fn-04: Shutter/AE Lock button, 92
C.Fn-05: AF assist beam, 92–93
C.Fn-06: Exposure level increments, 92–93
C.Fn-07: Flash firing, 93, 141
C.Fn-08: ISO expansion, 94
C.Fn-09: Bracket sequence/Auto cancel, 94–95
C.Fn-10: Superimposed display, 95
C.Fn-11: Menu button display position, 95–96
C.Fn-12: Mirror lockup, 96
C.Fn-13: AF-point selection method, 96–97
C.Fn-14: E-TTL II, 97, 141
C.Fn-15: Shutter curtain sync, 97–98, 151
C.Fn-16: Safety shift in Av or Tv, 98
C.Fn-17: AF-point activation area, 98–99
C.Fn-18: LCD displ -> Return to shoot, 99
C.Fn-19: Lens AF Stop button function, 99–100
C.Fn-20: Add original decision data, 99–100
cable release, 258
calibration, 258–259

camera bodies
 event photography, 151
 nature/travel/landscape photography, 163
 portrait photography, 188
 stock/editorial photography, 208
 wedding photography, 221
camera profile, 259
camera rotation devices, wedding photography, 222
Camera Settings (C) mode
 customizable mode, 23, 31
 event photography, 153–154
 Mode dial control, 5
 nature/travel/landscape photography, 168
 portrait photography, 192
 registering camera settings, 105–108
 stock/editorial photography, 209–210
candid shots, wedding photography, 231
Canon 250D/500D series close-up lenses, 129
Canon Digital Photo Professional, metadata, 16
Canon dSLRs, DiG!C II image processor, 250
Canon Ee Black Mask Focusing Screen Set, 34–36
Canon Ee Crop Line, focusing screens, 34–36
Canon EF 1.4 II extender, 128–129
Canon EF 2x 11 extender, 128–129
Canon EF12 II extension tube, 129
Canon EF25 II extension tube, 129
Canon EOS 5D
 CMOS sensors, 248–250
 Custom Functions, 89–102
 default image settings, 109
 default shooting settings, 108
 EF-S lens incompatibility, 10, 113
 firmware updates, 243–244
 image sensor cleaning, 64–66
 registering camera settings, 105–108
 restoring default settings, 63–64
 specifications, 251–255
 supported printers, 11
 TV connections, 11
Canon Speedlite System Digital Field Guide
 (J. Dennis Thomas), 144
Canon's Digital Photo Professional (DPP), 236–241
Canon's Digital Professional, 236–241
card readers, CF card folder creation, 23
catchlights, 142
CCD (Charged-Coupled Device) sensors, 248–249
celestial shots, B (Bulb) mode, 30–31
cell phones, nature/travel/landscape photography, 166
Center-weighted Average metering, exposure calculation method, 39
ceremony shots, wedding photography, 225–227

CF (CompactFlash) Card slot, 11–12
CF card eject button, side panel access, 11–12
CF card error warning (Err CF), 13
CF card full warning (Full CF), viewfinder, 13
CF Card slot, side panel access, 11–12
CF (CompactFlash) cards
 Access lamp, 8
 creating folders, 22–23
 disabling Shoot w/o card, 57
 erasing images, 61–62
 event photography, 151
 file numbering systems, 19–22
 firmware update, 243–244
 formatting frequency, 62
 nature/travel/landscape photography, 165
 portrait photography, 188
 protecting images, 62–63
 speed ratings, 56
 stock/editorial photography, 208
 wedding photography, 222
Charged-Coupled Device (CCD) sensors, 248–249
charity events, 148
chroma noise, 259
chromatic aberration, 259
chromatic difference of magnification, 259
circle of confusion, depth of field, 179
circular polarizer, wedding photography, 222
Clear settings screen, restoring default settings, 63–64
click-balancing, color testing, 74
close-up lens, 129
close-up shots, Self-timer mode, 55–56
CMOS (Complementary Metal Oxide Semiconductor), 248–250, 259
color balance, 259
color cast, 259
color space
 Adobe RGB versus sRGB, 67–69
 Av (Aperture-Priority AE) mode, 30
 defined, 259
 Full Auto mode settings, 24
 ICC (International Color Consortium) profiles, 69
 selecting, 69–70
 Tv (Shutter-Priority AE) mode, 27
Color temp control, 73–74, 80–81
color temperatures
 Kelvin scale, 70–71
 measurement techniques, 76
 specifying, 80–81
 white balance settings, 73–74
color tones, Picture Styles adjustments, 83
color/light temperature, 259

combs, portrait photography, 189
commands
 Playback menu, 15
 Set-up menu, 15–16
 Shooting menu, 14
Compact Battery Pack (CP-E4), 222
CompactFlash (CF) Card slot, 11–12
compensators, zoom lenses, 119
Complementary Metal Oxide Semiconductor
 (CMOS) , 248–250, 259
compression
 defined, 259
 JPEG file format, 17–18
 RAW format, 18–19
computers
 CF card folder creation, 22–23
 event photography, 151
 nature/travel/landscape photography, 166
 portrait photography, 189
 stock/editorial photography, 208
 wedding photography, 222
concerts, event photography, 148
conference rooms, event photography, 154
contact sheets, index display, 60–61
Continuous mode, AEB (AutoExposure
 Bracketing), 46
Continuous numbering, 19, 22
Continuous Shooting mode, burst rates, 54–55
contrast, 83, 259
contrasty, 259
controls
 bottom panel, 11–12
 front panel, 9–10
 function groupings, 4
 lens, 11–13
 rear panel, 7–9
 side panel, 10–11
 top panel, 4–7
 viewfinder display elements, 13–14
conventions, event photography, 148
cool, 259
copyrights, image protection, 242
cosmetic bags, 189, 231
CP Direct, printer support, 11
CR2 file formats, RAW files, 18–19
CR2016 battery, estimated life, 11
Create folder screen, 23
crop, 260
cross lighting, nature/travel/landscapes, 180
cross-type sensors, AF points, 33
Custom Functions
 C.Fn-00: Focusing screen, 101
 C.Fn-01: Set function when shooting, 90

C.Fn-02: Long exp. noise reduction, 91
C.Fn-03: Flash sync speed in Av mode, 91, 141
C.Fn-04: Shutter/AE Lock button, 92
C.Fn-05: AF assist beam, 92–93
C.Fn-06: Exposure level increments, 92–93
C.Fn-07: Flash firing, 93, 141
C.Fn-08: ISO expansion, 94
C.Fn-09: Bracket sequence/Auto cancel, 94–95
C.Fn-10: Superimposed display, 95
C.Fn-11: Menu button display position, 95–96
C.Fn-12: Mirror lockup, 96
C.Fn-13: AF-point selection method, 96–97
C.Fn-14: E-TTL II, 97, 141
C.Fn-15: Shutter curtain sync, 97–98, 141
C.Fn-16: Safety shift in Av or Tv, 98
C.Fn-17: AF-point activation area, 98–99
C.Fn-18: LCD displ -> Return to shoot, 99
C.Fn-19: Lens AF Stop button function, 99–100
C.Fn-20: Add original decision data, 99–100
 control groupings, 4
 FP flash (high-speed flash sync), 141
 landscape/nature set sample, 103–104
 restoring default settings, 101–102
 setting, 101
 wedding set sample, 102–103, 105
Custom Functions screen, settings, 101
Custom WB screen, settings, 76
custom white balance, 153, 191–192

D

databases, workflow element, 242
date formats, date/time settings, 16–17
date/time battery, estimated life, 11
date/time, settings, 14, 16–17
day, date/time settings, 16–17
daylight-balance, 260
DC coupler cord hole, 9–10
DCIM folder, 23
dedicated flash, 260
depth of field
 circle of confusion, 179
 defined, 260
 macro lens, 124
 nature/travel/landscape photography, 178–179
 previewing in the viewfinder, 9–10
 telephoto lens, 122
 wide-angle lens, 121
Depth-of-field preview button, 9–10
Detail set screen
 Picture Style parameter editing, 86
 user-defined Picture Styles, 88
detail shots, wedding photography, 227–228
diaphragm, 260

diffractive optics (DO), lenses, 117
diffused light, 173, 190–191
diffuser, 260
DiG!C II image processor, 250
digital noise, 51, 263
Digital Photo Professional (DPP)
 RAW format conversion, 236–241
 selecting/rejecting images, 242
Digital Professional Pro, RAW, 236–241
Digital terminal, printer connections, 11
dioptric adjustment knob, rear panel control, 9
Distance scale, lens control, 12–13
distortion
 normal lens, 123
 TS-E (Tilt-and-Shift) lenses, 121, 125
 wide-angle lens, 121
DO (diffractive optics), lenses, 117
Dots Per Inch (DPI), 260
Drive mode/ISO selection button, 5
drive modes
 Av (Aperture-Priority AE) mode, 30
 Continuous mode, 54–55
 Full Auto mode settings, 24
 Self-Timer mode, 55–56
 Single Shooting mode, 54
 Tv (Shutter-Priority AE) mode, 27
Drive-ISO button, 53–54, 56
driver's license, nature/travel/landscapes, 166
dust/water-resistant construction, L-series lenses,
 116
dynamic range, 40, 260

E

early morning light, nature/travel/landscapes, 170
editorial photography
 assignment aspect, 205
 backup gear, 212
 camera familiarity, 213
 day rates, 213
 economic opportunity, 203–205
 editor coordination, 211
 gear bag contents, 207–209
 innovative conceptual approach, 203–204
 leave space for text 211
 lifestyle images, 203
 model releases, 212
 niche content opportunity, 205
 resources, 206–207
 shooting techniques, 209–213
Ee-A (Standard Precision Matte), 35
Ee-D (Precision Matte w/Grid), 36
Ee-S (Super Precision Matte), 36
EF (Electro-Focus) lens mount, 114

EF extenders, AF performance enhancements, 37
EF Lens mount index, 9–10
EF lens mount, Lens release button, 9–10
effects, Monochrome Picture Style, 88
EF-S lenses, Canon EOS 5D incompatibility, 10, 113
Electro-Focus (EF) lens mount, 114
e-mail, sRGB color space images, 68
Enlarge button, 7, 8–9
Erase button, 8, 62
Err CF (CF card error warning), 13
E-TTL II (C.Fn-14), 97
Evaluative metering, 38, 175
Evaluative mode, Full Auto mode settings, 24
Evaluative Through-The-Lens II (E-TTL II), 131–133
event photography
 art director rapport, 148
 assignment expectations, 155
 award ceremonies, 148
 backup gear, 155
 camera familiarity, 156
 conventions, 148
 creative variations, 155
 gear bag contents, 151–152
 marketing opportunity, 147
 model releases, 156
 one-of-a-kind images, 147
 on-site printing, 148
 pre-planning, 155
 P (Program AE) mode, 26
 resources, 149–150
 shooting techniques, 153–157
 sports circuits, 147
 traditional shots, 155
everyday shots, Av (Aperture-Priority AE) mode,
 29–30
EXIF. *See* metadata
ExpoDisc, click-balancing, 74
Exposure Compensation
 defined, 260
 nature/travel/landscape photography, 175
 pros/cons, 47–49
 viewfinder display element, 13–14
Exposure level increments (C.Fn-06), 92–93
exposure level indicator, 13–14
Exposure Level Meter, 46, 49
exposure meter, 260
exposures
 AE Lock (Auto Exposure Lock), 43–45
 AEB (AutoExposure Bracketing), 45–47
 defined, 260
 Exposure Compensation, 47–49
 histogram evaluations, 40–42
 JPEG format, 43

Continued

exposures *(continued)*
 metering modes, 38–39
 nature/travel/landscape photography,
 174–177
 RAW format, 43, 234
 Shutter button control, 7
 Tv (Shutter-Priority AE) mode, 26–28
 viewfinder display element, 13–14
EX-series Speedlites. *See also* Speedlites
 220EX, 134–137
 430EX, 134–137
 580EX II, 134, 136–137, 142
 comparison tables, 136–139
 E-TTL II technology, 131–133
 event photography, 151
 high-speed sync flash, 132–133
 MR-14EX (Macro Ring Lite), 135–136, 138–139
 MT-24EX (Macro Twin Lite), 135, 138–139
 selection considerations, 133–134
 ST-E2 (Speedlite Transmitter), 136, 139, 143
extenders, 128–129, 165, 260
extension tubes, 129, 165, 260
external flash, flash sync contacts, 5
eyes, catchlights, 142

F
Faithful Picture Style, 82, 84
family relationships, wedding photography, 232
family shots, wedding photography, 228–229
family snapshots, P (Program AE) mode, 26
fast, 260
FE (Flash Exposure) Lock, 13–14
FE (Flash Exposure), FE Lock button, 8–9
FE Lock (FEL) Busy display, viewfinder display, 13
FE Lock (Flash Exposure Lock), Speedlites, 140
FE Lock button, rear panel control, 8–9
FE Lock/FEB in-progress, viewfinder display, 13–14
FEB (Flash Exposure Bracketing), Speedlites, 140
FEL (FE Lock) Busy, viewfinder display, 13
file extensions, file naming conventions, 19
file formats
 .CR2, 18
 defined, 260
 JPEG versus RAW, 17–19
files
 Auto Reset numbering, 21
 batch actions, 242
 batch renaming, 241
 Continuous numbering, 19, 21
 folder naming conventions, 22–23
 image group conversions, 242
 IMG_ naming conventions, 19
 Manual Reset numbering, 21

fill flash, event photography, 154
Filter effects, Monochrome Picture Style, 88
Filter mount thread, lens control, 12
filters, 172, 261
final proofs, wedding photography, 232
fireworks, M (Manual) mode, 30–31
firmware, updates, 243–244
fisheye lens, 261
fixed-pattern noise, 51
flare, 261
flash
 bounce flash, 142
 catchlights, 142
 E-TTL II technology, 131–133
 event photography, 154
 flash sync contacts, 5
 PC terminal connections, 10–11
 portrait photography, 188
 stock/editorial photography, 208
 sync speeds, 5
 wedding photography, 222
 wireless setups, 143
flash bracket, wedding photography, 222
Flash Exposure (FE) Lock, 13–14
Flash Exposure (FE), FE Lock button, 8–9
Flash Exposure Bracketing (FEB), Speedlites, 140
Flash exposure compensation button, 5
Flash Exposure Compensation, Speedlites, 140
Flash Exposure Lock (FE Lock), Speedlites, 140
Flash firing (C.Fn-07), 93
Flash mode, viewfinder display element, 13–14
flash sync cord, PC terminal connections, 10–11
Flash sync speed in Av mode (C.Fn-03), 91
flash sync speeds, Tv (Shutter-Priority AE)
 mode, 27
flash sync, EX-series Speedlites, 132–133
flat, 261
floating systems, lenses, 116
fluorescent lighting, preset white balance, 71
fluorite, 261
f-number, 260
focal length, 37, 261
focal point, 261
focus
 AutoFocus modes, 31–37
 backfocusing, 37
 defined, 261
 focusing distance range selection switch, 12–13
 nature/travel/landscape photography, 177
 Shutter button control, 7
Focus conformation light, 13–14
Focus mode switch, lens control, 12

focus modes
 Av (Aperture-Priority AE) mode, 30
 Full Auto mode settings, 24
 Tv (Shutter-Priority AE) mode, 27
focus preset, lenses, 117
Focusing distance range selection switch, 12–13
Focusing ring, lens control, 12–13
Focusing screen
 C.Fn-00, 101
 Ee-A (Standard Precision Matte), 35
 Ee-D (Precision Matte w/Grid), 36
 Ee-S (Super Precision Matte), 36
 viewfinder display element, 13
folders
 Continuous numbering system limitations, 22
 creating, 22–23
 naming conventions, 22–23
 numbering systems, 19–22
formal portraits, wedding photography, 228–229
Format screen, formatting CF cards, 62
FP flash (high-speed flash sync), Speedlites, 141
frame, 261
front light, 261
front panel controls
 DC coupler cord hole, 9–10
 Depth-of-field preview button, 9–10
 EF Lens mount index, 9–10
 Lens contacts, 9–10
 Lens lock pin, 9–10
 Lens release button, 9–10
 Mirror, 9–10
 Self-timer lamp, 9–10
f-stop. See f-number; apertures
Full Auto mode
 AWB (Automatic White Balance), 73
 Mode dial control, 5
 point-and-shoot functionality, 23–25
 versus P (Program AE) mode, 25–26
Full CF (CF card full warning), 13
full-time manual focusing, lenses, 116
functions. See Custom Functions

G

gaffer's tape, nature/travel/landscapes, 166
ghosting, 261
gigabyte, 261
glue, wedding photography, 231
Golden Hour, nature/travel/landscapes, 171
GPS location devices, nature/travel/landscapes, 166
graduated neutral-density filters, 172
grain. See noise
gray card, 74, 261
gray-balance, 261

grayscale, 261
group shots
 portraits, 199–201
 weddings, 228–229
 wide-angle lens, 120

H

handheld incident light meters, 191
high-contrast lighting, 45–47
High-Dynamic Range (HDR) imaging, 46–47
highlight, 261
high-school portraits, 184–186
high-speed flash sync (FP flash), 13, 141
histograms, 40–42, 261
HMI lighting, portrait photography, 197
hot shoe, 5, 262
hue, 262

I

ICC (International Color Consortium), 69
ICC profile, 262
IDs, nature/travel/landscape photography, 166
illumination button, LCD panel, 5
image compositing, 45–47
image editors
 batch file renaming, 241
 image group conversions, 242
 IPTC templates, 242
 metadata, 16
image quality, 24, 27, 30
image sensor, cleaning, 64–66
image stabilization (IS) , 12–13, 116, 262
Image Stabilization (IS) lenses, 125–126
Image stabilizer mode switch, lens control, 12–13
Image stabilizer switch, lens control, 12–13
images
 Auto Playback, 61
 backing up, 241
 batch actions, 242
 batch file renaming, 241
 copyrights, 242
 erasing, 61–62
 file format quality issues, 20–21
 index display, 60–61
 JPEG versus RAW file format, 17–19
 jumping between, 59–60
 metadata, 16, 233
 Picture Styles, 81–88
 playback display settings, 57–59
 protecting, 62–63
 RAW format characteristics, 234–236
 single-image display, 58–59
 single-image w/shooting information, 58–59
 storage strategies, 242
 zooming, 60

IMG_, file naming conventions, 19
incident light meters, 191
incident meters, Exposure Compensation, 47
Index button, rear panel control, 8–9
index display, image viewing, 60–61
indoor shots, portrait photography, 193–199
Infinity compensation marks, lens control,
 12–13
infinity, 262
Info button, rear panel control, 7–8
inner focusing, lenses, 116
International Color Consortium (ICC), 69
International Organization for Standardization
 (ISO), 262
IPTC templates, workflow element, 242
IS (image stabilization), 12–13, 116
IS (Image Stabilization) lenses, 125–126
ISO
 Av (Aperture-Priority AE) mode, 30
 default range, 50
 digital noise, 50–51
 Drive-ISO button, 53–54
 event photography, 153
 extended range settings, 53–54
 Full Auto mode settings, 24
 range expansion, 50
 sensitivity settings, 49–54
 Tv (Shutter-Priority AE) mode, 27
ISO (International Organization for
 Standardization), 262
ISO expansion (C.Fn-08), 94
ISO selection/Drive mode button, 5

J

Joint Photographic Experts Group (JPEG) format
 AE Lock (Auto Exposure Lock), 43–45
 AEC (Auto Exposure Compensation),
 43, 47–49
 custom white balance settings, 72–73
 defined, 262
 event photography, 154
 exposure techniques, 43
 file naming conventions, 19
 histogram evaluation tools, 40–42
 nature/travel/landscape photography, 168
 stock/editorial photography, 210
 versus RAW format 17–19
 wedding photography, 218
joystick, Multi-controller, 8
Jump button
 jumping between images, 59–60
 moving between menu items, 4
 rear panel control, 7–8

K

Kelvin scale, 70–71, 262
keystoning, wide-angle lens, 121
Kodak, wedding albums, 220

L

landmarks, travel photography, 181
landscape photography
 creative vision, 167
 cross-lighting, 180
 Custom Functions sample, 103–104
 depth of field, 178–179
 exposures, 174–177
 gear bag contents, 162–166
 previsualizing the image, 180
 research, 180
 resources, 160–161
 Self-timer mode, 55–56, 180
 shooting techniques, 166–181
 side-lighting, 180
 travel-related opportunity, 159–160
 wide-angle lens, 120
Landscape Picture Style, 82, 84
landscapes, telephoto lens, 122
laptop computers
 events, 151
 nature/travel/landscapes, 166
 portraits, 189
 stock/editorial photography, 208
 weddings, 222
Large/Fine JPEG, Full Auto mode settings, 24
LCD (Liquid Crystal Display), 262
LCD displ ↻ Return to shoot (C.Fn-18), 99
LCD panel, 4–7
LCD panel button, 5–7
Lens AF Stop button function (C.Fn-19), 99–100
Lens contacts, front panel control, 9–10
lens controls, 11–13
lens hood, lens flare, 181
Lens lock pin, front panel control, 9–10
lens mount, Lens release button, 9–10
Lens mounting index, lens control, 12
Lens release button, front panel control, 9–10
lens sleeves, nature/travel/landscapes, 163
lenses
 accessories, 128–129
 AF Stop button, 117
 AL (aspherical elements) designation, 115
 bokeh characteristics, 120
 close-up, 129
 compensators, 118
 DO (diffractive optics), 117
 EF (Electro-Focus) lens mount, 114

EF-S incompatibility, 10, 113
E-TTL II support, 132
event photography, 151
extenders, 128–129
extension tubes, 129
floating system, 116
focus preset, 117
full-time manual focusing, 116
inner focusing, 116
IS (Image Stabilization), 116, 125–126
lens hood, 181
Lens release button, 9–10
L-series, 115–116
macro, 116, 124–125, 128
nature/travel/landscape photography, 165
normal, 123
portrait photography, 188
prime versus zoom, 117–120
rear focusing, 116
single-focal-length, 117–118
stock/editorial photography, 208, 210
telephoto, 122–123, 127–128
TS-E (Tilt-and-Shift), 121, 125
USM (Ultrasonic Motor), 115
variators, 119
wedding photography, 222
wide-angle, 120–122
Library of Congress, image registration, 242
light meters, reflective versus incident, 191
light stands, 151, 222
lightbox, event photography, 151
lighting
 AF performance enhancements, 36–37
 ambient light, 195–196
 cross-lighting, 180
 event photography, 154
 indoor portraits, 194–194
 loop lighting, 197
 mixed light, 195–196
 nature/travel/landscape photography, 169–173
 outdoor portraits, 189–191
 reflective versus incident light meters, 191
 side-lighting, 180
 Speedlite as auxiliary light, 142–143
 studio portraits, 197–199
 windows, 194–195
lightness, 262
linear, 262
Liquid Crystal Display (LCD), 262
Long exp. noise reduction (C.Fn-02), 91
loop lighting, portrait photography, 197
lossless compression, 18–19, 262
lossy compression, 17–18, 262

low-light shots
 AF performance enhancements, 36–37
 B (Bulb) mode, 30–31
 nature/travel/landscape photography, 177–178
 One-Shot AF mode, 34–35
L-series lenses, technologies/features, 115–116
luminance, 262

M

M (Manual mode), 5, 23, 30
macro, lens designation, 116
macro lenses
 Canon types, 128
 high magnification, 125
 shallow depth of field, 124
 wedding photography, 222
 working distance, 125
Macro Ring Lite (MR-14EX) Speedlite, 135–136, 138–139
Macro Twin Lite (MT-24EX) Speedlite, 135, 138–139
magnification
 extension tubes, 129
 macro lens, 125
Main dial
 AF point display, 13
 AF-point selection/Enlarge button, 8–9
 manually selecting AF points, 32–34
 Self-timer mode setting, 56
 top panel control, 5–7
makeup brushes, wedding photography, 231
Manual (M) mode, 5, 23, 30
manual mode, 262
Manual Reset, file numbering system, 21–22
mascara, wedding photography, 231
maximum burst, viewfinder display element, 13–14
megabyte, 262
megapixel, 262
memory card, 262
Menu button display position (C.Fn-11), 95–96
Menu button, 4, 7–8
menus
 control groupings, 4
 control selections, 4
 moving between items, 4
 Playback, 15
 Set button, 8
 Set-up, 15–17, 22–23
 Shooting, 14
metadata
 defined, 16, 263
 IPTC templates, 242
 RAW format, 233
Metering mode button, 5

metering modes
 35-zone TTL, 38
 Av (Aperture-Priority AE) mode, 30
 Center-weighted Average metering, 39
 Evaluative metering, 38
 Full Auto mode settings, 24
 Partial metering, 39
 Spot metering, 39
 Tv (Shutter-Priority AE) mode, 27
midday light, nature/travel/landscapes, 170
middle gray, 263
midtone, 263
Mirror lockup (C.Fn-12), 96
Mirror Lockup, nature/travel/landscapes, 175
Mirror, front panel control, 9–10
mixed light, indoor portraits, 195–196
Mode dial
 AEB (AutoExposure Bracketing) settings, 46
 Av (Aperture-Priority AE) mode, 23–24, 29–30
 B (Bulb) mode, 23–24, 30–31
 C (Camera Settings) mode, 23, 31
 defined, 263
 Exposure Compensation settings, 49
 Full Auto mode, 23–25
 M (Manual mode), 23–24, 30
 P (Program AE) mode, 23–26
 Shooting mode selections, 4, 5
 top panel control, 5
 Tv (Shutter-Priority AE) mode, 23–24, 26–28
model releases, 156, 212
moir(e), 263
Monochrome Picture Style, 82, 85, 88
monopods
 event photography, 151
 nature/travel/landscape photography, 165
 portrait photography, 188
 stock/editorial photography, 208
 wedding photography, 222
month, date/time settings, 16–17
moving subjects
 AI Focus AF mode, 34–35
 AI Servo AF mode, 34–35
MR-14EX (Macro Ring Lite) Speedlite, 135–136, 138–139
MT-24EX (Macro Twin Lite) Speedlite, 135, 138–139
Multi-controller
 AF point display, 13
 AF-point selection/Enlarge button, 8–9
 image zooming, 60
 manually selecting AF points, 32–34
 rear panel control, 8
 White-Balance Shift, 79
MyPublisher, wedding albums, 220

N

nail files, wedding photography, 231
natural light, nature/travel/landscapes, 169–173
nature photography
 AE Lock (Auto Exposure Lock), 43–45
 creative vision, 167
 cross-lighting, 180
 Custom Functions sample, 103–104
 depth of field, 178–179
 exposures, 174–177
 gear bag contents, 162–166
 image mood/texture/depth, 159–160
 previsualizing the image, 180
 research importance, 180
 resources, 160–162
 Self-timer mode, 55–56, 180
 shooting techniques, 166–181
 side-lighting, 180
neutral density filter, 165, 172, 263
Neutral Picture Style, 82, 84, 85
night shots
 B (Bulb) mode, 30–31
 nature/travel/landscape photography, 177–178
No CF card warning (No CF), 13
noise, 51, 263
nonlinear, 263
normal lens, 122–123
normal lens/zoom setting, 263
notebooks, nature/travel/landscape photography, 166

O

On/Off switch, 8, 49
one-light setup, portrait photography, 197
One-Shot AF mode, 34–35, 46
open up, 263
Orientation locking knob, lens control, 12
outdoor shots, 71, 189–191
overexposure, 30–31, 263

P

P (Program AE) mode, 5, 23, 25–26
panning, 12–13, 263
panoramas, M (Manual) mode, 30
Partial metering, 39, 175
passports, nature/travel/landscape photography, 166
PC terminal, flash unit connections, 10–11
people shots, travel photography, 181
perspective, 122–123
Photo District News (PDN), 186
photo labs, 68, 220

photo packages, 186, 218
Photoshop
 batch actions, 242
 HDR (High-Dynamic Range) imaging, 45–47
 ICC profile support, 69
 image group conversions, 242
 image processing, 242
 metadata, 16
Photoshop CS3, 68, 237
photosite, 263
PictBridge and Bubble Jet Direct, printer
 support, 11
PictBridge and CP Direct, printer support, 11
PictBridge, printer support, 11
Picture Style screen, 85, 87–88
Picture Style selection screen, 86–87
Picture Styles
 Faithful, 82, 84
 Landscape, 82, 84
 Monochrome, 82, 85, 87
 nature/travel/landscape photography, 166, 168
 Neutral, 82, 84
 parameter editing, 83, 85–87
 Portrait, 81, 84
 selecting, 85
 Standard, 81, 84
 user-defined, 87–88
pincushion distortion, 263
pixel, 263
Pixels Per Inch (PPI), 264
plane of critical focus, 263
plastic tarps, wedding photography, 231
Playback button
 erasing images, 62
 image display, 58–59
 index display, 61
 jumping between images, 59–60
 rear panel control, 7–8
Playback menu
 Auto Playback, 61
 commands, 15
 image review time settings, 57
 protecting images, 63
Playback mode
 AF-point selection button, 8–9
 Enlarge button, 8–9
 histogram display, 42
 histogram selections, 42
 image zooming, 60
 Index mode button, 8–9
 manually selecting AF points, 33
 Reduce mode button, 8–9
Playback tab, control groupings, 4

polarizing filter, 165, 172, 264
portable backgrounds, 152, 208
portable storage device
 event photography, 151
 nature/travel/landscape photography, 166
 portrait photography, 189
 stock/editorial photography, 208
 wedding photography, 222
portrait photography
 AE Lock (Auto Exposure Lock), 43–45
 ambient light, 195–196
 art director interaction, 201
 C (Camera Settings) mode, 192
 capturing the spirit, 183
 children's proportion, 199
 contrast for composition strength, 200
 custom white balance, 191–192
 focus on the eyes, 199
 gear bag contents, 187–189
 group arrangements, 199–201
 indoor shots, 193–199
 kids rule, 200
 lifestyle shooting approach, 184–186
 minimizing signs of aging, 199
 mixed light, 195–196
 mood setting, 201
 one-light setup, 197
 outdoor shots, 189–191
 resources, 186–187
 showing versus telling, 201
 studio lighting, 197–199
 subject bonding, 200
 telephoto lens, 122
 wedding photography, 228–229
 window light, 194–195
Portrait Picture Style, 81, 84
PPI (Pixels Per Inch), 264
pre-ceremony shots, wedding photography, 223
presunrise light, 169
presunset light, 170
prime lenses, 117–118
printed/bound albums, 220
printers, 11
printing, Adobe RGB color space versus sRGB
 color space, 68
Program AE (P) mode, 23, 25–36

Q

Quick Control dial
 Access lamp, 8
 AEB (AutoExposure Bracketing) settings, 46
 AF point display, 13
 AF-point selection/Enlarge button, 8–9

Continued

Quick Control dial *(continued)*
 Auto Playback setting, 61
 color space setting, 70
 color temperature settings, 73–74
 Custom Function settings, 101
 custom white balance settings, 76–77
 date/time settings, 16–17
 erasing images, 62
 Exposure Compensation settings, 49
 file numbering, 22
 firmware updates, 243–244
 firmware version display, 243
 folder creation, 23
 formatting CF cards, 62
 histogram selections, 42
 image review time settings, 57
 index display, 61
 ISO settings, 53–54
 jumping between images, 59–60
 manually selecting AF points, 32–34
 moving between menu items, 4
 On/Off switch settings, 8
 Picture Style parameter editing, 86
 Picture Style selection, 85
 preset white balance settings, 73
 protecting images, 63
 rear panel control, 8
 registering camera settings, 107–108
 restoring default settings, 63–64
 sensor cleaning, 65
 Set button, 8
 specifying a color temperature, 80–81
 user-defined Picture Styles, 87–88
 White-Balance Auto Bracketing, 77–78
 White-Balance Shift, 79

R

rainbows, photo techniques, 180
RAM (Random Access Memory), 264
random noise, 51
RAW format
 AEB (AutoExposure Bracketing) sequence
 conversions, 46
 bit depth, 235
 click-balancing, 74
 conversion programs, 236–239
 custom white balance settings, 72–73
 defined, 264
 event photography, 154
 exposure techniques, 43
 file naming conventions, 19
 histogram evaluation tools, 40–42
 image characteristics, 234–236
 metadata, 233
 nature/travel/landscape photography, 168
 sample conversion, 239–241
 stock/editorial photography, 210
 versus JPEG format, 17–19
 wedding photography, 218
RAW+JPEG formats, 210, 218
Really Right Stuff Pro Flash Bracket (WPF-1), 222
rear focusing, lenses, 116
rear panel controls, 7–9
reception shots, weddings, 229–230
Reduce button, 8–9, 60
reflective light meters, 191, 264
reflectors
 bounce flash, 142
 defined, 264
 event photography, 152
 portrait photography, 188, 191
 stock/editorial photography, 208
Remote control terminal, N3-type connections,
 10–11
remote controllers, nature/travel/landscapes, 165
Remote Switch RS-80N3, 10–11
resampling, 264
resolution, 264
resources
 events, 149–150
 landscapes, 106–162
 nature, 160–162
 portraits, 186–187
 stock/editorial photography, 206–207
 travel, 160–161
 weddings, 219–220
RGB (Red, Green, Blue), 264
RGB color model, 20–21, 235
RGB histogram, exposure evaluation, 41–42
ring flash, 264
rotation devices, wedding photography, 222
rubber bulb blower, sensor cleaning, 64–65

S

safety pins, portrait photography, 189
Safety shift in Av or Tv (C.Fn-16), 98
saturation, 83, 264
scene coverage, telephoto lens, 122
scroll bars, moving between menu items, 4
Select folder screen, 23
Self-Timer drive mode
 AEB (AutoExposure Bracketing), 46
 Full Auto mode settings, 24
 nature/travel/landscape photography, 180
 Self-timer lamp, 9–10
 when to use, 55–56

Self-timer lamp, 9–10
Sensor cleaning screen, 65
sensors, 75–55, 248–250
Set button
 AEB (AutoExposure Bracketing) settings, 46
 date/time settings, 16–17
 file numbering 22
 folder creation, 23
 histogram selections, 42
 manually selecting AF points, 32–34
 menu item selections, 4
 menu selection/confirmation, 8
 Quick Control dial, 8
 rear panel control, 8
 submenu display, 4
Set function when shooting (C.Fn-01), 90
Set-up menu
 commands, 15–16
 Custom Function settings, 101
 data/time settings, 16–17
 disabling Shoot w/o card, 57
 extended ISO settings, 54
 file numbering, 22
 firmware updates, 243–244
 firmware version display, 243
 folder creation, 23
 formatting CF cards, 62
 registering camera settings, 107–108
 restoring default settings, 63–64
 restoring registered settings to defaults, 108
 sensor cleaning, 65
Set-up tab, control groupings, 4
sharp, 264
sharpen, 264
sharpness, Picture Styles adjustments, 83
Shooting menu
 AEB (AutoExposure Bracketing) settings, 46
 color space setting, 70
 commands, 14
 custom white balance settings, 75–77
 Picture Style parameter editing, 85–87
 Picture Style selection, 85
 specifying a color temperature, 80–81
 user-defined Picture Styles, 87–88
 White-Balance Auto Bracketing, 77–78
 White-Balance Shift, 79
shooting modes
 Av, Aperture-Priority), 5, 29–30
 B (Bulb), 5, 30–31
 C (Camera Settings) mode, 5, 31, 105–108
 M (Manual), 5, 30
 manually selecting AF points, 32–34
 Mode dial controls, 4–5

P (Program AE), 5, 25–26
Tv (Shutter-Priority AE), 5, 26–28
Shooting tab, control groupings, 4
Shutter button
 AE Lock setup, 44–45
 AF point display, 13
 AF point selection, 7
 drive modes, 54–56
 exposure control, 7
 manually selecting AF points, 32–34
 remote control terminal connections, 10–11
 top panel control, 5, 7
Shutter curtain sync (C.Fn-15), 97–98
shutter, 264
shutter release, Self-timer lamp, 9–10
shutter speeds, 13, 26–28
Shutter/AE Lock button (C.Fn-04), 92
Shutterfly, wedding albums, 220
Shutter-Priority (Tv Shutter-Priority AE)
 defined, 264
 semiautomatic mode, 23, 26–28
side lighting, 180, 264
side panel controls, 10–12
silhouette, 265
Single Lens Reflex (SLR), 265
Single Shooting mode, burst rates, 54
Single Shot mode, Full Auto mode settings, 24
single-focal-length lens, 117–118
skin tones, Exposure Compensation, 47–49
slave, 265
slide shows, Auto Playback, 61
slow, 265
SLR (Single Lens Reflex), 265
snapshots, P (Program AE) mode, 26
snow scenes, Exposure Compensation, 47–49
softboxes, wedding photography, 222
specifications, 251–255
speed, 265
Speedlite AF-assist beams, 36–37
Speedlite Transmitter (ST-E2)
 event photography, 151–152
 portrait photography, 188–189
 stock/editorial photography, 208
 uses, 136, 139, 143
 wedding photography, 222
Speedlites. *See also* EX-series Speedlites
 auxiliary light use, 142–143
 bounce flash, 142
 catchlights, 142
 FE Lock (Flash Exposure Lock), 140
 FEB (Flash Exposure Bracketing), 140
 Flash Exposure Compensation, 140
 flash sync contacts, 5

Continued

Speedlites *(continued)*
FP flash (high-speed flash sync), 141
lighting extremes, 144
PC terminal integration, 10–11
portrait photography, 188–189
stock/editorial photography, 208
wireless setups, 143
sport venues, event photography, 147
Spot meter circle, viewfinder display element, 13
spot meter, 265
Spot metering, 39, 175
sRGB color space, 24, 67–69, 265
Standard Picture Style, 81, 84
stands, stock/editorial photography, 208
stationery subjects, One-Shot AF mode, 34–35
ST-E2 (Speedlite Transmitter)
events, 151–152
portraits, 188–189
stock/editorial photography, 208
uses, 136, 139, 143
weddings, 222
stepladder, wedding photography, 222
stock photography
assignment aspect, 205
backup gear, 212
camera familiarity, 213
day rates, 213
economic opportunity, 203–205
editor coordination, 211
gear bag contents, 207–209
innovative conceptual approach, 203–204
leave space for text, 211
lifestyle images, 203
model releases, 212
niche content opportunity, 205
resources, 206–207
shooting techniques, 209–213
stop down, 265
stop. *See* apertures
storm chasing, nature/landscape/travel, 160
Storm Jacket, weather-proof camera
protectors, 163
studio lighting, 197–199
studio shots, color temperature settings, 71–72
subfolders, 22, 242
subject contrast, AF performance
enhancements, 37
submenus, moving between menu items, 4
sunrise light, nature/travel/landscapes, 169
sunset light, nature/travel/landscapes, 170
Superimposed display (C.Fn-10), 95
sync flash, EX-series Speedlites, 132–133

T
Tagged Image File Format (TIFF), 265
TC-80 N3 Remote Controller, 165
telephoto, 265
telephoto effect, 265
telephoto lenses
AF Stop button, 117
Canon types, 127–128
DO (diffractive optics), 117
Image stabilizer mode switch, 12–13
narrow scene coverage, 122
nature/travel/landscape photography, 165
perspective, 123
portrait photography, 188
shallow depth of field, 122
slow speed, 123
stock/editorial photography, 208
wedding photography, 222
terminals, side panel controls, 10–12
Thomas, J. Dennis (*Canon Speedlite System Digital Field Guide*), 144
Through The Lens (TTL), 265
TIFF (Tagged Image File Format), 265
Tilt-and-Shift (TS-E) lenses
Canon types, 128
distortion correction, 121, 125
time delay shots, B (Bulb) mode, 30–31
time zones, date/time settings, 17
time/date battery, estimated life, 11
time/date, settings, 14, 16–17
times, image review settings, 57
tissues, wedding photography, 231
tonal range, 265
Toning effects, Monochrome Picture Style, 88
top panel controls, 5–7
tracking sheets, workflow element, 242
travel photography
creative vision, 167
cross-lighting, 180
depth of field, 178–179
exposures, 174–177
gear bag contents, 162–166
landmarks, 181
people shots, 181
previsualizing the image, 180
research, 180
resources, 160–162
Self-timer mode, 180
shooting techniques, 166–181
side-lighting, 180
specialty areas, 159–160
travel-related publications, 159

Tripod mount, lens control, 12
tripod socket, bottom panel connection, 11–12
tripods
 events, 151
 nature/travel/landscapes, 165
 portraits, 188
 stock/editorial photography, 208
 weddings, 222
TS-E (Tilt-and-Shift) lenses
 Canon types, 128
 distortion correction, 121, 125
TTL (Through The Lens), 265
tungsten lighting, 265
Tv (Shutter-Priority AE) mode
 Mode dial control, 5
 semiautomatic mode, 23, 26–28
TV (television), Video Out terminal connections, 11
twilight, nature/travel/landscapes, 170

U

UD/fluorite elements, L-series lenses, 115
ultra-low dispersion (UD) lens, 265
Ultrasonic Motor (USM), lens designation, 115
umbrellas, 151, 222
underexposure
 defined, 265
 M (Manual) mode, 30–31
unsharp mask, 265
updates, firmware, 243–244
user-defined Picture Styles, registering, 87–88

V

value, 266
variable neutral-density filters, 172
variators, zoom lenses, 119
Velcro strips, wedding photography, 231
Video Out terminal, TV connections, 11
viewfinder
 AE Bracketing (AEB), 13–14
 AE Lock, 13–14
 AF points, 13–14
 aperture display, 13–14
 CF card error warning (Err CF), 13
 CF card full warning (Full CF), 13
 compensation adjustment display, 5
 defined, 266
 depth-of-field preview, 9–10
 dioptric adjustment knob, 9
 display elements, 13–14
 exposure compensation, 13–14
 exposure level indicator, 13–14
 FE Lock (FEL) Busy display, 13
 FE lock/FEB in-progress, 13–14
 Flash Exposure (FE) Lock, 13–14
 Flash mode, 13–14
 Flash ready, 13–14
 Focus conformation light, 13–14
 Focusing screen, 13
 High-speed sync (FP flash), 13
 maximum burst, 13–14
 No CF card warning (No CF), 13
 shutter speed, 13–14
 Spot meter circle, 13
 white balance correction, 13–14
vignetting, 266
VisibleDust, sensor cleaning, 64–65

W

warm, 266
warm-up filters, 172
water/dust-resistant construction, L-series lenses,
 116
WB correction/WB bracketing screen, 77, 79
WB SHIFT/BKT control, 77, 79
weatherproof sleeves, 207
weather-proofing, nature/travel/landscapes, 163
Web images, sRGB color space, 68
Web sites
 Alamy, 204
 American Society of Media Photographers, 149,
 206
 American Society of Photographers, 150
 American Society of Picture Professionals, 206
 AsukaBook, 220
 BetterPhoto.com, 187
 Canon Digital Learning Center, 150
 Canon Explorers of Light, 150, 160–161, 187
 copyright.gov, 242
 Corbis, 204
 Creative Eye, 206
 The Digital Journalist, 206
 Digital Photography Review, 50
 Digital Railroad, 150
 EP (Editorial Photographers), 206
 event photography, 149–150
 Event Photography System, 150
 event-oriented programs, 150
 ExpoDisc, 74
 Express Digital, 150
 firmware updates, 243
 FotoMagico, 219
 Fred Miranda, 161
 Getty Images, 204
 iDVD, 220
 iFly.com, 162
 Imaging-Resource, 166

Continued

Web sites *(continued)*
 jAlbum, 220
 Jim Reed's weather photography, 204
 Ken Rockwell/bokeh article, 120
 landscape photography, 160–161
 Lauren Greenfield, 210
 Meg Smith, 224
 model/property releases, 150
 More Photos, 150
 National Geographic, 161
 National Geographic Traveler, 161
 National Press Photographers Association, 206
 Nature Photographer Magazine, 160
 Nature Photographers Online, 160
 nature photography, 160–161
 North American Nature Photography
 Association, 161
 Performer Software, 150
 Photo Reflect, 150
 Photographer's Market, 161
 Picasa, 150, 220
 Plus, 150
 PPA (Professional Photographers of America),
 187
 Really Right Stuff, 222
 Showit Web, 219
 Singh-Ray's Vari-ND Variable Neutral Density
 Filter, 172
 Slideshow Company, The, 220
 Society of Sport and Event Photographers, 149
 Society of Wedding and Portrait
 Photographers, 186
 software updates, 243
 Soundslides, 219
 Stephen Wilkes, 167
 Stock Artists Alliance, 207
 Stock Photo Price Calculator, 207
 Storm Jacket, 163, 207
 Transportation Security Administration, 162
 travel photography, 160–161
 Travels to the Edge with Art, 160
 US Copyright Office, 207
 VisibleDust, 64
 WhiBal cards, 74
wedding photography
 avoiding advice, 232
 AE Lock (Auto Exposure Lock), 43–45
 backup gear, 232
 bridal magazines, 216
 candid shots, 231
 ceremony shots, 225–227
 contracted-shooting time, 231
 Custom Functions sample, 102–103, 105

 detail images, 227–228
 family relationships, 232
 family shots, 228–229
 final proof showing, 232
 formal portraits, 228–229
 gadget-bag contents, 231
 gear bag contents, 220–222, 231
 multifaceted field, 215–216
 photo packages, 218
 portrait shots, 228–229
 pre-ceremony shots, 223
 preplanning, 215
 P (Program AE) mode, 26
 printed/bound albums, 220
 RAW+JPEG formats, 218
 reception shots, 229–230
 refreshments, 232
 remaining calm, 232
 resources, 219–220
 shooting techniques, 222–232
 subject bonding, 215, 231
 visual story-telling, 215–216
WhiBal cards, click-balancing, 74
white balance
 auto bracketing, 77–78
 Av (Aperture-Priority AE) mode, 30
 click-balancing, 74
 color temperatures, 70–74
 custom white balance settings, 72, 74–77
 defined, 266
 Full Auto mode settings, 24
 preset settings, 71, 73
 specifying a color temperature, 80–81
 Tv (Shutter-Priority AE) mode, 27
 viewfinder display element, 13–14
 White-Balance Shift settings, 78–79
White balance/AF mode button, 5
white cards, click-balancing, 74
White-Balance Auto Bracketing, setting, 77–78
White-Balance Shift, settings, 78–79
wide angle, 266
wide-angle lenses
 AF performance enhancements, 37
 angle of view, 120–121
 distortion, 121
 event photography, 151
 extensive depth of field, 121
 keystoning, 121
 nature/travel/landscape photography, 165
 perspective, 122
 portrait photography, 188
 stock/editorial photography, 208
 wedding photography, 222